# Female Bodies on the American Stage

# Female Bodies on the American Stage

## Enter Fat Actress

Jennifer-Scott Mobley

palgrave
macmillan

First published in 2014 by PALGRAVE MACMILLAN* in the United States—a division of St. Martin's Press LLC, 175 Fifth Avenue, New York, NY 10010.

Where this book is distributed in the UK, Europe, and the rest of the world, this is by Palgrave Macmillan, a division of Macmillan Publishers Limited, registered in England, company number 785998, of Houndmills, Basingstoke, Hampshire RG21 6XS.

Palgrave Macmillan is the global academic imprint of the above companies and has companies and representatives throughout the world.

Palgrave* and Macmillan* are registered trademarks in the United States, the United Kingdom, Europe and other countries.

ISBN: 978-1-137-43066-3

Library of Congress Cataloging-in-Publication Data

Mobley, Jennifer-Scott, 1970–
 Female bodies on the American stage : enter fat actress / by Jennifer-Scott Mobley.
       pages cm
 Based on the author's thesis (doctoral)—City University of New York.
 Includes bibliographical references and index.
 ISBN 978-1-137-43066-3 (alk. paper)
    1. Theater—Casting—United States. 2. Body image in the theater—United States. 3. Actresses—United States—Social conditions. 4. Overweight women in literature. 5. Overweight women—United States. I. Title.
 PN2293.C38M63 2014
 792.02′80820973—dc23

                                                            2014008960

A catalogue record of the book is available from the British Library.

Design by Amnet.

First edition: September 2014

10  9  8  7  6  5  4  3  2  1

For all my beautiful students,
especially those friends of ED; you are perfect.

# Contents

List of Illustrations ix

Acknowledgments xi

Introduction 1

1   The Body as a Cultural Text 9

**Part I   Fat Dramaturgies**

2   Fat Center Stage 31

3   Fat Love Stories 49

4   Monsters, Man Eaters, and Fat Behavior 63

**Part II   Fat Subjectivities**

5   Bodies Violating Boundaries 85

6   Fat Black Miscegenation 97

7   Queering Fat 113

8   Fat-Face Minstrelsy 123

**Part III   Reclaiming Fat**

9   Dangerous Curves 141

10   Enter Fat Actress 163

Conclusion: Rethinking Realism 175

Notes 187

Bibliography 209

Index 217

# List of Illustrations

| 1.1 | Lillian Russell, 1861–1922 | 13 |
| 1.2 | Picturesque America, anywhere in the mountains | 15 |
| 4.1 | Kathleen Turner in *Who's Afraid of Virginia Woolf*? | 80 |
| 8.1 | Kirstie Alley at the *Fat Actress* premier | 129 |
| 10.1 | Melissa McCarthy at the 2011 Emmys | 166 |
| 10.2 | Lena Dunham at the 2013 Golden Globes | 171 |

# Acknowledgments

I am delighted to finally have the opportunity to thank those people and institutions that helped make *Female Bodies on the American Stage* a reality. This work began as a dissertation project in the Theatre Studies program at the City University of New York Graduate Center; therefore I must first express my gratitude to Judith Milhous, my dissertation chair, and Pamela Sheingorn, both of whom encouraged me to pursue this project and acted on my committee, as well as the rest of my committee, David Savran and Maurya Wickstrom. Thank you all for your guidance and feedback throughout the process.

I owe thanks to the New York Public Library of the Performing Arts, which awarded me a short-term research fellowship that enabled me to bring the final manuscript to fruition. I'm grateful to the librarians in the Theatre on Film and Tape Archive who helped me locate materials, and I'm especially indebted to Jeremy MeGraw, who patiently helped me track down photos.

I am terribly grateful for the editorial staff at Palgrave, especially to Robyn Curtis whose enthusiasm for the project facilitated my progress, and to Erica Buchman who has been immeasurably helpful and patient throughout. Thanks also to Daniel Gundlach whose "fresh eyes" and feedback were truly invaluable.

I am also indebted to the Women and Theatre Program of ATHE for providing me a home for my scholarship as well as camaraderie and mentorship. I'm so grateful to all those who have graciously moderated or served on panels that I've organized, read my work, offered me guidance and feedback, and whose work has inspired me: Jill Dolan, Rose Malague, Maya Roth, Erica Stevens-Abbitt, and particularly Sara Warner, who has been the most generous of mentors and a staunch advocate and cheerleader. I also owe thanks to my Rollins colleagues for their enthusiasm and support, particularly Jennifer Cavenaugh for her advice, feedback and our writing dates. My colleagues from the CUNY Graduate Center have made the journey meaningful and offered me support and friendship over the years. Thanks to Amy Hughes for her warm encouragement and to Ken Nielsen, who has shared his brilliant insights and brainstormed many

an idea with me on cocktail napkins, and especially to Jill Stevenson, who has been a dear friend throughout every step of the process and would have picked me up and carried me across the finish line if she had to.

I'm also grateful to the "civilians" in my life who offered me support and ideas, sent me newspaper articles, copyedited drafts, and let me brainstorm with them endlessly: Sea Aviar, Bill Broderick, Routh Chadwick, Cheryl Della Pietra, Kelly Matika, and Karen Hardcastle. Mom and Dad: You gave me my passion for reading and learning. Thank you for your love and for always believing in me. Thanks to Carter and Karen for your encouragement. And to Mark Ransom, my copyeditor, meal-cooker, cocktail shaker, hand-holder, cross-country chauffer, and creative muse, thanks for the many debriefing sessions at Cody's and everything in between. I would not have wanted to do this without you by my side.

# Introduction

Many were stunned when they heard the news that iconic American actor James Gandolfini had suffered a fatal heart attack. Within hours of the announcement, some who had worked with him were tweeting to express sadness and their regard for him as a performer and colleague, but other anonymous or noncelebrity tweeters took the opportunity to crack a joke at the expense of his fat appearance or even suggest that he deserved to die because he was fat. One remarked, "People say they are shocked by the death of James Gandolfini. Really? Do they think enormous fat men live forever?" Another tweeted: "James Gandolfini died because he was fat and unhealthy. End of Story." Another quipped (referencing Gandolfini's Emmy-winning portrayal of the mafia character Tony Soprano on HBO's series *The Sopranos*), "For James Gandolfini I propose not a minute of silence but a minute of strained heavy breathing, followed by some cannoli."[1]

Americans hate fat people. To be fat is to be aberrant, to be "othered," and to be stigmatized in America. At least that is what the news and media suggest, thus enabling fat to remain a (largely acceptable) site for social, political, and legal prejudice. Indeed, fat prejudice is the last remaining acceptable social and legal bias toward an individual or identity group. Unlike gender, race, or sexuality discrimination, which over the course of the last century have arguably decreased, although certainly not disappeared entirely, fat discrimination has increased. Certain companies penalize their workers for being "overweight" by increasing insurance rates or offering fewer perks to individuals perceived to exceed weight guidelines. Insurance companies can choose to deny coverage or raise premiums relative to weight standards. Fat people are less likely to get jobs and more likely to be paid less than their counterparts.[2] Fat is targeted daily in virtually every media form as alternately loathsome, disgusting, shameful, or comical; it is something to be disdained, feared, and avoided at all costs. Fat is depicted in popular media as a social blight threatening the well-being of our nation not just physically but politically, economically, and morally. Fat is the physical manifestation that signals an individual's unwillingness

to live up to the American Dream; it is a semaphore that marks a body as lacking in self-reliance, a failure of free will and self-determination, and it exposes our weakness as a culture.

To be a fat white woman is to be a particular pariah. She defies a myriad of cultural, moral, and social rules, which mark her as inferior and subject her to derision. Like most middle-class white girls growing up in the United States, I was acutely aware of the stigmatization associated with being perceived as "overweight," and this awareness intensified when I became interested in theatre and performing. As an actress I quickly learned that the way people perceived my size, which at five foot eight and 150 pounds was not slender enough to be a "neutral" female body, strongly influenced the roles in which I was cast. As I made the casting rounds for stage and screen, regionally and in Los Angeles and New York, multiple agents and casting directors advised me to "lose twenty-five or gain fifty" because my appearance rendered me "unbelievable" in leading female heteronormative roles. From Desdemona to Laura in the *Glass Menagerie*, to Nora in *A Doll's House,* perceptions of my body size, not my skill, were a central consideration in my casting. When I was cast in certain roles, I often received critical feedback regarding the way my size somehow colored the narrative of the play. Not surprisingly, I was often cast in roles much older than my actual age. This was somehow considered more realistic than casting me as the heteronormative age-appropriate romantic female lead. On the other hand, I was a shoe-in for any age-appropriate role that called for a lesbian.

These experiences inspired the central inquiry of this book, which is, How do Americans read or interpret fat females in representation? How do we aesthetically define what constitutes a fat or "overweight" female body? What is the significance of the favored cultural aesthetic of beauty as represented by extremely slender white women frequently with artificially enhanced breasts? What are the deeper social and political ramifications of the proliferation of this model in the media? As a theatre scholar and practitioner, my study is rooted in live performance; on one hand, theatre is arguably the least guilty of all popular entertainment in rigidly adhering to this aesthetic, but on the other, it is a powerful place to interrogate this phenomenon because of the nature of live performance where spectators are in the presence of live bodies.

This book investigates what the figure of the fat woman signifies, primarily in theatre but also in other media forms such as television and film. I begin by exploring a cultural shift. In the late nineteenth century bodies of celebrated female performers were what I call "more-than": that is, visually ample, busty, fleshy, soft, and curvy or round. The popular aesthetic for beauty praised women's bodies for being "more-than" because a bodacious figure demonstrated health, wealth, and fertility. However, over the course

of the twentieth century the "more-than" bodies of these female perform-
ers once revered because of their embodied visibility, even celebrated for
their uniqueness and fleshy curves, were compelled to disappear, to dis-
cipline themselves into a neutral canvas—an excessively slender, homog-
enous figure—upon which roles could be "realistically" portrayed for an
American audience.

Throughout this book I use the word *fat* as both a descriptor and a kind
of lived identity. Like other scholars in the emerging field of Fat Studies, I
wish to remove pejorative connotations from the word as well as to dis-
tinguish it from medical implications associated with the word *obesity*,
and thereby to reclaim *fat* in a more theoretical context. I aim to destabi-
lize negative stereotypes and imbue the word *fat* with fresh sociopolitical
implications similar to the way in which the word *queer* has evolved in the
academy and in lesbian, gay, bisexual, and transgender/transsexual arenas.

I am also keenly aware that fat is deeply subjective; an individual's defi-
nition of what visually constitutes a fat person varies significantly relative
to their race, culture, socioeconomic status, and personal aesthetic. Thus
I position fat as fluid and inclusive of any woman's body that is consid-
ered excessive or somehow outside the standard of American society's
perceptions of normal or neutral, whether it is considered "overweight"
or "oversize." This "more-than-ness" might include a woman who is of
above-average height, broad shouldered, thick waisted, or large breasted,
to someone you might describe as "big boned," "chunky," "zaftig," or simply
fat. In this respect, fat encompasses a range of nonnormative body types.
Moreover, I purposefully avoid the words *obese* and *overweight* because
of their implied medical connotations and (frequently inaccurate) health-
value assessments.

This book seeks to understand the evolving and nuanced ways Ameri-
cans "read" fat in performance as influenced by our culture and the so-
called rise of the "obesity epidemic." I focus on a selection of primary texts
from twentieth and twenty-first century plays as well as the bodies of select
female performers who, I will argue, are a kind of embodied cultural text.
In the case of the latter I will examine the critical reception of actresses'
performing bodies and how that colors spectators' responses to the fat
actress's interpretation of a role. From a casting perspective, what assump-
tions about a character are made and inscribed for audiences when the size
of a performer's body somehow exceeds society's notion of a neutral body?
In the case of the former, I will identify what playwrights are expressing
when they specifically create fat female characters or somehow distinguish
a character's personality and interaction through language and stereotypes
associated with fatness. Why is it that when we have a character with some
excessive trait, very often casting turns to body types considered fat or

"big"? My study focuses primarily on fat or unconventionally big female bodies, because adding fat men complicates the discussion exponentially in terms of gender roles and assumptions and would double the length of this study. Many of my examples are drawn from theatre, which as I mentioned, is a fruitful place to investigate these questions because of the live immediacy of a performer's body. Unlike film or television, spectators are in the presence of the performer's full body. There is no directing the spectator's gaze or disguising a performer's shape through camera angle or artful cropping of the frame.

Furthermore, I limit my analyses to plays and cultural texts rooted in the tradition of realism, which is the prevalent mode of theatrical performance style that reaches a wide middle-class audience. I explore models of representation that fit within a broad field of cultural production encapsulated by theatrical realism and within that various subsets, restricted fields which assume a primarily white, middle-class audience. I am focusing on this demographic of a middle-class audience not only as the primary consumers of commercial theatre (frequently rooted in realism) but also as the biggest consumers of mass-media entertainment and therefore the most susceptible to marketing trends in product consumerism as well as the proliferation of women's images associated with it. I believe the audience-spectator contract implicit in realism as a theatrical style stipulates that these fat performing bodies are "real" or authentic and influences critical reception of performers and the characters they are playing. As Elin Diamond points out: [R]ealism celebrates positivist inquiry, thus buttressing its claims for 'truth to life' . . . Realism is more than an interpretation of reality passing as reality; it *produces* 'reality' by positioning its spectator to recognize and verify its truths . . . Because it naturalizes the relation between character and actor, setting and world, realism operates in concert with ideology.[3]

When an audience watches a performer in the mode of realism, they assume an underpinning of psychological makeup for a character that is integral to what I am exploring. In other words, if spectators accept that the performing bodies are real and authentic and agree that performers and playwrights are attempting to present logical reality to an audience who is supposed to approach the play empirically, understanding actions and characters as indicative of their personal viewpoint, appreciation of that character differs from watching a performer in the mode of fantasy, absurdism, or extreme satire, such as when a "normal-sized" actor dons a fat suit, as Gwyneth Paltrow did for *Shallow Hal* (2001), for example. I suggest that most people have a visceral response to being in the presence of a real flesh-and-blood fat person or, in the case of film and television, to believing they are seeing a real fat person, or to witnessing the truth of a fat person's story. A counter example would be the performances of Lisa

Mayo of Spiderwoman Theater (or any number of lesbian/feminist art-
ists) who perform deconstructed, fragmented texts in nonrealistic modes,
often appearing in drag, or undressed, displaying fat bodies and "imper-
fect" breasts and so on. Because this kind of theatre makes no claim to be
realism, critical reception to Mayo's performing body (race aside) is not
comparable to critical reception should she play Mama in Marsha Nor-
man's *'night, Mother,* for example. Although some of the plays I will discuss
have nonrealistic elements, they all call for an acting style that draws on
the tradition of realism and Stanislavski-based character interpretation,
which aims for psychological development of character and truthfulness
of emotion.

This book explores the ways that fat actresses in dramatic and other
mediatized representations are imbued by writers, directors, and specta-
tors with a variety of stereotypes and psychological pathologies that are
constructs of American cultural attitudes toward fat. The United States has
a unique cultural perspective on fat, steeped in our founding traditions
of self-determination and puritan morality, exacerbated by our material
abundance and capitalist economy.

Following the introduction, the first chapter, "The Body as a Cultural
Text," offers a brief historical overview of changing attitudes toward fat
and dieting in the United States since the late nineteenth century and out-
lines my theoretical framework. Tracing the evolution of attitudes toward
female bodies in performance from the celebration of stars such as Lillian
Russell to current reception of fat bodies, I illustrate how the female body
is, itself, a cultural text upon which we map changing social and political
values. Positioning the medical and media discourse surrounding fat and
the "obesity epidemic," I briefly offer research and a counter narrative to
the widely held beliefs perpetuated by the media surrounding the relation-
ship between health risks and body size. The book is then divided into
three sections, "Fat Dramaturgies," "Fat Subjectivities," and the final sec-
tion, "Reclaiming Fat," which includes the chapters "Dangerous Curves"
and "Enter Fat Actress." "Fat Dramaturgies" consists of three chapters that
explore what I call "fat dramaturgy," or the ways in which playwrights use
fat to construct characters or shape plots. These chapters emphasize textual
analyses of American plays primarily from the past thirty years that spe-
cifically incorporate fat female characters or somehow use fat stereotypes
as a metaphor to explain characters' behavior or psychology. I also con-
sider actresses who originated "fat lady roles" or received particular criti-
cal attention in their roles. I discuss how their bodies functioned as a lens
through which audiences read their onstage character.

Chapter two, "Fat Center Stage," explores the fat dramaturgy of plays
that directly call for a fat character or feature women's bodies and dieting

as the central part of their subject matter. I discuss what this means in terms of character psychology and dramatic structure. For example, I look at Lynn Redgrave's breakout performance in *My Fat Friend* on Broadway in 1972 in the context of her well-publicized weight loss at the time.

Chapter three, "Fat Love Stories," examines plays that treat the problem of romantic love between a "normal-sized" man and a fat woman. Examining plays ranging from Eugene O'Neill's *A Moon for the Misbegotten* (1947), featuring actresses including Colleen Dewhurst and Cherry Jones, to Neil LaBute's *Fat Pig* (2004), starring Ashlie Atkinson in the title role, I identify how, despite the span of over sixty years between the plays in question, a through line connects all the heroines in terms of their psychological makeup.

Chapter four, entitled "Monsters, Man Eaters, and Fat Behavior," identifies a number of plays written by men that construct female characters and shape their personalities through a myriad of negative stereotypes associated with fat women as voracious consumers who threaten equilibrium in the world of the play. Frequently, powerful female characters or those who are seen as inappropriately aggressive are identified as fat either directly in the text or metaphorically, and characterization is subsequently reflected in the casting of a fat actress—a female performer who is perceived as "more-than." Fat women are also frequently characterized as sexual predators or masculine and thus emasculating to male protagonists. With examples such as Martha in Edward Albee's *Who's Afraid of Virginia Woolf?* (1962) as well as numerous characters from Tennessee Williams's canon, I will demonstrate how playwrights create characters by using associations explicitly linked to fat/consuming women.[4] This chapter establishes the concept of "fat performativity" and the ways in which playwrights use what is culturally perceived as fat behavior as a dramaturgical strategy.

The second section is called "Fat Subjectivities." These four chapters explore fat subjectivities and the various intersections among "othered" bodies in performance. Here I consider fat not only as a lived identity but as a performative strategy. As a counterpoint to exploring texts written by white playwrights about white women and geared toward a homogenous, white, heteronormative middle-class audience, the first three chapters in this section explore plays written by female playwrights and playwrights of color potentially intended for a more diverse audience. Chapter five, "Bodies Violating Boundaries," studies female subjecthood as represented through some of Paula Vogel's characters who attempt to negotiate and frequently violate American cultural boundaries of body size and consumption. Vogel ironically challenges popular narratives by depicting sympathetic characters who suffer physical or psychic violence in the course of the dramatic action because they exceed their boundaries either spatially

in the world, by being fat, having excessive proportions, or by eating too much (also associated with outspokenness). By looking at a cross-section of Vogel's plays, such as *How I Learned to Drive* (1997), *Hot 'N' Throbbing* (1993), *Baltimore Waltz* (1990), and *The Oldest Profession* (1981), I demonstrate how women's bodies become a site of danger when they exceed culturally acceptable margins of body size. Furthermore, I examine the relationship between their appetite for food and sexual appetite.

Chapters six and seven, called "Fat Black Miscegenation" and "Queering Fat" respectively, examine plays that feature women of color or lesbian characters. I assert that in various modes of representation there is a connection between fat and racial or sexual otherness. In addition to asking how American audiences read a fat black (female) body versus a fat white body in performance, I explore the link between fat and racial or sexual difference as depicted in cultural texts. Fat, like race, is something worn on the outside. It is immediately visible to the spectator. A fat person cannot "pass" visually as normative. On the other hand, fat, like homosexuality, is considered by some to be a choice and thus is deeply imbricated with questions of agency and (religious) morality. These chapters explore the interplay between fatness and racial or sexual otherness through plays including August Wilson's *Ma Rainey's Black Bottom* (1984), Suzan-Lori Parks's *Venus* (1995), the musical *Hairspray* (2002), and *The Killing of Sister George* (1965), which exploits the stereotype of the fat lesbian, as well as *The Secretaries* (1994) by the Five Lesbian Brothers.

Chapter eight, "Fat-Face Minstrelsy," interrogates television network programming that capitalizes on the national obsession with fat and the obesity epidemic in part by presenting stereotypes. I focus on Kirstie Alley's self-produced TV show *Fat Actress* (2005), which exploits fat stereotypes and engages in anti-woman, anti-fat, self-loathing comedy to such a degree that I argue it creates a kind of "fat-face minstrelsy."[5] Alley's performance and the "weightist" comedy of the program hark back to the racist humor of popular-culture entertainments ranging from blackface minstrelsy and Jumpin' Jim Crow to *Amos-n-Andy*. Alley's "fat-face minstrelsy" preys on grotesque fat stereotypes and thus capitalizes on the national panic surrounding obesity. I contrast Alley's program with the first season of *Mike & Molly*, another half-hour comedy featuring fat actress Melissa McCarthy (recently called "tractor sized" and a "hippo" by film critic Rex Reed).[6] I identify the cultural and market appeal for this fat humor.

The last section, "Reclaiming Fat," focuses more exclusively on female performing bodies and the reemergence of female body diversity in popular representations—the return of the "fat" actress. I examine specific performances/performing bodies from Roseanne to Claudia Shear and Lena Dunham, creator and star of the HBO series *Girls*, to analyze the ways in

which they embrace, exploit or reject cultural assumptions about fat. I address a variety of media including theatre, television, and stand-up comedy, and look at how some artists have used their unconventional body type overtly as a political weapon or, more subtly, to enhance a theme within a larger narrative. For example, I begin chapter nine, entitled "Dangerous Curves," by examining Claudia Shear's performance in *Blown Sideways Through Life* (1995) through the lens of identity/gender theory in order to show how Shear uses her "invisible-conspicuous" body to invert the hegemonic power matrix in which thin is equated with power and status.[7] There is also a strong tradition of stand-up comediennes writing their own material who have crossed over into film or TV and who challenge cultural assumptions about body size through their routines and their actual performing bodies, among them Roseanne and Margaret Cho, each of whom also embodies other qualities commonly associated with fat.

The latter half of this chapter, "Rethinking Realism," builds on Anthony Kubiak's theory that "[T]heatre as a phenomenon represents a historically situated critical feedback loop that moves from play to culture, from culture to unconscious subject, and back again." Furthermore, he asserts that U.S. culture has been unknowingly immersed in, and formulated through, cultural practices of seeing and being seen. Americans, Kubiak states, have a "habit of relying upon reenactment and repetition to establish the truth of events and the authenticity of people." Thus, in U.S. culture, the copy threatens to overtake the original in its claim to the authentic.[8] I argue that the theatrical style of realism is so invested in the "cult of slenderness" that any performing body that does not adhere to Hollywood standards of beauty may actually be understood as "unrealistic" by a contemporary audience. In other words, contemporary audiences are so conditioned to seeing the homogenous female form in leading roles in film, television, and on stage—this form being the extremely slender woman—that were Rebel Wilson, for example, to be cast as a romantic lead in a play, many spectators would likely find it "unbelievable."[9] Her appearance would either distract from the storytelling or add a layer of meaning to the story regardless of the actual script. This theory also applies to television; when Lena Dunham's character on *Girls* had sex with a character played by Patrick Wilson, a conventionally attractive (and slim) man, critics and viewers responded virulently, arguing that the characters were "unrealistically" coupled and sexually incompatible due largely to Dunham's figure. Thus, this chapter considers recent developments in television and film in order to explore trends in programming that are empowering fat actresses and potentially disrupting weightist narratives. It concludes with a "Fat Manifesto," a discussion of how we might fully reclaim fat from the margins of culture through rethinking realism.

# The Body as a Cultural Text

## Mythologies of the Female Body

In order to position my argument within a cultural context, I begin by offering a brief historical overview of the mythologies, iconography, and ancient narratives associated with women's bodies, followed by a trajectory of dieting culture in the United States. I am not the first to suggest that female bodies continue to serve as a lightning rod for cultural fears and prejudices. From the earliest philosophers, such as Aristotle, Plato, and Descartes, who linked the masculine to a "higher" plane of spirituality and reason in contrast to the feminine, which was linked to all that was earthly and flesh bound, to the discourse of modern psychology including Freud and Lacan, the female body has always been viewed as problematic, mysterious, and sexually dangerous.[1] Simone de Beauvoir points out in *The Second Sex* that the philosophical categories of Self/Other have been superimposed on the binary oppositions in Western culture of man/woman. The male Self has traditionally been associated with the mind as something transcendent, while the female Other is trapped in the body, associated with the biological processes of menses and childbirth and therefore defined and evaluated by bodily functions, shape, and size.[2] It follows logically that fat women are targeted by "weightism" more than men, because according to the aforementioned paradigm, which is at the base of Western philosophy, a woman *is* her body, her body *is* her identity, and her fatness points to a multitude of social and cultural transgressions. The fat female form is associated with a myriad of negative connotations as well as with racial and sexual otherness. Her fat body provokes ideological questions of morality, control, and self-discipline.

Beginning with the earliest fairytales heard in childhood and extending to the advertising we face every day, a woman raised in the United States is barraged with stories and images that tell her that her body is potentially dangerous, dirty, leaky, hairy, flabby, and therefore an implied threat to the social order that must be controlled and disciplined. As Paul Campos states

in his groundbreaking book *The Obesity Myth*, "[W]e live in a culture that tells the average American woman, dozens of times per day, that the shape of her body is the most important thing about her, and that she should be disgusted by it."[3] Certainly, despite advances made in women's civil rights in the last fifty years, thanks in part to our capitalist and consumer culture and the explosion of visual media, the pressure on women to maintain a certain homogenous standard of slenderness and beauty has, if anything, grown.

Legends, fairytales, and religious parables from Western European culture are filled with stories of women as monstrous consumers and destroyers of men, whose vengeance and sexual power are linked to their voracious appetites. For example, the Bible holds many stories conflating female sexuality with appetite and danger. Adam and Eve were cast out of the Garden of Eden owing to Eve's defiance in eating the apple. Not only did her unruliness bring about this loss of innocence for mankind, but henceforth a woman's body was marked with original sin.[4] The vengeful Salomé (urged on by her adulterous mother) demanded that King Herod present her with John the Baptist's head on a plate as a reward for her sensual dance.[5] Traditional Western European fairytales and oral tradition are also filled with stepmothers, witches, and other evil women who eat their victims. Who can forget the witch in *Hansel and Gretel*, who lured innocent children with sweets in order to fatten them up and eat them herself? Snow White's wicked stepmother feeds Snow White the poisoned apple, and she "dies" with her first bite. Mother Goose's English nursery rhymes abound with fat, troublesome wives, such as Jack Sprat's wife who "could eat no lean." Monstrous mermaids appear in many cultural mythologies. Their common feature is the threat they pose to sailors due to their habit of falling passionately in love and forgetfully dragging their sailor-objects below the sea, thus drowning them. In Great Britain the traditional mermaid was also a giantess up to one hundred and sixty feet tall who, while not always vengeful, would still kill a man with her "big love."[6] The notion of women as dangerous eaters continues to prevail in American cultural texts. Contemporary advertising frequently characterizes female consumers as out of control, at the same time encouraging women to "be bad" and indulge in that ice cream or forbidden dessert.[7] The fat woman who accidentally crushes a man or some other smaller creature is a staple joke in commercials and movies.

In middle- and upper-class culture, fat white women are simultaneously invisible and conspicuous. They are often viewed as second-class citizens, objects of shame, fear, and loathing.[8] Assumptions are made about women's moral character, class, and emotional pathology based on this outward appearance. Indeed, as I stated in my introduction, fat prejudice has become the one socially acceptable bias based on outward appearance. If, as Mary Douglas asserts, "the body is a powerful symbolic form, a surface on

which the central rules, hierarchies, and even metaphysical commitments of a culture are inscribed and reinforced through the concrete language of the body," then the increasing anxiety about fat bodies reflects deeper cultural meaning.[9] As Pierre Bourdieu and Michel Foucault have pointed out, the body is a direct conduit for social control, and in contemporary culture the discipline of the female body in particular is an enduring example of social, political, and gender oppression.[10] As I have discussed, in Western philosophy a woman's body is traditionally associated with the base and material, and indeed her body is her identity, whereas a man's identity is connected to his soul and intellect. Thus, in order for a woman to make the transition from nature to culture, she must control her earthly appetites with food consumption as the outward metaphor and discipline her body into what Foucault calls a nonthreatening "docile body."[11]

Foucault has argued that modern societies are no longer structured such that the monarch (an individual) wields authority over an anonymous body of subjects. Rather, authoritative power is created via a network of cultural practices, social institutions, and modern technologies.[12] The female body and societal constructs of femininity are at the center of this patriarchal structure in the United States, which continues to oppress women of all classes and races. In an age where women are seemingly more free in the public arena, the constraints of culturally prescribed femininity (including, at the top of the list, weight control) have intensified so that a modern, middle-class woman in particular spends an inordinate amount of time and money pursuing the ever-evolving, homogenous ideal of slender beauty.

In *Discipline and Punish*, Foucault also points out that the "classical age discovered the body as an object and a target of power."[13] He traces the movement in Western European cultures in which punishment and discipline moved from public displays of corporeal and capital punishment to social hierarchies and punishments that seek to control and imprint societal rules upon the individual's conscious mind and soul. In modern society, political allegiance and appropriation of bodily labor are no longer sufficient. Society must produce "docile bodies," wherein size, movement, and gesture must be regulated. Foucault's discussion of the Panopticon, Jeremy Bentham's model for a prison, in which each inmate is alone, shut off from communications with others, but constantly visible from a central tower, is a useful metaphor for understanding modern social control and the insidious psychic influence on women in contemporary America. The effect of the Panopticon is "to induce in the inmate a state of constant and permanent visibility."[14] In this age of technology, thanks to home computers and the Internet, individuals are at once more isolated than ever in terms of daily human interaction with a community, while these same advances allow for instant, global communication. Women have so deeply

assimilated the messages of mass media concerning beauty and slenderness that we operate under a version of Foucault's Panopticon.

Moreover, women police themselves from within. Any woman who engages in ubiquitous rituals of beauty maintenance such as applying and checking her makeup in the mirror multiple times a day, coloring her hair at regular intervals, waxing facial and body hair, monitoring her food intake, expressing or feeling shame when she consumes any food that she considers "bad," and who diligently exercises to discipline her figure to embody the firm and slender beauty norms popularly represented in mass media, is an inmate of the Panopticon, a self-policing subject. She is constantly engaged in self-surveillance, trying to live up to American ideals of beauty. The time and money, not to mention emotional investment, that go into these beauty practices exemplify the way in which women are insidiously oppressed by cultural beauty standards.[15] Indeed, if we take representations of women as seen in widely disseminated cultural texts such as television, film, and advertising as the contemporary beauty ideal, then we accept a beauty standard that is virtually impossible to achieve in nature: that of a tall, light-skinned, slim hipped, extremely thin woman with large breasts. Many of these images are altered by technology or portrayed by models/actresses who are surgically enhanced, yet they are still represented as the (possible) ideal. In fact, without the help of implants, it is rare that a woman can maintain such a low percentage of body fat and still have large breasts. Supermodel Linda Evangelista, who claims authenticity as far as her appearance is concerned, has been quoted saying, "the whole thing about models, and I hate using this term, but we are genetic freaks."[16] Regardless, a significant majority of middle- and upper-middle-class American women with varying levels of education and economic status either continue to pursue this ideal or at least remain highly conscious of it.

Thus, the female body is more than biological; rather it is a historicized cultural text that is shaped and understood in the context of the social and economic organization of our society. The perfectly slender, toned female body understood as the health and beauty ideal is a construct evolved from many cultural influences and practices, the least compelling of which are the debatable health benefits.

## How Did We Get Here? Fat History in America

In order to illuminate the cultural mechanisms through which the female body is constructed in present-day society, here I will offer a historical overview of attitudes about fat and trends in dieting in the United States. To understand what fat means in representation, what a playwright is communicating when calling for a fat character, or how an American audience reads a fat body onstage, it is necessary to see the roots of the cultural construction of

fat beginning around the turn of the nineteenth century into the twentieth century. This is when excess weight became undesirable and repulsive, a sign of weak self-discipline and poor moral character. Dominant white middle-class culture has developed a unique perspective on fat and dieting that is inextricably linked with our forefathers' Puritan morality and Victorian work ethic as it came into conflict with capitalist ideals and the growth of American consumerism.

Cultural historians agree that the American obsession with a trim figure and weight loss is not new.[17] The beginnings of the weight loss movement can be traced back to the nineteenth century, where one finds advertisements for weight loss alongside recipes for cakes in *Godey's Ladies Book* (est. 1830) and *Ladies Home Journal* (est. 1883) and similar publications as early as the 1890s. However, during most of the nineteenth century plumpness in women was considered fashionable, a sign of health, and linked to successful motherhood and fruitful pregnancies. Elizabeth Cady Stanton was admired for her rotund figure, as were American stage actresses such as Lillian Russell, who was the most photographed woman in America and weighed over two hundred pounds at the height of her popularity.[18]

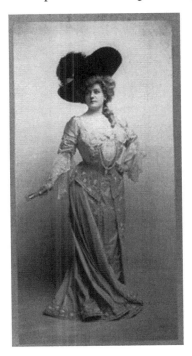

**Figure 1.1**    Lillian Russell, 1861–1922
Library of Congress Prints and Photographs Division Washington, LC-USZ62-62694.

Clothing such as corsets and bustles were designed to emphasize roundness and add fullness rather than hide it. Men who were round or had a paunch were regarded as powerful and successful. However, a combination of factors began the anti-weight movement, and men were equally targeted by this anti-fat campaign until the period from 1920 to 1960, when women became the primary target.

Included in these "anti-fat factors" were changes in fashion. For example, by the 1890s the uncorseted body became increasingly stylish among the middle class, and so more pressure was on women to maintain a slender figure without the help of this constricting undergarment.[19] As infant mortality rates declined and (contraband) birth control methods came into more frequent use, women were having fewer babies, and the decreased emphasis on motherhood likewise lowered the value placed on a matronly body. As circulation of print media increased during the nineteenth century, more women than ever were exposed to the recipes, advertising, fashion pictures, dress patterns, and homemaking advice disseminated by these periodicals. Between 1895 and 1914 Charles Davis Gibson's drawings of the ideal Gibson Girl became one of the most widely publicized female images in the United States. Drawn from the artist's imagination, the Gibson Girl represented the ideal woman, with ample bosom and visible hips but athletic looking, taller, and more slender than previous widespread images of women such as Lillian Russell. So at the same time popular print media became available to more women, images disseminated on those pages represented the "perfect American woman"—who was, in fact, not real, although many assumed there was a specific live model for the plucky Gibson Girl.[20] The popularity of the fictional Gibson Girl presages the power of media to construct the female body through proliferation of images epitomizing homogenous beauty.

Of course, in many ways the industrial revolution impacted changing attitudes about body size. At the dawn of the twentieth century, the U.S. economy became less rooted in agriculture and manual labor. The middle class was expanding, thanks to modern technology and a blossoming economy. Machines became available to do many jobs previously accomplished only through manual labor, and more workers held desk jobs—or at least jobs less rigorously physical. Thus, the middle class began to enjoy more relative leisure time than ever before in American history. Clothing became a manufactured commodity and generic sizes were established, whereas previously women made their own clothes to fit themselves and their families. By the twenties, bathroom scales and mirrors, the ultimate devices for assessing one's appearance, became a standard part of middle-class bathrooms and bedrooms.[21] Americans began to enjoy abundance as consumers of food and goods. As a middle class came into being, so did a more sedentary lifestyle for many, which resulted in weight gain for some.

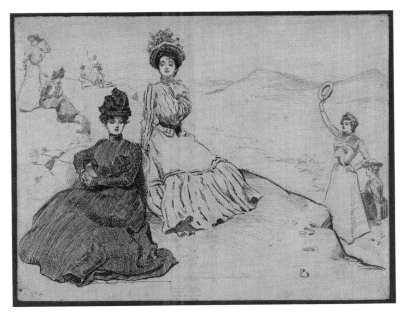

**Figure 1.2**   Picturesque America, anywhere in the mountains
Library of Congress Prints and Photographs Division Washington, LC-DIG-cai-2a12817.

Middle-class preoccupation with weight gain is evidenced by the increase in the early twentieth century of print media advertising weight-loss products and publications from medical authorities on the topic of weight-loss or obesity. Indeed, weight loss, and fad diets became part of American culture. The word *diet* was no longer associated strictly with nutrition but with its present-day connotation of food-intake prescriptions aimed at weight loss and increased "well-being." Medical practitioners shaped their discourse in concert with the growing middle-class ideology surrounding food consumption and consumer excess that associated weight gain with a host of antisocial, immoral behaviors. The middle class turned to doctors, whose credibility as professionals of medical science was also increasing at this time, to help them control their weight. Doctors extended fat prejudices further by linking heaviness in medical discourse with a variety of unrelated health concerns from dyspepsia to paralytic diseases and tuberculosis. Some of the first diet clinics and diet gurus began to spring up between 1880 and 1920. Horace Fletcher, who like many diet gurus past and present had a personal dieting success story, developed a science of mastication that claimed to promote weight loss. It was widely

written about in women's popular magazines.[22] Thus, the term *Fletcherism* became part of the national dialogue, and Fletcher became one of the first Americans to make his fortune in the diet industry, promoting his ideas on the lecture circuit and publishing several books on the topic.[23]

The United States grew rapidly and underwent remarkable economic and population growth. This set the stage for middle-class Americans in particular to develop a very complex and contradictory relationship with food, eating, and material abundance. The demonizing of fat and the new-found emphasis on weight loss may have been exacerbated by the increasing religious diversity and freedom that represented the American Way. In the first part of the twentieth century, the progressively secularized middle class began to emphasize weight control as a sign of good character and morality. Diet consciousness increased further after World War I along with other cultural constraints directed at perceived physical or emotional excesses, including for example more stringent attitudes toward homosexual behavior. Restraint emerged as a cultural imperative to compensate for new areas of social and religious freedom in a growing consumer economy.[24] Disciplined eating became a moral tool in a society where increasing economic abundance and growing leisure time seemed to weaken the Victorian work ethic of the previous generation.[25]

In this newly secularized culture, Americans substituted dieting for morality and religious qualities of abstinence and deprivation that harked back to Christian and Puritan ethics of earlier generations. In advertising, the battle of the bulge frequently deployed evangelical rhetoric that echoed biblical struggles of fallen angels and so on. Controlling one's appetite or spiritual fasting has played a significant role in diverse religions throughout human history. However, as religious discipline declined for many middle-class Americans, fat became a "secular sin." Between 1880 and 1920 print media demonstrated a growing attitude toward fat as immoral and indicative of weak character, evoking disgust beyond aesthetic fashion concerns and health considerations. During WWI, influenced by wartime rationing, "healthy eating" and eating in moderation became associated with patriotic duty. In 1918, an article in *Nation 101* stated: "Any healthy, normal individual who is now getting fat is unpatriotic."[26] Thus, appearing overweight became synonymous with lacking moral character, having a poor work ethic, and even being anti-American!

Furthermore, between 1920 and 1960 the anti-fat crusade in America took on a misogynist tone, and the medical establishment and advertisers began to target primarily women. Indeed, many feminists and cultural theorists including Susan Bordo, Susan Faludi, and Naomi Wolf argue that, as civil rights and social freedoms for women increased in the United States, the acceptable beauty standard for a woman's size decreased.

One concrete illustration of this trend of the ever-shrinking American ideal of female beauty is the Miss America Pageant, "coincidently" established the same year women got the vote.[27] The 1922 Miss America, Mary Campbell, stood five feet seven inches tall and was considered "flapper thin" at 140 pounds. By the 1990s the average Miss America contenders were approximately five inches taller and fifteen pounds *lighter* than their 1950s predecessors.[28] In 1924 a doctor quoted in the *Journal of the American Medical Association* exemplified the developing misogyny permeating weight-loss rhetoric: "Overweight is also a mar to female beauty . . . An excess of fat destroys grace and delicacy. A fat face has a monstrous uniformity. No theatrical producer would hire a plump actress to mirror the real depths of the human soul."[29] Emily Post's etiquette books first appeared in the 1920s, explicitly stated that fat was a drawback for women and made them less dignified, but she said nothing about fat men.

If by the 1920s weight control was established as a kind of moral category—a reflection of Americans' need to demonstrate moderation in an increasingly abundant economy with ever-loosening Christian values—then women in particular were compelled to compensate as they fought for more social freedom and reproductive rights. Also in the 1920s, creams and drugs, including amphetamines, designed to fight fat became available in the marketplace. Thus, as women became greater consumers of beauty products in general, consumer culture imposed control over women's bodies, obliging them to regulate their appearance through dieting and makeup.[30]

Evidence for the increasing intensity with which American culture celebrated slimness and vilified fat women can be found in various popular representations as early as the 1920s. Cultural icons of slender feminine beauty emerged, such as Disney's waif-like *Snow White* (1937) and Paramount Studio's cartoon diva, the childlike teeny-bodied sexual parody, Betty Boop (1930). At the height of her popularity in the late twenties and early thirties, Mae West's bodacious figure was already considered excessive—"more than" enough. It is no coincidence that her favored gowns were retro in style and that she made her big break into stardom after years of struggle by creating a notoriously risqué persona and infamously producing, writing, directing, and starring in her play *Sex* (1926), about a "bad girl" who was good to men. West was a forerunner of fat behavior that I will discuss in chapter four, but in self-authoring, she wrested power from those that would control her image and capitalized on cultural assumptions surrounding fat. However, West was the exception, not the rule. Among other iconic images of slender beauty were Alberto Vargas's hand-painted, "perfectly" proportioned, semi-nude pinup girls, which became famous in the 1940s, and Mattel's busty *Barbie* doll was born in 1959. Here we see again the female body literally being constructed, frequently by male creators,

and subsequently iconized in the American cultural landscape as a paragon of beauty.

Further examples of increasing misogyny toward women perceived as fat can also be found in women's magazines between 1940 and 1950, which are filled with articles expressing disdain toward fat women. A diet industry emerged around this kind of editorial rhetoric. In these magazines a woman with a "weight problem" was characterized as lazy, undisciplined, evasive, self-hating, a failure to society, and an object of ridicule and disgust. "Psychiatrists have exposed the fat person for what she really is— miserable, self-indulgent, and lacking in control."[31] Another article reads, "[A]re you aware that fatness has destroyed your sex appeal and made you look older, somewhat like a buffoon whom people are inclined not to take seriously in any area on any level?"[32] This kind of rhetoric is part of the cultural fabric from which we have constructed fat women in representation.

Fashion trends provide another example of how the cultural expansion of women's rights coincided with increasing pressure for women's bodies to be controlled. The freer and less constricting a woman's clothing became, the more importance was attached to her actual body being small and contained. Over the course of the century, as corsets disappeared, more revealing garments were considered socially acceptable and fashionable. Beginning with the flapper's costume, it became an acceptable social convention for women to show their bodies as long as the exposed parts were slender and disciplined.[33] A toned, slimmer body was an outward sign that, despite newfound sexual freedom, a woman could still restrain her biological appetites.[34] Conversely, sluttish behavior in a woman was frequently conflated with undisciplined eating habits, and visible fat was a kind of "Scarlet A" telegraphing promiscuity. Returning briefly to Mae West, she was a shrewd self-promoter to construct her bawdy persona to reflect her fat figure. Generally speaking, as women in the United States gained sexual independence, a woman admired for her beauty as well as her implied morality was no longer round and curvy (suggesting pregnancy and motherhood as it had in the early nineteenth century) but slender—a visible nonmother. There was a brief reappearance of the rounder female figure in the early fifties as demonstrated by Marilyn Monroe and other beauty icons of that era, which may have been influenced by the baby boom and a renewed cultural emphasis on maternal values following WWII.[35] Nevertheless, as an overall trajectory in the latter half of the twentieth and early twenty-first century, women have been encouraged to compensate for more sexual freedom by controlling their bodies in another way: maintaining a very slender body.

Post-WWII baby-boomer culture also saw an explosion of diet paraphernalia and consumer products directed toward female consumers, which has grown steadily to the present day. The fiscal growth of the

diet industry between 1960 and 2006 illustrates this point. For example, in 1964 Weight Watchers, formed just a year earlier, had an annual business of $160,000. Just six years later in 1970, Weight Watchers was earning $8 million annually. In 1990 the diet industry as a whole was estimated at $33 billion annually, with recent estimates rising to $60 billion.[36] Diets and diet products comprise a perfect self-perpetuating industry because, statistically speaking, over 90 percent of dieters re-gain the weight they have lost. Since WWII, fashion magazines laden with advertising and articles about dieting have proliferated, including *Seventeen*, directed at teenagers, and *Cosmopolitan* (est. 1886), which when taken over by Helen Gurley Brown in 1970 focused on sexuality, diet, fitness, and beauty. By the 1980s, women's magazines such as *Ladies Home Journal* and *McCall's* typically averaged two diet articles per issue. Jack LaLanne, one of America's first health gurus, also surfaced after WWII and frequently compared his fitness campaign to that of evangelist Billy Graham, thus carrying forward the tradition of dieting as a substitute for religious crusade.

Moreover, being overweight became synonymous with certain psychological pathologies. Thanks to media rhetoric and medical discourse it became widely believed that individuals who failed to achieve the ideal slimness must have something psychologically wrong with them. Compulsive overeating or excessive weight gain became a universally acknowledged signal of emotional maladjustment in the eyes of both the medical establishment and laypeople.[37]

This association of fatness with emotional maladjustment is crucial to understanding the ways we now view fatness in representation. In the United States the expansion of the middle class and the suburbanization that followed the Second World War put more individuals under the scrutiny of middle-class values, while more strongly linking weight gain and overeating with morality and mental health.

## Where Are We Now? Americans and Fat in the Twenty-First Century

Research tells us that during the last twenty-five years, even as slenderness standards have been more rigorously promoted than ever, the weight of the average American has in fact, increased. In the past fifteen years American attitudes as represented in the media and by the medical community have intensified from being preoccupied with weight loss to an obsession with fat as a worldwide health threat and harbinger of the fall of Western civilization.

One need only turn on the news or open a paper to read the latest health warnings associated with being overweight. According to popular media,

childhood obesity is at an all-time high in the United States. Some medical experts predict that the current generation of children will have shorter lifespans than their parents as a result of increasing childhood obesity and type-two diabetes. Gastric bypass surgery, now covered by many insurance companies, has become an increasingly popular surgical intervention for weight loss and has been made available to a wider socioeconomic range of individuals. Published studies from various medical authorities have linked obesity and a sedentary lifestyle to premature deaths and rising healthcare costs. There is no denying that Americans, especially children, are becoming fatter, and this could pose some health concerns. Certainly, there is much that medical experts have yet to understand about obesity including what, exactly, the risks are and at what point being fat becomes a significant health risk.

However, as Paul Campos points out in his book *The Obesity Myth*, fear tactics used in the media and the medical and cultural discourse surrounding America's weight problem exaggerate the health risks of being overweight and further contribute to the stigmatization of fat in our country. Campos is not alone in investigating the implications of the fat-obsessed media and medical culture. In his book, *Fat Politics: The Real Story Behind America's Obesity Epidemic,* J. Eric Oliver reports on a survey he conducted on Lexis-Nexis of major newspaper and magazine article headlines that mentioned the words *obesity* and *epidemic*. In 1994 the number of articles was thirty-three. It rose to 107 in 2000, and by 2004 the number of headlines featuring *obesity epidemic* had risen to seven hundred. A sample headline from 2004 found in the *New York Times* read "Death Rate from Obesity Gains Fast on Smoking." This is just one example of how the American preoccupation with fat and so-called obesity continues to intensify in the twenty-first century.[38] Campos offers a surprising critique of many of the medical studies that are the cornerstones of our current beliefs about diets, obesity, and wellness as represented in mass media. For example, in 1995 the *New England Journal of Medicine* published a study called "Body Weight and Mortality Among Women," which asserted that women of average height who were just twelve or more pounds overweight had a 60 percent higher mortality rate. This study was highly publicized and lent credibility to the notion that being even slightly overweight posed grave medical risks. However, Campos demonstrates the inadequacies in the study: data on 115,195 (predominantly white, middle-class) nurses, followed for sixteen years, became medical and media gospel. Without going into all of Campos's detail, some examples of the discrepancies between data and conclusion are the following: only 4,276 or 4.5 percent of the subjects died during the study, and the mortality rate of those with a body mass index (BMI) of 19 to 24.9 and those with the "overweight" range

of 25 to 31.0 was nearly identical. But more shockingly, the study did not factor in heredity or smoking as part of the overall equation.[39] This particular study, which (tenuously) linked being just ten pounds overweight with increased mortality, became one of the foundational arguments for doctors and the diet industry warning American women that they were risking their lives by failing to lose those last few pounds. Campos looks at several watershed studies that link obesity with health risks and mortality and finds repeatedly that the conclusions drawn fail to take in various mitigating factors such as heredity, smoking, and so on. He argues that "despite the profound effects wealth and poverty have on health . . . despite the striking correlation in America between increasing weight and decreasing social class, almost none of the studies that purport to measure the health risks of fat even attempt to control this factor."[40] Furthermore, Campos points out the obvious problem with claims that link heart disease to weight: deaths from heart disease in the United States have decreased at the same rate that obesity rates have increased. Along with many others researching the so-called obesity epidemic, Campos concludes that:

> For the vast majority of larger-than-average Americans, there is very little credible evidence that weight represents any sort of significant independent health risk. Being heavier than average may be a sign of other factors that are health risks, especially a lack of physical activity, but there is no real evidence that weight itself causes undue health problems, at least not until one reaches the body mass that is more than one hundred pounds above average for persons of a particular height . . . There is at present no credible evidence that losing weight is a desirable strategy for maintaining or achieving good health.[41]

Glenn Gaesser makes similar assertions in his book *Big Fat Lies*, offering a careful reading of scientific literature that actually reveals that being overweight is not as bad for one's health as the media would have us believe. For example, there is no link between fat-clogged arteries and obesity. He even provides data that suggests that there might in fact be health benefits to being overweight.[42]

This kind of skewed data and reporting is part of the way fat bias is woven into our cultural fabric and our consumer economy. It is not surprising that published obesity research invariably concludes Americans are overweight and should be focusing their time and money on diets and diet products. Laura Fraser points out in *Losing It: America's Obsession with Weight and the Industry That Feeds on It* that less than 1 percent of the federal health research budget is dedicated to obesity issues. Therefore obesity research in America is invariably funded by the diet and pharmaceutical industry—those who have the most to gain from conclusions that label fat

as a disease requiring medial intervention—clearly not disinterested third-party funding.[43]

It is important to consider these alternative views about weight loss and obesity because they challenge deeply held American beliefs concerning fat. The widely disseminated rhetoric of the medical and science community is funneled down through the media to middle-class Americans. The media capitalizes on cultural fears and prejudices to the point of obscuring facts and manipulating data in order to get the results a public is predisposed to hear: fat is bad and dangerous. Certainly these conclusions propel the booming diet industry as well as a pharmaceutical industry eager for an "easy sell" to a nation of middle-class individuals predisposed to viewing themselves through a lens still influenced by Puritan ideology, wherein contemporary Western lifestyle is lazy and gluttonous, lacking in discipline and morality. The suggestion is that weight *is* within our control in a fast-paced culture where individuals may feel less in control than ever, and if Americans could only master it, they could ward off a myriad of diseases. Put another way: "The simplification and misreading of evidence about human body size reinforces our cultural prejudices about the sinfulness of fat rather than alerting us to the mysterious dynamic and contingent processes of biological and cultural evolution that continue to shape individuals and societies."[44]

## The Fat Blame Game: Race, Class, Gender

Clearly, attitudes about fat in America are relentlessly negative and abound with assumptions about the character of a fat person.[45] Why has fat has become a target of contempt in the United States? Among other factors, our aversion to fatness is partially rooted in anxiety surrounding socioeconomic status. Particularly white middle-class Americans, those most targeted by and susceptible to anti-fat messages, hate fatness because to be fat violates our founding creed of temperance and self-reliance. If one is fat, one visibly lacks the moral and ethical resources to advance socioeconomically.[46]

In other words, fat people are visibly marked, and we must consider this in terms of how to read a character onstage or in cultural representation. The actor's live performing body is a cultural marker, and the size of that body tells a story before the actor moves or says a word. People who appear fat are coded as not only gluttonous and weak-willed but also lustful, greedy, lazy, stupid, loud-mouthed, irrational, and, most importantly, lacking in any kind of self-control. Here I am deliberately using the phrase *appear fat* because I assert that in the United States our idea of what a fat person looks like has changed over the years to a more slender visual.

I believe that all the media emphasis on obesity and the notion that has emerged in the past fifteen years that the entire country could stand to lose some weight has shaped our aesthetic to the point that today in 2014 we might consider the same actress fat who would have been a sex symbol years ago. Lillian Russell, Marilyn Monroe, and even Madonna circa 1982 were all considered icons of beauty and sexiness in their time but would be considered fat by a contemporary audience.

The fact is that unbiased obesity research to date has discovered very little about why some people gain more weight than others and suggests that very often fat people do not eat more than thin people. Research has proven conclusively that dieting fails insofar as 90 percent of dieters regain the weight they have lost within five years. A recent study published in the *New England Journal of Medicine* (Fall 2011) indicates that individuals who diet experience an altered biological state following weight loss whereby hormones that suppress hunger and stimulate metabolism decrease as a result of dieting and remain decreased up to a year, challenging conventional thinking about the relationship between weight loss and will power.[47] This and other studies indicate a certain "biological determinism" that makes some individuals susceptible to weight gain while others are not. Moreover these studies indicate that the pursuit of weight loss is virtually fruitless for some, which casts new light on the concept of will power and the belief that all fat people choose to be fat. Nonetheless, the medical and diet industries continue to promote diets as a viable solution, putting responsibility on the willpower of the individual, who, when he or she fails to lose weight or maintain a slender figure, reinforces these cultural stereotypes.

Furthermore, fat is inextricably linked with social status in America. In fact dieting culture as disseminated in mass media enforces class stratification, which occurs when upwardly mobile white women, who are presumably the most viable product consumers, are targeted by these messages. This is in contrast to minorities and lower-income fat Americans, who are somewhat passed over as potential marketing targets and neglected by the medical establishment. In the following quote Oliver explores fat prejudice in America and persistent cultural attitudes about obesity that ultimately link fat, class, gender, and race in our country.

As with blacks and the poor, fat people are thought to violate some of the most fundamental tenets of American culture: that all people are fundamentally responsible for their own welfare; that self-control and restraint are the hallmarks of virtue; and that all Americans are obliged to work at improving themselves ... And, as we've seen, they also come from America's Anglo-Protestant heritage that emphasized individuals' unique

responsibility for demonstrating their worth before God. This individualism has also been accentuated by two hallmarks of American economic development—laissez-faire capitalism and entrepreneurship—which both celebrate the good that individual initiative promotes in the free market.[48]

Thus, being viewed as overweight defies all the principles on which this country was founded. Fat people go against our collective social, political, and economic ethos. The bottom line is that a fat person violates deeply held American beliefs of individual freedom and responsibility by failing to control herself or himself and conform to hegemonic values and beauty aesthetics that appeal to middlebrow tastes and white middle- and upper-class culture.

Furthermore, Oliver argues that American principles of individualism that are at the core of fat bias can also be applied to economic and racial bias. Many race scholars have noted that whites frequently "couch their racial resentment in the rhetoric of individual responsibility. Blacks are not denigrated because they are fundamentally less intelligent, lazy, or some other stereotype; rather blacks are denigrated because they fail to embrace the principles of individual self-reliance and self-control."[49] Blacks, like the poor (a frequently overlapping demographic), are presumed responsible for disparities in wealth and lack of employment and education opportunities because of their moral failings. These attitudes give middle- and upper-middle-class whites license to blame these various minorities for their own oppression. They also further entrench economic and racial stratification in our country with the flawed supposition that health—in the form of slenderness—and wealth are within the grasp of the poor or minorities if they would only try harder.

In chapter six I will discuss in more detail the interplay between fatness and blackness or racial otherness in representation. But the idea that fat people, like minorities and the poor, choose not to live up to their individualistic, patriotic duty is critical to understanding the way in which fat characters or fat performers are pathologized in representation. Furthermore, there is a subtle connection between queerness and fat in representation as well. However, as I will discuss in detail in chapter seven, arguably fat prejudice is more similar to homophobia than racism because of questions of agency. Despite Oliver's assertion above, the surface argument is that individuals have no choice in their skin color, but some believe that fat people and queer people choose their deviant behavior and therefore deserve the social reprobation and government-sanctioned discrimination. On the other hand, skin color and fatness are immediately visible to the spectator, whereas gay or transgender individuals can pass within white heteronormative culture if they choose to. Nevertheless, we

shall see that in representation they are sometimes lumped together as cultural deviants.

These links between fat, black, and queer can be found, albeit subtly and semiotically, in various cultural representations and print media forms. An example of popular print media using "exposé" reporting style that purports to give the facts about our national health crisis is Greg Critser's cover story in the March 2000 issue of *Harper's* magazine entitled "Let them Eat Fat: The Heavy Truths About American Obesity." The following lengthy quote presents itself as legitimate clinical research drawing on the latest science and illustrates a number of ugly cultural assumptions about obesity in America, including the link between fat, race, and homosexuality as threats to national identity. Critser's racist, homophobic language and condescending tone exemplify the kind of rhetoric in print and electronic news media that couches racial and economic prejudices in disingenuous concern about our national obesity epidemic.

> At my local McDonald's, located in a lower-middle income area of Pasadena, California, the supersize bacchanal goes into high gear about 5 p.m., when various urban caballeros, drywalleros, and jardineros get off from work and head for a quick bite. Mixed in is a sizeable element of young black kids traveling between school and home, their economic status apparent by the fact that they have walked instead of driven. Customers are cheerfully encouraged to "supersize your meal!" . . . Suffice it to say that consumption of said meals is fast, and in almost every instance I observed very complete . . . If childhood obesity truly is "an epidemic in the U.S. the likes of which we have not seen before in chronic disease," then places like McDonalds and Winchell's Donut stores, with their endless racks of glazed creamy goodies, are the San Francisco bathhouses of said epidemic, the places where the high-risk population indulges in high-risk behavior.[50]

I see a link between this kind of discourse and Foucault's theory of *scientia sexualis*, wherein the more sexuality became watched and regulated in society, the more so-called perversions cropped up in scientific and cultural discourse. Critser's tasteless metaphor comparing the obesity epidemic to the spread of AIDS in San Francisco bathhouses in the eighties suggests that we have aimed our obsession with deviant sexuality and the discourse surrounding it into the last politically correct target: eating and fat.

Certainly we can conclude that fat is a class and race issue that is propagated in cultural representation by mass media and the medical establishment in this country. It is middle-class women emulating mediatized representations of health and sexuality who least need to lose "those last ten pounds," which, as I have demonstrated, have virtually no significant health consequences, who drive the multibillion-dollar diet industry. Yet

minorities and working-class women (and their children), who may or may not have more valid health concerns as a result of obesity and poor nutrition, are neither fairly represented in the media onslaught promoting the slender American ideal nor targeted by the medical or diet industry. Lower-income individuals simply don't have the economic means to pursue a perfect figure, which necessitates spending time and money at the gym, shopping and preparing healthy food, and so on. Thus, an overweight body is also an outward marker of social class. Or as Susan Bordo points out, with plastic surgery becoming commonplace in a consumer marketplace that disseminates the idea that we are defective, perfection can be bought if you have the means. On the other hand she points out that "[p]overty has always been visible on the human body, but with money now able to buy perfection, the beauty gap between the rich and the poor is widening into a chasm."[51]

Not only are middle-class women driving this capitalist diet machine as consumers of diet products but, as many feminists have pointed out, women's bodies actually are the material of capitalist reproduction. The female body itself is commodified in Western culture and is bought and sold in various marketplaces from fashion and advertising to music videos and pornography.

### Fat White Women

Critser's article notwithstanding, middle-class and upper-middle-class white women are arguably the most targeted by fat prejudice. Research tells us that a fat white woman will earn less and is less likely to be promoted than her thin counterpart.[52] A white woman who is considered significantly overweight (fifty-plus pounds) earns 6 percent less in her annual income, and this does not occur for women of color or men in the same category of fat.[53] Fat white women are five times more likely than their male counterparts to report feeling ashamed about their weight and are twice as likely to diet. African American and Latino women do not suffer the same pressure to be thin from within themselves or their community. They are more likely to report satisfaction with their bodies, although statistically America's poor and minority communities are more likely to be overweight according to current government and medical standards. Nor do women and girls of color suffer from anorexia in nearly the same numbers as white girls. Fat white women are more likely than fat white men to be harassed and abused in public and less likely to get married.[54] Much feminist theory has posited that contemporary weight standards are just another mechanism in the patriarchal machine to undermine women's power and independence. Oliver adds to this theory that middle-class

and upper-middle-class white women are a primary target because, at this moment in time in the United States, they are more likely to elide class and social boundaries than any other minority. He says, "White, affluent women face the most severe beauty standards precisely because they are in the most advantageous position to challenge male power. Unlike minorities or the poor, who face racial and class barriers to political and social equality, affluent white women are only hampered by their sex."[55]

Thus, the fat (white) female body is the very antithesis of Foucault's "docile body," defying all cultural and social conventions. If, as Judith Butler asserts, "rhetoric can control discourse and communication-speech acts are the primary processes through which identities are negotiated and narratives are constructed," then the fat female body is a cultural construction loaded with significance.[56] In what is still essentially a patriarchal culture, a woman's sex alone renders her substandard in the public sphere according to centuries of Western thought, but add to her sexed body fatness, and she is a double threat to society. Her fat body is subversive and disruptive, and I will demonstrate the ways in which these culturally constructed attitudes about fat women play out onstage and in representation.

Part I

# Fat Dramaturgies

# 2

# Fat Center Stage

This first category of so-called fat texts includes those in which the fat female body is directly addressed as part of the subject matter. In Bourdieu's terms, as dramatic texts intended for live performance, all the pieces discussed in this chapter fall into a restricted field of cultural production.[1] Unlike film or TV, live performance reaches a limited audience of viewers who have not only the economic means and sociocultural impetus to see theatre, possibly an indicator of higher education, but also geographic proximity to the theatre.[2] The plays and productions I will discuss are geared toward different audience subsets, more specialized, nuanced, and restricted fields, but most would be considered to have commercial appeal and thus be economically attractive for a theatre to produce. All these plays take the (fat) female body literally as the central part of their subject matter, and I will identify what this means in terms of character psychology and dramaturgy. For example, Charles Laurence's *My Fat Friend* (1974) and Jim Brochu's *Fat Chance* (1993) feature the protagonists, originally played by Lynn Redgrave and Rue McLanahan respectively, padded and costumed to appear overweight. Both pieces dramatize the transformation of the fat woman from overweight to svelte and use fat primarily for comic effect. The content and fat narrative of these plays, written by men and geared toward a commercial audience, differ somewhat from Laura Cunningham's *Beautiful Bodies* (1987), Madeleine George's *The Most Massive Woman Wins* (1994), or Eve Ensler's *The Good Body* (2004).[3] The latter are feminist plays, many of which have enjoyed less commercial success, initially opening in regional houses and seeing subsequent productions largely in university theatre venues; through pathos and satire these playwrights attempt to shed light on the complicated relationship between women and their bodies. The characters and their stories actively confront the pressures in American culture to be thin and beautiful.

### Fat Broads on Broadway

*My Fat Friend* by Charles Laurence originated at the Globe Theatre in London and opened on Broadway at the Brooks Atkinson theatre on March 31, 1974, and ran through December 7, 1974, for a total of 288 performances.[4] The cast featured a newly slimmed down Lynn Redgrave, fresh from her Academy Award-nominated, internationally successful role in *Georgy Girl* as Vicky, the fat bookstore owner. George Rose played her feisty, gay lodger Henry, who drives much of the plot. Reviews of the American production suggest that Rose, in the role of Henry, stole the show. Rose was nominated for a Tony and won the Drama Desk Award in 1974. The predominance of a gay character and the alliance between fat and gay characters in this play could make *My Fat Friend* a candidate for chapter seven, "Queering Fat." In fact, *Time* magazine reviewer Lance Morrow wrote, "the play might better have been called My Fag Friend."[5] On the other hand, since the plot of this play focuses squarely on the problem of a fat woman, I see it as a strong illustration of the way in which a playwright engages fat dramaturgically and the way in which the casting—in this case of a celebrity fat actress—enhances storytelling and audience reception.

The narrative of the play is simplistic, or as theatre critic Clive Barnes put it: "Despite its fat subject, it is a thin play, but it gives an opportunity for a trio of very funny performances and a new view of the onstage homosexual."[6] Vicky is a lonely, somewhat surly but witty, compulsive overeater who runs her own bookshop connected to her London flat. She has two gay male lodgers, the flamboyant Henry and the younger, subdued James, who is an aspiring novelist and a great cook. Because James is always preparing wonderful meals, Henry holds him responsible for Vicky's most recent weight gain, which has put her over the edge emotionally. In the opening scene she has a revelation that she is fatter than ever and deplores her shape, even as she continues eating and Henry insults her. A good part of the first act is sustained by many wisecracks and fat jokes among the three friends, but the major plot point is that a gentleman caller, Tom, comes into the bookstore, meets Vicky, and asks her on a date. They have a wonderful time, but he must leave the country for several months for business. Upon his departure, Henry (whose name could be a reference to *Pygmalion's* Henry Higgins) proposes that Vicky lose weight and surprise her new paramour when he returns for Christmas. By the second act Vicky has dramatically transformed her figure, with Henry verbally abusing her all the way. However, Tom returns from his business trip, and we discover that he actually liked the way Vicky looked before she lost weight, so she breaks off the relationship with him. Tom, who has brought her candy and other sweetmeats from his travels, hints that she could gain some weight

back, and she retorts, "No, I'll make bloody sure I don't. This is me, I like the way I am and I haven't enough spirit to be a pioneering sex symbol."[7] Newly in control of her life as a thin person, she decides it is time for James and Henry to move out. End of play.

For comic effect Laurence engages many of the classic fat jokes and fat pathologies that I have discussed in chapter one. Vicky is the quintessential fat girl. She has relatively low self-esteem, makes self-deprecating jokes, but just cannot stop eating. She hides candy and sweets, pours extra sugar over her cornflakes, eats to salve all of her emotions, and doesn't even notice she's eating until she catches a glimpse of herself in the mirror or notices that her jaws hurt from chewing. She is characterized as a liar both by Henry's comments and by his description of her past behavior. For example, when Vicky is out (actually buying a new dress for her date), Henry explains to young James what she is most likely up to:

> HENRY. The clever cunning cow . . . Well it's obvious. She wouldn't dare sit here in the fat dress and make a pig of herself, so she's decided to cheat. One last glorious tour around the chip shops stuffing herself silly, I bet . . . I know her better than you do. It's like living with an alcoholic, junky, kleptomaniac. You wait, these next few weeks are going to be murder. She'll announce some grand new diet and beg us both to help her and then she'll be up to every trick in the book. She'll sit here large as—larger than life, moaning away and nibbling a carrot and all the time there'll be cream cakes behind the cistern and Mars bars up her knickers.[8]

This monologue touches on nearly every aforementioned fat stereotype, although in the course of this play Vicky does not lie, hide food, or complain overly about her diet. She does drink excessively in one scene and she does smoke, which Henry praises as a good alternative to eating. However, from a viewer perspective, the smoking reinforces the notion that she is orally fixated and must substitute cigarettes for food.

As Vicky prepares for her date, Henry teases her mercilessly that Tom must be a monster of some sort to go out with her. Vicky insists Tom is "normal," but Henry advises her to bring a silver bullet, crucifix, and pepper spray on her date. In another stereotypical behavior, Vicky frequently engages in self-deprecating humor, quipping to Tom: "Always ready to eat—story of my life."[9] When she returns from her date having had a wonderful time, Vicky admits:

> VICKY. We went to a marvelous restaurant where I tried to be good but eventually made an incredible pig of myself. The sweet trolley alone was paradise.[10]

Clearly the playwright relies on all commonly held assumptions about fat women, including the self-awareness that eating is bad and within their control, if only they exercised restraint.

The second act begins four months later and opens with the grand revelation that Vicky has dropped forty-plus pounds, which is accomplished theatrically by the actress removing padding before appearing in the second act. By now Vicky is so enthusiastic and "in control" that she is taking diet pills and turning down the weekly sanctioned treat that Henry allots her. On Christmas Eve the three roommates eagerly await Tom and his reaction to Vicky's new body. Tom arrives and is clearly surprised at her appearance and asks if she is ill. She refuses to join him in a drink because "Dr. Henry," who has achieved the "world's first body transplant," made her give up alcohol as part of her weight-loss program. Vicky further emphasizes her lack of self-control and personal agency by giving all the credit for her accomplishment to Henry, whose support included berating her, infantilizing her, and watching her run laps around the park. When they are left alone, Tom confesses that he preferred her at her old weight and is appalled that she is trying to lose still more. Vicky declares she prefers her new body above anything, and Tom leaves.

During the dénouement scenes, Vicky and Henry try and understand why Tom preferred Vicky fat. They essentially conclude that Tom was indeed the monster that Henry thought he was for being attracted to a fat woman. Regardless, Tom's response does suggest that he was more interested in Vicky's body than anything else about her, which is a surprising yet still misogynist reversal. Nonetheless, her weight loss has miraculously made Vicky a saner, more balanced, independent woman. She muses:

> VICKY. When Tom left this evening I was disappointed and a bit annoyed but I wasn't shattered—none of my usual reactions, I didn't rush to the nearest piece of cake, and suddenly I realized why—I'm a different person, Henry, externals do affect one's way of thinking and I think it would be impossible for me not to change my way of living.[11]

With this speech the slim Vicky, now in control of her life because she is in control of her weight, asks the abusive Henry to move out, thus reinforcing another fat stereotype, which is that weight loss actually changes a person's character.

Referring back to my statement about the way in which *My Fat Friend* intersects with "queer fat," it is notable that throughout the play Henry characterizes himself as a kind of pariah and outsider due to his homosexuality. He suggests that his alliance with Vicky is in part due to their mutual status as societal outcasts and lumps James, who is in the closet and socially

awkward, into this mix as well. He quips to James, who has maintained that he cares for Vicky regardless of her appearance and dislikes her dieting:

> HENRY. You're pretty peculiar too. You know, it's a funny sensation and one I never thought I would experience, but for the first time in my life I feel completely and utterly normal.[12]

As I shall discuss in greater detail in chapter seven, *My Fat Friend* illustrates, as do many plays and cultural texts featuring fat characters as subversive individuals, the link between fat and gay identities. In this case, while Vicky is fat she is a "fag hag," but when she loses weight, she dismisses her two gay friends, implying that she can now enter the realm of heteronormativity.

I must now move from the text of *My Fat Friend* to discuss the performance of Lynn Redgrave in the title role, which added complexity to the critical reception of this play and its relative popularity. Redgrave was one of the first celebrities to undergo a public battle with weight loss and spin her transformation into publicity by advertising for Weight Watchers in the 1980s.[13] However, at the time of *My Fat Friend* in 1974 she had only recently left behind her *Georgy Girl* reputation as the hefty Redgrave sister. When the play opened in the United States, the *New York Times* featured an article entitled "Lynn Redgrave Fat? Only with Pads Now." Below her picture, the caption reads, "Lynn Redgrave who went from 180 pounds to a svelte size ten by eating only one meal a day." The focus of the article is not particularly on the play but on Redgrave's weight-loss journey following *Georgy Girl*. She talks about all the diets she has tried and how the only success she has found to maintain her "Ford Model" figure is to eat only one meal a day, usually of steak or lamb chops, spinach, and an apple. If she gets really hungry during the day she allows herself to eat the apple earlier than the dinner meal time. Years later, following her success as a Weight Watchers spokesperson, it came to light that Redgrave struggled with bulimia. At the time of the interview in 1974, Redgrave told *The New York Times* that she was finally inspired to lose weight because she didn't like the parts she was being offered and desired to be taken seriously as an actress. Redgrave says, "I didn't want to limit myself professionally because of my physical size." Nearly forty years later, celebrated American actress Cherry Jones, a fat actress whom I will discuss further in chapter in four, echoed Redgrave's words. Jones, who lost weight in preparation to play Amanda in *The Glass Menagerie* (2013), told her interviewer, "[t]he fact of the matter is, you can add a little weight with some extra padding, but you can't shave it off. So if you want to have more options as an actor, you need to watch your weight, and I've ignored that fact for several years quite happily."[14] I find it striking

that Jones, a highly regarded, two-time Tony-Award-winning stage actress, whom I will argue possesses a nonneutral "more-than" body type, is preoccupied with weight loss.

Returning to Redgrave, it is ironic that neither she nor the interviewer comments that, despite her weight loss, she is still playing a fat girl in a comic role. The only difference is that she gets to take the fat off in the second act. She goes on to say that she is influenced to shape her appearance "the way magazines tell us to. And I'm as guilty as everybody else. If we all lived in the times of Rembrandt and Rubens, Twiggy would have to go to a fat farm to get fat."[15] One of her final comments in the article concerns her constant worry that her kids will turn into fat people.

The irony of Redgrave padding up for her role as Vicky would not have been lost on her American audience. Did the fact that she had actually suffered as a real fat person add some pathos to her performance? Perhaps knowing that she was no longer fat in real life but only playing a fat person enabled audiences to enjoy the fat jokes made at her character's expense. Returning to my assertion in the introduction, I believe that spectators respond viscerally to being in the presence of a live fat body. Many experience disgust, revulsion, or fear contamination from a fat body. Some might feel pity or fear.[16] However, the publicity surrounding Redgrave's weight loss reassured audiences that no matter how believably fat she appeared in the first act, her fat was merely a costume.

Jim Brochu's *Fat Chance*, which premiered at the Colony Studio Playhouse in 1993, starring Rue McLanahan, is even more formulaic and "thin" than *My Fat Friend* in terms of dramaturgical and literary merit. The play did not make it to Broadway but had a healthy shelf-life, particularly in the Los Angeles area and also regionally.[17] The structure of the play is more or less a sitcom. Brochu appears to have written *Fat Chance* with commercial success in mind, aiming to entertain a predominantly middle/upper-middle-class, white audience with middlebrow tastes influenced by television, which one would find in the small suburban playhouses of the greater Los Angeles area.[18] In that sense, I believe the play fits into the same cultural field of production that might attract a Broadway audience.

Like *My Fat Friend*, the simple, if far-fetched, plot of *Fat Chance* centers on a character who is fat. The character description reads: *"Matisse 'Mattie' Salinger—She admits to forty. Spoiled, self indulgent, successful, dynamic. One of the more famous artists in the country. She has a weight problem and a secret."*[19] So Mattie—whose name rhymes with fatty—is clearly set up to embody many of the stereotypes of a fat woman, including duplicity. And these fat pathologies play a significant part in the unfolding of the story.

Mattie is essentially an agoraphobic. Despite her success as an artist, she has not left the house in years. Presumably she is so ashamed of

her appearance that she will not be seen in public. She is a sculptor who sculpts the body parts of models whom she contracts through an agency. Her housekeeper, Aura, brings her food and cooks and cleans for her. Like Henry in *My Fat Friend*, Aura babies Mattie at times, functions as Mattie's voice of reason at other times, and delivers the ubiquitous fat jokes. The opening scene finds Mattie on the sofa watching soap operas and eating candy so rapidly and unconsciously that she empties the box and brings an empty hand to her mouth before realizing there's nothing in it. She rummages around and finds cake, which she covers with whipped cream and eats. She then fills her mouth with whipped cream from the can, making for a sight gag.

A phone call from Victoria, her acid-tongued mother who is also her agent, destroys Mattie's eating reverie. Victoria announces that Mattie must appear at her next gallery opening. Mattie flatly refuses. Throughout the play Victoria's coldness toward Mattie is represented as an instigating factor for Mattie's present self-destructive behavior, alluding to the widely held belief that being overweight is symptomatic of some kind of mental disorder. In this case, Mattie eats to compensate for a lack of love from her mother. Soon a mysterious, handsome young stranger named Alex appears at Mattie's door to borrow jumper cables. It is not long before this charming drifter, who happens to have a perfect body, decides to stay and be her next model.

The next scene begins three days later. Mattie and Alex have embarked on a sexual relationship, which, it seems, is a pattern for Mattie. Her promiscuity is yet another common stereotype associated with fat women. Although they have been voraciously making love (Mattie can hardly believe that someone has a greater appetite for sex than she does), Mattie follows every lovemaking session by eating candy, and she refuses to allow Alex to see her naked with the lights on. When he asks if she is ashamed of her body, Mattie says: "Are you kidding? Everybody is ashamed of my body."[20] Yet Alex is suspiciously undeterred by her fatness. Eventually Mattie's mother reveals that she hired Alex to build Mattie's esteem, and ideally be her date to the art opening. Mattie is crushed, despite Alex's protestations that he has indeed fallen in love with her.

When Mattie discovers her mother and Alex's betrayal, she turns to food to drown her sorrows. First, she asks everyone to leave, stating:

MATTIE. (*walking to the kitchen, zombie-like.*) Only bologna sandwiches are my friends now. Would you excuse me while I eat myself to death. (*Mattie exits to the kitchen.*)[21]

She then runs away from home like a child. Eventually the police find Mattie drunk and deliver her home. Mattie has been hit by a car (no damage

to the car, as the joke goes) and requests another cocktail. Victoria tells her she has had enough to drink, and Mattie responds: "How can a person who does all things to excess have enough?"[22] As with Vicky in *My Fat Friend*, this fat character has remarkable self-awareness of the character flaws that have led to her scorn-worthy condition. Notice also how these plot events rely on the same stereotypes of the fat woman as childish, lacking in self-control, prone to excessive drinking and lying, and emotionally damaged by some childhood trauma. The scene concludes with drunken Mattie confronting Victoria for her callous lack of mothering, and they hash out all her childhood traumas and begin to make peace.

Thus, having solved all the psychological problems that made Mattie into an eating machine, the playwright begins the final scene on the night of her art opening and with the grand reveal of a slimmed-down fat woman. Stage directions read: "*Mattie has changed. She looks like Cinderella going to the ball—thinner, chic and very attractive.*"[23] The play ends in true fairytale style. Her mother arrives with a peace-offering gift. Mattie is touched and almost begins to "overflow" or "blubber," as her mother puts it.[24] Nonetheless, their mother-daughter relationship is on the mend. Alex, the "handsome prince," has remained loyal and, even though Mattie has ignored all his letters, shows up to escort her to the opening. She protests mildly before conceding, and they kiss. End of play.

*My Fat Friend* and *Fat Chance* rely entirely on stereotypes of fat women as pathological. Vicky and Mattie are aware that they have a problem with food but simply cannot help themselves. However, some of their self-analytical remarks sound more like the playwrights' commentaries on the characters and reflections of the playwrights' attitudes about fat than the truthful subjectivity of someone who actually is afflicted with an emotional disorder. Regardless, both plays are completely driven by all the assumptions many people make about fat women, including that they should lose weight, indeed that they *want* to lose weight and will not be happy until they do so. Mattie and Vicky are depicted variously as isolated, lonely, opinionated, boisterous, maladjusted, and out of control emotionally as well as in their eating. They are incapable of taking care of themselves physically and emotionally, and this paves the way, dramaturgically, for Henry and Victoria, their respective antagonists, to complicate the action. In both plays the interference of another character is what moves the plot forward and enables the fat woman to change her physical appearance, an action that is linked directly to her emotional recognition and transformation. The fat protagonists have almost no agency in terms of making any changes, but are compelled to do so by the actions of others. It is also worth emphasizing that since both plays call for the actress to transform in the second act, neither role can be played by an actual fat actress. As I mentioned, the comedy

in these plays relies on the audiences' suspension of disbelief. Audiences ascribe the fat pathologies that I have discussed as part of the "psychological realism" of the characters, but they are able to find humor in the narrative, rather than being distracted or disgusted by the actress's fat bodies, because they know that the bodies onstage are not really fat.

### Feminist Fat Onstage

The title of Laura Cunningham's play *Beautiful Bodies* is somewhat misleading, suggesting that the play will interrogate issues surrounding women's bodies or celebrate the female form, but it actually glosses over these concerns. *Beautiful Bodies* troubles precepts of feminist dramaturgy in the same way that Wendy Wasserstein's *Heidi Chronicles* does; the realistic format of the play and the character narratives are still firmly entrenched in patriarchal mores.[25] Although the play is written by a woman and features female characters talking extensively about what it means to be a woman in the 1980s, they are still trapped in the domestic, feminine sphere. The setting is a baby shower, and the discussions revolve around stereotypically female issues of marriage, children, beauty, and friendship and how they all do not know how to be liberated in this post-feminist era. As Sue-Ellen Case points out, the constraints of realism present a particular problem for feminist playwrights.

Realism, in its focus on the domestic sphere and the family unit, reifies the male as sexual subject and the female as sexual "other." The portrayal of female characters within the family unit—with their confinement to the domestic setting, their dependence on their husbands, their often defeatist, determinist views of opportunities for change—makes realism a "prison house of art" for women, both in their representation on stage and in the female actors' preparation and production of such roles.[26]

Cunningham's characters are "liberated" career women; they have babies out of wedlock and openly discuss and enjoy sex. Yet the realist style of the text still inevitably constrains them to positioning themselves within the framework of a heteronormative, patriarchal society. Set in New York City in the late eighties, the circumstance of the play is that Jessie is throwing a baby shower for Claire. Claire is an eccentric musician who got pregnant from a one-night stand and intends to raise the child herself. She is visibly pregnant. Jessie has invited Claire and four other women, all of whom are old friends, to her NoHo loft. Much of their discussion about their bodies is rooted in American cultural assumptions about women and weight. Their struggles are perhaps painted more sympathetically than Vicky's or Mattie's, but many of the jokes are still at the expense of women's bodies.

Nina is the character who comes closest to fulfilling fat stereotypes in the way that Vicky and Mattie do, albeit more subtly. Her character description reads: *"Nina is thirty three, but is an all together bigger woman: bigger voice, bigger breasts . . . we see she is faddishly dressed in a designer outfit that is almost too small."*[27] Throughout the play Nina tends to depict all the stereotypes associated with fat girls. She is highly opinionated, the most likely to use vulgar language, and the most sexually demanding. When the friends talk about sex, Nina is the most adamant that a lover should have a big penis and muses that she might draw a map on her body to point men to her clitoris. She is on a diet, however, fulfilling the idea that she must control her appetite in some area. If she is sexually free, she must compensate by slimming down. She refuses wine in favor of Diet Coke most of the evening and brings her own diet shake to drink while the others enjoy a full meal prepared by their host. Of the six women gathered for this baby shower, Nina is the most sexually active. She goes through the most men and coaches her friends on how to get over the loss of them quickly. She claims she doesn't mind that the men in her life leave, but even as she asserts this she *"unconsciously seizes a piece of chocolate cake, devours it in compulsive need."*[28] Here again we have a playwright using a character's eating to express certain psychological needs.

Nina is drawn in contrast to Lisbet, who is so malnourished following a breakup with an indifferent boyfriend that she is no longer a print fashion model but instead poses for *The Journal of the American Medical Association* because she so accurately embodies the look of depression. Lisbet has a wispy voice, is walked all over by men, and has a difficult time asserting herself. Nina is also strongly contrasted with Martha, who is the most uptight and conservative of the women (and who makes the most derogatory remarks about Nina's weight). Martha is very slim, corporate, and buttoned up in her appearance. She has the most masculine demeanor and expresses the most traditional view of the group, which is that women should get married and have children. Later she reveals that she only has sex once a year. There is a subtle semiotic line drawn between skinny, sexless Lisbet and Martha, and curvy, salacious Nina and fecund Claire, who eats heartily throughout the play.

Despite its feminist leanings, Cunningham's *Beautiful Bodies*, which premiered in 1987 at the Whole Theatre in Montclair, New Jersey, and sees regular college productions still, uses fat very similarly to Laurence and Brochu. Fat is a staple joke and a means to express certain female character flaws. The realistic style and domestic scenario make the play approachable for young actresses and white, middle-class, conservative audiences. The assumption that any woman can and should be slim is taken for granted, and every time Nina or Claire eats, one of the other characters remarks on

it. As far as food and eating go, the party line in *Beautiful Bodies* remains the same.

On the other hand, Madeleine George's *The Most Massive Woman Wins*, which premiered at the Public Theater in New York in 1994 as part of the Young Playwrights Festival, is a stronger counter-example to the aforementioned "Broad Broads." In certain regards, George's characters embody the stereotypes I have discussed, or at least they believe they fit the stereotype as expressed through their monologues. But in this case, the playwright explores the psychology of their behavior from the perspective of women suffering under cultural imperatives of beauty and body size. The characters demonstrate how deeply white, middle-class American women have assimilated messages about eating, fat, sexuality, and body shame that are part of our culture.

The setting of *The Most Massive Woman Wins* is the waiting room of a liposuction clinic. Not surprisingly, of all the plays discussed so far, this piece is the least realistic in terms of a linear cause-and-effect plot. At times the characters play other characters in order to flashback to an event in the past. They frequently use direct audience address and sometimes underscore the onstage action by singing childhood nursery rhymes. The effect is similar to a Greek chorus. When one character utters a short line of dialogue and then the next character chimes in, they all become "every-woman." On the other hand, the emotional life of each individual character is still rooted in psychological realism, and they each have specific narratives of their experience with their imperfect, fat bodies. The audience is expected to understand the characters as fully developed psychological portraits of real people and to relate to them as such; they are not icons or metaphorical emblems for a "type" or an idea as we might find in a Greek tragedy or a Brechtian parable. The four female characters, Sabine, Carly, Rennie, and Cel, range in age from 17 to 31 and are somewhat diverse socially and economically. In the stage directions the playwright indicates that not all the women need to appear overweight. They have all decided on liposuction because they believe there is something wrong with their bodies. In Carly's case, the eldest and a mother, her boyfriend has told her she is fat and given her money for liposuction.

On one hand these characters often enact the very stereotypes that other playwrights I have discussed use for comic effect. However, the difference in George's play is that the characters try to get to the bottom of their subjective cultural experience that has created their dysfunctional relationships with food and their bodies. The first sequence of dialogue addresses the way in which these women feel "out of control" and yet desperately need food for reasons beyond their understanding. Their feelings reflect the kind of advertising rhetoric Susan Bordo discusses in *Unbearable Weight*, which promotes the idea that eating delicious food makes

women "bad," or that women should "lose control" just once for Duncan Hines Cakes or some other forbidden, calorie-laden treat.[29] The characters in *Most Massive Woman* know it is "wrong" to eat compulsively, but the pressures of their lives compel them to do so, and then they are left feeling ashamed and worthless. Like Foucault's Panopticon, they police themselves and are their own "worst enemy." They discuss the emotional consequences of overindulging in food and why they are constrained to have liposuction:

| | |
|---|---|
| RENNIE: | You may be making like everything is fine fine fine but you know what what you've done, you bit it, you blew it. |
| CARLY: | It's your fuckin fault—you lost control. |
| CEL: | You know better than that. |
| SABINE: | So it's time to make an adult decision. |
| CARLY: | (*Smacks her own butt*) Throw out the evidence. |
| RENNIE: | You think of every sin in your past— |
| CEL: | Every slice of pie— |
| CARLY: | Every French fry— |
| SABINE: | Every chocolate croissant— |
| RENNIE: | You know it's all in there, simmering under your skin, and the nice man is gonna get rid of it all. Purify you. |

. . .

| | |
|---|---|
| SABINE: | You are responsible for your own behavior. |
| ALL: | You are responsible. |
| RENNIE: | You are guilty.[30] |

This passage shows that the characters believe there is something wrong with them because they cannot master their figures and their food intake. Carly blames herself for "losing control," Rennie calls food a sin, harking back to the notion that fat is a secular sin. They see themselves as prisoners of their bodies and their behavior as deserving of public scorn and shame. They no longer trust themselves and willingly undergo medical mutilation to atone for their "sins."

As the play unfolds, the four characters recount various childhood traumas in gym class and at the hands of critical parents that have led to their feelings of worthlessness. In doing so they articulate the struggle and incongruities of their feelings about themselves and their bodies and the profound impact body image has on the life of many women in America. Carly and Rennie seem to have submitted to the idea that there is something inherently wrong with them and have spent their lives trying to change their appearance and failing, thus reinforcing their feeling of powerlessness. They refer to themselves frequently as weak and wimpy.

In a flashback sequence Carly tries to understand how her beautiful, skinny daughter allowed herself to get pregnant. She says, "I thought only fat girls didn't know what they were doing."[31] Of course, this is a critique directed at herself. When she suggests to her daughter that she tell the boy (father) about her condition, the daughter reminds her that boys don't like bossy girls. Sadly, both Carly and her daughter have deeply assimilated all the messages concerning a woman's place in our culture, which disempowers both of them in different ways. In order to gain love and approval, a girl must be slim and acquiescent. Carly is a failure. She is overweight and potentially bossy, and her own daughter recognizes this as behavior that violates societal expectations.

Sabine has a more complex relationship with eating and body image. In another flashback sequence, Sabine argues with her professor as to the relevance of writing her thesis on eating disorders and the subjugation of women through body image. The professor argues not only that her topic is insignificant but that everyone should be responsible for themselves (harking back to Oliver's argument that fat prejudice arises from core American values of individuality). Her professor believes women should simply "get over" the eating disorders that Sabine argues are caused by looking at two-dimensional images. Sabine asserts that, "[C]onformity to societally established standards of beauty has a much greater impact on women's lives than men's; this includes social status, marital status, income, and work-related achievements."[32] In the end, we learn that although Sabine recognizes she is a victim of society, she cannot bear the social stigma of being fat. She needs to feel sexually viable and be validated for her appearance in order to boost her esteem. She knows that by conforming she is submitting to the "undeclared war against women." Yet she concludes: "If I can't change the world, I have to change myself."[33]

This statement brings up some post-feminist questions and ideas around the willingness to submit to cultural standards of beauty. Some feminists argue that doing so affirms the individual subject, which could still be considered one aim of feminism. Sandra Lee Bartky summarizes the tension between feminism and cultural beauty imperatives:

> To have a body felt to be 'feminine'—a body socially constructed through the appropriate practices—is in most cases crucial to a woman's sense of herself as female and, since persons currently can be only male or female, to her sense of shame as an existing individual. To possess such a body may also be essential to her sense of self as sexually desiring and desirable subject. Hence, any political project which aims to dismantle the machinery that turns a female body into a feminine one may well be apprehended by a woman as something that threatens her with desexualization if not outright annihilation.[34]

Bartky's quote helps explain why it is so important for some women to feel sexually viable in our culture. If she cannot position herself in society in

relation to her femininity and beauty, she has no identity. The quote is particularly provocative juxtaposed against the final image of the play, which is the moment when the play significantly deviates from the mode of realism in favor of a final tableau that is theatrically dramatic. The character Cel, who has been consistently unable to tame her flesh into behaving exactly as she thinks it should, first resorts to cutting herself and finally opts for self-immolation as her "final solution" to "get rid of all the flesh at once."[35] This chilling image is the ultimate metaphor for a woman's desire to escape the cultural constructs of body image. Cel cannot live within her own body because she cannot discipline it to adhere to cultural standards of slenderness, and so she purposely sets herself on fire, hoping that without her fat, she will finally feel free.

Arguably, the characters in *The Most Massive Women Wins* exemplify the emotional volatility that is part of the fat stereotype. They create their own suffering and eating disorders by getting fat or failing to lose weight. They acknowledge their eating as compulsive. On the other hand, their experience of their bodies in relationship to cultural standards creates a chicken-or-the-egg question. Economics aside, which comes first? Do poor body image and some preexisting emotional deficiency result in disordered eating and diet habits? Or does the inability of the women to maintain their figures within strict cultural guidelines of beauty create the poor body image and obsessive behavior? The play poses the questions but leaves us with no answers.

Eve Ensler tries to get to the bottom of those questions in *The Good Body* (2004). *The Good Body* is uniquely positioned between the aforementioned performance fields. Although the one-person format and feminist nature of the material typify the kind of piece geared toward an off-Broadway audience, thanks to the massive international success and dissemination of *The Vagina Monologues*, Ensler's name (and the word vagina) have become household words.[36] Thus, there was a kind of ready-made Broadway audience for *The Good Body*, which opened at the Booth Theatre (which seats approximately eight hundred) on Broadway in 2004 and played for forty performances. In a vein similar to that of *The Vagina Monologues*, Ensler aims to break down the symbolic violence directed toward women by a culture obsessed with weight and body size.

In her introduction, Ensler tries to explain her impulse to create this play following the success of *The Vagina Monologues*. Her research and experience of performing and promoting *The Vagina Monologues* enabled Ensler (and many other women) to make peace with the cultural shame surrounding vaginas and female sexuality. However, she writes:

> The deadly self-hatred simply moved into another part of my body. *The Good Body* began with me and my particular obsession with my "imperfect"

stomach. I have charted this self-hatred, recorded it, and tried to follow it back to its source. Of course the tools of my self-victimization have been made readily available. The pattern of a perfect body has been programmed in me since birth. But whatever the cultural influences and pressures, my pre-occupation with my flab, my constant dieting, exercising, worrying, is self-imposed. I pick up the magazines. I buy into the ideal, I believe that blond, flat girls have the secret. What is more frightening than narcissism is the zeal for self-mutilation that is spreading, infecting the world . . . This play is my prayer, my attempt to analyze the mechanisms of our imprisonment, to break free so that we may spend more time running the world than running away from it.[37]

The show is a series of monologues based on interviews with a wide cross section of women of all ages talking about their bodies. The inter-viewees include Helen Gurley Brown, editor of *Cosmopolitan*; actress and Lancôme model Isabella Rossellini, who was fired when she turned forty; a Puerto Rican woman from Brooklyn who fears the spread of her thighs; an African American teenage girl at a fat camp; a thirty-five-year-old model who willingly undergoes multiple plastic surgery procedures such as lipo-suction and breast implants at the hands of her plastic surgeon husband; a seventy-four-year-old African Masai woman; and a middle-aged woman from India, among others. In the Broadway production, Ensler played all the characters including herself. But the piece can be done with several actors playing the different characters and has been produced in this man-ner at Hartford Stage and Pittsburgh Theatre Center, among other venues.[38]

Ensler has many laughs at her own expense, highlighting the absurd double-bind in which many American women willingly participate. In her opening monologue she contemplates how she has always wanted to be considered a "good girl," which is inextricably entwined with being skinny. She punctuates this monologue and later segments of the show by doing sit-ups on an exercise ball at the same time she is describing her own expe-riences surrounding food and exercise:

> My body will be mine when I am thin . . . I will vanquish ice cream. I will purge with green juices. I will see chocolate as a form of self-punishment . . . Bread is Satan . . . I stop eating bread. I watch AB-Roller infomercials until four a.m. as I eat a bag—no a family size bag—of peanut M&M's . . . The next day I bite the bullet, well, at least I bit something, and hire Vernon, a fascistic trainer. Of course he is totally flat and muscular. He looks at me with pity and punishment. Right away he has me lifting heavy objects. Very heavy. The good news is I'm so fucking sore I can't move my head so I am unable to see my disgusting stomach anymore.[39]

Here again, as in *The Most Massive Woman Wins*, the protagonist, who does not appear particularly fat, understands to some degree her irrational

behavior but feels powerless to stop obsessing about it. Nonetheless, she keeps the audience laughing with her tongue-in-cheek observations.

Ultimately, Ensler has to leave the country to make peace with her lumpy belly. She goes to Africa where her Masai friend tells her to regard her body as a tree: one tree is not more beautiful than another simply because it is different. In India she confides that she hasn't left the gym in order to sightsee, to which her Indian friend replies, "You only know one country—a little country, your body with a population of one. You spend all your time fixing and renovating it. You need to look up."[40] Finally, she finds herself risking her life, hidden beneath a burka, sneaking ice cream with Afghani women in a tent being circled by the Taliban. On one hand, the multiculturalism of *The Good Body* reminds contemporary American women living in a particular cultural moment that other values pertain in other times and places. Ensler aims to put American cultural and social myopia in perspective. She suggests that Americans expect our culture to shape the rest of the world and even refers to America as "exporting eating disorders." With this final moment she may be asking why it should not occasionally be the other way around. Why can't American women take strength from other cultures? However, I believe Ensler does not entirely achieve her goal of dismantling American cultural constructs by conducting interviews outside the United States. She compares herself to women in completely different cultural circumstances who live under more overt and violent forms of cultural oppression and decides that her "imperfect" body may be okay after all. For me, this is a weak conclusion that seems intended to shame American women, who are lucky enough to eat ice cream without the threat of a public flogging or execution, into eating with gusto and gratitude because we can. This obsession with slender bodies that she is interrogating is a uniquely American construct. By pulling in other cultures, Ensler is less effective in breaking down American cultural mechanisms that keep even the most feminist women such as herself monitoring their weight and obsessing about carbohydrates.

*New York Times* reviewer Charles Isherwood was also not satisfied with *The Good Body*. He wrote:

> The proliferation of televisions shows depicting desperate self-improvement stunts ("The Swan," etc.) may attest to the continuing relevance of the issues Ms. Ensler raises, but it is disappointing that she fails to explore areas that might add new dimensions to the discussion. And perhaps she is a little guilty, as are those innumerable books and magazines, or helping to hype a pathology even as she offers her own form of therapy . . . It's sad to report that Ms. Ensler's analysis of the complicated relationship between self-esteem and cellulite is itself little more than skin deep.[41]

The last tableau of the show is Ensler rapturously eating ice cream and celebrating her "good body." I heard a rumor later that the ice cream was, in fact, fat-free Tofutti.

Ensler and the voices expressed in *The Most Massive Woman Wins* are struggling with what Bourdieu would call symbolic violence. They are somewhat aware that their attitudes about their bodies perpetuate their oppression but feel powerless to change these attitudes. In his book *Masculine Domination*, Bourdieu describes symbolic violence as a product of culture and points out the multiple layers of social and economic factors at work in creating aesthetics for the female body.

> Symbolic force is a form of power that is exerted on bodies, directly and as if by magic without any physical constraint; but this magic works only on the basis of the dispositions, deposited like springs, at the deepest level of the body . . . This transformative action is all the more powerful because it is for the most part exerted invisibly and insidiously through insensible familiarization with a symbolically structured physical world and early, prolonged experience of interactions informed by the structures of domination.[42]

He goes on to explain why many women are unwittingly complicit in their oppression.

> Because the foundation of symbolic violence lies not in mystified consciousness that need only be enlightened but in dispositions attuned to the structure of domination of which they are a product, the relation of complicity that the victims of symbolic domination grant to the dominant can only be broken through a radical transformation of the social disposition that lead the dominated to take the point of view of the dominant on themselves.[43]

Thus, it is no surprise that Ensler can accept her body outside the United States. She radically alters her perspective when she communes with her African, Indian, and Iraqi subjects, and this enables her to step out of Bourdieu's paradigm of symbolic domination. Unfortunately, most American women, who do not have the opportunity to travel extensively in foreign countries and have bodily experience of other cultures, cannot even fathom such a shift.

This chapter has explored plays written and performed in the last quarter of the twentieth century to see how playwrights use fat dramaturgically as subject matter or central idea.[44] Patterns emerge. All of these playwrights use fat to establish their female characters; their oversize bodies are a metaphor for some emotional deficiency or psychological or behavioral quirk that is similar in all the roles discussed here. In the case of comedies such as *My Fat Friend* and *Fat Chance*, fat women are the butt of jokes; they are

loud-mouthed, emotionally volatile, childish overeaters who cannot help themselves. The momentum in these comedies centers on their struggles (and the struggles of those around them) to change their size, which in turn changes their personality and behavior and brings a new harmony to the world of the play. The comedy also seems to rely on the actress actually *not* being fat, so that the audience can be assured that the character will undergo a transformation.

The plays written by women, *Beautiful Bodies, The Most Massive Women Wins*, and *The Good Body* all endeavor to address questions of body size and dieting from a woman's perspective as a playwright and with female characters. However, *Beautiful Bodies* essentially capitalizes on the same stereotypes as the aforementioned comedies. *The Most Massive Woman* attempts to solve the "chicken or the egg" question in terms of presenting each character's narrative and trying to identify how she became either overweight or completely dysfunctional in her relationships with food. Likewise, *The Good Body* tries to understand why an avowed feminist activist can still be dieting and struggling with self- image. Ultimately, Ensler fails to offer any real explanation or hope for change and paints herself into the same corner as many psychically damaged American women, forever obsessed with food and her body.

# 3

# Fat Love Stories

Very often the excess weight of a fat woman is seen as a visual metaphor for sexual aggressiveness. Thus, one role a fat actress is consigned to is that of the slut or prostitute. However, this chapter explores the ways in which four male playwrights treat the problem of a romantic love between a fat woman and a "normal-sized" man. Eugene O'Neill's *A Moon for the Misbegotten* (1952), Edward J. Moore's *The Sea Horse* (1969), Terrence McNally's *Frankie and Johnny in the Claire de Lune* (1988), and Neil LaBute's *Fat Pig* (2004) are all, in essence, love stories. *Fat Pig* and *The Sea Horse* expressly call for a fat woman, while *A Moon for the Misbegotten* and *Frankie and Johnny* call for an "oversize" actress and someone with "non-conventional good looks" respectively. Despite the spread of years between these pieces, there is a through-line connecting all the heroines in terms of their emotional makeup and the ways in which they interact with their suitors as potentially romantic subjects.

I will discuss the oldest play first. Written in 1943, *A Moon for the Misbegotten* was first produced in 1947, and by all accounts was not a success. It was one of O'Neill's last plays and was written in the same period as his other autobiographical plays, *The Iceman Cometh* (1939) and *Long Day's Journey Into Night* (1941). *Moon* tells the story of two social misfits, Josie Hogan and Jim Tyrone, who come together for a night and share their secrets in order to find redemption in one another. In the script O'Neill describes Josie, the protagonist of the play, as follows:

> Josie is twenty eight. She is so oversize for a woman that she is almost a freak—five feet eleven in her stockings and weighs around one hundred and eighty. Her sloping shoulders are broad, her chest deep with large, firm breasts, her waist wide but slender by contrast with her hips and thighs. She has long smooth arms, immensely strong, although muscles show. The same is true of her legs.

> She is more powerful than any but an exceptionally strong man, able to
> do the manual labor of two ordinary men. But there is no mannish quality
> about her. She is all woman . . . The map of Ireland is stamped on her face . . .
> It is not a pretty face.[1]

As with all his stage directions, O'Neill is very detailed in his description
of Josie. Although he does not specifically call her fat in the above quote,
in the original production he kept encouraging Mary Welch, who origi-
nated the role of Josie, to eat potatoes and bananas so that she would better
resemble his idea of the character.[2] Clearly it was important to O'Neill that
the actress playing Josie appear oversized in order to embody the character
he had in mind. Although he relies on some stereotypes, O'Neill uses fat
more abstractly to deal with the problem of his plot than some of the previ-
ous plays I have discussed.

Josie is an eccentric spinster living with her irascible father, having sent
her brothers away for their own good. She is responsible for the mainte-
nance and success of their farm and more or less functions as a surrogate
wife to her father Phil Hogan, who is happy to keep her since she does the
work of two men, and he believes she is too ugly to make an advantageous
marriage. Josie has given up all hope of finding a husband, believing she is
too large, unattractive, and surly. However, she does have a special relation-
ship with their neighbor and landlord, Jim Tyrone, who is handsome and
wealthy but also a depressed, philandering alcoholic. From a dramaturgical
perspective, O'Neill sets Josie as counterweight to Jim Tyrone. Josie must
be ugly on the outside so that she may redeem Tyrone, who is ugly on the
inside.

Because she perceives herself as ugly and is reluctant to abandon her
father, Josie cultivates a bawdy, gruff persona that belies her true emotions
and keeps away potential suitors. She deliberately circulates rumors about
herself to make people believe she is promiscuous. In fact, she goes out
drinking with men and is able to drink them under the table. By the time
they are alone with Josie, she can easily stifle their drunken advances and
they pass out. They are too embarrassed to reveal to their buddies that Josie
squelched their sexual advances, because each man she encounters in this
way believes all the other barflies have successfully bedded her. And for
her part, Josie puts it out that she has bedded all these men. Only her father
and Jim Tyrone know the truth; Josie is a virgin. In creating Josie, O'Neill
plays with fat stereotypes ironically. Josie isn't actually a booze-swilling,
bed-hopping, foul-mouthed broad. She is only pretending in order to pro-
tect herself emotionally and spare herself the disappointment of not find-
ing romantic love. In fact she has romantic feelings for Jim, but he is too
emotionally damaged to reciprocate.

She is well aware that Tyrone is a playboy who travels to New York and beds beautiful actresses—Broadway "tarts"—whom she teases him about as though she were one of the guys, to whom she frequently compares herself unfavorably. Like some of the previously mentioned fat characters, Josie is a master at self-deprecating humor. Tyrone has a genuine affection for Josie and even an attraction to her. But he is wallowing in self-pity and shame and is drinking himself to death in response to his mother's death. He can only have sexual intimacy with nameless prostitutes and showgirls (whom he calls "pigs") as a kind of self-punishment. On the night Josie and Jim share their secrets, Josie has contrived with her father to get Jim drunk and in her bed so that her father can blackmail Jim into not selling the farm out from under them. The unquestioned assumption between father and daughter is that Josie, "the great cow" will be unable to seduce Jim unless he is drunk.

The following passage from act three is part of the complicated dance that leads up to the confessions and typifies Josie's sexual bravado and emotional bluffing, which belie her true feelings for Jim. Her self-deprecating and teasing manner is a blueprint for the fat roles discussed later in this chapter. The passage also hints at Jim's melancholy notions of romance, which will make it impossible for Josie and him to become lovers. Josie has just filled his glass with more of her father's top-shelf whiskey.

TYRONE.     (*Kiddingly*) I might forget all my honorable intentions, too. So look out.

JOSIE.     I'll look forward to it—and I hope that's another promise, like the kiss you owe me. If you're suspicious I'm trying to get you soused—well, here goes. (*She drinks what is left in her glass*) There, now I am scheming to get myself soused, too.

TYRONE.     Maybe you are.

JOSIE.     (*Resentfully*) If I was, it'd be to make you feel at home. Don't all the pretty little Broadway tarts get soused with you?

TYRONE.     (*Irritably*) There you go again with that old line!

JOSIE.     Alright I won't! (*Forcing a laugh*) I must be eaten up with jealousy for them, that's it.

TYRONE.     You needn't be. They don't belong.

JOSIE.     And I do?

TYRONE.     Yes, you do.

JOSIE:     For tonight only, you mean?

TYRONE.     We've agreed there only is tonight—and it's to be different from any past night—for both of us.

JOSIE.     (*In a forced, kidding tone*) I hope it will be. I'll try to control my envy for your Broadway flames. I suppose it's because I have a picture of them in my mind as small and pretty—

TYRONE.     They are just gold digging tramps.

| JOSIE. | (*As if he hadn't spoken*) While I am only a big, rough, ugly cow of a woman. |
| TYRONE. | Shut up! You're beautiful. |
| JOSIE. | (*Jeeringly, but her voice trembles*) God pity the blind! |
| TYRONE. | You are beautiful to me. |
| JOSIE. | It must be the bourbon—[3] |

As the night wears on, Jim will never be able to convince Josie that she is beautiful, because Josie equates his seeing her as beautiful to his being sexually attracted to her. Unfortunately for Josie, Jim needs forgiveness from her more than he needs her romantic companionship. Josie hopes to consummate their relationship as lovers, but Jim sees women only as Madonnas or whores, and Josie falls into the former category. To make love to her would sully the beauty of his feelings for her. He reveals to Josie that, following his mother's death, he traveled by train with her corpse for burial. In a drunken haze, he made love to a prostitute repeatedly, quite literally over his mother's dead body.

Eventually Josie understands he needs absolution more than physical intimacy, whereupon she abandons her hopes for a romance and offers him her forgiveness. The hulking Josie gives up her dreams in order to offer him salvation, realizing that they can never be together intimately but that she can offer him purity and beauty. He sleeps in her lap through the remainder of the night. Jim awakens refreshed for the first time in years, and although it is clear that he will still continue to drink himself to death, he will go to his grave with more peace in his heart, having watched a beautiful sunrise in Josie's platonic embrace.

Consider how specific O'Neill was that the type of woman to embody Jim Tyrone's confessor must be so oversize. Was he implying that the actress should not be considered sexually viable to the audience or to Jim? Why is it important that Jim Tyrone's confessor be a giantess? Is it, as Barbara Gelb suggests in a *New York Times* article commenting on the 2000 Broadway revival starring Cherry Jones, that O'Neill "wanted whoever played the role to convey a quality of supernatural power? He wished Josie to be seen as Jim's savior, the one person to whom he could confess his betrayal of his mother and be given absolution in his mother's name."[4] On the other hand, O'Neill's attempts to get the original actress to gain weight suggest that his call for "so oversize a woman that she is almost a freak" was quite literal and that he interpreted oversize as not only tall but also fat, or at least visually overweight relative to some standard he had in mind.

Whatever O'Neill's intentions were, it is important to discuss the actresses who have played the role of Josie on Broadway and their critical reception. As I mentioned, the initial production, starring Mary Welch,

the trim ingénue that O'Neill was trying to force-feed, was essentially a flop. However, the 1974 revival directed by José Quintero and starring Colleen Dewhurst was critically acclaimed. It was a highlight of Dewhurst's career, earning her a Tony Award. She was fifty years old at the time and tall and heavyset for an American actress. The production ran for 313 performances and was made into an Emmy-nominated television movie. Her performance alongside Jason Robards as Jim Tyrone is considered by most the watershed moment in the play's production history. Although reviewers did not dwell on Dewhurst's size per se, they praised her performance as "beautiful" *despite* the confines of her/Josie's appearance. Dewhurst, who is tall and broad shouldered, wore no makeup in the role. Her costume was a very thin shapeless dress that not only emphasized her thick frame, but the paunch of her stomach which protruded as she moved about. The dress was also cut very wide and low at her bosom so that her breasts, which hung rather low and naturally, as if she were not wearing a bra, threatened to spill out of her costume.[5] In her performance, Dewhurst embodied the strapping Josie, standing as tall as her costars and easily lifting up chairs and moving them around. She also portrayed a virginal Madonna. When Tyrone broke down crying, Robards lay in Dewhurst's lap with his face pressed into her breast, quite literally enacting the iconic mother and child pose. Dewhurst's success in the role, which I attribute not just to her considerable skill as a performer but to positive critical reception of her body as believable in the part, paved the way for future interpretations.

With each subsequent revival, the appearance of the actress playing Josie has always been a point of discussion. The play was revived again in 1984 starring the fine-featured, lithe Kate Nelligan and ran for only forty performances. Nonetheless, critic Frank Rich praised the production and spent a paragraph describing her transformation from "fine boned actress" known for her feminine, upper-class roles to someone whose "flat forehead suggests a heritage more Cro-Magnon than aristocratic" and whose eyebrows are "thick and mannish."[6]

Subsequent Broadway revivals in 2000 and 2007 starred Cherry Jones and Eve Best respectively, and both ran significantly longer than the Nelligan revival. Was this because the actresses' body types were more suited to play the giantess Josie? While not everyone would describe these actresses as fat, both are oversize by contemporary American standards of beauty (although Eve Best is still "fine-boned" according to Ben Brantley).[7] Undisputedly one of the finest American stage actresses of the last quarter century, Cherry Jones is featured in several fat roles I will discuss. I believe this is because her size and shape categorize her as a fat actress. She is very tall and broad shouldered. Unless she is wearing a corset to shape her figure, her waist to hip ratio appears the same, giving her a boxy, thick appearance.

Although she never fails to generate chemistry with her male costars, Jones is also an out lesbian, which is relevant given the fat/queer connections I will discuss in chapter seven. Eve Best, who is also very tall and broad shouldered, often falls into this honorary fat category as well. Indeed, Jones's and Best's acting resumes hold several of the same roles, including Ruth and Arthur Goetz's *The Heiress*. Certainly something about their appearance links the two women in their ability to play the oversize, unattractive Josie, and reviewers cannot resist discussing the appearance of the actress in terms of her size-appropriateness. Ben Brantley reviewed both productions seven years apart and uses nearly the same language to describe both actresses. He refers to Cherry Jones's "wrestler's arms" and to Eve Best as clomping about the stage "like a wrestler in search of a match."[8] In the case of Josie, it seems that reviewers cannot separate the character's emotional nature from the actresses' physical type, and indeed the most praiseworthy performances are by actresses whose physical "more-than-ness" accentuate Josie's exterior bravado.[9]

The next play in my progression of fat romantic roles is *The Sea Horse* by Edward J. Moore. Written over the course of several years between 1969 and its opening in 1974, *The Sea Horse*, which won Moore the Vernon Rice Drama Desk Award for Outstanding Playwright, harks back to some of the fat conventions established in *A Moon for the Misbegotten* and looks forward to *Frankie and Johnny* in terms of how a fat female body factors into inspiration and dramaturgy. *The Sea Horse* opened at Circle Repertory Theatre in 1974 and then moved to the Westside Theatre in April of 1974, playing at the same time as the successful Dewhurst-Robards *A Moon for the Misbegotten* revival.

In his preface, as well as during an interview with Mel Gussow, playwright Moore admits that his inspiration for writing the play was a particular actress, Susan Riskin, who was his real-life love interest at the time. He originally wrote the play under the pseudonym James Irwin for Riskin and himself to perform in Uta Hagen's master acting class. In his preface Moore admits that he could not accept Riskin because of her size and wrote scenes between them to try and exorcise his feelings.[10] He let go of the alias when the play gained traction and told Gussow: "I had a hangup about physical looks. I always wanted to be seen with beautiful girls. I fell in love with Susan but I couldn't believe it. She was a big fat lady—200 pounds."[11] Although he developed and rehearsed the role with Riskin, Conchata Ferrell eventually played the role off-Broadway and won the 1974 Theatre World Award and the Drama Desk Outstanding Performance Award for her portrayal of Gertrude Blum. Nowadays Ferrell may be most recognized for her recurring role as Berta, the saucy housekeeper in TV's successful (and disturbingly misogynistic) series *Two and a Half*

*Men.* In this television role, her character enacts virtually all of the fat stereotypes discussed in this book, including being both sexually voracious and deviant. Significantly, Ferrell's first major television role was a reprise of her role as the bawdy prostitute in Lanford Wilson's *Hot L Baltimore* in a TV series of the same name (1975).

*The Sea Horse*, which is kitchen-sink—or in this case barroom—realism in style, tells the story of two social misfits who bond sexually out of desperation and struggle to find some glimmer of romance and happiness in their otherwise brutal lives. Harry is a merchant seaman who is frequently out at sea for lengths of time. When he is in town, he stays at the Sea Horse, a bar that caters to the longshoreman crowd, owned by Gertrude Blum, known affectionately by her regulars as "Two-Ton Dirty Gerty." The character description for Gertrude reads: "She is in her late thirties, a big woman weighing about two hundred pounds. Fat but not flabby, and stands five foot seven or eight."[12] Harry, who is prone to drinking too much, is a simple man who realizes after weeks at sea that he is no longer satisfied with a purely physical relationship and a place to sleep. He has decided he wants to marry Gertrude and settle down and perhaps have children. His return from a voyage and his proposal are the inciting incidents of the play. Gertrude is the boisterous, cynical, foul-talking proprietor of a rough bar, who claims she enjoys numerous men other than Harry for sexual pleasure and is appalled at his proposal. She violently rebuffs his romantic overtures, insisting that she has no interest in the life he is offering her, nor does she truly believe he is in earnest.

Gertude is a version of O'Neill's Josie, albeit conceived post 1960s sexual revolution; her sexual bravado and her rough talk are a mask for a woman who fears rejection yet longs to be loved tenderly by a man. *Times* reporter Gussow notes the similarities between Gertrude and Josie:

> Miss Ferrell (who played the fat garrulous prostitute in *Hot L Baltimore*) is Gertude Blum, "two ton Gertie," . . . she is strong as a bouncer, and there is a sawed-off baseball bat behind the bar counter waiting for obstreperous customers. But like Josie in *A Moon for the Misbegotten*, the bluster is a façade. The impudence—and even the fat—is a way to avoid confronting herself. Miss Ferrell, who never forgets the softness behind the swagger, is lovely.[13]

Through the course of the play, the saintly Harry, who is genuinely in love with Gertrude, tries to persuade her that his intentions are sincere. Like Jim Tyrone, Harry can get any girl he wants, but he has decided that he wants Gertrude to be the mother of his child, casting her as a Madonna in the same way Jim does Josie. Gertrude keeps Harry emotionally at bay with cynical, witty wisecracks and bawdy talk, when in truth she would like to accept his proposal. She embodies many of the fat stereotypes I

have discussed. She swears like a sailor and eats compulsively. She frequently insults Harry's masculinity and intelligence—embodying the "man eater"—a stereotype that is fully realized in Albee's Martha in *Virginia Woolf.* For example, Gertrude teases Harry so mercilessly about his romantic proposal that he jumps up in anger with clenched fists, and she says: "You don't have any balls, Harry. You belong in a dress! Who'd wanna run away with you?"[14] In fact, during this scene she succeeds in goading Harry into attacking her physically. When he can take her mockery no longer, he lashes out verbally and calls her a "lard ass," among other insults. She, in turn, attacks him physically. Harry restrains Gertrude and then strikes her, which effectively terrifies her and leaves her crying hysterically like an injured child. This concludes the first act.

In the second act—or "the morning after"—the two warily circle around each other. Harry tries to recoup the emotional damage he has wrought by hitting Gertrude, and she returns to her nonchalant, tough-talking self, although, like Josie awaiting Jim in her shabby Sunday dress for their moonlit date, Gertrude wears a dress this morning. It is "old fashioned and a bit snug," and it hints at her secret desire to be treated like a lady rather than the tough broad she pretends to be. Eventually Harry manages to wring her secret from her. When she was young (and not fat), her first husband abused her physically and forced her to work the rough bar alone, during which time she was gang raped. This trauma scarred her physically as well as emotionally; Gertrude is unable to bear children. Since that incident (and the death of her father—recall Mattie's fat pathology in *Fat Chance*)—she has been unable to trust men. She concedes that she deliberately grew fat as a form of self-protection. The play ends on a hopeful note with Harry proclaiming his love and commitment despite her abrasive behavior and refusal to believe in him. And, even as she protests that she does not trust him, Gertrude allows him to embrace her, as he promises her she will learn to trust him. Although the ending might be considered cliché today, reviewers championed the 1974 production, which extended its limited engagement at Circle in the Square and transferred to the Westside Theatre. They attribute the play's success to the standout performances of Edward Moore and Conchata Ferrell.[15]

Frankie of Terrence McNally's *Frankie and Johnny in the Claire de Lune,* which premiered at Manhattan Theatre Club in 1988, continues the progression with another tough-talking, independent female character who is actually hiding the scars of spousal abuse. Although McNally does not explicitly call for a fat actress, the character description for Frankie reads, "Striking but not conventional good looks. She has a sense of humor and a fairly tough exterior. She is also frightened and can be hard to reach."[16] This character description could easily be for either of her oversize predecessors

Josie or Gertrude. The playwright also notes that Johnny's best feature is his personality but mentions that he is in good physical shape. Remarkably, in *The Sea Horse* Moore also makes a point to describe Harry as "athletic and powerful" in his appearance. Both playwrights seemed to find it significant that the male characters should be considered relatively fit and attractive in contrast to their fat (i.e., unattractive) love interests.

Another parallel between *The Sea Horse* and *Frankie and Johnny* is that McNally wrote the play with Kathy Bates in mind, just as Moore wrote with his fat girlfriend Susan Riskin in mind.[17] Both playwrights come up with very similar emotional pathologies for their respective fat actresses. Like her predecessors, Josie and Gertrude, the character of Frankie is vulnerable and fears rejection, which she compensates for by being emotionally unavailable and using foul language and wisecracks to unman her would-be suitor, Johnny. Like Jim Tyrone and Harry, Johnny is a romantic dreamer who puts Frankie on a pedestal. He guilelessly declares his love for her.

The opening moments of *Frankie and Johnny* take place in the dark, and all the audience can hear is the sound of the two noisily making love. The lights rise after they have climaxed. We learn that Frankie is a waitress and Johnny is a short-order cook at the same diner. They are both lonely, socially isolated, working-class misfits with few prospects personally or professionally. Frankie intended only to enjoy some sexual relief with Johnny and then send him on his way. She gets up and makes him a meatloaf sandwich for the road. Johnny, a hopeless romantic, has other plans. As they trade stories over sandwiches, Johnny realizes how much they have in common and insists that they are soul mates.

Johnny spends the rest of the play trying to convince the guarded, reticent Frankie to open up to him emotionally and give their love a chance. In the following passage we see Johnny placing Frankie on a pedestal, casting her as potential mother to his children. Just as Jim recoils from Josie's coarse language, Johnny cannot bear to hear Frankie swear. Frankie, in turn, acts out the stereotype of the foul-mouthed, abrasive fat girl, pushing him away.

| | |
|---|---|
| JOHNNY. | I might as well come right out with it: I'm in love with you. I personally think we should get married and I definitely want us to have kids, three or four. There! That wasn't so difficult. You don't have to say anything. I just wanted to get it on the table. Talk about a load off! |
| FRANKIE. | Talk about a load off? Talk about a crock of shit! |
| JOHNNY. | Hey, come on, don't. One of the things I like about you Frankie, is that you talk nice. Don't start that stuff now. |
| FRANKIE. | Well fuck you how I talk! I'll talk any fucking way I fucking feel like it.[18] |

Frankie then goes on to reveal some of the reasons for her reluctance to let Johnny in. As with several of the other fat characters I have discussed, she lost a parent (in this case her mother). Like Gertrude, Frankie was a victim of domestic abuse and is physically unable to have children as a result of sexual assault, which is framed as the primary reason she does not want to get close to Johnny.

Johnny dedicates himself to getting her to trust him and believe in romance, but like Gertrude, Frankie uses every possible tactic to rebuff him, including emasculating him, in this case rather literally. At the end of act one Johnny convinces the radio disc jockey to play their song and Frankie to let him spend the night. The two retire to make love once again. This time Johnny is unable to perform. The second act opens with the two negotiating this unfulfilled expectation. To lighten the mood, Frankie tries to get Johnny to make her a Western sandwich.

> JOHNNY.    Alright alright! (*He starts getting ingredients out of the refrigerator and slamming onto work counter.*) I just wish somebody would tell me how we got from mini-sex problem to major pig out.
> FRANKIE.   I don't think there's a connection.
> JOHNNY.    I wasn't going to tell you this but since you're not sparing my feelings, I am not going to spare yours: this is the first time anything like this has happened to me.
>
> . . .
>
> FRANKIE.   Then don't blame me your dancing dog didn't dance when you told it to. That sounds terrible. Don't blame me for your limp dick. Now where's my Western?
> JOHNNY.    You expect me to make you a sandwich after that?
> FRANKIE.   After what?
> JOHNNY.    Insulting my manhood.[19]

The conversation not only paints Frankie as a "man eater," callously emasculating Johnny, but highlights the connection between sex and food for Frankie, as with many characters I will discuss later. After each love-making session, Frankie turns to food. In this case, Johnny's being a cook makes him the perfect paramour.

Eventually, Johnny wears Frankie down and she reveals her scars to him, specifically the marks left by her ex-lover's belt buckle. This act of trust brings them together and, as in *The Sea Horse*, the play ends on a hopeful note, with Frankie acquiescing to dance in the moonlight to Debussy. Then the two awkward lovers brush their teeth before retiring in order to wake up next to each other in the light of day.

Among all these "Fat Love Stories," certain similarities emerge. The men are all dreamers who fall for oversize women not so much as sexual

creatures (although Gertrude and Frankie do have sex with their partners) but rather as their romantic ideal, their personal Madonna, savior, and future mother of their children. Indeed, Harry and Johnny are saintly in their dedication to women who continually rebuff them and are considered physically unattractive by most standards. The women are all unable to trust or accept love and test the men's sincerity, using similar tactics, including foul-mouthed scolding, insulting their masculinity, and withholding or denying their true feelings. All three women also share sexual secrets that add emotional scars to their flawed physicality. In Josie's case it is her virginity, and for Gertrude and Frankie it is rape and abuse. And despite their paramours characterizing them as Madonnas, all three will remain childless due to their perceived or real physical deficiencies. Both Gertrude and Frankie eventually confess that they are infertile as a result of previous sexual assault. And although Josie does not share this trauma, the ending of the play suggests that she will not seek another romantic partner and at twenty-eight in 1923, when the play is set, it seems reasonable to assume she will never marry or have children. This is paradoxical, considering fatness in many cultural references is most often linked to fertility, but in the case of these plays, fatness is a metaphor for barrenness as much as emotional damage. In other words, the playwright renders these characters as fat as an outward expression of their psychological and reproductive shortcomings.

Neil LaBute's *Fat Pig*, however, takes a sharp turn in a new direction for fat roles. Like the aforementioned playwrights, he explicitly calls for a fat actress, and the plot of the play revolves largely around questions of her size. It is also a love story but, unlike *Sea Horse* and *Frankie and Johnny*, does not end happily, nor does it resolve with self-recognition as *Moon* does. This is because LaBute, known for his ruthless portraits of social behavior, is the only playwright in this section who is actively interrogating cultural codes surrounding fat women in American society, rather than using fat dramaturgically as a metaphorical expression of a character's emotional pathology.

*Fat Pig* premiered in November 2004 at the MCC theatre in New York City and featured well-known television and film celebrities in all but the title role. It played simultaneously with Ensler's *The Good Body*. However, it ran much longer, turning over cast members, who were obliged to return to their television and film commitments when the run was extended.[20] In a way, *Fat Pig* takes on the question posed by Henry in *My Fat Friend*, who assumed that the only reason Tom would date Vicky was because there was something wrong with him. In the case of *Fat Pig*, the male love interest, also named Tom, struggles with this exact supposition. Much to his own surprise, he falls in love with Helen, who is fat.[21] When he learns her name,

he can't resist quipping "of Troy?" To which Helen replies, "Right, the thousand ships and all. But that was just so they could carry me back."[22]

LaBute describes the character of Helen only as "plus size. Very." And LaBute doesn't describe Tom at all, although the dialogue and the casting of Jeremy Piven, who originated the role, indicate that he is on the handsome side. The play opens with Tom bumping into Helen at a crowded cafeteria-style restaurant, where he takes a seat next to her because no others are available. Helen has been quietly eating her three slices of pizza. In the original MCC production, Helen, played by Ashlie Atkinson, ate her large meal, including the pizza, salad, two puddings, and garlic bread, as the audience filed in. The audience around me was visibly disconcerted. Murmurs erupted when she reached for the bread following her first slice of pizza. The choice to have the actress—a real fat woman—unapologetically eat pizza in front of an audience was remarkably subversive, effectively engaging the audience viscerally to consider their own feelings about fat.

As dictated by the script (and effectively portrayed in the MCC production), Tom and Helen have instant chemistry. She is a librarian and a movie buff. She eventually diffuses Tom's embarrassment about her size by addressing it directly. When he tells her she has a terrific laugh (and a "potty mouth"), Helen is quick to point out to him that women of her size always get compliments that avoid commenting on their overall appearance, such as having pretty eyes or a nice personality. Although throughout the play Helen makes some self-deprecating remarks, she is comfortable with her size, even as she knows others are not. She recognizes the social dilemma and makes the remarks in part because she is interrogating and testing as well as capitulating to what is expected of a fat woman: shame and apology. When they part, Tom takes her phone number, and Helen reveals her vulnerability in contrast to some of the previous fat heroines when she says: "There's every reason why I'll never hear from you again, I mean, besides the obvious one . . . Please do not let yourself be afraid of me or taking some kind of blind chance, or what people think . . . because this could be so nice."[23]

In the following seven scenes, Tom wrestles with just that. LaBute juxtaposes scenes between Tom and Helen, which are sweetly intimate, with scenes between Tom and his coworkers. The honesty between Helen and Tom is starkly contrasted to Tom's exchanges with Carter, his snarky, admittedly superficial best friend, and Jeannie, a coworker whom he dated briefly. Tom tries to hide his romance with Helen because he knows how his coworkers will react. Meanwhile, even as they enjoy romantic and sexual encounters, Helen is painfully aware that Tom has not introduced her to any of his friends or taken her anywhere highly public. When his coworkers discover Tom's secret, they are ruthless, just as he feared. Narcissistic

Jeannie feels not only jilted but personally attacked and humiliated by his choice to date someone whom she refers to as "huge," a "fat chick," and finally a "pig." Carter, who calls Helen a circus freak, posts her picture on all the office screensavers and eventually counsels his friend that he is "begging for trouble" by dating Helen. He informs Tom that it doesn't matter that Helen has many attractive qualities about her as a person; the fact that she is fat puts her outside of Tom's social circle. When Tom argues that it should not be all about appearances, Carter suggests he turn on a TV.

Tom tries to stand by his scruples and his genuine love for Helen and takes her to the company picnic—a beach volleyball party. Helen gamely arrives in a bathing suit carrying a vast picnic lunch and sits down with Tom, who has strategically made their camp far away from the center of the party. Helen suggests they join the volleyball game, but Tom cannot bring himself to do it. This is the only time Helen eats clearly as an emotional response to something upsetting her. Helen presses him to disclose what is troubling him, although it is clear she has known all along but dared hope that he might buck convention. He is too embarrassed to be seen with her.

In the MCC production, directed by Jo Bonney, Ashlie Atkinson appeared in a bathing suit alongside Keri Russell (who played Jeannie and was well known at the time for her turn in the lead role of TV series *Felicity*). During this scene there was a deliberate tableau featuring the two actresses side by side, allowing the audience to really compare their two bodies. Russell's ribs were strikingly visible even from the back of the house. Atkinson had visible rolls of fat around her midsection and very chubby arms and legs, although the flesh didn't hang, which I believe is an important distinction when considering the level of disgust or fear of contamination that fat bodies elicit. The degree to which the rolls of flesh hang or appear beyond an individual's control and threaten to jiggle or "leak" sweat are more repugnant than fat which is disciplined—firmer and more contained by controlling garments or relative musculature.

Interestingly, reviewers disagreed on whether or not Atkinson was actually fat enough. John Simon of *New York Magazine* claimed there was no chemistry between Piven and Atkinson. He also stated that he found the romantic scenes between them hard to watch. Perhaps he could not suspend his disbelief enough to accept that Jeremy Piven could credibly engage sexually with Atkinson. Piven, whom most would consider "Hollywood handsome" and a leading man, was popular at the time for his leading role in HBO's *Entourage*. Atkinson, who has gone on to have a stage and TV career, was relatively unknown at the time and, of course, fat. Simon's response was in contrast to most other reviewers including Ben Brantley of the *New York Times* and Dan Bacalzo of *Theatremania*, who remarked on their excellent chemistry (which was also my opinion when I saw the

play). Bacalzo wondered if it would be different if Atkinson was more than merely plump, but grossly obese. The differing opinions on what exactly is fat highlight the subjectivity of perceptions.[24]

Eventually, Tom confesses that he is a weak person, and he simply can't imagine having Helen as a long-term romantic partner because of her appearance. She tells him that she loves him so much that he is the first person she has been willing to change her appearance for and volunteers to get surgery or do Slim-fast or something else drastic. But it is too late for Tom. Just as Jim, Harry, and Johnny idolize their romantic counterparts, Tom places Helen on a sort of moral pedestal above him. Even though he does not have the strength to date a fat girl, he loves her too much to ask her to change or to allow her to see him weather the challenges of being in love with her, because he knows he will fail her.

Just as patterns of fat dramaturgy emerge in the previous chapter, the heroines of the "fat love" plays all adhere to a prototype of character psychology and behavior, despite the span of nearly sixty years in which they were written. They are all fiercely independent and unable to accept or trust love. They all wear a mask of sexual bravado and wit that covers their true feelings. The implication for most of the characters is that their fat, which perhaps has arisen from some emotional scar, protects them from being hurt any more than they already have been. Their suitors are all romantic dreamers, which implies that men have to be fantasists to even consider dating a fat woman or that a woman's fat somehow desexualizes, her allowing her to be the object of chivalrous, platonic love. Helen in *Fat Pig* is the possible exception to some of the stereotypes. While most of the characters I have mentioned, both comic and romantic, embody many of the fat stereotypes, Helen seems to have them imposed upon her by the characters in the play. They have all assimilated cultural beliefs about fat women and refuse to accept her as "normal," although LaBute paints her as the most well-adjusted character onstage. Nonetheless, to create a dramatic narrative, all the plays in this chapter capitalize on cultural constructions of fat, including assumptions about the emotional makeup of a fat woman that I established in chapter one.

# 4

# Monsters, Man Eaters, and Fat Behavior[1]

This chapter explores a number of plays that construct female characters and shape their personalities through a myriad of negative stereotypes associated with fat. I mainly focus on the portrayal of fat women as voracious consumers who threaten the equilibrium of the world of the play. I use the word *consumer* both for its economic connotations and for its other meanings to refer to women who eat, devour, and destroy what is around them, literally or emotionally. I want to highlight the connection between portrayals of women as primary consumers of products in a capitalist marketplace and portrayals of fat women as excessive, wasteful consumers of food, drink, and physical as well as psychic space in our culture.

The fat female body and/or weight loss is not the central focus of these plays, unlike those in the previous chapters. Rather, dramaturgically speaking, the strong female characters portrayed in these plays disrupt the stasis of the play with their immoderate behavior and therefore drive the plot forward. The next plays I will cover do not explicitly call for fat actresses, but within the texts there are more subtle semiotics that connect the excessive behavior of the character with her body type. Frequently, powerful female characters, or those who are seen as inappropriately aggressive (sexually or otherwise) or overly passionate, are identified as fat either literally or metaphorically, and this is subsequently reflected in casting. Another part of this characterization includes "animalizing" the female. Often, playwrights endow aggressive female characters with animal traits or behaviors, as described in stage directions. And although the playwrights do not always call for a fat actress to play these roles, within the plays, other characters often remark on the size of such a character. As a result, casting has often turned to actresses who are "more-than" in some way, and critical reception has hinged on those choices. This chapter explores fat performativity

by deconstructing texts of several American playwrights and exploring how they utilize what is culturally perceived as "fat behavior" as a dramaturgical strategy. With the following examples, I suggest that playwrights capitalize on cultural fears and prejudices concerning the fat female body and use the associations explicitly linked to fat/consuming women to create characters who embody what I call fat behavior, and thus contribute to dramatic conflict within the play.

In order to explore fat behavior as a dramaturgical strategy, I begin by defining the phrase *fat behavior*. Fat behavior refers to the qualities and characteristics that Western culture, Americans in particular, attach preconsciously to fat female bodies. These include the assumptions I describe in chapter one of a fat woman as out of control on a physical and emotional level, outspoken, and voracious in her appetite for food, sex, and power. Furthermore, as I have discussed, the perception of which bodies we culturally construct as fat in terms of aesthetics covers a wide range of female body types. This can include any woman's body that is considered "more-than," falling outside the boundaries of the normative light-skinned, slender, proportionate white female—the iconic "Barbie Beauty"—frequently depicted in popular media. The parameters of what constitute a fat woman in popular representation such as film, television, and advertising is even more subjective and perverse than for the average woman. Thus, in the context of hegemonic Western culture, fat bodies, specifically fat (white) female bodies are powerful signifiers, and, in the framework of theatrical representation, a fat female body telegraphs specific character attributes to an audience. The fat female as a semiotic figure is inextricably bound up with a myriad of cultural stereotypes that associate her size—an indicator of her vast appetite—with her deviant, unruly fat behavior.

I also link fat behavior to inappropriately masculine behavior from a woman because it implies a woman who does not abide by gender roles. She assumes roles of power and leadership typically associated with men. For example, fat behavior might include consuming a "masculine" amount of food or alcohol, or literally taking up too much space not only in size but in bodily gesture. I am not the first Fat Studies scholar to explore the idea of fat behavior. In her book *The 'Fat' Female Body*, Samantha Murray furthers this description when she writes, "I would argue that we have a well-developed and readily deployed 'literacy' when it comes to reading bodies . . . The logic that governs this 'body literacy' is, in some respects, a very tacit, fundamental and unspoken one . . . [C]ultural meanings have become so familiar to us, they operate without question."[2] Murray goes on to describe all the negative assumptions associated with the fat female that I have discussed.

All of these negative cultural perceptions contribute to the way in which we read fat female bodies onstage and are examples of fat behavior. Fat behavior goes beyond the physical appearance of an individual; it is part of a lived identity.[3] In order to illustrate how fat behavior works onstage, I will first examine several of Tennessee Williams's heroines whose fat behavior consumes the world around them. Serafina from the *The Rose Tattoo* (1951), Maxine from *The Night of the Iguana* (1961), and Leona from *Small Craft Warnings* (1972) all differ from Williams's better known heroines such as Blanche, Laura, and Alma in that they possess sexual agency and are not emotionally crushed by the end of the play. In fact, they generally accomplish their objectives even though they are portrayed as sexually voracious, exhibiting various excessive behaviors that threaten to devour the characters around them literally, emotionally, or psychologically. Next I will look at the ways in which Edward Albee exploits the stereotype of the voracious woman in *Who's Afraid of Virginia Woolf?* (1962) with his characterization of the booze-swilling, "braying," promiscuous Martha, who is perhaps the ultimate "man eater."

## Devouring Women: Tennessee's Tramps

I begin this discussion with a play that could potentially fit in the previous chapters because the character in question is, in fact, repeatedly described in the text as "plump" and even "fat," but unlike in the previous fat texts, weight is not what drives the plot forward. Instead, it is Serafina's fat behavior in Tennessee Williams's *The Rose Tattoo* that creates the conflict of the play. And like Moore and McNally, Williams wrote the play with a specific actress in mind: the voluptuous, Italian-born Anna Magnani.[4] Williams wanted to create a character who could benefit from Magnani's zaftig appearance and passionate acting style. Serafina was the result, and she is characterized by excessive, obsessive behavior, or fat behavior. Actresses who have subsequently taken up the role have embodied the "more-than-ness" necessary to play Serafina.

The narrative of the play follows the story of Serafina, a proud Sicilian seamstress living with her daughter in a tight-knit immigrant community. In the opening scene, she is anticipating the return of her beloved husband, Rosario, a truck driver who bears a rose tattoo on his chest. In the stage directions, Williams specifically describes Serafina as "a plump little Italian opera singer . . . Her voluptuous figure is sheathed in pale rose silk . . . She sits with plump dignity, she is wearing a girdle." She raves about her passion for her husband, eagerly awaiting his return, rhapsodizing that her "heart is too big to swallow."[5] However, she is grief stricken when she receives the news that her husband has been killed in an accident.

As the play progresses, Williams characterizes Serafina with fat behavior, which creates dramatic conflict. In response to her husband's death Serafina completely lets herself go emotionally and physically, not caring for her appearance or basic hygiene.[6] Her weight gain and her uncleanliness are physical manifestations of the disorientation of her spirit. In her book *Purity and Danger*, Mary Douglas explores cultural attitudes and fears about dirt and uncleanliness. She notes that, "[a]s we know it, dirt is essentially disorder. There is no such thing as absolute dirt: It exists in the eye of the beholder . . . Dirt offends against order."[7] In addition to a myriad of emotional pathologies, fat is also frequently associated with filth and threatens to contaminate those around it. Indeed, I could substitute the word *fat* for *dirt* in the above quote. Serafina's condition following the death of her husband plays on these closely linked cultural fears of dirt and fat. They both invoke fear and represent disorder.

Williams not only invokes this cultural fear of dirt but also animalizes Serafina in ensuing scenes. For example, he stages an altercation between Serafina and her daughter, Rosa, whom she has locked up to prevent her going to graduation. The stage directions clearly indicate that Serafina is living in filth; she is not taking care of herself and is treating her daughter like an animal by locking her up naked. Williams extends the animal metaphor in his stage directions when Rosa's teacher and the neighbor women try to intervene; Serafina tries to chase them all away, responding with "a long, animal howl of misery," and as she nearly collapses in distress, the neighbor women support "the heavy sagging bulk" of Serafina's grief-stricken body.[8] Serafina's behavior is violent and irrational, and it is described in the text with various animal metaphors. Like a bull, she "plunges out into the front yard in her shocking dishabille, making wild gestures," even as her daughter begs her not to embarrass her further.[9] Eventually, Rosa escapes to her graduation but not before calling her mother "disgusting."

In the scene immediately following, Serafina attempts to pull herself together to attend her daughter's graduation, but before she can do so she has another encounter that reveals several more underlying assumptions about fat behavior. Customers Flora and Bessie come to collect a shirt. While they wait, they discuss their sex lives and call out the window to passing men, for which Serafina chides them. Flora exacts her revenge:

> FLORA. (*acidly*) Well, ex-cuse me! (*She whispers maliciously to Bessie.*) It sure is a pleasant surprise to see you wearing a dress, Serafina, but the surprise would be twice as pleasant if it were the right size. (*To Bessie, loudly*) She used to have a sweet figure, a little bit plump but attractive, but sitting there at that sewing machine for three years in a kimono and not stepping out of the house has naturally given her hips![10]

Serafina defends her figure, but the women respond with further cattiness. Flora and Bessie insist that she is jealous of their popularity with men, and Serafina retorts, "When I think of men I think about my husband. We had love every night of the week. We never skipped one, from the night we married till the night he was killed."[11] The more they goad her, the more Serafina emphasizes the sacredness of her relationship with her husband and insists that she *knows* what lovemaking is and they do not. The women then insinuate that her husband was unfaithful. This reduces Serafina to an animal state again, and she attacks them with a broom and they leave, at which point Williams's stage directions once again call attention to her size and her animal behavior indicating that "[s]he moves about helplessly, not knowing what to do with her big, stricken body, panting and mumbling, she thrashes crazily around the small confines of the parlor."[12]

Serafina becomes obsessed with discovering the truth and vigorously and shamelessly pursues the town priest to reveal her husband's confessions. He denies her request and insults her by declaring that she is "not a respectable woman." When Serafina debases herself and agrees with him, he goes on to say, "No, you are not a woman, you are an animal!"[13] Again, Serafina agrees with his assessment and, according to the script, nearly attacks the priest before townspeople escort him to safety. Maureen Stapleton, an actress whose weight fluctuated throughout her career, originated the role on Broadway and won a Tony for her portrayal of Serafina.[14] Stills from the production highlight her more-than-ness in terms of her bodily size and gesture. In the highly regarded 1995 revival of the play at Circle in the Square, Mercedes Ruehl played Serafina and did, in fact, attack and knock down the priest. Throughout the production, Ruehl, who is not as full figured as Magnani or Maureen Stapleton were, was physically powerful, appearing dangerously stronger than anyone else onstage.[15] Ruehl's costumes in the role also emphasized the character's lack of containment; frequently her dresses would slip off of her shoulders or hang in such a way as to threaten exposure.

Williams's characterization of Serafina relies on many of the stereotypes associated with fat women and manifests in fat behavior. For example, her obsessive grief for her husband suggests someone imbalanced or unable to control herself. During the scene in which she argues with the neighbor women about her daughter's graduation, Williams's stage directions suggest that she is a cornered animal. She howls, screeches, plunges, and crouches at various points in the scene, and they grapple with her as if she were a wild bull. This crazed behavior is associated with her weight gain and her poor hygiene, which is well established in these scenes. Even her somewhat implausible insistence that she and her husband made love every night is a kind of fat behavior. Many might consider it excessive to

have sex every day, and certainly telling virtual strangers about this behavior is overly familiar. Serafina has no boundaries.

Serafina's excessive grief is the dramaturgical device that creates imbalance in the world of the play. The mores of the culture in which she was brought up require that Serafina play the role of the dutiful Catholic widow who denies her sensuality and zest for life and dons black to mourn her husband indefinitely. But as Williams characterizes her, this dictum is in such conflict with her sensual nature that it manifests in her excessive conduct. Her erratic behavior disrupts the world of the play and victimizes her daughter. The arrival in the second act of Alvaro, another handsome fruit truck driver, begins Serafina's journey back to normalcy. In Alvaro she sees aspects of her dead husband and takes this as a sign they are "meant to be." Serafina puts extreme faith not only in her religious beliefs but also in superstitions. This is a fat behavior in that she views her life as beyond her control; in this case she sees it in the control of vaguely defined universal forces. In other words, she does not take responsibility for her actions, which is another quality consistently attributed to fat people. They share a bottle of Spumante, and Alvaro tells her about himself. When she laughs heartily as the cork pops from the wine, the following conversation ensues.

ALVARO.    I like a woman who laughs with all her heart.
SERAFINA.    And a woman that cries with all her heart?
ALVARO.    I like everything that a woman does with all her heart.[16]

He is attracted to the very behavior—fat behavior—that has ostracized her from her daughter and her community. As she tells him her story, he begins to fall in love with her and declares that he is looking for someone. "I don't care if she's a little too plump or not such a stylish dresser," he says, which is clearly directed at Serafina's unkempt appearance. Alvaro, whose family name, Mangiacavallo, means "eat a horse," is the first character who is not frightened by her passion. As his name suggests, Mangiacavallo is so big and garrulous that he could almost literally "eat a horse."[17] This is the man who is prepared to woo Serafina—a woman whose repressed passions turn her into an animal. Only his appetite is big enough to consume the animal she has become. In naming him Mangiacavallo, and characterizing Serafina's ardor as all-consuming, Williams seems to equate passion with consumption. By the end of the scene, she has agreed to a date.

The play culminates with Serafina and Alvaro making love and Serafina reconciling with her daughter. Order is restored to the world of the play because Serafina has found a man who can slake her extreme passion. The arc of Serafina's character suggests that while she may always have been prone to plumpness and excessive behavior, the loss of her first

husband—and her sexual satisfaction with him—turns her into a fat, dirty woman who acts like an animal. She gets fatter when she is not being fed sexually, suggesting that she substitutes food for sex. But the fact that Alvaro is finally able to woo her hints that her appetites can be satisfied with the passionate love of a man.

Ten years after *The Rose Tattoo*, Tennessee Williams created another ravenous woman with Maxine Faulk in *The Night of the Iguana*, which opened on Broadway in 1961.[18] Maxine is not necessarily the central character in this play, but she might be described as the antagonist. Her fat behavior is an obstacle to the hero's goal of redemption and well-being. The play takes place in the summer of 1940 at a secluded hotel atop a steep hill that overlooks the ocean in Costa Verde, Mexico.[19] Maxine, who is recently widowed, is the hotel owner. She is described in the stage directions for the opening scene as a "stout, swarthy woman in her middle forties—affable and rapaciously lusty. She is wearing a pair of levis and a blouse that is half unbuttoned."[20] Maxine displays a variety of fat behaviors. She is bawdy, prone to cursing, sexually aggressive, and drinks heavily throughout the play. Her heavy drinking is a metaphor for her sexual appetite, which is depicted as all-consuming. As owner of the hotel, she also violates gender stereotypes in the way she barks orders at the Mexicans who serve her.

The inciting incident of the play is the arrival of Maxine's old friend Reverend Shannon, a defrocked priest who is now a tour guide, leading tour buses of church ladies on extended getaways along the Mexican jungle coast. When he arrives at Maxine's hotel, he is drunk and in the midst of a nervous breakdown (a variation on others he has had before). Shannon has more or less taken his tour group hostage and is insisting that they stay at Maxine's. The conflict of the play centers on Shannon's struggle with his inner demons—what he calls "spooks"—and his quest to recover his dignity. At the hotel he is torn between two forces: his old friend Maxine, who is painted as a destructive agent tempting him toward total ruin and dependence on her, and Hannah, a slender guest at the hotel who encourages him to sober up and regain his humanity, which he feels he has lost. Hannah is a sketch artist and earns her (very modest) living sketching people's portraits at resorts. Williams connects her artistic vision and her spiritual vision by characterizing her as someone who is able to see into people's souls. Hannah is the opposite of prurient. She is patient, kind, modest, and uninterested in sexual contact. Despite her lack of sexual experience, she sympathizes with Shannon's struggles (he has a proclivity for sex with minors as well as a problem with alcohol). She contrasts sharply with Maxine, who is depicted as sexually rapacious and dangerous.

Just as Williams characterizes Serafina with animal metaphors in *The Rose Tattoo*, Maxine is also frequently animalized in the text. For example,

her laugh is described as follows: "Maxine always laughs with a single harsh, loud bark, opening her mouth like a seal expecting a fish to be thrown to it."[21] She laughs frequently, often sarcastically, throughout the play, and the stage directions always emphasize that it is a "bark." Also like Serafina, Maxine is very much driven by her sexual appetite. She has recently been widowed, and she sees Shannon as a potential replacement husband. In the first scene Shannon, in the throes of his breakdown, struggles into the hotel, hoping for solace from his griping tourists, and is shocked by Maxine's overtly unbuttoned, sexual appearance:

MAXINE.     Well! Lemme look at you!
SHANNON.   Don't look at me, get dressed!
MAXINE.     Gee, you look like you had it!
SHANNON.   You look like you have been having it, too. Get dressed!
MAXINE.     Hell, I am dressed. I never dress in September. Don't you know I never dress in September?
SHANNON.   Well, just, just—button your shirt up.[22]

Maxine, who is literally falling out of her clothes, immediately tells him that her husband, Fred, is dead and makes a point to inform Shannon that they had not had sex in years, which seems to have rendered him dead to her before he actually died. Like Serafina, she exceeds social boundaries by blurting out all of this personal information. Maxine spends the rest of the play trying to convince Shannon that they are a perfect pair of outcasts and that he should embrace his hedonistic side and retire from civilized society with her.

Shannon's unhappy tourists are also offended by Maxine's appearance and rough talk (as well as suspicious that Maxine will give their unruly guide a kickback). The leader of the tourist insurrection, Miss Fellowes, heads into the hotel office to use the phone. For his part, Shannon is truly offended by, or perhaps fearful of, Maxine's sensuality:

SHANNON.   Why did you have to . . . ?
MAXINE.     Huh?
SHANNON.   Come out looking like this. For you it's funny but for me it's . . .
MAXINE.     This is how I *look*. What's wrong with how I *look*?
SHANNON.   I told you to button your shirt. Are you so proud of your boobs that you won't button your shirt up? Go into the office and see if she is calling Blake Tours to get me fired.[23]

Clearly, Maxine's overt sensuality cannot be contained and is a menace to Shannon's delicately balanced psyche. During act two, lusty Maxine and angelic Hannah engage in a power struggle for Shannon's attention.

Shannon has affection for Maxine but sees her hedonistic behavior as a threat. Unlike Hannah, she encourages him to forgo drying up and have a drink, believing he will feel better for it. This is a kind of gender-stereotype role reversal, wherein the man is trying to stay sober enough to maintain his wits and avoid being taken advantage of by the woman, who is plying him with alcohol as part of her seduction. Williams subtly codes Maxine as fat through fat behavior and Shannon's interaction with her. Maxine's appetite for sex and alcohol threatens to consume Shannon's last scrap of sanity and dignity. Significantly, each time Maxine is too forward with Shannon, he responds defensively, either by insulting her weight or comparing her to an animal. Williams equates her aggressive sexual nature with animal behavior and fat—an outward sign of excess. Maxine encourages Shannon to have a drink and he deflects her: "Maxine honey, whoever told you that you look good in tight pants was not a sincere friend of yours."[24]

Later, as Maxine tries to distract Shannon from Hannah (again, by offering him a drink), he refuses her with another insult about her size, although, just as Serafina defended her full figure, Maxine spins the insult into an opportunity to extol her sexual virtues:

SHANNON.  Maxine, your ass—excuse me Miss Jelkes—your hips, Maxine, are too fat for this verandah.

MAXINE.  Hah! Mexicans like 'em, if I can judge by the pokes and pinches I get in the busses to town. And so do the Germans. Ev'ry time I go near Herr Fahrenkoph he gives me a pinch or goose.[25]

Indeed, Maxine is unabashed about her sexuality. Williams's stage directions pointedly describe her gaze as salacious and hint that, in addition to pursuing Shannon, she is interested in the handsome Mexican boys who inhabit her hotel.

Later, in act three, Maxine begins a different seduction tactic. She tries to convince Shannon that he is a better match for her than her deceased husband was. She animalizes herself when she describes the lack of physical and emotional intimacy between them in contrast to the connection she and Shannon have:

MAXINE.  Yeah, well, Fred and me'd reached the point of just grunting.

SHANNON.  Maybe he thought you'd turned into a pig, Maxine.[26]

Thus, Shannon articulates the animal metaphor that the text hints at throughout. Despite the insult, Maxine tries another tactic to woo Shannon. She reminds him that they share a history and that she knows about the various childhood traumas and transgressions in his past that have

led to his breakdown. Instead of proving that she understands him, this line of reasoning terrorizes Shannon. He snaps completely and has to be restrained. Maxine ends up having to tie him to the hammock for his own protection. Only Hannah can reason with him.

Eventually, through Hannah's gentle coaching and their philosophical conversations, Shannon is able to stabilize emotionally. Shannon further contrasts Hannah with voluptuous, passionate Maxine by referring to her as "Miss Thin-Standing-Up-Female-Buddha." Hannah is able to offer him hope for the human spirit and frees him from the hammock. He in turn, frees the iguana who has been tied to the porch—a captive that the (savage) Mexicans and Maxine intended to slaughter and eat. This act of grace toward the trapped iguana, precipitated by Hannah, frees Shannon emotionally.

Although Maxine is not explicitly described as fat in the text, there are several lines that hint she is fat or "more-than," and many of her character traits fall into fat behavior. The text makes clear that she is a sexual predator and that she frequently violates social boundaries. Not only is she unabashedly the boss of her Mexican staff, but she drinks, swears, and is overly frank with everyone. Her lasciviousness and amoral outlook are a complicating factor in Shannon's quest for beauty and human decency. In the original Broadway cast, Maxine was played by Bette Davis, who was fifty-three at the time. Although Davis might not be considered fat most standards, her appearance was certainly "more-than"; her beauty was unconventional because of her extreme features, her mouth and especially her eyes were oversize. Moreover, the persona she established for herself in Hollywood was that of a dominating, larger-than-life woman. The voluptuous Ava Gardner played the role alongside Richard Burton for the movie version. In a 1996 revival, Vincent Canby of the *New York Times* criticized Marsha Mason's interpretation of Maxine, stating: "The kindest thing to say about Ms. Mason is that she is miscast as the robust, tough-talking Maxine. Being light of weight as a theater presence, she has to push hard to suggest an edgy, hard drinking, unsentimental earth mother, someone with a fondness for beach boys, two at a time."[27] Note that the reviewer uses "light of weight" as a metaphor to express Mason's (an Academy-Award-winning actress) inadequacies. According to Canby, she did not carry the weight to play the rapacious Maxine. On the other hand, I would argue that even beyond the aesthetic of body size, there is a fat identity that is established by Williams, which is embodied in characters such as Maxine and Serafina and enhanced when a fat actress plays the part.

The last ravenous woman from Williams's canon I will cover is Leona Dawson from *Small Craft Warnings*, which premiered off-Broadway in 1972.[28] By all accounts this production failed, and the play has seldom been

revived. *Small Craft Warnings* was written in the latter half of Williams's career and deviates from his successful playwriting formula of the late fifties and early sixties. The play, which takes place in a bar, is somewhat experimental in style, with characters directly addressing the audience. It does not have a strong linear plot, although all the characters are fully drawn psychological portraits of lost souls who inhabit this same seaside bar. The fat identity of Leona is more blatant than the aforementioned roles of Serafina and Maxine, as she is described in the text as fat. She also embodies much of the fat behavior I have discussed. Helena Carroll, who was fat by contemporary standards, originated the role of Leona Dawson, who is the force that drives the play forward. Both the stage directions and other characters call her fat, and her obstreperous fat behavior disturbs the equilibrium of the world of the play and sets the evening in motion. Without Leona, the other characters would have their usual night of liquor-induced calm and stasis. Leona's entrance is described in the stage directions as follows: "The door bursts open. Leona enters like a small bull making his charge into the ring. Leona, a large, ungainly woman, is wearing white clam-digger slacks . . . a sailor's hat which she occasionally whips off her head to slap something with.[29]

Leona's first line is a threat directed at Bill, the gigolo who has been living with her for free in exchange for sexual favors. Leona is having a bad night because it is the anniversary of her brother's death. She has cooked a ceremonial meal for herself and has been drinking during the process. Bill sneaked out to the bar during one of her weeping jags about her lost brother. Within moments of Leona's entrance, Bill begins flirting with Violet, a waiflike prostitute who subsequently begins to grope him under the table. Leona catches her, and one of the driving through-lines for the rest of the play is the power struggle between brawny Leona and shrinking Violet for Bill's attention. Leona also wants everyone in the bar to share in her grief and possibly comfort her on the anniversary of her brother's death, and she keeps playing a violin sonata on the jukebox.

Arguably, *Small Craft Warnings* is not a plot-driven play but more of a portrait of eight lonely people who are stuck in their lives and have only the bar—Monk's Place—in common. Leona is the disruptive force in this otherwise stagnant world. She picks fights, some of them physical, with literally everyone in the bar at some point. She drinks to excess throughout the play. Her first argument is with Violet over the groping incident. When everyone else in the bar sides with Violet and begins to ignore Leona, Leona changes tactics and turns her attention to a gay couple, Quentin and Bobby, who have just entered the bar. Like Serafina and Maxine, she is overly familiar, ignoring boundaries of social politeness. She has never met these men but is immediately inappropriately personal with them.

LEONA.    There's some kind of tension between you. What is it? Is it guilt feelings? Embarrassment with guilt feelings?

. . .

QUENTIN.  Don't you think you're being a little presumptuous?
LEONA.    Naw, I know the gay scene. I learned it from my kid brother. He came out early, younger than this boy here. I know the gay scene and I know the language of it and I know how full of sickness and sadness; it's so full of sadness and sickness, I could be almost glad that my little brother died before he had time to be infected . . . Now what went wrong between you before you come in here, you can tell me and maybe I can advise you. I'm practically what they call a faggot's moll.[30]

Surprisingly, they do tell her their story despite her inappropriate behavior. On the other hand, the alliance between the gay couple and Leona is another example of the subtle connection in various cultural texts between gay and fat identity that I will explore further in chapter seven. When the gay couple leaves, she moves on to pick a fight with the bartender, who will not serve her any more alcohol because she is a mean drunk. He suggests that Bill (the gigolo) take Leona home.

LEONA.    Christ, do you think I'd let him come near me?! Or my trailer?! Tonight?! (*She slaps the bar several times with her sailor cap, turning to the right and the left as if to ward off assailants, her great bosom heaving, a jungle-look in her eye.*)[31]

Williams's stage directions emphasize not only her size but also her animal quality. In another instance, Leona tries to prevent the "Doc" (who is drunk and no longer has a license) from leaving the bar to deliver a baby. She sits on his doctor's bag. The stage directions read: *"She is then warily approached from three or four sides by Monk, Doc, Bill, and Steve as trainers approaching an angry 'big cat.'"*[32] And during a later altercation between Leona and the police, Bill says: "No man can hold that woman when she goes ape. Gimme a dime, I'm gonna call the Star of the Sea psycho ward."[33]

*Small Craft Warnings* is one of Williams's later plays, and Leona is perhaps a culmination of the devouring heroines that precede her in his canon. Her frank sexuality is in keeping with the trajectory of the women's movement and the sexual revolution in the United States at the time Williams was writing. However, arguably, her disruptiveness is not entirely negative in this piece. She is more pragmatic and proactive than any of the other characters in the bar, who allow their lives to slip away in booze-induced sadness and helplessness. Her demanding presence, her excessive drinking, and her grief over

her brother's death shake up the seaside bar for the night, and the result is that Bill the gigolo decides to move on, Violet finds a new home at the bar with Monk, and Leona decides to pack up her camper and head to a new town.

These three Williams heroines all demonstrate various types of fat behavior. All of them are characterized by their excessive emotional outbursts and overly aggressive behavior, sexually, emotionally, and otherwise. They generally do not assume personal responsibility for their actions, and they often emotionally harm those around them with their insensitive, immoderate behavior. Dramaturgically speaking, their fat behavior is one of the driving forces of Williams's plot in each case. Owing to Williams's "fat" characterizations, frequently the actresses who received the best critical reviews in the roles of Serafina, Maxine, and Leona have been fat or large actresses by contemporary standards.

### Albee's Ultimate Man Eater

The next play in my series of ravenous women is perhaps the best example of a playwright relying on cultural assumptions to depict an all-consuming, uncontrollable woman with ravenous appetites: Martha in Edward Albee's *Who's Afraid of Virginia Woolf?*, which has engaged audiences since its Broadway debut in 1962 when it starred Uta Hagen and Arthur Hill. More than the aforementioned Williams plays, *Virginia Woolf* has withstood the test of time and enjoyed long-running success, as demonstrated by multiple regional and Broadway revivals, including one on Broadway in 1976 that was directed by Albee himself, starring Colleen Dewhurst and Ben Gazzara. The play was also made into a successful film directed by Mike Nichols and starring Elizabeth Taylor and Richard Burton. It has seen a hearty life in regional and community theatre productions. The 2005 Broadway production starring Bill Irwin and Kathleen Turner was well received critically, and the run was extended. And in 2012, barely six years later, a Steppenwolf production transferred to Broadway featuring Tracy Letts as George and Amy Morton as Martha. The production, directed by Pam McKinnon was nominated for multiple Tony Awards and won three including Best Revival. Clearly, *Who's Afraid of Virginia Woolf?* has become a middlebrow theatrical staple that continues to have widespread appeal to American audiences. Certainly there are a multitude of reasons for the play's continued popularity, most obviously the craft and mastery of Albee's playwriting and the compelling characters he created. George and Martha's complex and cruel relationship continues to resonate with twenty-first-century audiences.

Perhaps one reason the play retains such power and interest, and is reproduced more often than other plays in this chapter, is that Albee

successfully taps into cultural fears and assumptions about male authority and female power in creating the characters and dynamics of the memorable couples. The antiheroine of the play is Martha, whom Albee describes as "a large, boisterous woman, 52, looking somewhat younger. Ample, but not fleshy." This character description is often taken quite literally in the casting process, and we must assume that even if Albee himself does not see Martha's physical appearance as integral to the character's identity, most casting directors do. The play revolves around the combative relationship between Martha and George and their mutually antagonistic behavior. However, the suggestion is that Martha's dominance over George creates an imbalance in the relationship that is intolerable for both. For the most part, George is painted as the long-suffering husband who only bares his fangs when Martha repeatedly attacks and humiliates him. His strategy is sophisticated and verbally eloquent. On the other hand, Martha's aggressiveness is depicted as a pathological behavior inextricably linked with her "large/ample" body. Like her predecessors in this chapter, Martha is frequently characterized as a monster, and her bold manner is likened to a variety of animal behaviors. Her overt sexuality is depicted as immodest, unnatural, and even castrating. Martha's body and personality are sharply contrasted with those of Honey—the foil—who in some ways serves as a model of a culturally assimilated wife.

Albee employs the same device of animal metaphors to illustrate Martha's subhuman behavior even more overtly than Williams does with his ravenous women. George constantly compares Martha to various animals and monsters, from donkeys and geese to a Cyclops. The play opens with Martha and George returning from a faculty get-together, whereupon the script indicates that the audience hears Martha's laughter before seeing her. Immediately gender roles are reversed when her voice dominates the space and George demurely shushes her. Within the first two pages of the script, as they rehash the evening's events, they argue about whether or not she "brays." Martha berates George for his passive behavior at the faculty get-together.

MARTHA.   You didn't *do* anything; you never *mix*. You just sit around and *talk*.
GEORGE.   What do you want me to do? Do you want me to act like you? Do you want me to go around all night *braying* at everybody, the way you do?
MARTHA.   (*Braying*) I DON'T BRAY!
GEORGE.   (*Softly*) All right . . . you don't bray.[34]

In the movie version of this scene their house is much disheveled, once again drawing a visual connection between fat and filth. Martha enters and

proceeds directly to the refrigerator. She stands with the fridge door open during much of this sequence eating a chicken leg with gusto and arguing with George with her mouth full of food. When she is finished, she throws the bone back into the fridge. The camera point of view is within the fridge.

Just as Williams establishes the predatory relationship between Maxine Faulk and her victim Shannon in *Iguana,* in this opening sequence of *Virginia Woolf,* Albee quickly establishes another inverted power relationship, where the woman insists on controlling. As they await their guests, George reminds her to keep her clothes on and refrain from pulling her skirt over her head. He then quickly adds, "your heads, I should say," referencing the stereotype that a woman who dominates verbally also has an uncontrollable sexual appetite, which is frequently linked to her appetite for food. I will return to that theme in future chapters with some of Paula Vogel's characters.

Although the character description does not precisely call for a fat actress, the role of Martha has traditionally been played by an actress who is "more-than," a performer who can embody her larger-than-life character. Audiences seem to equate Albee's "boisterous, ample" Martha with an actress who is "more-than," somehow outside of the contemporary normative cultural aesthetic for an attractive female figure. (It was the film version of this play that inspired Liz Taylor to gain weight, which was openly part of the movie's promotion. It arguably increased her credibility as a "serious" actress, and she won an Oscar for her portrayal.) When Martha is played by a fat actress, the casting taps into a well of cultural prejudices toward fat women as untamed and unsocialized. Certainly the way in which Albee stereotypes Martha's insatiable thirst for alcohol and sex harks back to an ancient trope of the powerful woman as all-consuming.

As I discuss in chapter one, there is a longstanding cultural intertwining of the female body with women's uncontrollable appetite for nourishment, sex, and power. In various cultural texts from pop songs to advertising, female potency is frequently conflated with hunger and eating; the sexually aggressive woman is a man *eater.* In the words of Susan Bordo, "[e]ating is not really a metaphor for the sexual act; rather the sexual act, when initiated and desired by a woman, is imagined as itself an act of eating, of incorporation and destruction of the object of desire."[35] Whether intentionally or not, Albee's Martha and Williams's women are crafted by appealing to these cultural fears. It is no coincidence that these roles, especially Martha, have become associated with so-called fat actresses, because their size embodies the fat behavior associated with these prejudices.

Martha's monstrousness is underscored by her insatiable appetite. She "consumes" everything from ice to George's ego to sex to alcohol. Throughout the play, Martha swills copious amounts of alcohol, which only seems

to sharpen her cruel wit. Early in the play, she boorishly tries to force George to give her a "sloppy kiss," and when he refuses, she demands another drink, suggesting a correlation between the kiss and the booze, as if they are interchangeable objects for consumption in Martha's eyes. If she cannot get into George's mouth, she will substitute the mouth of the glass. Her ability to drink straight liquor throughout the night and retain her wit (she tells George, "Look, sweetheart, I can drink you under any goddamn table"[36]) is contrasted to Honey's ladylike lack of tolerance for alcohol. Martha drinks like a man, and this too is a kind of fat behavior. As he fixes their drinks, pointedly serving Martha her "rubbing alcohol," George reminisces about their early courting days, when she drank "real ladylike little drinkies."[37] In fact, as everyone else tries to keep up with Martha's boozing, Honey ends up getting sick in the bathroom, and Nick is eventually rendered impotent. George seems less affected, but Martha clearly retains her wits and her sexual appetite in a most unladylike way.

Later in the play, she again forces herself on George, and when he acquiesces and kisses her, she puts his hand on her breast. He refuses her and openly humiliates her for her "blue games in front of the guests."[38] Martha retaliates by seducing Nick, and when he fails to satisfy, her she verbally chews him up:

MARTHA.    (*Her glass to her mouth*) You're certainly a flop in some departments . . .
NICK.      I'm sorry you're disappointed.
MARTHA.    (*Braying*) I didn't say I was disappointed! Stupid!
NICK.      You should try me sometime when we haven't been drinking for ten hours, and maybe . . .
MARTHA.    (*Still braying*) I wasn't talking about your potential; I was talking about your goddamn performance.[39]

Not even a younger man can satisfy Martha's appetite.

Similar to the way in which Williams contrasts lusty Maxine and angelic Hannah, Albee further establishes Martha as excessive by setting up Honey as a foil in terms of her physical size and more demure behavior. Honey may be as controlling as Martha, but her tactics are passive-aggressive. The men seem to appreciate this arguably more feminine version of manipulation. Martha describes her as "slim hipped" and throughout the play Honey's slim hips are openly discussed. In their first private conversation, George and Nick compare their wives' ages and weight. George declares, "Martha is a hundred and eight . . . years *old*. She weighs somewhat more than that."[40] As Nick reveals their story, Honey's slim hips become a symbol of her frailty and subservience, and George seems to long for a slim-hipped wife who embodies all the retiring qualities that Honey possesses. When

Honey disappears into the bathroom to vomit, Nick says, "She . . . really shouldn't drink. She's frail. Uh, slim hipped, as you'd have it . . . She gets sick quite easily." To which George ruefully replies, "Martha hasn't been sick a day in her life."[41] Martha's strapping constitution is negatively contrasted with Honey's sickliness, which seems to mark her as the more feminine of the two, although neither are fertile. Honey has "hysterical pregnancies," while Martha has "no pregnancies at all." Although both women are flawed in this regard, the inability to conceive on Martha's part is painted as unnatural, subversive, even monstrous, when juxtaposed against Honey's hysteria, which is more feminine.

Naomi Wolf's *The Beauty Myth* points out that the focus on the smallness of women's bodies has grown in the United States at the same time women's civil rights have arguably been increasing. She asserts that "a cultural fixation on female thinness is not an obsession about female beauty but an obsession about female obedience."[42] It seems that Williams and Albee subscribe to this logic and suggest through their characters that the larger a woman's size, the less obedient she is by nature. If she can defy the national aesthetic with her physical form, audiences will assume that her behavior is equally subversive. In her seminal text *Revolting Bodies*, Kathleen LeBesco points out the perceptual link between fat and rebellious behavior but repositions the traditional negativity associated with fat behavior into a positive. She views the "revolting body" as rich with political potential to overthrow authority and reject oppression. LeBesco argues that fatness can be understood as a subversive practice in the face of sociopolitical oppression.[43] Certainly Martha's behavior, like that of Williams's characters, does much to illustrate this culturally dictated supposition of fat behavior as "revolting" but with the negative connotations I have described throughout the book rather than the liberating qualities that LeBesco suggests.

Martha has failed to assimilate the cultural imperative that women contain themselves in terms of body size and outspokenness, while Honey (whose name implies her sweet submissiveness) does a better job of embodying the ideal American wife. Although it is eventually revealed that Honey is just as flawed and manipulative as Martha, her outward behavior is more culturally appropriate. She takes up very little space and rarely asserts herself except at her most intoxicated moments. Her dainty politeness, her deferential worship of her husband, her childish demeanor, and her inability to hold her liquor mark her as sufficiently obedient in stark contrast to Martha's loud-mouthed, irascible behavior. Even Martha's laugh is out of line. However, I am inclined to deconstruct Honey's vomiting and suggest that her body is actually rebelling against these societal restraints. Unlike Martha, Honey is incapable of rebelling outwardly against her

social role, but she resists passive-aggressively, which manifests physically in vomiting and false pregnancies.[44]

Critics of the 2005 Broadway revival could not resist discussion of Kathleen Turner's bodily appearance. The opening line of Ben Brantley's glowing *New York Times* review is "Which are you betting on? The body or the brain?" Among other praises he offers about her performance is her "lack of vanity."[45] In a subsequent article, Brantley tries to identify why *Virginia Woolf* was arguably more successful than the two nearly simultaneous Broadway revivals of Williams's plays, and he connects the success of the revival to Turner's appearance. He writes: "Blanche, Amanda, and Martha have all been around the block a few times and on progressively unsteady feet. Yet of the three actresses playing them, only Ms. Turner looks as if she has been there, done that and paid the price . . . Although Blanche and Amanda have suffered from hard times and bitter betrayals, Ms. (Jessica) Lange and Ms. (Natasha) Richardson have the faces (and bodies) of women who have known only passing acquaintance with worry."[46]

Brantley goes on to describe Turner's "boxy, unflattering suit that makes her look as frumpy as any middle-class, middle-aged professor's wife who doesn't think a lot about clothes." In other words, aside from Turner's acting skills, he seems to credit her successful interpretation of the role to her appearance. He suggests that Lange and Richardson were too attractive

**Figure 4.1**    Kathleen Turner in *Who's Afraid of Virginia Woolf?*
© Darryl Bush/San Francisco Chronicle/Corbis.

(i.e., slender and botoxed) to effectively portray heroines who have lived hard lives, while Turner's chunky appearance gave her the "worried" look that enhanced her interpretation. For a movie actress, Turner's appearance has changed significantly over her career and diminished opportunities for her in Hollywood. Her weight gain has garnered much attention in the press, like that of so many Hollywood actresses, but instead of becoming a marketing tool for a diet product, Turner, in this case at least, has parlayed her mature, nonsurgically enhanced body into an asset for playing stage roles that call for sexually aggressive, domineering women.[47] For example, in 2012 Turner directed herself in the title role of a revival of *The Killing of Sister George* at the Long Wharf Theatre, a play I will discuss in more detail in chapter seven. In his review of that production, *New York Times* critic Charles Isherwood remarks that one would never associate Turner with any quality of vulnerability and goes on to describe her performance as "brutish."[48]

With these characters created between 1951 and 1962, Williams and Albee solidify a kind of fat identity exemplified if not literally, as when the texts call for a fat/big actress, then symbolically, through writing characters who exhibit fat behavior. Williams and Albee rely on the cultural construction of a fat woman as all-consuming and out of control. Serafina, Maxine, Leona, and Martha all display excessive qualities and destructive behaviors that consume the world around them. They love too passionately, like Serafina, or pursue sex immodestly, like Maxine and Martha. They all drink or eat too much and bully the men around them. As a general rule, the most successful portrayals of these roles have been by actresses who were considered "more-than" or fat by contemporary cultural standards.

Part II

# Fat Subjectivities

# 5

# Bodies Violating Boundaries

This chapter explores a group of plays from Paula Vogel's canon. Written more recently than the aforementioned Williams and Albee plays, Vogel's work offers a slightly different take on the idea of ravenous women and fat behavior informed by her subjectivity as a lesbian feminist playwright. Although her characters are not necessarily described as fat or animalized the way Albee's and Williams's women are, they have their own version of fat behavior that frequently precipitates violence toward them. Many of her characters exceed physical or behavioral boundaries of what is culturally acceptable for women, and this creates or adds to the conflict within these plays. However, just as Neil LaBute's *Fat Pig* works *against* the fat stereotypes depicted in the earlier plays, the characters in Vogel's plays also in some ways refute the fat identity invoked by Williams and Albee. Some of the characters exhibit the fat behaviors I have discussed, but more significantly, all are *treated* as fat (in terms of negative responses) by the other characters. Vogel seems to object to the complicity Albee and Williams assume with the audience when they use fat to create antagonistic characters who victimize those around them with their fat behavior. Vogel inverts that established paradigm and creates protagonists who eat too much, are outspoken, or exceed their physical boundaries, and are themselves victimized by the other characters in the play. In other words, audiences recognize the fat behavior of Serafina, Maxine, Leona, and Martha as negative. On the contrary, Vogel's feminist take establishes her hungry women as sympathetic protagonists. Vogel explores fat subjectivity with her characters, characterizing them with rich interior lives that are already imprinted with anti-fat ideology. The audience is meant to be on their side and to be disturbed when they are physically or emotionally brutalized.

Like Albee's and Williams's work, Paula Vogel's canon initially does not seem to be particularly body-conscious. Yet a closer look at many of her

plays reveals a surprising attention to physicality—both to women's bodies and to their appetites, or lack thereof. Female characters frequently discuss food in specific and sometimes erotic terms. And Vogel often calls attention to a character's appearance by way of pointing out a "flaw." Structurally speaking, Vogel's plays do not always fall neatly into the models of American realism. Yet, her attention to creating characters with psychological truth, and the ways in which these characters express distinctly female-gendered concerns around body consciousness, creates a level of realism and pathos as well as an authentic female subjectivity with which audiences identify. However, although Vogel is a highly regarded playwright, none of the plays I will discuss has been on Broadway, in contrast to the aforementioned Williams and Albee plays, of which only one did *not* see one or several Broadway productions. Vogel's primary venues are off-Broadway (nonprofit) theatres and college productions, and thus the plays are part of a more restricted field of cultural production than Broadway. This is also a lingering example of the ongoing disparity in productions for female versus male playwrights in the United States.

In addition to embodying the humanist values that are at the heart of Vogel's themes, woven into her complex tapestry of form and content, many of her female protagonists navigate the minefield of body loathing and food obsession that are associated with being an American woman. Vogel's characters attempt to negotiate and frequently violate American cultural boundaries of body size and consumption and are victimized by society for their transgressions. By looking at a cross-section of Vogel's plays, including *How I Learned to Drive* (1997), *Hot 'n' Throbbing* (1993), *Baltimore Waltz* (1990), and *The Oldest Profession* (1981), this chapter demonstrates how women's bodies become a site of danger when they exceed culturally acceptable boundaries of size. I will also examine the relationship between women's appetite for food and their sexual appetite.

The most recent of these plays, *How I Learned to Drive*, details the coming of age of L'il Bit under the specter of her pedophiliac uncle's care. The play was originally published in a two-play collection entitled *The Mammary Plays*, suggesting the importance of breasts—explicitly feminized protuberances of fat on the female body—as a thematic underpinning to these works.[1] Even L'il Bit's name points to the significance of body proportion in the character's trajectory. She was dubbed L'il Bit moments after she was born. Her mother, whose nickname is "The Titless Wonder," lovingly describes the moment when she discovered her infant lacked a penis, stating that she "whipped your diapers down and parted your chubby little legs—and right there between your legs there was—just a little bit."[2] It is a nickname L'il Bit comes to hate as a teenager. However, her prepubescent physical status shields her from the male attention and sexual violence that

come to her only when her body matures. Indeed, her abundant breasts become a literal and metaphorical focal point of the play. It is true that large breasts are highly valued erotic signifiers in our culture (as opposed to fat elsewhere on the body), but in L'il Bit's case, her large breasts exceed normative boundaries of the female body (at least according to local standards) and thus expose her to physical and emotional danger.

Clearly L'il Bit's "assets" are a source of pride and admiration for her family as depicted in this dinner-table exchange:

> FEMALE GREEK CHORUS (As Mother). Look Grandma. L'il Bit's getting to be as big in the bust as you are.
>
> L'IL BIT. Mother! Could we please change the subject? . . . (*To the audience*) This is how it always starts. My grandfather, Big Papa, will chime in next with—
>
> MALE GREEK CHORUS (As Grandfather). Yup. If L'il Bit gets any bigger, we're gonna haveta buy her a wheelbarrow to carry in front of her—
>
> L'IL BIT.—Damn it . . .
>
> MALE GREEK CHORUS (As Grandfather). –Or we could write to Kate Smith. Ask her for somma her used brassieres she don't want anymore—she could maybe give to L'il Bit here—
>
> L'IL BIT.—I can't stand it. I can't.
>
> PECK. Now, honey, that's just their way—
>
> FEMALE GREEK CHORUS (As Mother). I tell you, Grandma, L'il Bit's at that age. She's sensitive, you can't say boo . . .
>
> MALE GREEK CHORUS (As Grandfather).Well, she'd better stop being so sensitive. 'Cause five minutes before L'il Bit turns the corner, her tits turn first.[3]

Grandfather goes on to suggest that a college education is wasted on her because her breasts are all the credentials she will need. Although *How I Learned to Drive* is set in the past—the era of the patriarchal nuclear family—the exchange also highlights misogynistic assumptions surrounding gender roles that continue to resonate with contemporary audiences. In this conversation, her Uncle Peck plays the hero, sensitive to L'il Bit's dignity, and sides with her against Grandfather's barrage of misogynistic comments. When L'il Bit storms out in a huff, Peck follows her. Here we begin to see that Peck has also noticed L'il Bit's breasts, with much more nefarious consequences for L'il Bit than embarrassment. Vogel crafts her characters' subjectivity with complex nuance, recognizing the paradoxical impulses as influenced by culture whereby L'il Bit is flattered by sexual attention, yet would prefer to be valued for her intellect; one of reasons that L'il Bit is attracted to Peck is his interest in her mind, but when he inadvertently uses language that objectifies her, she pulls away.

Later we see L'il Bit victimized by her peers—both boys and girls—for her abundant breasts. She describes her boobs as "alien life-forces" that will eventually devour her and envisions them as radio transmitters that send out signals to mesmerize men. Like the Sirens, her breasts lure hapless men to dash themselves on the "rocks" of her chest. However, ultimately it is L'il Bit herself who is broken by these mammary-rocks as the object of Peck's concupiscence.

I am not arguing that Peck's predatory behavior would be different toward L'il Bit if she happened to be flat-chested. Indeed, larger breasts suggest a mature woman's body, which would seem to go against Peck's proclivity for young girls. Yet at the same time they give her the perfect Virgin/Whore appearance that pop icons such as Britney Spears and Miley Cyrus have popularized—essentially a child with a woman's body. Furthermore, assuming the breasts are real, they are, of course, composed largely of fatty tissue. In other words, breasts are concentrated fat intrinsically linked to female sexuality further complicating the association of female sexuality as a hunger metaphor and fat as an outward signifier of that threat.[4] Certainly, it is not only L'il Bit's breasts that make her desirable to Peck. But Vogel deliberately includes this detail not only as a signifier of the slippage between girlhood and womanhood but also, I suggest, as a sign that, on a certain level, L'il Bit's large, real breasts lack ladylike containment. These protuberances enter the room before her and have a personality of their own. In other words, they take up too much space in the same way a fat woman's body does. L'il Bit's breasts exceed spatial boundaries of the body, which, in Vogel's world, mark her for unwanted attention or violence. However, unlike Williams's and Albee's characters, excessive size does not necessarily denote consumerism but a threat to patriarchal order that must be contained. Vogel employs feminist and Brechtian dramaturgy in order to turn a humanistic mirror on a world in which women are violated because of their size and appetites.

One element of fat prejudice and oppression is the implicit belief that women should take up less space than men. Women who take up more than their share of space either by being tall, fat, or with bodily gesture are regarded with hostility. A woman who becomes large either through fat or muscle mass, or failing to keep her legs crossed when she is sitting, violates gender assumptions whereby the female is subordinate to the male. When a woman's stature or body mass is as largeor larger than a man's it upsets heteronormative gender roles.[5] Part of the production of "docile bodies" in American culture includes the notion of containment—literally the delimitation of the female body in spatial relations.

L'il Bit's breasts cannot be contained and therefore pose a threat to masculine domination. Vogel's haunting parable demonstrates how, through no fault of L'il Bit's own, her failure to contain her body—her large

breasts—makes her a target for sexual violence. Because of her youth, she does not have a sense of ownership of her breasts yet; they victimize her. (The play depicts L'il Bit primarily between the ages of eleven and eighteen. Her first sexual encounter with Peck occurs when she is twelve, and she has fully developed breasts by the age of thirteen.) But she lives in a world where the more womanly one's appearance is (e.g., full hips and breasts, rounder curves), the more imperiled one is at the hands of misogynistic or cultural violence. Indeed, a similar theme emerges in *Hot 'n' Throbbing*.

The Woman in *Hot 'n' Throbbing* also fails to contain her body, but her crime is even greater than L'il Bit's. According to the text, she is actually "overweight," which is assumed to be something she can control but does not. Thus, the consequences the Woman faces for violating cultural boundaries are more dire than those L'il Bit endures. The character never directly addresses the issue of her weight, but Vogel is careful to include details that are intrinsic to understanding her as an American woman with a "weight problem." The Woman is described in the list of characters as an "on-again, off-again member of Weight Watchers."[6] Early in the play, her fourteen-year-old daughter demonstrates that she has already internalized the importance of weight control as a beauty standard. She actually teases the Woman (her mom) in response to her parental concern about the appropriateness of her outfit:

WOMAN.    Those pants are too tight. Did you spray paint them on?
GIRL.    Betcha wish you had my thighs, huh Ma?
WOMAN.    We are not discussing the subject of my thighs. You are not leaving this house dressed like that.[7]

It is obvious from this brief exchange that the Woman's thighs *have* been a topic of conversation.[8]

If the idealized female body is culturally encoded to mark a woman as passive physically, taking up as little space as possible in terms of size and gesture, a fat female body violates these spatial boundaries.[9] The Woman's refusal or failure to comply with the Man's (or culture's) standard of thin beauty marks her as, if not openly defiant, then subversive. There may be power in her refusal, as some feminists assert, but in homogenized American culture, she is courting social opprobrium with her figure. The Woman is not only overweight, but she writes erotica, which is also outside the sphere of ideal feminine behavior. In this way, she exhibits unruly behavior, which correlates to her unruly body size. The fact that she has the audacity to shoot her (overweight) husband in the butt further points to her failure to adhere to societal constraints. Her unwillingness to tame her body manifests in feisty behavior and is deeply threatening to the Man.

Later in the play, another brief exchange implies that the Man (her ex-husband, who has a history of abusive behavior) has likely used the Woman's weight as a way to manipulate and control her and to crush her self-esteem. He baits the Woman by commenting on her size:

MAN.        You're looking good. Filling out a little bit?
WOMAN.    I've quit smoking. Or I'm trying to—
MAN.        It looks good on you . . . really.[10]

This exchange begins the downward spiral that will ultimately end in violence. He continues to bait and tease her by telling her that her business card, which features a rhinoceros in a G-string, "looks a little like you—*before* Weight Watchers." He systematically dismantles her esteem by going on to insult everything about her work. He wears her down to the point of agreeing to have sex with him. Despite brief intrusions by both the children, they are about to get to business when she reveals that she keeps condoms in the house to "be prepared." Something inside the Man snaps.

The Woman not only fails to contain her fat body but also, by her possession of condoms, reveals that she does not curb her sexual desires. Ironically, her willingness to engage in sex with the Man, her ex-husband and the father of her children, points to her inability to control her appetite. Thus she has violated culturally ascribed boundaries of both size and consumption. As the Man attacks her he says (through the mouthpiece of The Voice, one of the Brechtian techniques Vogel employs): "I'm beating you to teach you a lesson. Understand? And I'll stop when I feel like it. Bitch. What makes you think with your big fat butt and your cow thighs, that you're worth eighteen bucks? Huh? What man would pay for that?[11] He directly associates her weight with her insubordination toward him. The manipulation of a woman's self-esteem is a typical spousal abuse pattern, and Vogel makes the Woman's weight a focal point, her chief vulnerability. Even though it is the condoms that set off the man, he doesn't insult her with pejoratives that refer to her sexuality, such as whore or slut; rather he berates her for being fat. Her oversized body marks her as uncontrollable, possibly even powerful, and the Man takes back control by strangling her with his belt. The Woman's suffering exceeds L'il Bit's in correlation with their relative infractions of cultural boundaries of body size. L'il Bit is merely naturally busty, an excess of a body part that has been sexualized and appropriated by patriarchal culture in the form of plastic surgery. Thus, L'il Bit survives to tell her sad tale, but the Woman is guilty of the ultimate infraction—being fat. Her violation of societal codes invites the violence that she receives. In both cases, their abundant bodies cross over culturally prescribed spatial boundaries and result in violence.

*The Baltimore Waltz* and *The Oldest Profession* depict characters violating cultural boundaries in a different way, living another kind of fat identity. But they too are eventually crushed for their transgressions. Their body size is not necessarily the issue, but their physical and emotional appetites are. Their fat behavior marks them for cultural violence.

The character of Anna in Vogel's *The Baltimore Waltz* perfectly illustrates the connection between a woman's hunger and her sexual desire. Anna, a first-grade teacher, has lived a very modest humdrum life until she and her brother Carl travel to Europe to find a cure for her A.T.D. (Acquired Toilet Disease), which we come to find out is only a fantasy of what might have happened. In fact, the journey Anna takes with her brother Carl to Europe to find a cure is a metaphorical one for the journey they actually take together in a Baltimore hospital room as she grasps around for a cure while he slowly dies of AIDS. It represents a trip that the playwright wishes she had time to take with her real-life brother, whose untimely death from AIDS-related complications prevented them from taking. It is significant in the play that the character Anna only indulges her hunger and her sexual desires in this alternate reality. Through brief, hilarious episodic scenes, Vogel traces the siblings' progress through major European cities. They arrive in Paris early in the trip, and Anna experiences European cuisine for the first time. She is spiritually transported because she has spent her life controlling her appetite and eating bland, convenient, pseudo-"healthy" prepackaged food, which is the hallmark of the American diet. The Garçon lusciously narrates (with a hint of satire) Anna's experience with French cuisine:

GARÇON (*With thick Peter Sellers French*). It was a simple bistro affair by French standards. He had le veau Prince Orloff, she le boeuf à la mode—a simple dish of haricots verts and médoc to accompany it all. He barely touched his meal. She mopped the sauces with the bread. As their meal progressed, Anna thought of the lunches she packed back home. For the past ten years, hunched over in the faculty room at McCormick Elementary, this is what Anna ate: on Mondays, pressed chip chicken sandwiches on white; on Tuesdays, soggy tuna sandwiches; on Wednesdays, Velveeta cheese and baloney; on Thursdays, drier pressed chicken on now stale white bread; on Fridays, Velveeta and Tuna. She always had a small wax envelope of carrot sticks or celery, and a can of Diet Pepsi. Anna, as she ate in the bistro, wept. What could she know of love?
CARL.    Why are you weeping?
ANNA.    It's just so wonderful.
CARL.    You're a goose.
ANNA.    I've wasted over thirty years on convenience foods.
            (*The Garçon approaches the table*)

GARÇON.    Is everything all right?
ANNA.      Oh god. Yes . . . yes—it's wonderful.
CARL.      My sister would like to see the dessert tray.
           (*Anna breaks out in tears again.*)[12]

Anna relates to the food with a lover's passion and responds to the Garçon's inquiry breathlessly—even erotically. This scene marks the awakening of her insatiable appetite, and it is not surprising that in the next scene she is in bed with the Garçon. In fact, this sensual epiphany unleashes Anna's promiscuous behavior, which eventually begins to alienate her brother Carl. At each new location, she picks up a man to have sex with. By indulging her appetite for food, she has released her sexual beast within, and her appetite is boundless.

Although Anna is not described as fat in the text, the character's fixation on food and sex constitute fat behavior, and she lives what I would call a fat identity. Casting in the original and subsequent productions seems to reflect this implied fatness and has often leaned toward actresses who are physically "more-than." The role was originated by Cherry Jones (recall that this "fat" actress also played Josie in *A Moon for the Misbegotten*) and, more recently, Kristen Johnston was fairly well reviewed as Anna in the 2004 Signature Theater revival. Johnston is extremely tall and large-featured for an actress, especially one who has had a significant television career, as Johnston has had.[13] Charles Isherwood was less impressed with her performance possibly because of her size. He called her a "blunt instrument, wielding her larger-than-life presence for maximum comic effect," which he felt was inappropriate.[14] Elyse Sommer of *Curtain Up* compared Johnston's performance favorably to Cherry Jones's and described her as "imposingly tall" and "robust."[15]

The awakening of Anna's appetite is certainly not the centerpiece of *The Baltimore Waltz*, but Vogel does include explicit details about the kinds on "non-foods" Anna has previously limited herself to, and there is no denying the connection between her licentious behavior and her discovery of good food. If we consider starvation a sort of insidious cultural violence inflicted on women, then Anna has been victimized and forced to contain herself for fear of losing control. Indeed, once she allows herself to enjoy food (in her alternate reality), she does "lose control" and engage in sexual activity that would be considered appropriate for a man but out of bounds for a woman. Arguably she is "punished" for her transgressive behavior, first by Carl's jealousy, which manifests in cruel taunts, and then by Carl's death, which snaps her back to stark reality. Here she is asked on a date by Carl's doctor but refuses, having returned to her controlled reality. Yet, in Anna and Carl's fantastic parallel universe, perhaps if she had never—to use the fat euphemism—"let herself go," she could have saved Carl.

Like Anna, in *The Oldest Profession* Vera, Ursula, and Edna also have very complicated relationships with food. Vogel describes this as a pattern play derived from the simplest of models—a traditional nursery song: "There are five blackbirds sitting on a fence, fly away blackbird. There are four blackbirds sitting on a fence, fly away blackbird," and so on.[16] The play tells the story of five elderly prostitutes struggling for survival in New York City shortly after the election of Ronald Reagan. It opens with Vera's lengthy homage to her most recent meal:

> VERA.  [A]nd so last night I thought a bit of fish would be nice for supper—not too heavy, not too light—so I bought just the nicest bit of fish at Joe's—fresh, pink—much nicer than the fish store up at 89th Street; their fish isn't fresh at all . . . lemon sole it was, very good and tender. I do so love a nice bit of lemon sole. I melted some unsalted butter in the skillet, and chopped up, oh, about this much scallion, and then I just sautéed it on each side until it flaked with a fork and then just squeezed lemon and parsley over it—and I tell you, it melted in my mouth. Just melted.[17]

This opening speech provides an important window into Vera's character. Like Anna, she describes the whole experience in a sensual manner. She revels in using her bare hands to measure the ingredients. And it is in most rapturous terms that she tells her colleagues "it melted in my mouth." Her homage is the stuff that "locker-room talk" is made of, except here the homage is to food. It is no surprise that Vera turns out to be the most sensitive of the women, the one who seems to like her job the most. It is also Vera who gets the most emotionally involved with her clients, going to visit them when they are incapacitated, attending their funerals, even going so far as to reach into the casket for one last fondle. Like her fat predecessors, Vera is emotionally excessive relative to her peers in the sex industry. Ursula, the most businesslike of the bunch, is constantly criticizing Vera for spending too much time with her clients, one of whom she "likes to cuddle with," another whom she "holds when he cries."

Throughout the play, Vera returns to food as her touchstone. After the first blackout, lights rise on Vera passionately describing the raspberries she shared with Lillian, who has just passed away. The speech is a continuation of her lengthy celebration of berries that closed the previous scene. After the third blackout, which marks the loss of Ursula, Vera and Edna share some chocolate. They pause, allowing the chocolate to melt in their mouths, enjoying the sensual experience despite their troubles.

Edna also embodies the connection between sensuality and emotional attachment to food. She is the most raucous of the four prostitutes and makes no bones about enjoying her sex and her meals. One of Edna's biggest complaints when they strike to protest Ursula's management is that

she is being forced to rush her lunch—an *hour* just is not enough. That she requires more than an hour to properly digest suggests something about her enjoyment of food and reverence for a meal. Like Vera, Edna is also the most likely to affectionately describe an encounter with a customer with sensual detail and unabashedly delights in food. Indeed, it is a cornerstone of their friendship.

After the fourth blackout, lights come up on Vera desperately trying to engage Edna's interest in food. She shrugs off Vera's attention, having lost the joie de vivre that made food and sex pleasurable. Furthermore, it is the lost reverence for personal, elegant food preparation and the emphasis on tasteless convenience food that kills Edna's "food libido."

> VERA.  How about if I go get something nice and light at the corner deli—what about a BLT on toasted rye, the way you like it?
> EDNA.  (*In a trance*) I don't know, take that BLT. You look at it and see a nice BLT, the way I used to. But now it's all different . . . there's a factory that's designed to make the bacon package somewhere; machines that do nothing else but cut the cardboard. And then there's the rye . . . someone is in a factory right now who's sole job is taking care of those little seeds . . . thousands of loaves on the conveyor belt being sliced and wrapped, loaded into big, greasy trucks . . . thousands and thousands just to make that one BLT.
> VERA.  (*Alarmed*) Edna!!
> EDNA.  I'm not hungry.
> VERA.  Look, I care. What if I made something from scratch . . . nothing out of a can.[18]

In the monologue that follows, Vera's description of cooking with her mother is a seduction, a last-ditch effort to engage Edna in her old pleasures of sensuality. Tragically, Vera has correctly identified the loss of Edna's appetite as the harbinger of her death, and after the last blackout, lights come up on Vera alone. In the 2004 production at the Signature Theatre in New York, Marylouise Burke, who played Vera, sat quietly for a moment before foraging in a garbage can to eat unwanted crusts of food. The irony that the most sensual consumer of them all was reduced to eating scraps of garbage was powerfully moving and also highlighted the theme that women who allow their appetites to rule their judgment will eventually find themselves in physical and emotional peril.

Ursula, on the other hand, embodies the ultimate in detachment—or so we think—until after her death. She is the most controlling, least sentimental, and most driven of the women. She might even be described as masculine in her highly disciplined self-management in contrast to the stereotype of women (not just fat women, but any woman) as hypersensitive and more

emotionally volatile. She gets annoyed when they discuss food or show any emotional attachment to their clients. Yet we discover after her death that she has been hoarding bags of sugar. Sugar was the mysterious commodity more "solid than gold, more stable than oil." The woman who took no sensual pleasure in life and had no cravings either for food or sex secretly stockpiled bags of sugar, shamefully hiding and forcibly containing her appetite for sweets. Vera or Edna would have baked with or eaten the sugar, but in order to maintain self-control and emotional detachment, Ursula methodically piled containers of this forbidden pleasure in her room. She kept it near, but never allowed herself to actually indulge in the sweetness, perhaps for fear of becoming as voraciously out of control as Vera or Edna.

I am not suggesting that Vogel's plays (or Williams's or Albee's plays for that matter) are *primarily* about women's bodies and/or the complexities of female consumption. However, tucked in among her more significant themes of incest, sexual abuse, domestic violence, politics, and AIDS are undeniable allusions to violence directed at women's bodies. Vogel's characters consistently violate spatial boundaries of appropriate body size or wrestle with hunger, either willfully containing or indulging their appetites, with no small consequences. Frequently, we see a direct correlation between a character's sexual desire and her appetite for food. Those who "let themselves go" either by gaining weight or slaking their desires for food and sex inevitably meet with tragedy. Thus, in order to ensure personal and emotional safety, Vogel's female characters must remain within the boundaries of socially acceptable size and culturally mandated appetite.

Yet, Vogel rejects the stereotypes invoked by her male predecessors by creating characters that establish a female fat subjectivity. In doing so, Vogel exposes the misogyny inherent in the assumptions made by Williams and Albee and their audiences when fat behavior is equated with destructive consumerism. Furthermore, Vogel's characters imply fat as an identity position—a societally imposed construct based on assumptions about women's bodies. Body type becomes a code, or a semaphore, for a certain kind of behavior, which in turn becomes a lived identity.

# Fat Black Miscegenation

As a counterpoint to exploring texts written by white playwrights about white women and geared toward a homogenous, white, heteronormative middle-class audience, this chapter examines plays, some of which were written by men and women of color, that explore racial subjectivity and representations of fatness and blackness onstage. This chapter investigates the connection between fat and racial otherness in various modes of representation. In addition to asking how white middle-class American audiences read a big black body versus a big white body in representation, I argue that there is an overlay and a blending in depictions of fat and racial difference in various cultural texts that result in a kind of representational "miscegenation."

Many feminists have critiqued medical discourse dating back to the seventeenth century as well as persistent cultural assumptions and representations that label the black female as more primitive and therefore more sexualized. On one hand, the accepted cultural aesthetic for a black woman's body allows for a much fuller figure than those of white women. Indeed, Americans are inculcated with the stereotype of the big fat black woman as a beloved mother figure, full of sassy remarks and motherly wisdom, or as powerful and domineering, but either way commanding respect. A domineering fat white woman in representation, however, is more frequently perceived as overbearing—an object of ridicule and shame. At the same time, both fat black women and fat white women are often similarly sexualized in representation. Fat, like race, is something worn on the outside. It is immediately visible to the spectator. This chapter explores the complex interplay between fatness and racial otherness through plays including August Wilson's *Ma Rainey's Black Bottom* (1984), Suzan-Lori Parks's *Venus* (1995), and the musical *Hairspray* (2002).

First I will explore the overlap between cultural assumptions surrounding fat white women and fat black women in representation, which will inform the discussion of the subtle alliance between fat white bodies and

non-Caucasian bodies in representation. Before discussing the plays, I will briefly position the black female body as well as the *fat* black female body, which in some instances are synonymous, in contemporary cultural representations. Both share with their fat white sisters a position outside white heteronormative notions of normalcy and beauty. Scholars have explored the ways in which the black female body has become both a cultural repository for deviant sexuality as well as a semiotic for primitivism. For example, Sander Gilman illustrates through nineteenth-century paintings, lithographs, and ultimately scientific discourse of that era how black female bodies were sexualized and understood as animal-like in their sexual appetites.[1] He notes that these narratives were created in order to position black sexuality (and beauty) as antithetical to the white European woman. One of Gilman's primary examples, the exploitation of Saartjie Baartman, the African indentured servant who was displayed throughout Europe as an oddity, perfectly illustrates European attitudes and fascination toward the black female body. Baartman's body had the common attributes of the African Khoi tribe, which included large buttocks or steatopygia, as well as extended outer labia, which were referred to in European medical discourse as "the Hottentot apron." Indeed, Baartman was known as "The Venus Hottentot" and was displayed by her captors in freak shows and even occasionally at wealthy dinner parties where men (and sometimes women) were invited to stare at her "extreme buttocks" and, for additional fees, to touch or poke her. Baartman was not the only African slave in Europe to be exhibited in this manner during this era. She was also studied by eminent scientist George Cuvier, who like other experts of nineteenth-century science, focused not just on her sexual attributes, but specifically the fatness of them, which were considered distinctive of her (black) sexual attributes. Essentially, Victorians conflated the protruding female black buttocks with what they regarded as the anomalies of a black woman's genitalia. They also closely associated the black body with prostitution and prostitutes who, according to many nineteenth-century scientific publications, generally exhibited a "peculiar plumpness."[2] The Victorian amalgam of the black woman's exotic, round body with that of plump prostitutes' bodies furthered the assumption of unbridled sexual appetite for both categories of women. The fascination with the (fat) black woman's non-European physical characteristics, as well as the commodification and sexualization of her person, laid the groundwork for the ways in which contemporary white America continues to view the black female body as primitive and sexually voracious. Indeed, as feminist theorist bell hooks points out, many black female entertainers such as Tina Turner and Diana Ross have capitalized on this stereotype, deliberately marketing themselves as "sexual savages" as part of their successful promotion.[3] The presumption of black women's

rapacious, possibly deviant sexuality aligns them with fat white women, who are also assumed to have insatiable sexual appetites. In this way, fatness and blackness intersect in the American cultural landscape.

In her book *The Embodiment of Disobedience: Fat Black Women's Unruly Political Bodies* (2006), Andrea Elizabeth Shaw expands on this idea. "This assessment of fatness and blackness as highly sexualized concomitantly supports a Western Patriarchal ideal of chastity and restraint as behavioral demonstrations of beauty. Within the parameters of Western hegemonic culture, black and fat women are incapable of sexual modesty because their very bodies, sexually active or not, are poignant sexual signifiers, permanently situating women who bear these features as sexually uninhibited, lacking sexual/bodily control and uncontrollable."[4] According to Shaw, a woman who is fat and black is doubly marked as hypersexual, first by her black skin and then by her fat.

Another cultural stereotype that continues to dominate representations of fat black women in particular is the "Mammy" character as embodied by Hattie McDaniel in *Gone with the Wind* or in advertising by Aunt Jemima or the original Quaker Oats trademark. Shaw unpacks the various ways the "Mammy" type plays into cultural readings of fat black women. She notes that generally, when black women manage to fit into ideals of Western beauty, they mimic white physiology and behavior, such as when the light-skinned, green-eyed, slender Vanessa Williams became the first black Miss America.[5] On the other hand, she notes that fat black women find acceptance through embracing a different cultural stereotype, that of the asexual, non-threatening, acquiescent, subordinate "Mammy" type. Mammy's physical embodiment of features that sharply contrasted with idealized white female identity helped sustain economic, gendered, and racial oppression as well as provided an oppositional standard against which white women's beauty could be measured. She views the figure of the fat black woman as a "shadow against which white woman's beauty may be foregrounded."[6] However, Shaw points out the inherent contradiction in the fat black woman's body when she posits that at the same time, "Her fatness signals an infinite reserve of maternal dedication, suggesting an inability of black women to be oppressed since their supply of strength, love, and other emotional resources can never be depleted."[7]

Following Shaw's analysis above of fat black women's bodies simultaneously representing the antithesis of white feminine beauty and signifying infinite resources of power, I assert that arguably one of the greatest anxieties toward fat *white* women's bodies is that they are crossing race lines. A fat *white* woman's body contradicts conventional Western European ideals of beauty which, both Gilman and Shaw note, is precisely the threat that fat black bodies pose to white patriarchal hegemony. Furthermore,

it follows from Gilman's and Shaw's arguments that within Western culture we have racialized fat and connect fat to the black or dark-skinned "other." Thus, fat white female bodies are linked to blackness and fat black (female) bodies in various modes of cultural representation. If the fatness of a black woman suggests an infinite reserve of strength and internal resources, it is not a far step to view the fat white woman's body as representing similar unbounded power. Both threaten the white male hegemonic equilibrium.

### Big Black Butts

The fat black female posterior, in particular, continues to be fetishized, sexualized, and acknowledged as a contested site of cultural consumption. Indeed, the fat black woman's big buttocks have become a provocative symbol through which to explore racial tension as exemplified by the title of August Wilson's *Ma Rainey's Black Bottom* and the subject matter of Suzan-Lori Parks's *Venus*. The big black (female) butt has a remarkable place in popular culture. Various cultural texts have appropriated the big black butt as a symbol of black female power and sexuality. Examples range from Granny Nanny, a nineteenth-century Jamaican folk hero who rescued slaves and led a rebellion against English colonists, who is mythologized in oral tradition as having stopped English bullets with her large buttocks, to rapper Sir Mix-A-Lot's 1993 double-Grammy-winning song, "Baby Got Back," which notoriously celebrates the black female derrière with the opening lyrics "I like big butts and I cannot lie," and then goes on to rejoice in black "bubble butts" and criticize small (white) butts as shown in *Cosmopolitan* magazine.[8]

The first play in my discussion, August Wilson's *Ma Rainey's Black Bottom* (1984), capitalizes on the cultural fascination with big black butts with its provocative title. "Black Bottom" is the name of an early American classic blues song that went through many incarnations of lyrics in which "black bottom" was a (depressed) geographic location as well as a body part. But the lyrics popularized by Ma Rainey, one of the early recording icons of jazz, also refer to the black bottom as a dance that calls attention to said body part. It is not hard to imagine Rainey, whose performances were notorious for their overt sexuality, emphasizing her rotund figure as part of her routine.[9] The lyrics are loaded with double entendre and include suggestive lines that celebrate the black bottom as both dance and an erogenous zone.[10]

The play is part of Wilson's cycle of ten plays that aim to capture the African American experience in each decade of the twentieth century.

Wilson bases his character on the real Gertrude "Ma" Rainey as an emblem of black exploitation and oppression in 1920s America.

The real Ma Rainey was a full-bodied woman who seemed to understand the power of spectacle as it related to her physical appearance and her stage persona. She was the first female blues singer to rise to fame and one of the earliest female blues recording artists. She wore outlandish costumes that emphasized her large size and wore makeup that was intended to lighten her features but by many accounts actually made her look more yellowish under the lights and further enhanced her extreme appearance. Her songs were openly sexual and frequently about aggressive women with passionate emotions and appetites. Similar to Mae West's strategic appropriation of fat behavior, Ma Rainey's cultivated stage persona was among the first to capitalize on white assumptions about the unbridled animal sexuality of (fat) black women. Her full figure and extravagant costumes were prominently featured in her promotional material. She became known as the "ugliest woman in show business." Harking back to Shaw's earlier quote about the connection between Western standards of beauty and patriarchal behavioral ideals of chastity and restraint, it is no surprise that the obstreperous, visually fat Rainey was given this nickname. Perhaps because of her willingness to embrace, indeed highlight, the "otherness" of her appearance as a fat black woman, Rainey was extremely successful, especially considering the racial oppressiveness of the era—the United States in the 1920s when African Americans still lived as second-class citizens under Jim Crow segregation.[11]

Wilson's Ma Rainey is not the protagonist of his play but functions more as the antagonist for Levee, the up-and-coming trumpet player in her band, who is dissatisfied with having his art and talent controlled by white men. The play takes place during the course of a day, as a band of musicians and Ma convene at a recording studio to make a record. Power struggles ensue between Ma and the musicians as to which songs to record and how. The spine of the play is all of the characters' dissatisfaction at the powerlessness of their position as oppressed black people in a white man's world. For Levee, Ma represents the oppression of black musicians, because despite her popularity and talent, she allows her white manager to control her career and recordings. However, as depicted by Wilson, Ma Rainey is not as docile as Levee believes her to be. Her rebellion is perhaps more subtle and passive-aggressive than Levee's, yet falls into the kind of truculent fat behavior I discussed in chapter four. She is domineering, bossy, and outspoken, refusing to be controlled by the men (black or white) around her.

Ma arrives late to the recording session with her entourage in tow. That a black woman in 1920s Chicago should have attendants immediately suggests her audacious self-importance. The entourage consists of her nephew

Sylvester, who acts as her driver/body guard, and Dussie Mae, a young attractive girl who we later come to find out is Ma's lover. And although fat behavior does not explicitly require a fat actress, in the case of Wilson's Ma Rainey, who is based on the actual person, the fat appearance of the actor is implicit and serves to underscore the fat behavior. The real Ma Rainey was reportedly bisexual, which identifies her with another fat behavior, that of sexual deviance. I will further explore this link between "deviant" sexuality and fatness in the next chapter. According to Wilson's stage directions she is "*a short, heavy woman. She is dressed in a full-length fur coat and a matching hat, an emerald green dress and several strands of pearls of varying lengths . . . she carries herself in a royal fashion.*"[12] Ma is pursued by the police, who are threatening to charge her with assault and battery for knocking down a cabbie who refused to serve them because they are black. This bit of action establishes that Ma is big enough and brave enough to knock down a man and sets the tone for her unruly behavior. In fact, the only reason they were hailing a cab is because her car was hit by another motorist, and the police would not believe that Ma was the owner of the car, so they impounded it. Irvin, her (white) manager, clears up the situation with the police, and Ma, who is upset and unsettled, immediately starts making further demands of him. She knows that she holds all the power in the relationship despite her race and gender because her voice is the commodity they need. The following exchange between Ma and Irvin demonstrates how her bossy actions belie the subjugation of her position as a black woman in early twentieth century America.

IRWIN.       You just sit and relax a minute.
MA RAINEY.  I ain't for no sitting. I ain't never heard of such. Talking about taking me to jail. Irvin, call down there and see about my car.
IRVIN.       Okay, Ma . . . I'll take care of it. You just relax. (*Irvin exits with the coats.*)
MA RAINEY.  Why you all keep it so cold in here? Sturdyvant try and pinch every penny he can. You all wanna make some records, you better put some heat on in here or give me back my coat.
IRVIN.       (Entering) We got the heat turned up, Ma. It's warming up. It'll be warm in a minute.

                              . . .

MA RAINEY.  Irvin, call down there and see about my car. I want my car fixed today.[13]

For the remainder of the play, Ma exerts her power over Irvin and Sturdyvant, the (white) producer, especially, but also over members of the band with her various demands. She is unapologetically a diva. No one can make money without Ma's voice interpreting the songs. First, she insists that her

nephew, who stutters, record the introductory patter on the song. He is disastrous, and the studio clock is ticking, but she does not relent. Then she refuses to sing until she has a cola and sends Irvin scurrying off to get one. Next, she denies Levee, who suggests some new ideas about which songs to cover and how to change the rhythms to sound more contemporary. Ma flatly refuses. She will only do "Black Bottom" her way. The producers tolerate her outrageous behavior because they will eventually get what they want from her: a hit recording that will make them far more money than they will pay her for the day's work. Ma knows this as well and exacts what little recompense she can with her petty tyranny in the studio.

In his glowing review of the original 1984 Broadway production, Frank Rich gushed over the performance of Theresa Merritt, the fat actress who played Ma Rainey, whom he describes as "despotic," "temperamental," and a "mountain of glitter." He goes on to say, "Miss Merritt is Ma Rainey incarnate. A singing actress of both wit and power, she finds bitter humor in the character's distorted sense of self: when she barks her outrageous demands to her lackeys, we see a show business monster who's come a long way from her roots."[14] In praising Merritt's performance, Rich's word choice implies all of the aforementioned cultural assumptions of fat behavior that we have seen with other fat white characters. She is despotic and monstrous, like Martha (*Who's Afraid of Virginia Woolf?*) and "barks" like Maxine (*The Night of the Iguana*).

On the other hand, Ma's fat black body is not only associated with these negative stereotypes but also, as Shaw points out, is a signifier of sociopolitical resistance. Shaw argues that the fat black woman's body (symbolically) retaliates against the impact of colonization, challenging dominant aesthetic norms that are political mechanisms for control. According to Shaw, "[h]er fat black body resists both imperatives of whiteness and slenderness as an ideal state of embodiment. Her large size also insists that her presence be acknowledged since a pervasive effect of colonization has been the effacement of a black female presence."[15] If we transfer this idea to *Ma Rainey's Black Bottom* and the character of Ma, we can view her body as a symbol of resistance, even though in many ways Wilson contrasts her with Levee as an example of acquiescence for allowing herself to be exploited. Therefore, while Levee may be correct that Ma is being taken advantage of by her white handlers, in her own way, Ma's body and flashy style actively resist her oppressors. She is well aware that in making the recording, Irvin and Sturdyvant want to separate her voice from her body and thus have a more contained commodity. Indeed, in the opening sequence of the play, prior to Ma's entrance, Sturdyvant is very preoccupied with containing Ma, urging Irvin to control her and "get her in and get her out." Once they have captured her voice electronically, they will no longer require her person to make

money. While she can, Ma embraces the power in her fat, black liveness. The semiotic meaning of Ma's fat black body is perhaps incidental to Wilson's intention in exploring American racism of the 1920s. But in creating the piece and dramatizing the character of Ma, Wilson harnesses the strength of her body as a symbol of resistance in his play about black oppression.

However, little more than a decade later, with her play *Venus* (1997), Suzan-Lori Parks directly uses that fat black female body to explore all of the issues of black female sexuality I have mentioned. Parks bases the character of Venus on Saartjie Baartman, but rather than depict her strictly biographically or with historical accuracy, she uses the gross exploitation of Baartman as an avenue to explore contemporary cultural attitudes about racialized bodies. Through the character of Venus, Parks interrogates the persistent cultural representation of black women as promiscuous, sexually savage, and perpetually available, as well as the view of the black female body as somehow abnormal or sexually deviant because of its shape. She particularly investigates white fascination with the fullness of black buttocks. The cover illustration of the TCG (Theatre Communications Group) text for the play, which is based on the many nineteenth-century drawings of Baartman, features an exaggerated profile silhouette of the "Venus Hottentot" nude, with huge buttocks and emphasizes that her body is the centerpiece of this play. Unlike Wilson's Ma Rainey, who reclaims some power and agency through her large size, Venus's excessive proportions serve only to further subjugate her.

Discussing *Venus* in her book *Black Feminism in Contemporary Drama*, Lisa M. Anderson points out that Suzan-Lori Parks "presents images or icons to us and then uncovers their origins, revealing them as problematic."[16] Venus's fat bottom is the symbol for all of the oppressive stereotypes and maltreatment heaped on black women in America throughout modern history. As Anderson says, "Parks probes the ways in which black women's sexuality has been represented as deviant; she also exposes the ways in which that perspective has led to both the iconization of black female sexuality in the image of the 'Venus Hottentot' and how the effects of that icon affect the lives of contemporary black women."[17]

The character of Venus is persuaded by "Brother" and "The Man" to travel from her native land to England, where she believes the streets will be paved with gold and she will be a dancer for a few years before making her fortune and retiring to her homeland a wealthy woman. Upon her arrival, she is betrayed and finds herself the central attraction in a freak show. She is treated cruelly and displayed by "The Mother-Showman"—a character Parks designates as female. The Mother-Showman essentially holds Venus captive and acts as her madam, displaying her alongside her "8 Human Wonders," which include other "freaks," such as a bearded lady, Siamese twins, and so on. That it is a woman who ends up pimping Venus is a commentary on the

ways in which women are complicit in their own cultural oppression, which is a topic the Five Lesbian Brothers take up in *The Secretaries* (1994), which I will discuss in the next chapter. Arguably, in this case, the white Mother-Showman sees herself as a superior to black Venus in the "chain of being" in keeping with commonly held Victorian views of science. However, Parks's dramaturgical style has such a modern feel and is so loaded with anachronisms that, despite the narrative being set in the nineteenth century, it is impossible not to view the play through a contemporary lens. The moment the Mother-Showman meets Venus, she knows she has found the ideal commodity to boost business. She practices her new pitch:

> THE MOTHER-SHOWMAN. With yr appreciative permission
> for separate admission
> we've got a new girl: #9
> "The Venus Hottentot"
> She bottoms out at the bottom of the ladder
> yr not a man—until you've hadder.
> But truly, folks, before she showed up our little show was in the red
> but her big bottoms friends'll surely put us safely in the black![18]

Using Parks's unique poetic dialogue, the Mother-Showman's speech above touches on many of the racist stereotypes I have mentioned and cleverly puns on the words "bottom" and "black," highlighting the myriad of word associations and also the cultural interplay between "black" and "bottom."

Later, when Venus has an idea she might have worked enough to move on, the 8 Wonders remind her: "Lovely Venus, with yr looks, there's absolutely no escape."[19] In essence, Venus is a prisoner of her bodacious buttocks. She cannot escape the Victorian sexual fascination with her full figure. Because her body exceeds cultural boundaries, like Vogel's characters from chapter five, her body becomes a site of danger—a target for physical and cultural violence.

Parks complicates (and fictionalizes) the story of Venus in some ways, by depicting her as somewhat complicit in her exploitation. Parks creates the character of the Baron Docteur, whom Venus willingly goes with to escape the Mother-Showman. A grotesque romance ensues between Venus and the Baron Docteur, who seduces Venus with chocolates and is openly fascinated with her body. The Baron Docteur is a fictional stand-in for Georges Cuvier, the nineteenth-century surgeon who was dubbed "the father of comparative anatomy," with whom Baartman had no romantic relationship in real life. In fact, Cuvier was eventually responsible for dissecting Baartman after her death and displaying her brain and genitals in a glass jar.[20] In

Parks's play, Venus believes she has sexual leverage over the Baron Docteur. She willingly has sex with him for chocolates and better living conditions than she had with the freak show. He impregnates her twice and performs abortions on her himself. Although she is no longer on public display, she is essentially a sex slave. The Baron Docteur's sexual obsession with Venus captures contemporary fascination with black female sexuality.

Furthermore, the romance between the Baron Docteur and Venus also serves to weave through the play the theme of chocolate candy as an aphrodisiac, a symbol of sensual excess, and a metaphor for black women's bodies. The Docteur constantly gives her chocolates in a heart-shaped box, echoing the heart-shape of her chocolate-colored buttocks. Eventually, failing to perceive her expanding middle as an indicator that she is pregnant, he criticizes her lack of self-control for eating too many chocolates:

> THE BARON DOCTEUR. You eat too many chockluts you know.
> I give em to you by the truckload but
> You don't have to eat them all.
> Practice some restraint.[21]

Venus's lack of restraint extends to her sexuality because she enjoys making love with the Baron Docteur, in marked contrast to his proper Victorian wife, who is jealous of Venus but maintains the sexual prudishness of her era. Late in the play, just before her death, Venus gives a "brief history of chocolates," mentioning that women eat chocolate to soothe themselves emotionally and, significantly, that chocolate is a stimulant and a source of pleasure.[22] She is talking about the candy, but the double entendre is clear.

The fat black female body, or in the case of *Venus*, the buttocks in particular, are part of the canvas on which Wilson and Parks explore racial tension and discrimination in American culture. Both playwrights recognize the power of their fat heroines. They understand that, although fatness is not considered outside of beauty standards for black culture and indeed is frequently celebrated there, in hegemonic white culture, fatness highlights racial difference and contributes to prejudice and segregation. Consequently, as I asserted earlier, fat has a racial connotation that adds to the stigmatization of a fat *white* woman and associates her fatness with "racial otherness" in the same way that a black person is marked by his or her skin color.

### Hairspray: Fat Black Miscegenation

Thus, in various cultural texts there is an alliance between blackness and fatness in representation. One movie-turned-musical-turned-movie musical

that illustrates this point is John Waters's *Hairspray*. For this discussion I will draw from the musical *Hairspray* (2002), with book by Mark O'Donnell and Thomas Meehan, music and lyrics by Marc Shaiman and Scott Wittman. *Hairspray*, which enjoyed a successful eight-year run on Broadway and subsequent touring productions, tells the story of Tracy Turnblad, described in the text as a "high-spirited, irrepressible, chubby teen girl."[23] Tracy's fatness is central to the plot of *Hairspray* and is the subject of many jibes and jokes. However, despite the taunts, Tracy is a light-hearted, typically rebellious teen and seemingly oblivious that others judge her to be defective due to her size. Set in 1962 Baltimore, the musical opens with Tracy greeting the day enthusiastically and singing, "Good Morning Baltimore."[24] The opening lyrics call attention right away to Tracy's size when she describes herself as hungry, but she reverses it immediately by confiding that food is not what she is hungry for. The lyrics play with stereotypes and suggest that her hunger is not a symptom of her emotional maladjustment but could possibly be a harbinger of her rebelliousness. Tracy's simplistic goals reflect her youth and are fairly typical, if somewhat ambitious, among her peers: She wants to get a spot as a dancer on the local *Corny Collins Show* (a dance program modeled after *American Bandstand*) and capture the heart of Link Larkin, the show's teen male dreamboat. And she honestly believes that both of these things are possible despite her chubby appearance.

The *Corny Collins Show* is introduced when Corny sings "Nicest Kids in Town," an anthem that essentially celebrates the white, upper-class homogeneity of the kids who dance on the program.[25] The *Corny Collins Show* is a segregated dance show produced and managed by Velma Von Tussle, who is a racist, villainous plotter, and, of course, thin. Aside from keeping blacks off the show, Velma's main concern is to make sure her own spoiled, conceited, pretty daughter Amber is the center of attention. In addition to being Link's girlfriend, Amber is angling to be "Miss Teenage Hairspray 1962." Looking at Amber on the TV, Tracy's mom, Edna, describes her as "a lovely slim girl," but Tracy is not intimidated because she knows she is a better dancer than Amber.[26]

When the opportunity to audition for the show comes along, Tracy skips school and goes to the audition. She is taunted by Velma, who sings, "Oh my god/How times have changed/This girl's either blind/Or completely deranged."[27] Amber and the other members of the audition council eagerly jump in to insult Tracy for her size, telling her she is "too wide from the back" and so on. But Tracy's biggest faux pas is when she is asked by Velma if she would swim in an integrated pool, to which Tracy replies: "I sure would. I'm all for integration. It's the New Frontier." Velma maliciously and gleefully sings "The Legend of Miss Baltimore Crabs" to Tracy in which she informs Tracy that her fat body was already a strike against her but

progressive attitude toward blacks ensures that she will be cast out of the auditions.[28] In other words, it is not only Tracy's fatness that results in her elimination but also her willingness to integrate.

The rest of the play follows Tracy's efforts to gain acceptance for herself on the dance show and then ultimately to achieve integration on the show. All the alliances she makes on her journey to a happy ending are with black characters or characters who are somehow aligned with the black community. They are all connected by their outsider status. Because her hairstyle is too big (another allusion to her overbearing size and personality—even her hair is too big), she is sent to detention, where she meets Seaweed and some other black kids. The black kids share dance moves with Tracy, and at the next high school dance, she is able to get herself discovered by Corny Collins himself and earn a slot on the show.

Her first day on the program, she manages to get Link Larkin—the heartthrob and Amber's (white) beau—to sing a song to her. Tracy joins in, and they serenade each other and conclude the song with a kiss. Link's singing style is clearly inspired by Elvis Presley. Link's rhythm, vocal technique, and persona cross over stylistically into black music, just as Elvis was initially associated with "colored music" of the era and was regarded suspiciously by whites who were proponents of segregation.[29] Like Elvis, Link is what I call a "transracial figure," an individual who blurs the black/white racial binary by effectively integrating aspects of both cultures into his or her artistry, creating a performative fusion that transcends racial boundaries. Thus, it is not surprising that the Link, as a transracial figure would not only be "color blind" but also blind to Tracy's fatness. Indeed, he finds himself attracted to her. His devotion to Tracy is sealed later during school gym class when Amber flattens her with a dodge ball, shouting, "Hey thunder thighs, dodge this!" and Link sides with Tracy. So does Seaweed, and he invites Link, Tracy, and her friend Penny to join him at a dance party in his (black) neighborhood, hosted by his mother, Motormouth Maybelle. Her name implies all the fat behavior I have discussed.

They are discovered enjoying themselves at the all-black party by Amber, who shouts, "Link, what are you doing in this huge crowd of minorities?"[30] With this statement, Amber lumps the fatties in with the blacks. Moments later, Amber's mother, Velma, and Tracy's fat mother, Edna, show up. Velma insults Edna and Tracy with an interesting jibe: "I guess you two are living proof that the watermelon doesn't fall very far from the vine."[31] On one hand she is making a fat joke, substituting the visual of a large watermelon versus a small apple "falling far from the tree." On the other hand, the choice of watermelon as the substitute fruit also includes the double entendre of the racist stereotype of blacks eating watermelon. Thus, the playwrights imbricate blackness and fatness.

After Amber and her mother leave, Tracy convinces Motormouth and the rest of her new friends to invade the all-white mother-daughter dance day on the *Corny Collins Show* and stage a kind of "dance-in." Edna initially hesitates to join in on the grounds that she is too fat to appear on TV. But Motormouth, who of course is black but wears a blonde wig, sings her song, "Big, Blonde, and Beautiful." This song celebrates female fatness with lyrics that revel in her voluptuous body, her appetite for food and love, and her unapologetic persona that mixes fat, blonde, and black. She encourages Edna to shed her self-consciousness and enjoy life.[32]

With this song, Motormouth further mixes black identity with fat identity. She is fat and black but blonde, while Edna is big, blonde, and white. The song draws no line of separation between black and white but connects them both through their fatness. Later, when they all storm the set of the dance show, Motormouth announces: "Well, ladies, big is back! And as for black, it's beautiful."[33] Thus, she further blurs strict delineation between big and black. For me, the blurring of lines between blackness and fatness results in a metaphorical fat/black miscegenation that provokes anxiety in the same way mixed race unions, and the threat of mixed-race progeny did in late nineteenth- and early twentieth-century. As evidenced by the recent not-guilty verdict in the Trayvon Martin trial, race relations in the United States continue to be deeply problematic, and the mixing of fatness with blackness in our cultural landscape implicates fat white bodies as racially "othered."[34]

The protest march on the dance show lands Tracy and her cohorts in jail, but Link comes to break her out (and offer her his ring). Motormouth then convinces Tracy to give it one more try, and they all crash the show again as it is televising the Miss Hairspray Contest. Tracy wins the crown in a dance-off and smuggles all the black kids in to dance. Tracy has achieved integration for the blacks and "the fats." In traditional musical style, the play *Hairspray* ends in a big song and dance number with blacks, whites, and fatties all dancing joyously, celebrating the coming of a new age.

To further investigate how we "read" these black, fat, and, in my next chapter, queer characters on stage I look to several theoretical frameworks including phenomenology and Cultural Studies. Integrating concepts of the "intercorporeal gaze" and "perceptual practices," I point to tendencies and mindsets of prevailing audience perceptions about not only race and homosexuality but also how they are inexorably linked to perceptions of the fat female body.

In her essay "Toward a Phenomenology of Racial Embodiment," Linda Martín Alcoff argues for the power of both visual and bodily perception when understanding bodies of knowledge, actual bodies of the flesh, and social bodies. She argues that bodies are read and positioned as "other"

based on any visible "non-white" bodily markers, and in this way links blackness and fatness. She asserts that we cannot underestimate the power of the visible in forming "metaphysical and moral hierarchies" as well as "racialized categories of human beings."[35] Alcoff argues that, "In our own materialist society, where science trumps religion and where cultural rituals—whether religious, patriotic, or familial—must increasingly revolve around the exchange of material commodities in order to retain their significance, what is true is what is visible. Secular, commodity-driven society is dominated by the realm of the visible. In such a context, visible differences operate as powerful determinants over social interaction."[36] Alcoff's framework offers potent evidence as to why fat bodies (and bodies of color) are so stigmatized in American culture—where the prevailing belief is that slenderness can be bought if one is "unwilling" to achieve it through the so-called natural means of diet and exercise. Even skin color and racial identity can be mitigated through cultured dress, customs, style, and gesture to emulate the white homogenous beauty aesthetic that predominates in the United States. Alternately, a white individual can reverse this process to achieve the kind of transracial status I discuss in relation to Link Larkin in *Hairspray*. However, Alcoff goes on to describe how we perceive other bodies not just through the visual but with a culturally embedded understanding, which we then embody ourselves. "[T]he realm of visible, or what is taken as self-evidently visible (which is how the ideology of racism naturalizes racial designation), is recognized as a product of a specific form of perceptual practice, rather than the natural result of human sight."[37]

Alcoff draws from Merleau-Ponty's concept that "perception represents sedimented contextual knowledges," and argues that we perceive otherness not just through visibility politics but through perceptual practices that engender a kind of experiential, embodied recognition.[38] This helps explain how fat bodies and black bodies are conflated as other in our cultural mindset. If recognition is embedded in perceptual practice, which includes a phenomenological psychic realm of awareness, it also offers an explanation as to how fat bodies can be lumped in with black bodies—and, as we shall see—queer bodies in American culture.

Samantha Murray expands on this idea of the othered body and the ways in which we read it. Drawing on Foucault's *Birth of the Clinic* and his concept of the disciplinary gaze as well as the essay "Mapping Embodied Deviance" by Jennifer Terry and Jaqueline Urla, Murray identifies the "epistemological force of medical discourse" in reproducing bodies of knowledge.[39] She asserts that as a result of medical discourse propagated by the clinic, individuals in Western European cultures tend to operate under the "spectre" of the normal body, which is a white, heterosexual, (healthy) male body. This, of course, implies a V-shaped male figure with no fleshiness in

the hips, buttocks, breasts, or stomach. Thus, men *and* women aspire to this normative body and are motivated by fear of deviance to position ourselves on the "normal" side of a normal/deviant binary. Furthermore, Murray asserts that not only are the responses of medical practitioners biased and gendered but they are biased and gendered at the perceptual level.[40] She argues that,

> The "clinical gaze" then, as a particular mode of perception, is inevitably intercorporeal: it does not simply function to constitute the 'other,' but is also fundamental to the reaffirmation of the 'self,' and the ideals on which the self is founded . . . Within this repetitive deployment of medical knowledges and discourses of health in the form of a disciplinary gaze, discursive power and authority is effected. The policing of 'improper' bodies mobilizes medical narratives and imperatives beyond the walls of the clinic into everyday intersubjective spaces and corporeal exchanges that are always discursively mediated by the authority of medical expertise and the concurrent moral value attached to the maintenancing one's body to attain/maintain health and normativity.[41]

In essence, Saartjie Baartman was victimized by this very dynamic, which Foucault maintains emerged in the nineteenth century, coinciding with her maltreatment at the hands of medical authorities. The black female body is already visibly on the wrong side of the normal/deviant binary, and, as I have discussed, this deviance extends to her sexuality. The fat white female in contemporary culture is also visibly on the wrong side of this normal/deviant binary. While it is true that queer bodies are more able to "pass" as normative because they are not necessarily visually marked, Alcoff's assertion above suggests that we perceive queerness as otherness on an intuitive level that is rooted in all our senses, not just the visual.[42] Thus, I will argue that, while queer bodies may be less visually deviant by these standards, using Murray's concept of the intercorporeal gaze and Alcoff's concept of perceiving other bodies, a queer body is easily categorized alongside a fat body or a black body as deviant from heteronormative aesthetics.[43]

# 7

# Queering Fat

Thus, there is an organic connection among fat, black, and queer as cultural signifiers of otherness. This phenomenon is frequently depicted semiotically in representation in various cultural texts. Tracy Turnblad's alliance with the black characters in *Hairspray* is one example, and I will explore the link between fat white women and black bodies further in my discussion of fat actress Kirstie Alley. Furthermore, as I pointed out in some of the plays from earlier chapters, we frequently see an implicit association with fat and gay characters, such as Vicky and James in *My Fat Friend*, or Maggie and Jerry, the gay cop in *Fat Chance*. And in *Ma Rainey*, Wilson is sure to include the character of Dussie Mae, Ma's lesbian lover. This is based on biographical fact, of course, but it is remarkable that the playwright opts to make that detail explicit in the narrative, which otherwise has nothing to do with Ma being lesbian. Andrea Elizabeth Shaw reminds us of the implied connection between black female bodies and deviant sexuality. "[T]he fat black woman's sexuality is sometimes positioned in tandem with culture's other sexual issues and beyond the scope of her individual behavior. As a result her "freakishness" is resituated from the site of her body onto the site of the popular body politic and becomes a reflection of her culture's sexual taboos. Her body is a venue of expression of cultural anxieties related to bodily transgression, particularly those that are sexual."[1] Certainly homosexual behavior can be lumped into these cultural anxieties, and a fat black lesbian would be the ultimate transgressor.

Shaw's quote helps position the next two plays in my discussion, which engage cultural assumptions about lesbians. If a fat black woman's body sometimes becomes a repository for various cultural sexual taboos, then her sexual "otherness" can be linked to the otherness of homosexuality regardless of race. Judith Butler offers further explanation for how queer is othered in our culture: "This very concept of sex-as-matter,

sex-as-instrument-of-cultural-signification, however, is a discursive for-
mation that acts as a naturalized foundation for the nature/culture distinc-
tion and the strategies of domination that distinction supports. The binary
relation between culture and nature promotes a relationship of hierarchy
in which culture freely 'imposes' meaning on nature, and, hence, renders it
into an 'Other' to be appropriated to its own limitless uses, safeguarding the
ideality of the structure of the signification on the model of domination."[2]
Despite recent strides in civil rights, queer bodies remain on the wrong
side of contemporary American cultural binaries, and although they may
not be visually marked like black and fat bodies, they share with fat bodies
the implicit cultural assumption that their otherness is somehow a choice.
Both queer and fat bodies experience varying degrees of stigmatization.

The next play I will discuss is *The Killing of Sister George* (1965), by
Frank Marcus, which exemplifies the overlay of cultural anxiety toward
fatness and deviant sexuality—in this case lesbianism and sadomasochism.
*The Killing of Sister George* not only makes use of negative stereotypes of fat
women and lesbians but also the cultural binary of the normative body or
the normal/deviant binary that relegates fat, black, and queer to the devi-
ant side of the equation. The play originally opened in London in 1965
and transferred to Broadway in 1966, where it ran for 205 performances.[3]
Beryl Reid won a Tony award for her portrayal of George, and she reprised
the role in the 1968 movie version of the play. The movie was given an
X-rating for portraying lesbians kissing both on the mouth and each other's
breasts. Most reviews following the initial release of the play and the movie
found the piece remarkable for its so-called frank portrayal of lesbians. It
was recently revived at the Long Wharf in 2012 with fat actress Kathleen
Turner directing and playing the title role. The production received tepid
reviews, but *New York Times* critic Charles Isherwood was sure to mention
that Turner was as skilled a "bellower" in this production as she had been
a "brayer" when portraying Martha and adds that he would never associ-
ate Turner with any quality of vulnerability.[4] In 2012, the play comes off as
quite dated in production, but it is not surprising that Turner and her pro-
ducers saw this role as a good fit for her considering her previous success
in stage roles that call for fat behavior.

Furthermore, to a present-day reader, the play panders offensively to the
ugliest stereotypes of lesbians and fat, indeed including the assumption that
all lesbians are fat. It was marketed in the sixties as a black comedy com-
menting on the British national pastime of watching soap operas.[5] Sister
George, whose real name is June Buckridge, is described in the text as a
"rotund, middle-aged woman."[6] She is a strident, aggressive, cigar-smoking
butch lesbian who earns a living as an actress on a BBC soap opera and lives
with her childlike lover, Alice (whom she calls Childie). At her insistence,

everyone, including Childie, calls her Sister George, which is her character's name on the show. Her insistence on being addressed as her character in real life hints at an emotional instability and an inability to separate fiction from reality. This pathological behavior conjures up assumptions about fat women that I have discussed in previous chapters. The fictional character of Sister George is the exact opposite of June's real-life personality. Sister George is a benevolent Mother Teresa-type, nursing nun who travels around the British countryside on her motor scooter delivering blessings and medicine to the inhabitants of the fictional country village Applehurst. In a way, June Buckridge and her stage persona, Sister George, embody the two sides of the normal/deviant binary I discussed earlier. Sister George adapts the "acceptable" interpretation of her fatness by being a nurturing Mammy-type, an asexual figure. But June is firmly on the deviant side of the divide, not only as a fat lesbian but as one who engages in fetishistic sexual practices.

In the opening scene, Sister George arrives home from work in a panic because she has overheard that ratings are dipping and they are going to kill off her character. The narrative of the play traces her eventual breakdown as she tries to resist the inevitable firing and keep her young lover, who is being courted by the same BBC executive who is trying to get her ousted—Mrs. Mercy Croft.

Marcus's Sister George is not only a fat lesbian but also a sexual sadist. Thus, she is a "triple threat" of social deviance. Her fat body and her homosexuality resist heteronormative standards of beauty and sexuality, and her sadomasochistic predilections solidify her as aberrant. Not only is she into S-M, but she is the "top"—the dominant—over the slender "girl-woman" Childie. Arguably, a female submissive, even in a lesbian relationship, would be marginally closer to social mores of feminine behavior. Sister George's "top" status is made clear in the second scene of the play, when she punishes Childie for yelling at her by demanding that she kneel at her feet and eat the butt of her cigar. The play is peppered with similar exchanges, where George unexpectedly, often in an irrational fit of jealousy, wields her dominance cruelly over Childie, who submits. George's moods are so mercurial that the sadomasochistic exchanges often seem ill-timed, and it is not clear whether Childie is a willing participant in the role-playing or genuinely fears for her emotional and physical well-being. Indeed, when she leaves George for Mrs. Mercy, she claims that George beats her, although we never see this enacted onstage.

Like characters I discuss in earlier chapters, Sister George exhibits a myriad of fat behaviors that characterize her as out of control, consuming, and emotionally destructive to those around her. The text is loaded with instances (as dictated by the playwright) of Sister George shouting

and bullying people as well as swearing, drinking heavily, and even physi-
cally attacking others. George's emotional abuse of Childie, under the guise
of role-playing, frequently brings Childie to tears. George has a physical
altercation similar to Ma Rainey's when, in a drunken stupor, she attacks
unwitting passengers (novitiate nuns!) in a taxi. This behavior is part of
what gets her sacked, in addition to her falling ratings and tantrums on the
set. Mrs. Mercy stops in to discuss the incident:

> MRS. MERCY. You boarded this taxi in a state of advanced inebriation
> and—(*consulting the paper*)—proceeded to assault the two nuns, subjecting
> them to actual physical violence![7]

Although Sister George makes public amends for her violent behavior,
apologizing to the convent and offering a donation, she can do nothing to
change the course of things at the station, and she is indeed written out of
the soap opera by the middle of the second act of the play.

Mrs. Mercy stops by to inform her that her character, Sister George,
will be on her motorbike on her way to help an ailing boy when she
will have a "collision with a ten-ton truck." She also adds that her death
will coincide with Road Safety Week, and they believe the loss of such a
beloved character will boost ratings. June, speaking in the first person of
herself as Sister George, tells her, "I've never ridden carelessly."[8] When
Mrs. Mercy insists it must be so, June/George goes on to ask questions
about how she will be buried. Again, we see her eerily unable to sepa-
rate herself from the character she plays. She exits with a bottle of gin to
console herself, and Mrs. Mercy uses this as an opportunity to move in
on Childie. As a final insult, on the day of Sister George's funeral, Mrs.
Mercy pops by once again and cruelly "comforts" George/June by assur-
ing her there's a role for her on their new children's show—playing Clara-
belle the Cow.

The character of Sister George embodies all the irony that the play-
wright can conjure to help him make a social commentary on our obses-
sion with fictional characters represented in mass-media programming.
She is a selfish, sadomasochistic lesbian who impersonates a nun who is
the pinnacle of generosity and kindness. She is a sexual deviant playing a
character who is sexually chaste. Yet both are social extremes, and I suggest
that the playwright deploys lesbianism and fatness as an illustration of the
absurdity of this character in order to highlight the foolishness of viewers
who believe in, or are engaged by, soap opera characters. In his review of
the play, Walter Kerr accused Marcus of "moral blackmail." In the follow-
ing passage, Kerr unpacks the tone of superiority Marcus assumes with this
black comedy that he finds distasteful.

One of the matters that causes him (Marcus) deep, malicious concern is the cessation of real life that takes place throughout England at 11:15 a.m. (Mondays through Fridays) when housewives stop work and make themselves willing slaves of the national network. For a few moments drudgery is outlawed and devotion begins. More than devotion. Belief begins . . . Whenever a radio-serial character dies, real flowers are sent, and even the studio executives wear black. We live in a society where the synthetic is more life like than genuine flesh and blood.[9]

In this case, the self-important playwright illustrates his moral point through the irony of the absolute disparity between June Buckridge's queer, fat, deviant behavior and that of her virtuous character, Sister George. It is also remarkable that in 1966 (when the above review was published), Kerr was already expressing concern about the extent to which synthetic representations are more lifelike than the real thing. This is a notion I will return to in my final chapter.

### Five Lesbians Flipping the Stereotypes: *The Secretaries*

The last play I will discuss briefly is *The Secretaries* (1994). The play was written collectively by The Five Lesbian Brothers, a feminist troupe comprised of performance artists/writers Maureen Angelos, Babs Davy, Dominique Dibbell, Peg Healey, and Lisa Kron. The text was originally performed at the WOW Café in New York City by the Brothers themselves and has gone on to be reproduced off-off-Broadway, regionally, and at colleges by other female performers.

This play contrasts with many aforementioned examples because the playwrights are deliberately engaging cultural stereotypes and assumptions as a means of social commentary, as opposed to deploying fatness and queerness incidentally as a means to unfold their larger narratives. On the other hand, *The Secretaries* is an apt conclusion to this chapter because of its activist stance and self-awareness. Like Paula Vogel deconstructing stereotypes and rejecting traditional narratives of female oppression by exploring fat subjectivity, the Brothers try to shine a light on the insidiousness of texts that disempower (fat) women through misogynist representations. Their material operates squarely in the traditions of queer theatre, which reject heteronormativity and cultural oppression of those who fall outside of hegemonic standards. *The Secretaries* offers an interesting counterpoint to the earlier plays because it looks at fat and lesbian characters from the perspective of a feminist queer lens. Using satire and irony, the Brothers deploy lesbianism and fatness in a very self-aware way in order to poke fun at the assumptions Marcus makes in *Sister George*.

In her introduction to the Brothers TCG collection of plays, feminist scholar Peggy Phelan describes their work as follows:

> They demonstrated how quotation from stereotypes, popular culture and accepted "truisms" can generate both great comedy and alternative political and performance tradition. When The Brothers raid accepted habits of mind—from television sitcoms to slapstick theatre—they increase the sources of lesbian history exponentially.
>
> The Brothers' work explores the possibilities of addressing theatre history's own relationship to what we might call lesbian epistemology, those cultural habits of the mind that produce knowledge unknowingly.[10]

Their work in general, and especially *The Secretaries*, responds to the implicit cultural stereotypes about lesbians, including that they are fat, man-eating, overbearing sexual deviants.

The play takes place "in and around the town of Big Bone, Oregon. Sometime before Windows 95."[11] Using the backdrop of a secretarial pool at a lumber mill, *The Secretaries* follows the induction of the "new girl," Patty, into the secret lives of her secretarial colleagues, Dawn, Ashley, Susan, and Peaches. The veteran secretaries initiate Patty into their world wherein they are models of feminine, secretarial perfection for twenty-eight days, catering to the male bosses at the mill and maintaining perfect attitudes and perfect figures (with the exception of Peaches), until they get their periods, at which point they engage in a food orgy and ritualistically murder a lumberjack. The play parodies a multitude of misogynist assumptions about women's homosocial group behavior including (but not limited to) the idea that women enjoy playing Twister at slumber parties clad in skimpy lingerie, that all women are all secretly femme lesbians who spontaneously engage in "girl-on-girl" action, that all lesbians are sexually voracious and want to turn straight women gay, that women happily subsist on Slim-Fast diet drinks, and that women in groups tend to menstruate simultaneously and instantly become murderous. However, *The Secretaries* does not only target patriarchal suppression of women by men but also the policing of women by women, whereby women oppress one another.

In their interview-style introduction to *The Secretaries*, the Brothers note that they were trying to interrogate sexism as well as confront issues of "body image and woman's cruelty to woman." Lisa Kron, who at the time was the "fattest" of the Brothers states,[12] "[t]he play examines the ways in which women are enforcers of sexism. The rules that are enforced involve weight, food, sexuality."[13]

The world of *The Secretaries* comically demonstrates this dynamic. For example, Susan, who is described in the stage directions as the office manager

and "cult leader," insists that all of the secretaries under her management photocopy their breasts and bottoms for her scrutiny. She monitors everyone's appearance from what they are wearing to what they are eating and how often they go to the gym. In fact, they all monitor one another's eating and exercising habits. Ashley, who is described in the stage directions as bulimic, is very happy to live on her Slim-Fast shakes alone, and they all encourage Patty, the new girl, to shun solid food and stick to the liquid diet. Peaches is the only one who cannot adhere to the all-liquid diet. At one point, Susan uses the photocopies of Peaches' body to try to humiliate her into losing weight.

On the other hand, Peaches is their star at "kill night," when the secretaries murder their lumberjack. It is not a surprise that the fat girl is the best at slaughtering the man and enjoys the murder ritual, which culminates in eating ice cream and pizza while covered in their victim's blood. Unfortunately, Peaches eventually comes under fire from the big boss, Mr. Kembunkscher, for being a size fourteen (no one is allowed to be over a size twelve). She enlists a reluctant Patty to slap her every time she catches her eating solid food. Many comic moments follow with Peaches attempting to sneak food and Patty slapping her.

However, Peaches quickly becomes frustrated with this dynamic, particularly since Patty does not have to stick to a liquid diet to maintain her slenderness. In the exchange that follows, we see the secretaries turn on one another for all of their various transgressions against the absurd patriarchal code to which they rigidly try to adhere. (At this point, Patty has violated both the "solid food" rule and the rule of abstinence imposed by Susan, because she has had sex with a male lumberjack.) Peaches responds to Mr. Kembunkscher's request for a report over the intercom:

PEACHES.   I'm having my lunch, you fat pig. You know, lunch? What people eat to live. I'm eating my lunch, you dumb fuck. Leave me alone.
DAWN.   Oh, shut up Peaches!
PEACHES.   Don't tell me to shut up! I starve myself and look at me, I'm fat. Patty eats whatever she wants whenever she wants to. She eats dinner! She eats dinner!
PATTY.   I'm sorry.
PEACHES.   Yeah, you're sorry and I'm fat.
ASHLEY.   Stop saying that word!!!
PEACHES.   FAT! FAT! FAT! How do you like that, you stupid anorexic?
. . .
PATTY.   The report!
PEACHES.   Oh fuck Kembunkscher, Patty! You fuck everybody anyway.
ASHLEY.   (*To Peaches*) If you don't shut your fat trap this minute, I am going to come over there and shut it for you, you whore!

PEACHES.  (*Referring to Patty*) I don't think I'm really the whore in this room, but you can call me that if you like.[14]

This is just one of several exchanges in *The Secretaries* that cleverly satirize the ways in which women undermine themselves, especially when it comes to issues of body size, eating, and sexual freedom. The above exchange also ingeniously highlights how fraught the word "fat" is in the American popular imagination. Fat, like "thin," "tall," or "brunette" is merely a physical descriptor. Yet, over the course of the last century the word has become synonymous with negative, pejorative connotations. It is such an insult that Patty cannot bear to hear Peaches repeat it over and over, let alone identify herself with it.

Dawn is the only lesbian in the group. Her character satirizes homophobic fears about queers "passing"; she is a femme-lesbian who passes for straight. Her character engages another cultural anxiety about the rapaciousness of lesbian sexuality and embodies the stereotype of queer hypersexuality by constantly trying to seduce everyone. She hits on Patty until she finally tricks her into going to a hotel. Patty engages in an experimental fling with her but makes it clear the next day that she prefers men. Nonetheless, Susan (the cult leader) harshly enforces the rule of abstinence she has imposed on all the secretaries. When she finds out (because Ashley tattles on them) that Dawn has seduced Patty, she pretends to seduce Dawn in order to discipline her; she acts as if she is going to perform oral sex on Dawn but bites her labia instead. The image of Susan emerging from beneath Dawn's skirt, wiping blood off her mouth conjures a multitude of cultural taboos and stereotypes, from lesbian sodomy to women's sexuality as dangerous and (literally) consuming.

In essence, the world The Five Lesbian Brothers create in *The Secretaries* is a parodic version of Foucault's Panopticon (see chapter one) in which discipline in the form of social institutions and cultural practices (re)makes the individual in the model of the perfect citizen—or what he calls the "docile body." The Panopticon is a model for an ideal prison, the salient disciplinary features of which would include very structured, boring, repetitive work (like that of a secretary) for the prisoner, as well as the prisoner being housed in a physical structure that places her under constant surveillance but disallows her from knowing when she is being observed. Foucault contends that prisoners exposed to this kind of discipline will eventually police themselves.[15] The secretaries are living in a Panopticon where they can never escape the disciplinary gaze because it comes from within themselves and those around them. These five women willingly, indeed emphatically, enforce patriarchal standards of beauty, weight, and sexuality among themselves.

## A Tangled Web of Otherness

In these two chapters I have tried, if not to draw a direct line, then to trace a web of connections among fat, race, and queer sexuality as they intersect in these play texts. Novid Parsi, a gay Iranian performing artist and playwright, illustrates my point when he describes his frustrating casting experiences as an actor in regional theatre in Texas: "Me, the Jewish girl, the Turkish girl, the black girl, the fat girl, the faggot: we made up a sort of family, a non-Von Trapp family." He goes on to describe himself as a "sexually, ethnically othered body onstage: a public spectacle."[16] Parsi discusses at length the various outsider roles he and his cohorts were relegated to in their homogenous white casting pool. Fatness and blackness are visible markers of outsider status in our culture. Examples like *Ma Rainey* and *Venus* demonstrate that onstage these visible marks of otherness can suggest either a character's subjugation or empowerment, and sometimes both simultaneously. I have discussed how both a fat female body and a black body are linked with sexual rapaciousness and even sexual deviance, which then links them to queer bodies as those who are outside the normal/deviant binary. Fatness and blackness are immediately visible to the spectator and associated with a myriad of cultural prejudices. Queerness, while not necessarily visible, is connected to fat not only because both are positioned outside heteronormative standards but also by the common cultural assumption that being queer and being fat are both a choice, while one's race, of course, is not. Regardless of this question of agency, I assert there is a complex interplay that connects fat bodies, queer bodies, and black bodies in various forms of representation.

# 8

# Fat-Face Minstrelsy

This next chapter is the first to move from live theatre to consider how fat subjectivity is portrayed on the small screen. Television, like the rest of mass media, is at the forefront of perpetuating cultural myths about fatness and fat people. Recent years have seen a trend in programming endeavoring to leverage the national fascination with fat, frequently by stigmatizing and mocking the fat subject while at the same time aiming to appeal to popular audiences, many of whom may very well be considered obese by national standards. In some instances, shows, particularly those in the reality TV genre such as *The Biggest Loser* and *Extreme Weight Loss*, exclusively cast "real-life" fat people, exploiting national fears and prejudices toward fat while dramatizing the weight loss of these individuals. Showtime's *Fat Actress* (2005), produced by and starring Kirstie Alley as the title character, was one of the forerunners of the fat TV genre. *Fat Actress* attempted an amalgam of reality weight-loss show and fictional serial narrative with Alley as the subject. More recently, some categorically fictional shows are exploring the marketing appeal of the fat subject as protagonist, such as *Drop Dead Diva*, which premiered on the Lifetime Channel in 2009, and *Huge*, which debuted on ABC Family network in 2010, and, most recently, *Mike & Molly*, which currently airs on CBS primetime. As of this writing, *Huge* has been cancelled, and *Drop Dead Diva* has been renewed for a sixth season, while *Mike & Molly* is into its fourth season.

I will focus on *Fat Actress* and *Mike & Molly*, both of which are half-hour comedies. As of this writing, *Mike & Molly* has gained some traction and may suggest the marketing potential for more shows focused on fat subjectivity. This may be partially due to the increasing popularity and recognition of the actress who plays Molly, Melissa McCarthy. Since the debut of *Mike & Molly* in 2010, McCarthy's success in mainstream movies has arguably changed the tides for fat actresses and paved the way for a fat performativity that is not abject, something I will discuss in the last

chapter. Yet, in the case of Kirstie Alley's *Fat Actress* and the early episodes of *Mike & Molly*, there is a commonality in the depiction of the fat subject that panders directly to all the aforementioned cultural stereotypes of fat people, particularly fat white women, as out of control, sexually voracious, verbally outspoken, psychologically damaged, and unable to contain themselves emotionally or physically. It results in a style of sitcom humor geared for popular appeal that I call "fat-face minstrelsy." Fat-face minstrelsy is fat behavior in excess with an emphasis on visual, vulgar comedy similar to the performance tropes that made blackface minstrelsy so popular in the nineteenth century. *Fat Actress* is emblematic of this "performance tradition," but *Mike & Molly*, albeit more nuanced and coded, represents a developmental stage in the trajectory of fat-face minstrelsy on television. After examining some of the stereotypes at play in *Fat Actress* and then the early episodes of *Mike & Molly*, I will demonstrate how Alley's fat-face performance and McCarthy's in *Mike & Molly* parallel some of the performer-spectator dynamics of nineteenth-century blackface minstrelsy.

With the first announcement in 2005 that Kirstie Alley was producing herself in a new Showtime TV program called *Fat Actress*, I hoped that Alley's performance would subvert the usual stereotypes and strike a liberating blow for fat actresses everywhere. The *Fat Actress* advertising poster suggested as much. It featured Alley glamorously made up, wrapped in a silk sheet, coyly biting at her finger, and throwing a seductive look to the camera, harking back to sexy Marilyn Monroe stills in which she posed nude swathed in red silk. The only hint of "fat" in the poster required closer scrutiny: Alley is lying atop a scale that is mostly obscured by her glorious mane of hair. The premise of the show was to be Alley's struggles as a fat actress in body-obsessed Hollywood. Her weight gains and losses had been fodder for gossip tabloids since her years starring in the successful sitcom *Cheers*, for which she won several Emmys and People's Choice Awards. Since that time, following her brief movie career, her body changed drastically. Her last network series was *Veronica's Closet*, which ran from 1997 to 2000. Toward the end of the run, she started to gain weight, and following the series close she gained upward of seventy-five pounds.

If Alley was struggling to find roles at her size in 2006, it could have been the opportunity to turn the mirror back on Hollywood and use the reality TV genre to represent herself as a sentient human being—possibly even a feminist, certainly a woman who was more than just a body—more than just a starlet whose career was destroyed by her inability to keep her weight down. In her essay "Fatties on Stage," Petra Kuppers reminds us:

> Most performers who started to explore the large female body as an arena
> of cultural politics seem caught in this labeling of loss of control . . . If their

performances try to reclaim the "body out of control" as a site of transgression and empowerment without attempting to question these very assumptions of fertility, grossness, carnival, and the grotesque, their work can easily fall back on the stereotype, still allowing no space for inscriptions of subjectivity. Instead showing the problems with the essentialist account of fat, they embrace the large woman as caught up in her (culturally determined) fat.[1]

Unfortunately, Alley's performance of herself falls squarely into this description. The comedy of the show is rooted in Alley's lampooning herself and performing every fat stereotype of an all-consuming woman out of control.

Alley's performance of herself as a fat woman relied on offensive fat stereotypes comparable to racist jokes that are no longer culturally acceptable—a kind of fat-face minstrelsy. In *Fat Actress*, Alley's comedy necessitated a particular cultural reading of her outward appearance, just as blackface minstrelsy did, and exploited culturally embedded tropes of fat women, akin to racist humor.

Alley embraces the weightist stereotype in the same way the *Amos-n-Andy* radio show and other popular entertainments of the Jim Crow era in the United States featured racist jokes about black people eating fried chicken and watermelon. She depicts herself, without a trace of irony, as a whiny "fatty," unable to control her appetite or her bowels, a consuming monster whose grotesque appearance is the object of amusement, fear, and scorn. The comedy in *Fat Actress* pandered to audience expectations of fat stereotypes in the same way blackface minstrel shows operated on a kind of humor that depended on the "otherness" of the object of ridicule (the black person). Moreover, Alley's exaggerated performance of fat in a program that touted itself as "reality" echoes the nineteenth-century white male performer blacking his face and dancing "Jump Jim Crow" for popular audiences throughout the United States.

In his book *Love and Theft: Blackface Minstrelsy and the American Working Class*, Eric Lott posits a nuanced performer-spectator relationship between the blackface performer and the white audience, which is more than just white audiences mocking black people and which relies in part on the performer's ability to remove the blackface and become white again. Lott argues against essentialist readings of minstrelsy performance that see it as a vehicle for black oppression and cultural containment. He argues that blackface minstrelsy performances were not so much a sign of white power but indicative of white anxiety toward black culture as well as white fascination with blackness. Lott also sees minstrel shows as part of the development of a new white working-class audience, whereby representations of blackness in minstrelsy established an "other" against which,

in contrast, they could define themselves. I assert that some of the audience enjoyment of *Fat Actress* as well as early episodes of *Mike & Molly* is rooted in this very same dynamic, wherein we can enjoy these performances because we identify ourselves as "not fat." Just as blackface minstrelsy was not performed for a black audience, *Fat Actress* especially is not for a "fat audience." Alley's performance assumes a "thin audience" or at least an audience that has been completely acculturated to view the fat body as pathologically flawed, so much so that even fat people abhor their own bodies and align themselves with the "other side."

Consider the style of comedy found in *Fat Actress*. Episode one, entitled "Big Butts," set up the premise for the series, wherein Kirstie played herself, and many celebrities such as John Travolta appeared as themselves, but other actors portrayed *fictional* characters based on real-life Hollywood personalities. The confusion between whether this was a reality show or a traditional sitcom with fictional characters is part of what complicates spectator positioning in the performer-spectator relationship and sets *Fat Actress* apart from *Roseanne,* for example, which clearly established a traditional fictional sitcom setting with the main character, Roseanne Conner, *based* on the real Roseanne Barr. In the opening sequence, we see Alley weigh herself, the shot focusing on the way in which her abundant body, swathed in a nightgown and robe, obscures, or perhaps crushes, the tiny, defenseless scale. She then collapses to the floor in horror at her weight and crawls to the phone. Between moans of "I'm dying," she tells her agent she will not accept the Jenny Craig commercial deal. The next sequence shows Alley with disheveled hair, still in her robe, voraciously eating a hamburger at the drive-thru while "chewing out her agent" for failing to get her jobs. As she does so, food spills down her bodice, which is a sexy lace brassiere that emphasizes her ample bosom.

On the one hand, Alley is horrified by the number on the scale, as any self-respecting fat American woman *should* be, but in the next breath she refuses to be a spokesperson for a diet company, seemingly a statement against cultural expectations or at least a rejection of the diet industry. As the character of herself, she claims she wants to lose weight and says insulting things about her own appearance. At the same time, she is conspicuously eating something fattening or unhealthy in almost every shot of the episode. The audience can only attribute her constant eating to deep self-loathing and an unwillingness to invoke willpower that borders on pathological behavior.[2] Again, this plays directly to cultural stereotypes that align women who appear fat with some sort of diagnosable pathology: a psychological, neurochemical, or physiological flaw. Her prominent eating also helps reinforce spectators' positioning themselves as "not fat," since the amount she eats, and the way she eats, is so grotesque that it is

only comparable to someone engaged in sport-eating, such as a pie- or hot-dog-eating contest.

Within these first few frames, Alley performs several of the classic fat-woman tropes that I have mentioned: She is "out of control," unable to contain her emotions, unable to even get dressed or groom herself before she goes out and eats more. Her howls and screeches highlight her mouth as a site of danger; dare to come near it and risk being eaten or screamed at. The sexiness of her bodice feeds into the cultural fear of fat women as hyper-sexual or predatory man eaters.[3]

Later in the episode, Alley decides she is not going to have "fat sex," asserting that while she has a healthy libido, she is too hideous to allow herself this pleasure. Here, her verbal declaration to abstain from sex because of her weight could be construed as an effort to allay the cultural fear of the fat-woman-man-eater. In desexualizing herself, Alley panders to negative assumptions about fat sexuality by trying to disavow her sexual appetite or at least promise that it is not as aggressive as her appetite for food. Yet, there is a reversal later in the episode, when she and her assistants decide that she should find a black man because "black men like fat women." Here, we see another connection between fatness and blackness; this alliance that crops up regularly between the fat white subjectivity and black subjectivity, and also appears in *Mike & Molly*. First, Alley goes to an all-black soul food restaurant but fails to pick up a black man. However, she eventually ends up having a sexual encounter with one of the black studio executives who asks her out. The scenes of their foreplay include him showing up at the door with flowers and her physically bowling him over in an effort to kiss him. The would-be lovers then parody the *9½ Weeks* "eating scene," with him feeding her all sorts of gooey things from the fridge and her submissively lapping it up from her position on the floor.[4] At one point, she barks like a dog. It is hard not to read this as a deliberate analogy equating the fat woman with an animal. When they finally get into bed, Alley is on top—a subtle semiotic that again points to the fat woman as overly empowered. Her partner compliments her body and slaps her playfully on the butt. She cannot believe his compliments are sincere and giggles and slaps him in the face. (Part of the comedy of their slapping match is that the lights are controlled by a "clapper," and he keeps turning the lights on with each slap in order to see her, but she keeps turning them off.) Eventually Alley laughs him out of the bedroom for being so silly as to want not only to make love to her but to actually see her fat body while they are doing it. On the one hand, this scene had the potential to affirm her fatness with the eating sequence and a sexual scenario with a willing partner who celebrates her body. Yet, her own behavior toward herself, the barking and driving him from the bedroom, upholds the hegemonic status quo with regards to

popular cultural views toward fat women: that of comical animal unworthy of sexual pleasure.[5]

With this seduction scene, we have both the racist and weightist stereotypes at play: because she is fat, a white woman, playing to the cultural stereotype that black men prefer fat women, she resorts to seducing a black man she would otherwise have no interest in. Alley's fatness muddies the black/white sexual binary and gives her a transracial status, sexually speaking. It is significant that her only sexual encounter of the whole series is with a black man—a racialized other. Alley purports to have a crush on singer-celebrity Kid Rock, whom she stalks throughout the series, and who appears in a later episode. She dates a rich older man, but never again do we see Alley actually engaged in sexual activity. In semiotic terms, her fat body belongs with a black body—they are both culturally marked as other.

Another episode, called "Charlie's Angels," is built around her meeting with a director who is interested in casting her as an Angel in his upcoming sequel. On the advice of her diet guru, Alley has taken laxatives as a means to lose weight. The joke is that she has eaten the whole box, once again voracious and out of control. By the time she gets to the meeting, the laxatives have kicked in, and the second part of the joke is her inability to control her bowels as she repeatedly excuses herself from the meeting and desperately tries to find a vacant toilet. However, Alley still gets the job, once she assures the director that she is not pregnant despite tabloid claims. The final sequence shows her on set in a flying harness, comically kicking and flailing about with a gun, while five strapping grips struggle to hold up her bulk in the harness. Eventually, they are unable to bear her weight any longer, and the scene is played to great comic effect as they drop her. Her costars in this fictional "Charlie's Angel" sequel are a dwarf and a Canadian. The joke, albeit lame, is clear: Alley is the Fat Lady in a freak show.

The comedy in all the episodes relies on viewing the fat body as other, similar to the way in which white audiences enjoyed minstrel performance. Alley puts on a kind of fat-face minstrelsy, engaging in fat-associative stereotypes, such as compulsive eating, poor judgment, questionable moral fiber (many episodes feature her blatantly lying or trying to steal or trick someone), and lack of control in all aspects of her life. In the same way blackface minstrel performers appropriated black culture and performed blackness, as Lott says, "mixing equal parts ridicule and curiosity," Alley performs fatness with an emphasis on the ridiculous. In trying to understand the pleasure of minstrel comedy, Lott asserts the necessity of "an implicitly triangulated, derisive structure of minstrel comedy, in which Blackface comic and white spectator shared jokes about an absent third party, usually resolved to a configuration of two people, the joker personifying the person being joked about." He goes on to offer a Freudian

**Figure 8.1**    Kirstie Alley at the *Fat Actress* premier

© J. Emilio Flores/Corbis.

construct of pleasure in comedy: "[I]n this way white ridicule could be passed off as 'naïve' black comedy, the sort of comedy, according to Freud, in which spectators indulge in lost moments of childish pleasure evoked by the antics of children or 'inferior people' who resemble them."[6] Lott points

out the inherent childish vulgarity of minstrel comedy, which depended on puns, nonsense songs, and absurd physical antics. Alley's fat-face performance relies on the same dynamic of vulgar comedy that emphasizes bodily and slapstick jokes. Spectators can laugh at the ridiculous antics of the fat lady because they see her as *other* than themselves and certainly inferior in every possible reading of the word.

By the time Alley began filming her series, she had indeed already accepted the offer to be Jenny Craig's spokesperson. The commercials were aired simultaneously with the series, featuring Alley as herself, assuring the viewer that she would lose weight with the help of Jenny Craig. A new commercial came out every few weeks, in which Alley danced around and showed off her figure and announced how much weight she had lost. So in a sense, just as the early blackface performer could wipe off his corking and become white again, these commercials assured us that Alley would be able to remove her fat-face and become "normal" again. Alley is not really a fat lady. She is performing herself as fat but she does not self-identify as fat (even though she is/was/is).[7] Her weight is just a costume to serve the comedy and will eventually be removed. She is not living a fat identity, but putting one on for the spectator's enjoyment.

There have been a number of movies that capitalize on the spectacle of the fat suit, such as Gwyneth Paltrow wearing fat drag in *Shallow Hal*, and Martin Lawrence as a fat lady in the very successful *Big Momma's House* franchise (which, of course, further complicates the scenario by adding race and gender to the drag). These actors literally wore fat suits. However, in my view, framed as it was within *Fat Actress* and the Jenny Craig commercials, Alley's real body functioned as a fat suit that she could, and eventually did, remove.[8] Lott points out the complicated spectator-performer relationship inherent in minstrelsy, whereby the actual black performer was initially not acceptable. He gives the example of P. T. Barnum finding an African-American boy who could dance better than the reigning blackface performer of the time, John Diamond. In order to enter the boy into a competition, Barnum corked up his already black face and put red lipstick and a wooly wig on him. The editor of *New York Aurora* recalled the incident, declaring: "Had it been suspected that the seeming counterfeit was the genuine article, the New York Vauxhall would have blazed with indignation."[9] In fact, William Henry Lane, or Juba, one of the first actual black men to enjoy success as a minstrel performer, was met with much resistance. He not only wore blackface over his own dark skin, but was advertised with promises such as: "The entertainment will conclude with the Imitation Dance, by Mast. Juba, in which he will give correct Imitation Dances of all the principal Ethiopian Dances in the United States. After which he will give an imitation of himself."[10] In other words, the

black man would perform a white man's idea of blackness for the audience's pleasure.

Alley's fat-face performance of herself as a struggling fat actress works in much the same way. The premise of the comedy hinges on the concept that she is not a "real" fat person and that neither she nor her audience identify themselves as fat. Even without the concurrent Jenny Craig commercials showing us her progress, the spectator knows Alley is a celebrity who has every possible means available to her to lose weight. Tabloids constantly feature movie actresses miraculously losing weight and quickly reshaping their bodies to appear highly toned after giving birth or after gaining weight for a role. If this same show had cast an unknown fat actress and there had been no promise of weight loss for the character by the show's conclusion, the proposed brand of humor in the script would not have worked. That *Fat Actress* ultimately was canceled reflects some of the inherent problems in the show's concept, not only lack of sophistication in the comedy but also confusion resulting from the reality aspect being complicated by scripted fictional narratives.

Fast-forward to the fall of 2010. Three programs featuring unknown or little known fat actresses in central roles appeared on network television: *Drop Dead Diva* debuted on Lifetime channel in 2009 and as of this writing is in its sixth season. On the other hand, *Huge*, which debuted on ABC in fall 2010, has come and gone, somehow failing to hit upon the winning formula. Most recently, *Mike & Molly* debuted on CBS. *Drop Dead Diva* and *Huge* are hour-long comedy-dramas more in the spirit of nighttime soap operas, in contrast to *Fat Actress* and *Mike & Molly*, both of which are half-hour situation comedies.

Significantly, *Drop Dead Diva* (DDD), a serial drama about a thin girl trapped in a fat girl's body is produced by Lifetime: a cable channel geared toward female viewers. The lead character is played by a fairly unknown actress, Brooke Elliott, and the program's narrative is structured around the fantastical body-switching concept whereby a shallow, skinny, beautiful girl dies and is reincarnated into the body of a smart, accomplished lawyer named Jane Bingum ("Plain Jane"—get it?). And while *DDD* does not indulge as overtly in fat-face minstrelsy as *Fat Actress* did, the fat stereotypes abound for the sake of both comedy and drama. Both personalities exist at once within Jane's body, where the conflict and humor revolve around the skinny girl getting used to being smart and the fat girl learning to have the confidence of a skinny girl.[11] The assumption is, of course, if the fat girl gains the self-esteem of a skinny girl, she will lose weight.

It is interesting that *Huge* was cancelled before *Drop Dead Diva*. Undoubtedly there are many reasons for this including the fact that *Huge* was on a bigger network (ABC) and *Drop Dead Diva* is on a cable network

(Lifetime), which suggests differences in viewer demographics as well as the field of cultural production. It might also be partially attributed to the fact that, more than its predecessors, *Huge* aimed to give its heroine, Will, a teenager forced to attend an affluent fat camp, some dignity. Arguably, *Huge* eschewed more fat jokes than it indulged. Throughout the season, Will (Nikki Blonski) struggled to maintain a level of self-respect despite all of the authority figures around her trying to convince her to submit to the hegemony of slenderness. Will rebels against enforced dieting, but ultimately the narrative of the program pathologizes her character as emotionally damaged—still another essentialist reading of fat. And while the show may have aimed to dramatize the lives of teens at camp in the style of a nighttime soap opera with fictional characters, the framework of *Huge*— a weight-loss camp—is still dangerously similar to the reality show formula of *The Biggest Loser,* in which a bunch of fatties compete under various humiliating circumstances to lose the most weight. In the world of *Huge*, stashing food and selling sweets to other campers is a bigger offence than running away from camp or sneaking off to make out. While *Huge* did not strictly adhere to the fat-face minstrelsy formula, some elements were certainly exploited.

Given its predecessors, when I heard about the latest program to feature fat actors coming to CBS in the fall of 2010—*Mike & Molly*—I was not nearly as optimistic about the show's potential to liberate fat from cultural stereotypes. In order to avoid the pitfalls of fat-face minstrelsy, *Mike & Molly* would have to be a romantic comedy about two people who just happen to be fat. Certainly there were new elements in the fat formula that offered possibilities. *Mike & Molly* was the first of these programs to more explicitly consider class in relation to fat—the characters are blue-collar. Mike is a cop, and Molly is a grammar school teacher, and both live in the suburbs of Chicago. Although the show does not directly address their socioeconomic demographic, the fatness of these blue-collar folks is a pointed contrast to similar romantic sitcoms such as *Everybody Loves Raymond*, where the characters are blue-collar, but the actors portraying them are Hollywood slim.[12] And, of course, another feature that sets *Mike & Molly* apart from its fat predecessors is that in addition to a fat white woman as the central character, the show features a fat (white) man. These new factors heralded promise for a fresh approach to fat in representation.

Yet, initially, *Mike & Molly* was more or less a progression in the evolution of fat-face minstrelsy. In fact, the inciting incident for the series, just as with *Fat Actress,* is that these characters are fat and want to lose weight. The comedic approach differs between the two shows, however, because of the "authentic" fatness of the performers. If, as Lott proposes, part of the pleasure of early minstrelsy "was that the blackface comic and the white

spectator shared jokes about an absent third party," then using the anal-
ogy of the real black body to the real fat body, the pleasure paradigm shifts
when we have "real" fat people on TV maintaining the status quo for tropes
about the "other" in a culture of conformity.[13] Mike and Molly identify as
fat, unlike Alley who rejects fat identity. With *Mike & Molly* the third party
is no longer absent but is now participating in the fat-face minstrelsy just
as early black performers did.

Also, in contrast to Alley's "character" in *Fat Actress*, who is in denial
about her fatness, Mike and Molly confront their "problem" in a proac-
tive way. They meet at an Overeaters Anonymous meeting. Nonetheless,
their weight is the fodder for most of the show's comedy. Mike is relent-
lessly mocked by his best friend and partner, Carl, who is not only slender
but black, in yet another example of the semiotic connection between fat
white bodies and black bodies in representation. Molly is teased by her
mother and sister with whom she lives. Her wine-swilling mom, played by
hyper-slender, surgery-enhanced Swoosie Kurtz, makes passive aggressive
remarks such as suggesting that Molly, who is lonely and wants to date, go
to a "Lesbo" club because "They like beefy gals," and later cheerfully telling
her, "not everyone can be a swan." Yet, like Kirstie Alley in *Fat Actress*, it is
the fat characters of *Mike & Molly* who disparage themselves most of all.
Both constantly make self-denigrating comments and thus adhere to cul-
tural expectations for fatness whereby the fat person who offends by their
very existence, should at least be filled with self-loathing and apologetic for
their size.

The actors who play Mike and Molly, Billy Gardell and Melissa McCarthy
respectively, were not well-known Hollywood stars when the show pre-
miered.[14] Both had performed some in standup comedy and McCarthy
had a supporting role on the popular TV show *Gilmore Girls*.[15] The pilot
of *Mike & Molly* capitalizes on the standup talents of the actors when each
of them "share" at the Overeaters Anonymous meeting. Mike announces
to the group, "I've had a good week. I lost about three pounds, and then I
took off my shirt and found it here," he says, pointing to the underside of
his bicep. He also tells the group that he experiences self-loathing. When
Molly shares with the group, she too sounds like a stand-up comedian
riffing on her size, beginning her remarks with a positive affirmation but
ultimately spinning them into self-deprecation.[16] She says, "I am smart,
funny, and there's nothing wrong with me as a person. I would like to be
able to walk into a nightclub without every queen in the room leaping on
me like I am a gay pride float." Here, as with the character Vicky in *My Fat
Friend*, we have a fat woman aligning herself with the gay community and
essentially self-identifying as a "fag hag." Molly concludes her speech by
stating that she just wants to "learn how to control her eating," which of

course panders directly to the cultural assumption that fat women cannot control themselves. It is noteworthy that, at least in the first four early episodes, Mike, who is significantly fatter than Molly, is characterized as the one who is able to follow his diet and "control himself." Furthermore, in keeping with the sitcom formula whereby it is acceptable—*believable*—that a fat man can find romance or be married to a slender woman but not the reverse, Molly may be visibly skinnier than Mike, but because she is not model-thin she is "equal" in size. Thus, in the world of the show these two fatties are perfectly matched for one another. Both of these distinctions highlight some of the differences in fat prejudices toward women versus toward men and suggest how it is still marginally more acceptable in our society to be a fat (white) man than a fat (white) woman.

Episode two of *Mike & Molly* is almost an encore performance of Kirstie Alley's fat-face minstrelsy in her episode "Charlie's Angels." This episode is structured around Mike and Molly preparing for their first date. Molly has a cold but does not want to cancel since it took Mike so long to ask her out in the first place. Because she is coughing and sneezing as she's getting dressed for her date, her mother hands her some cough syrup, which she guzzles almost entirely before her mother mentions that it has codeine in it. Like Alley overdosing on laxatives, here we have the fat girl accidentally over-medicating herself by greedily knocking back a whole bottle of medicine just because it is something orally consumable. Mike comes to the door for their date, and her mother goes down to greet him while her sister helps her find a more flattering outfit since the first one "made her look like Kathy Bates in *Misery*." Because Molly has overdosed on codeine, she passes out. In the meantime her mother is downstairs entertaining Mike, helpfully "complimenting" him by remarking that Molly "used to date queer cross-dressers" and hinting that he is a step up from them.

Eventually Molly's sister revives her from her codeine-induced slumber by giving her several diet pills; now Molly is high and wired and this sets the tone for their first date, in which she enacts every possible negative stereotype of the out-of-control fat woman. She is voracious not only for food but also sex. She not only guzzles all the wine at the table but also makes wildly inappropriate sexual remarks to Mike throughout their date. He notices her aggressive behavior and asks her if she is feeling okay; she answers, "Why don't you feel me and find out?" After the meal he asks if she enjoyed her snapper, and she replies, "Sure, do you like your penis?" She verbally assaults—or chews out—the waiter for offering them dessert and stereotyping them as eaters and then staggers to bathroom where she passes out. More comedy ensues as Mike is forced to breach the sanctity of the ladies room to rescue her, and we cut to the ride home with Molly apologizing profusely for her behavior. However, the pièce de resistance of

fat behavior has yet to come; Molly concludes the date by vomiting out of Mike's car door in the ultimate gesture of unrestrained fat behavior.[17]

In the next episode, "First Kiss," Molly expands on her fat behavior by emasculating Mike at bowling. Like her predecessor Martha in Albee's *Who's Afraid of Virginia Woolf?*, Molly is characterized as the fat-woman-as-man-eater. She is a threat to Mike's masculinity. Not only is she is a better bowler than he is, but she corrects his poetry reference and suggests an alternate route to drive. When Mike drops her off at the end of the date, his male ego is clearly insulted, and he very obviously rejects the opportunity to give her a goodnight kiss. She retaliates by shouting after him, "You bowl like a girl!" He retreats to his friend Carl's house to nurse his wounds and asks Carl's sassy grandmother (who lives with Carl) for advice. Mike tries to explain what went wrong with Molly by telling Carl's grandmother, "Well, my penis has been hiding for a couple of hours," making the castration metaphor quite explicit. Molly—the hungry fat woman—has consumed his manhood. He goes on to say, "She beat me at bowling . . . she covered my ass in Pledge and wiped the floor with me." Carl's grandmother, who is more or less characterized as the "nurturing mammy" that I discussed in chapter seven, spells it out with a trace of irony concluding, "You had a date with a smart, capable woman and it threatened your masculinity."

However, in a continuation of the gender reversal wherein Molly has robbed Mike of his masculinity, the episode concludes with Mike contritely apologizing to Molly for losing his temper because she was a better bowler. He takes her bowling again, and they kiss. This romantic gesture is starkly contrasted with Kirstie Alley's refusal to have "fat sex" or the sexual parodies depicted on *Fat Actress*. The visual image of two fat people kissing romantically and "realistically" on primetime TV is striking. Indeed, this gesture sparked a national controversy. *Marie Claire* magazine columnist Maura Kelly responded to seeing two fat people kissing on TV by publishing a blog entitled "Should Fatties Get a Room?" in which she declared, among other fat-phobic remarks, "So anyway, yes, I think I'd be grossed out if I had to watch two characters with rolls and rolls of fat kissing each other . . . because I'd be grossed out if I had to watch them doing anything. To be brutally honest, even in real life, I find it aesthetically displeasing to watch a very, very fat person simply walk across a room—just like I'd find it distressing if I saw a very drunk person stumbling across a bar or a heroin addict slumping in a chair."[18] Perhaps this is where *Mike & Molly* breaks some new ground. Yet, from a feminist perspective, it is worth noting (and apparent in the TV-framed shot) that the actor playing Mike is much bigger than the actress playing Molly, and this suggests that semiotically, next to a black man, the only appropriate sexual partner in pop-culture representations for a "fat" woman is a much fatter man.[19]

During her stint on *Gilmore Girls*, McCarthy was fat by Hollywood standards (she played a chef), however she was somewhat bigger by the time she appeared as the romantic lead in *Mike & Molly*. Because these performers were relatively unknown at the time of the program's debut, Mike and Molly were presented as the "genuine article." Unlike Kirstie Alley, these actors had very limited celebrity recognition and therefore might be understood by viewers as authentic fat people. Yet, they are playing characters, not themselves. If *Fat Actress* was the pinnacle of fat-face minstrelsy on television, in which the inauthentic fat lady was able to remove her fat-face, I see *Mike & Molly*'s casting of actual fat people as the next stage in the progression of fat-face minstrelsy, similar to the way in which blackface minstrelsy evolved in the United States.

Following the Civil War, some black performers formed minstrel troupes and attempted to capitalize on white audiences' fascination and interest in seeing "genuine negroes." William Henry Lane—Master Juba—had paved the way for actual blacks to perform in minstrel shows but maintained the tradition of blacking up his (already black) face. But post-Civil War black minstrel troupes performed *without* corking up their faces, in response to audience demand for authenticity.[20] Arguably, this was a small advancement for blacks in society. Although the roles were degrading (black performers were expected to speak in "negro dialects" and dance stereotypical routines associated with blackness), it also allowed some blacks to work onstage and achieve some measure of success in the blossoming industry of popular entertainment. They were obliged to perform in minstrel style in keeping with the stereotypes enacted by their blackface predecessors, but the fact that the performers were actually black added an appeal of authenticity. Similarly, McCarthy and Gardell are the *real thing*; they are actual fat people performing stereotypes established by fat-face minstrelsy. This contrasts with Alley's fat-face performance as herself because her long-standing media presence, coupled with her Jenny Craig commercials, attempted to reassure viewers that her fat was a temporary costume—effectively a fat suit. Because McCarthy and Gardell were little-known at the time, their fat is somehow *more* real; they are authentically fat.

Yet, like the first black minstrel performers, Gardell and McCarthy were obliged to perform the fat-face minstrelsy tropes for the sake of comedy. As Mike and Molly, they embraced their role as second-class citizens in popular representation in order to gain entrance to a nationally syndicated sitcom. In essence they performed their own fatness as authentically fat performers, in the same way that black performers eventually participated in the minstrel shows that were cultural appropriations of their talent and traditions. Like the first black minstrel entertainers, Gardell and McCarthy

were compelled to perform within the confines of the very performance tropes that stereotype and oppress them.

### Epilogue for *Mike & Molly*

As I mentioned, *Mike & Molly* is now entering its fourth season and has maintained a respectable place in the ratings. In 2011 Melissa McCarthy won an Emmy for her portrayal of Molly. Her celebrity status has grown significantly since the show's inception, which I will discuss further in my final chapter. In my view, with each passing season, the performance of fat-face minstrelsy in the show has decreased somewhat. The episodes are less peppered with fat jokes and less centered around Mike and Molly's attempts to lose weight. The narratives focus in typical sitcom style more on domestic scenarios of the working-class family as established by shows such as *Roseanne*, *The King of Queens*, and *Everybody Loves Raymond*. The jokes are still rather broad, but the couple's fatness is increasingly incidental to the central narrative. Indeed, since he has begun to lose weight, Gardell has stated in interviews that the "show is about two people falling in love, not about weight."[21]

## Part III

# Reclaiming Fat

# 9

# Dangerous Curves

The previous chapters explore the ways in which playwrights use fat dramaturgically, either as a plot point or, more subtly, when fat behavior enhances a character or drives the plot forward in some way. With plays such as *A Moon for the Misbegotten*, *Who's Afraid of Virginia Woolf?*, and *The Rose Tattoo* I have demonstrated instances in which the playwright did not always explicitly call for a fat actress in the character description, but the roles have traditionally been played by fat actresses who were somehow outside the normative standards of beauty because they embody the qualities the playwright is suggesting with the character. Talented actresses such as Colleen Dewhurst, Maureen Stapleton, Cherry Jones, and Kathleen Turner who, because of their "more-than-ness," fall outside the heteronormative paradigm or the normal/deviant binary that I have discussed, have sometimes benefited from this casting dynamic.

## Performing Bodies: Subverting Stereotypes vs. Retaining the Status Quo

This chapter explores performers who deliberately use their bodies to exploit cultural stereotypes about fat. Here, I am investigating the ways in which the performers themselves use their bodies to reinforce or reject stereotypes of fatness. In this section I will be focusing more on performances or critical reception of performances as the starting point, rather than texts. In some cases, such as with Margaret Cho's *The Sensuous Woman*, there is no text. Some of these performances assume an activist stance and attempt to subvert patriarchal power structures with their performing bodies, such as the solo performance of Claudia Shear in *Blown Sideways Through Life* (1995) or that of comedian and performer Cho in *The Sensuous Woman* (2007).[1] Cho and Shear endeavor to use embodied performances of their fat identity as political weapons, seeking to subvert

or upend fat stereotypes. Others capitalize on cultural assumptions about fat, such as Roseanne Barr's early stand-up performances and her successful series *Roseanne* (1988–1997). What connects all these fat performances, regardless of whether they are live or televised, fat-positive or fat-loathing, is that the women are all performing a version of themselves (as Kirstie Alley was in *Fat Actress*). None of these performers endeavor to embody a character outside her own persona. Instead, the actresses create characters based on themselves. Not surprisingly, the shows were all initially self-produced. For me, they represent a provocative cross-section of "fat performances" that are representative of an evolution of cultural perceptions and reactions to the fat woman in representation.[2]

Before discussing the performances, I must note that all of these performers willingly participate in a representational economy of visibility politics. Indeed, my premise here is to explore potential for empowerment through increased visibility of the fat female. This is counter to Peggy Phelan, who advocates in her foundational book *Unmarked* for removal of oneself from the politics of visibility as a position of power. She argues that to be seen is to "be seized," which is automatically to be part of the patriarchal economy of representation that turns difference into sameness.[3] She reminds us that, "[T]he process of self-identity is a leap into a narrative that employs seeing as a way of knowing." She also suggests that, "[R]eading the body as a sign of identity is the way men regulate the bodies of women," and therefore sees the removal of oneself from the "visibility trap" as having greater potential for empowering women.[4] She asserts that women cannot be impartially represented because the moment they are seen, they are subject to the "male gaze" and a whole patriarchal system of knowledge and assumptions. However, I am arguing that fat women, who are "invisible" in terms of the heteronormative sexual economy of representation, can find power in this "invisible-visibility." These performers are all deliberately using their bodies within the representational economy of visibility and seek empowerment through being seen—or at least by challenging the notion that the "relationship between cultural representation and identity is linear."[5]

## Claudia Shear's Dangerous Curves

In chapters six and seven, I demonstrated the complex web of interconnectivity among race identity, gender identity, and fat identity in representation. In her seminal text *Gender Trouble*, theorist Judith Butler reminds us that the production of identity is deeply connected to the "heterosexual matrix" and the "grid of cultural intelligibility through which bodies, genders, and desires are naturalized."[6] David Savran concludes in *Taking It*

*Like a Man* that "gendered identity, on account of its contingency, is of all identifications the one most subject to intensive social pressures, the most anxiety ridden, the most consistently imbricated in social, political, and economic negotiations, and thus the most sensitive to the barometer of culture."[7] I suggest that we could include body type as another identity paradigm analogous to Savran's and Butler's because it is also deeply subject to cultural pressure. In this first section, I explore the ways in which performer Claudia Shear's "invisible-conspicuous" body inverts the hegemonic power matrix, wherein thin is equated with power and status, by examining her performance in *Blown Sideways Through Life* (1995).

Indeed, the following quote from Shear's autobiographical play expresses many of the prejudices and stereotypes I have discussed in previous chapters. "Being Fat is the absolute nadir of the misfit. You're a misfit because nothing fits. You don't fit in. You're not fit. You're fat. Fat doesn't have the poetic cachet of alcohol, the whiff of danger in the drug of choice. You're just fat. Being fat is so un-American, so unattractive, unerotic, unfashionable, undisciplined, unthinkable, uncool. It makes you invisible. It makes you conspicuous."[8]

Shear's remark about fat being un-American also harks back to J. Eric Oliver's argument that I outlined in chapter one. His premise is that the "ideology that underscores [fat] prejudice is an ethos of individualism and self reliance."[9] He reminds us that fat people violate some of the fundamental tenets of American political and social culture, such as the belief that individuals are responsible for their own welfare and are obliged to work at improving themselves. Fat people violate American principles of laissez-faire capitalism, entrepreneurship, and the free-market, which champion the belief that anyone can achieve their goals if they work hard enough. He also notes that this cultural assumption is part of what colors contemporary attitudes toward the poor in America. The unspoken assumption is that fat people could lose weight and poor people could become middle class if they only helped themselves. Shear's autobiographical performance in *Blown Sideways Through Life* depicts her as in breach of both of these American values; not only is she fat, but she is poor. We will see that the specter of anti-Americanism haunts the performances of some of the other fat performers I will discuss later in this chapter.

When Claudia Shear wrote and performed *Blown Sideways Through Life* as a vehicle for herself, she claimed that one of her main objectives was to get an agent. In the words of *New York Times* critic Frank Rich, "Claudia Shear is a Brooklyn-born woman of uncertain age (the late 30s perhaps?) who personifies two middle-class nightmares. She is fat, and she cannot keep a job."[10] Rich's words would aptly describe any unfortunate, overweight, jobless American, but when these words are applied to an aspiring actress, the

situation goes from "middle-class nightmare" to disastrous. That Shear had to write, perform, and essentially produce her own material just to be seen onstage speaks to the dearth of opportunities for actresses whose bodies do not fit within the culturally acceptable range of slenderness. Fortunately for Shear, audience response was overwhelmingly positive, and the show was a success, making its way from the New York Theatre Workshop to a commercial run at the Cherry Lane Theatre, where it ran for 221 performances and garnered her an Obie.[11] The success of this show helped pave the way for more career opportunities for Shear; she went on to write and star in another vehicle, *Dirty Blonde*, which is about another iconic fat actress, Mae West. *Dirty Blonde* ran for 352 performances and was nominated for multiple awards including a Tony for best actress for Shear.

The text of *Blown Sideways Through Life* and Shear's performing body are commentaries on the cultural construction of the feminine body and its subsequent production of identity and power. They simultaneously deconstruct and uphold normative cultural reproductions of American women. Although *Blown Sideways* was well received, critics and reviewers often revealed a discomfort with the performance by encoding their reviews with language that suggested hostility or disdain. For example, Rich's review is entitled "Fat and 64 Jobs Later, Misfit Finally Finds a Niche on the Stage." Not only is Shear "fat" (as opposed to voluptuous or some less loaded adjective), but she is a "misfit" who finally finds a place in the world—onstage, which, of course, is not reality. In a sense, the implication is that she has no place in the real world. Granted, Rich (or the editor who created the headline) is playing off of Shear's own words of self-description. However, by choosing to headline the review with the words "fat" and "misfit," he (or she) is reinforcing exactly the kind of "weightism" that Shear is defying simply by performing as her "fat self." As with his review of *Ma Rainey's Black Bottom*, Rich consciously or unconsciously gravitates toward language that highlights cultural assumptions about fat and emphasizes the correlation between fat and misfit. His word choice reinforces the otherness of fat that I have discussed.

Rich was not the only reviewer who seemed troubled by Shear's size. When the play moved to Broadway in 1995, another reviewer described Shear as "hefty and lusty" and commented that "as a performer she is quite the egoist. Is she narrating or boasting, exposing her life or canonizing it? Settle down, you want to say. (At moments you want to scream it.)"[12] This suggests the reviewer's discomfort with a fat woman assuming a place of power center stage and demanding to be heard. The choice of the adjective *lusty* is particularly suspect, as the text contains virtually no references to her romantic life or sexual appetite. It is true that the descriptor *lusty* could be referencing Shear's energy and enthusiasm, but the reviewer's phrasing

could also allude to the stereotype of a fat woman's rapaciousness. Shear also called her own lighting and sound cues from the stage, another unsettling performance of empowerment. Could reviewers' aversion to Shear be directed not only toward her explicit performing body but to the underlying threat of a fat female body as empowered, figuratively breaking the mold of hegemonic dictates for a culturally assimilated woman?

According to a *Newsweek* interview, Shear was 5'3" and "200-plus pounds" when she conceived the show, but "she's much thinner now," interviewer Marc Peyser is quick to point out, as if to assure the reader/spectator that he or she will not be overwhelmed by Shear's monstrous presence.[13] The picture accompanying the article shows Shear reclining, looking zaftig but attractive in my view, and certainly not the grotesque form viewers would instinctively associate with a woman of more than two hundred pounds. Regardless of her actual weight, according to standards I have discussed, Shear's body is widely considered outside of normative boundaries. In her own words, she is "unattractive, unerotic, unfashionable, undisciplined."[14] I suggest that that the text of *Blown Sideways* illustrates this cultural truth of disempowerment through Shear's dramatization of her personal experiences of weightism and losing job after job. However, at the same time, her live performing body subverts this social code that oppresses fat women by taking center stage and telling her story. Shear uses the medium of theatre and solo performance to make her voice heard to an audience of people who might otherwise have overlooked or ignored her because of her appearance.

In her discussion of the formation of gender identities, Judith Butler touches on the political and cultural inscriptions on the human body. Butler draws on Mary Douglas's argument in *Purity and Danger* when she asserts that "[a]ny discourse that establishes the boundaries of the body serves the purpose of instating and naturalizing certain taboos regarding appropriate limits, postures, and modes of exchange that define what it is that constitutes bodies."[15] The pop-culture visual vocabulary relentlessly disseminated in all media forms is such a discourse. The boundaries of the appropriate American female body are limited to very particular criteria, as I discussed in my introduction. Butler goes on to point out that "what constitutes the limit of the body is never merely material, but that the surface, the skin, is systematically signified by taboos and anticipated transgressions . . . the boundaries of the body become the limits of the socially hegemonic."[16] If, as Butler suggests, gender is a cultural construct established by repetition and reproduction, so too is the ideal female form a result of perpetual visual bombardment of young, excessively slender, primarily white women. Shear crosses bodily boundaries with her nonnormative, unfamiliar body. She violates the limits of the "socially hegemonic"

by writing a text that gives voice to a person who falls outside cultural standards and by displaying her "transgressive" body in performance.

Shear describes her fat body both as "invisible" and "conspicuous." Because her size violates normative boundaries, she effectively performs power by taking up more space than is usually allotted for women. Her "invisible-conspicuous" fat body is, in fact, more visible surface although her fatness renders her invisible in the heteronormative sexual economy. Thus she is simultaneously invisible and conspicuous. Moreover, drawing from Susan Bordo's argument in *Unbearable Weight*, in which she discusses the conflation of female appetite for sex and food with destruction, a fat woman's body as a semaphore for unquenchable hunger is a threat to masculine hegemony; her curves signal danger!

In *Blown Sideways*, this performance of power is executed not only through the visual of Shear's subversive body as heroine of the narrative but through the text itself. Frank Rich's observation is significant: "She is fat, *and she cannot keep a job*."[17] For Rich, this is an obvious cause and effect scenario; fat people are incapable of keeping jobs. Naturally, a fat white woman who refuses to conform to society's body boundaries will be an insubordinate worker. Indeed, Shear's narrative of sixty-four jobs seems sufficient evidence for such a claim. By chronicling her experiences in the job market, Shear illustrates a prejudice against fat women, or perhaps more accurately a correlation between fat women and their perceived insubordination.

Shear's inability to hold a job is linked throughout the text to her bad attitude. I hypothesize that her "bad attitude" might, at least in some part, be a reflection of her employers' fat prejudices, and more specifically, their fears surrounding her powerful, consuming body. Shear begins her show by detailing some of the typical instructions she received from her employers:

And they tell me, "Chill on the conversation."

"Don't stand over there!"

"Be nice to the customers!"

"Put your book away! NO reading allowed!" . . .

"Watch your mouth!"

"No eating!" . . .

And then, later, I hear, "Uh, there's been complaints about your attitude."

"You were heard whistling in the elevator . . ."

"You talk too much . . ."

"Your laugh is too loud . . ."

"You have to do what we tell you to do. No arguments!"[18]

Note that several critiques from her employers are explicitly directed toward her mouth, her eating and reading habits, and her attitude, all of which might be construed as signifiers for her rabid consumption and innate social deviance as reflected by her size. In every case, the comments Shear receives from her employers suggest their discomfort with any behavior they associate with her personal initiative. Such benign gestures as whistling or laughing loudly, which could be seen as attributes of an upbeat individual welcome in the workplace, are vilified and held up as justification for firing her:

And finally:

"Listen, we're going to have to let you go . . ."

"Well, it's my way or the highway."

"You're fired!"

And every time I say, "All right, all right, all right."

But sometimes, sometimes I say, "FUCK YOU!"[19]

With this parting shot, Shear realizes all of her employers' fears and delivers exactly the kind of unruly behavior they have associated with her on sight. A fat woman is a threat to an ordered work environment.[20] Most likely Shear is exaggerating the number of jobs from which she was fired, and she may be underplaying her own culpability for the sake of her narrative, yet she certainly capitalizes on the cultural stereotype that associates fat women with unruly behavior. This stereotype of unruliness can be seen in performances of other fat actresses such as Roseanne, Rosie O'Donnell, Kathy Bates, or Camryn Manheim. Yet, the question remains as to how much of their behavior is actually boisterous. Is it possible that the same behavior from a slender woman would not be interpreted as disruptive? A space-taking or unruly body automatically threatens the harmony of American cultural power structures. Without ever speaking, a fat woman is actively subversive.

Shear's play and her performance of herself touch on significant issues in the formation of identity through heteronormative tropes. By exploring her own experience in the workplace, she illustrates prejudice and fear directed toward her consuming body, highlighting cultural assumptions about the subversive nature of fat women. She also performed her invisible-conspicuousness through the staging of the piece. Her neutral costume of black pants and a blue shirt at times threatened to camouflage her against the blackbox backdrop of black floor and blue wall. Frequently the lighting would pull in very close to illuminate only her face and her body would disappear into the shadow. However, Shear would then call another light

cue, which would illuminate her fully as she energetically danced around using the entire performance space. Indeed, the final moments of her performance were a wild, celebratory, Eastern-influenced dance.[21] Ultimately, Shear refused to be enslaved by cultural prejudices surrounding her fat figure, and in this way both her invisible-conspicuous performing body and her text were groundbreaking.

### Putting Her Body Where Her Mouth Is: Margaret Cho's Sensual Woman

Another performer who has used her embodied performance to subvert popular representations of idealized beauty is Margaret Cho. I begin my discussion of Cho's activist performance by positioning her work as a stand-up comedian and political activist, as well as by offering a selection of some of the criticism aimed at Cho by her detractors. Although she does not exclusively identify her material as feminist, at the heart of her comedy are many feminist concerns. Many of her routines question patriarchal, right-wing government and social policies that oppress women and minorities. Undeniably, she is a comic for social change, and she is particularly active in promoting lesbian, gay, bisexual, transsexual (LGBT) acceptance and equality. The quotes I have assembled below are taken from Cho's blog. She posted the emails she received after making some anti-Bush administration jokes during her comedy spot at the MoveOn.Org Awards in 2004. Not only does Cho's hate mail expose racism, bigotry, and weightism, it also demonstrates the cultural belief that being fat is not only anti-American but an outward semaphore for liberal ideology in the minds of certain right-wing factions. Nearly every email (and I have culled out a small fraction of the material) attacks Cho for being ugly, fat, or a pig (in addition to all the other vitriol). I hesitate to add that by 2004, Cho, who has openly struggled with her weight, had rebounded from an eating disorder activated by her producer's requests during her TV series, and was at the lower end of her weight spectrum when she made this appearance.[22] Significantly, many of the emails also abuse her for being a dyke, reinforcing the queer-fat connection that I discuss in chapter seven. Somehow, in the minds of her detractors, Cho's race, her "fatness," and her queerness are inextricably connected and are part and parcel of her liberal politics.[23]

For me, these disgusting emails are an apt starting point to frame Cho's mission in creating *The Sensuous Woman*. Because her detractors targeted her fatness—linking her political views to her actual body—it seems appropriate that Cho eventually created a piece in which her unruly body spoke louder than her comedic rhetoric.

Here is a suggestion for your "show," wear a tent shaped piece of Plexiglas on your head and bill yourself as the "BIG FAT ASSED HUMAN CHINESE BUFFET."

Shut up, lose weight and take a bath.

I find you to be a disgusting, misguided PIG!

GOOK CUNT, You fat ass slant eyed WHORE. YOU SUCK LIBERAL COCK

right wingers unite to fight liberal fat bitches like you!!!!

This may shock you, but you are a NOBODY. You're an obese, Oriental . . . lesbian—THAT is your claim to fame.

Fat Cunt Chinese women. Bush is the best!

Way to go you fat slope whore. Go back to Korea you obese pig.

slut and a lard ass. Please take Rosie O'donnel back home with u, I'm sure yall will have a lot of fun together eating sushi and having dildo fights.

insecure, arrogant, butt-ugly, obnoxious, potty-mouthed, uneducated, fat liberal who makes fun of God and christians all the time.

Harro ms cho: we grive u new klorian name, u = wan fat ho u arsso Femernazi

Put the cheeseburger down, pull Clinton's dick out of your mouth, and wise up. Because the people who adore you have AIDS for a REASON.[24]

Notice also some of the other fat associations in these slurs, such as lack of cleanliness ("take a bath") and linking her fatness and subversive behavior to the AIDS epidemic, just as journalist Greg Critser did in his op-ed article about the obesity epidemic, quoted in chapter one.

Cho's past performances have frequently focused on her own struggles with her weight, and a central component of her routines was comically indicting the diet and beauty industry and openly discussing the horrors of her own experience as a Korean-American entertainer trying to fulfill unrealistic standards of American slenderness and beauty. In *The Sensuous Woman*, Cho embodied her political comedy in a new way by stepping out of her traditional mode of stand-up and using live theatre and a burlesque format to interrogate assumptions about female beauty as well as gender and sexuality. In a series of burlesque numbers with song, dance, comedy monologue, and striptease, Cho and her company played with stereotypes and defied media-generated images of beauty and sexuality. Cho declared that "feeling beautiful is a political act," and among other skits, used her own "imperfect" body in erotic dance. Her company of performers featured a diversity of body types performing in comic and erotic skits. Like Shear, Cho used her unruly body to upend patriarchal power structures.

When I saw the show in October 2007 at the Zipper Factory in New York City, the piece began with ten minutes of Cho's topical scathing stand-up. The monologue centered on Britney Spears's recent lackluster performance at the MTV Video Music Awards and the subsequent media frenzy to denounce Spears and particularly to critique her body. This provided perfect fodder for Cho's theme. She ranted "leave Britney ALONE!"[25] Cho went on to attack the media, who delighted in calling Britney fat, pointing out the insanity of beauty standards for slenderness as depicted in the mass media.

The show unfolded in traditional burlesque style and was composed of dance routines juxtaposed with comedy sketches and song, with Cho providing the patter between some numbers and performing as a dancer in several segments. As Cho told the audience in the opening monologue, her mission with *The Sensuous Woman* was to celebrate the beauty and sexuality in all types of bodies and all sexual proclivities. Cho, who as I mentioned has very publicly struggled with her weight throughout her career, eventually abandoned dieting forever and has made it her battle cry to accept her own figure just as it is and to encourage her audiences to do the same. Her decision to accept her own body and promote diversity (including fat bodies) is truly an act of political defiance in the context of the ways in which her detractors align her fatness with civil disobedience and anti-Americanism. In my view, *The Sensuous Woman* fell short of its huge ambitions by mixing issues of body diversity for women in American culture with questions of sexual diversity. However, the show did relentlessly destabilize heteronormative assumptions about body size and sexuality.

Cho's performing body is the centerpiece of *The Sensuous Woman*, but the varied body types and performance styles represented in the piece reject American beauty standards as they are disseminated in contemporary popular culture. As Shear initially did with *Blown Sideways*, Cho, who is the central performer, self-produced *The Sensuous Woman* and gathered a supporting cast of nonnormative body types and gender representations to participate in a show that aimed to break down the normal/deviant binary of beauty and sexuality. For example, the first performer following Cho's standup was Selene Luna, a 3'10" little person who started her number in a baby carriage. She then performed a traditional burlesque routine, stripping down to panties and pasties. Luna's small adult body performing all of the traditional classic burlesque moves had a destabilizing effect. Luna did not mock or comment on her nonheteronormative appearance but performed her sensual dance in all erotic seriousness.

Cho herself performed several traditional burlesque numbers, including "Chairman Mee-Oow," in which she entered dressed in a Red Army uniform and danced to stereotypically Asian music complete with gongs.

She eventually stripped down to pasties and twirled not only her tassels but streamers, and eventually the Communist flag, while displaying her body. Here, Cho's nearly nude body, which is covered in tattoos, defied the standard of the white, toned, silicone-breasted, slim-hipped exotic dancer in commercialized pornography and strip clubs. While Cho does not have rolls of fat and might not be considered fat by some standards, there is not a significant difference between the size of her waist and her hips. She has a long, straight trunk, smallish breasts, and a rather flat behind. Her atypical figure is further highlighted by the tattoos covering most of her back and a significant part of her arms and legs. Her unruly body and her joy in dancing naked made a political statement—her answer to the cruel vitriol spewed at her during the course of her career.

Certainly Cho's tattooed figure embodied rebellion against contemporary homogenized standards of the white, slender, disciplined, erotic woman. However, *The Sensuous Woman*'s mission to celebrate female bodies in all shapes was perhaps even more effectively captured by a burlesque number performed by Dirty Martini. Dirty Martini is an accomplished fat burlesque dancer who has an established following in the burlesque circuit. In Cho's show, clad in red, white, and blue stars and spangles, she performed a traditional burlesque strip down to pasties and a G-string to the tune of Dolly Parton singing "Proud to Be an American." As part of the dance sequence, she first pulled a lengthy string of dollar bills from her mouth and then another chain from between the folds of her ample butt cheeks, all the while gyrating her hips seductively. It was a uniquely effective metaphor commenting on American consumerism, highlighted by her large size. She performed her routine with a wink and a nod to the audience as far as the song and the political jibe, but not in apology for her fat figure. She concluded her number with the ubiquitous tassel twirl, spinning her large, somewhat pendulous breasts while waving sparklers. The audacity of a fat woman dancing erotically without apology is in itself a political statement in our culture. But add to it Dolly's patriotic anthem, which saw many remakes following 9/11 and was used, not ironically, in commercials selling American-made pickup trucks, and Dirty Martini's performance flew in the face of a multitude of American values. Interestingly, her politically challenging fat performance also evoked the anti-Americanism that is frequently associated with fat. When I saw the show, two men next to me got up and left following her performance.[26]

Feminist scholar Jill Dolan explores the possibilities for female performers to use their nude bodies within the mission of feminism. She points out that the relationship between female erotic performer and male spectator-as-masochist, who pays to be teased by the performer he cannot have, relies on a power structure based on economics: "Spectators pay to see the image

of the stripper as commodity; they buy control over the gaze. Whether they position themselves as sadists or masochists, their power lies in controlling the illusion that the stripper is performing for them."[27] Dolan notes that in some cases, feminist performers such as Karen Finley have used their naked bodies to "disarm desire." By presenting her body as foul and defamed, covering it with various substances, Finley interrupts male consumption of her nude body. In other words, Finley may be naked, but she does not "give them their money's worth." Dirty Martini's erotic dance fails to honor the exchange Dolan describes above in a different sort of way. Dirty Martini presents herself for consumption, but, because her figure is so unexpected in an erotic context, she violates the performer-spectator contract. Perhaps this is why the men left following her performance. Dolan also notes that female artists who have presented their nude bodies in the vein of cultural feminist performance, such as Carolee Schneeman of "interior scroll" fame or Hannah Wilke, had bodies that were considered beautiful by cultural standards, which in some ways legitimized their nudity. Although Dolan categorizes Finley's work as more in the vein of material feminism, I would include Finley in that circle of "legitimized nudity" because although she smeared herself with food such as yams, honey, or chocolate representing feces in various performances, she had a great body by contemporary cultural standards of beauty.[28] Finley may present herself as already consumed, but by virtue of her slim, firm, well-proportioned figure she is still participating to some degree in the patriarchal economy of visibility rather than disrupting it.[29] However, Dirty Martini's fat body does disrupt this economy, although her goal and that of *The Sensuous Woman* are quite the opposite. In fact, both Cho and Dirty Martini reverse Finley's paradigm by attempting to incite desire from their spectators rather than thwart it with bodies that defy cultural expectations for beauty. Nonetheless, by failing to adhere to the standard, their bodies subvert the male gaze even as they dance to invite it.

Another performer Cho included, who, in my view, gave one of the more provocative feminist performances in *The Sensuous Woman*, was Ryan Heffington: a man. For me, his performing body highlighted the cultural truth that the beauty ideal of the (sexualized) female figure as proliferated by the media is more readily achieved and performed by a biologically male person than by a woman. His routine was a kind of stripper-drag that supports Samantha Murray's assertion in chapter six that the only "normal" or healthy body is that of a straight, white heterosexual male. Sporting long hair, stiletto boots, and an eighties style one-piece leopard unitard, Heffington emerged from the back of the house to the driving musical strains of the eighties pop favorite "Dirty Diana." The follow spot took a moment to find him, and when it did, as I watched him gyrate like a pole

dancer at a strip club, I believed I was looking at a woman. As he danced closer, I realized that he was a man—no effort to conceal the bulge under the leotard—and he had a mustache and goatee, as well as visible body hair. Nonetheless, as the performance continued and he performed classic female stripper moves, which are notoriously athletic and powerful, I had to remind myself repeatedly that I was watching a man.[30]

My confusion underscores how the so-called erotica of contemporary striptease is in some ways better fulfilled with a man's body than a woman's. It also points to the homoerotic aesthetic inherent in contemporary representations of the ideally sexualized woman. Heffington's slender, muscular figure is exactly the kind of shape (minus large fake breasts) that we expect to see grinding against the poles, performing leaps, jumps, push-ups, rolls, and kicks.[31] When he gave us the classic "behind shot," his lean, toned male buttocks accurately replicated contemporary striptease scenarios as performed by dancers at high-end clubs geared toward white, middle-class, male-dominated but not exclusively male audiences, or as reproduced in various popular cultural texts, such as the film *Striptease* (1996), which featured the impossibly toned (and airbrushed) Demi Moore, or in any of the numerous dancers featured weekly in the strip-club backgrounds of TV series such as *The Sopranos*, *The Wire*, or even *How I Met Your Mother*.[32] Heffington's lean, muscular body—genetically male—has all the attributes that women (who are biologically programmed to have more body fat) strive for in order to emulate popular sex symbols. Of all the performers in *The Sensuous Woman*, Heffington, a man, had the most culturally acceptable body as a model of female sexuality. For me, this was a powerful commentary on how extreme the standards of heteronormative beauty have become in the twenty-first century. Heffington's performance also corroborates Judith Butler's notion that gender is performative and culturally constructed. Although he exposed enough of his male attributes for us to understand that, biologically, he was a man, his parody was entirely gendered as female.

Cho's final number also riffed on this theme. This time she performed a flirtatious fan dance to the strains of Wagner's *Liebestod* from *Tristan und Isolde*. She coyly concealed her body, even as she gracefully swept around the stage, hinting that she was completely naked behind the fans. When the final strains of the music boomed out, she reached the climax of her routine and dropped the fans to proudly reveal her naked body. However, what was concealed beneath the fans was a surprise. Her own female genitals were concealed by a prosthetic flaccid penis. This choice can be read in a number of ways. Is it a parody of erotic performance suggesting that what men really desire are women with penises? Does it hint that on some level Cho has internalized misogyny so deeply that a woman's genitals can

be improved by a penis? Perhaps this was a nod or a challenge to her large fan constituency of gay men. This penis functioned as Cho's "fig leaf," concealing her own sexual organs. However, I am inclined to see it as Cho's attempt to further destabilize our notions of beauty and sexual identity. With this comical gesture, she rallies for social change, suggesting a new frontier in which there is a blending of genders and the male/female binary is destroyed.

In *The Sensuous Woman*, Cho and her cohorts embodied political protest rather than spoke it. She challenged cultural assumptions about sexuality, beauty, gender, and power simply by joyfully dancing nude, leaving her racist, weightist, right-wing critics with no forum or mode of communication to silence her.

As I mentioned, many of these so-called fat performers have only been able to achieve success performing roles based on comic personae of themselves. However, as of this writing, Margaret Cho is making another foray into the world of playing a fictional character. She is appearing as Teri Lee, the loyal secretary to the fat heroine on the Lifetime television series *Drop Dead Diva,* which I discussed in chapter eight[33] It is possible that the "fat friendly" material of the show, and the fact that Cho is playing a minor role, may afford her more success with a character outside of herself. However, historically it seems that female performers with unruly bodies have better success playing characters based on themselves, such as Roseanne Barr/Arnold, whom I will discuss next.

### Rowdy, Rude Roseanne: Pioneering Unruly Behavior

Chronologically, the success of stand-up comedian-turned-sitcom-star-turned-talk-show-host Roseanne Barr largely preceded the aforementioned performers. However, I see Roseanne as an intermediary figure in the evolution of fat performativity from fat-face minstrelsy to more nuanced fat subjectivities. Her career trajectory and her embodied performance of herself fall somewhere between the autobiographical performances of Shear's one-woman show, Cho's stand-up shtick, Kirstie Alley's faux "reality" series based on herself and Lena Dunham's self-authored performance of the fictional character Hannah Horvath in the HBO sitcom *Girls* (premiered 2012).[34] Roseanne got her start in the early eighties as a stand-up comedian who rejected the label "housewife" or "homemaker" for her preferred moniker: "domestic goddess." She strategically positioned herself within her comedy as an overweight, blue-collar housewife. Her comedy was aimed at a working-class female audience, and she shrewdly embraced her fatness as part of her identity, knowing that many working-class women in America looked like she did and could relate to her circumstances.

She joked that she sold "Stubby Kaye Cosmetics" (as opposed to Mary Kay), and that a fat mom was a better mom than a skinny mom because a depressed fat mom (and she does suggest that her fatness is a reflection of her stay-at-home depression) will share pudding, Oreos, and marshmallows with her kids and let them enjoy a "sugar high" and subsequent sugar crash, while a skinny mom will insist her kids go outside and run off their youthful energy.[35]

Roseanne knew her audience and marketed herself as lower class. J. Eric Oliver reminds us of the very real inverse statistical relationship between economic wealth and higher education and fat in America: "[F]at prejudice is so intertwined with class and racial prejudice because America's poor and minorities are much fatter on average than its middle-class whites . . . Body sizes also vary consistently by education and income—27 percent of high school dropouts are obese compared to only 16 percent of college graduates; people below the poverty line are 15 percent more likely to be obese than those not in poverty."[36]

Roseanne's autobiographical stand-up reproduced this cultural truth. She self-identified as a fat, poor, working-class mom doing the best she could and ironically proclaimed herself a domestic goddess. She exploited cultural assumptions of fatness and class and gained popularity with audiences that saw themselves reflected in her persona.

This recognition led to the production of her TV sitcom, Roseanne, in which she portrayed herself—or the TV persona she had created for herself—as part of a fictional working-class family. The show enjoyed a successful long run from 1988 to 1997 and garnered multiple awards, including three Golden Globes and at least one Emmy for Roseanne and her cast mates John Goodman (who played her fat husband) and Laurie Metcalf (who played Roseanne's sister).[37] Roseanne, who produced more than two-thirds of the episodes, successfully capitalized on her fatness by creating a character based on herself that appealed to a blue-collar aesthetic and that she could believably portray despite her size. I position her sometimes-contradictory performance of self somewhere between Margaret Cho's overtly activist stance and Kirstie Alley's self-flagellating, degrading comedy. On one hand, like Shear and Cho, Roseanne in many ways used her unruly fat body to challenge social boundaries of female, fat, and class oppression. Many consider her series groundbreaking. Roseanne was one of the first sitcoms to feature a mom as the central, driving character, and one of the very few to feature a white working-class family. On the other hand, like Mae West, Roseanne shrewdly created her opportunity by embracing many of the stereotypes associated with fatness and exhibiting fat behavior veering toward Alley's style of fat-face minstrelsy. However, scholar Kathleen Rowe makes an argument that Roseanne's cultivated

persona of fat slovenliness is an expression of feminist activism. She cites Bourdieu's *Distinction* to support her assertion. She writes,

> By being fat, loud, and ever willing to "do offensive things," the star persona "Roseanne Arnold" displays, above all, a supreme ease with her body—an ease which triggers much of the unease surrounding her because it diminishes the power of others to control her. Pierre Bourdieu describes such a manner as an "indifference to the objectifying gaze which neutralizes its powers . . . [and] appropriates its appropriation." It marks her rebellion against not only codes of gender but those of class, for a culture's norm of beauty or the "legitimate" body—fit and trim—are accepted across boundaries while the ability to achieve them is not . . . Instead she reveals the social causes of female fatness, irritability, and messiness in the strains of working class family life. For "Roseanne Conner," junk food late at night may be a sensible choice for comfort after a day of punching out forks on an assembly line.[38]

Prior to 1990, Roseanne's apparent indifference to the male gaze could be construed as feminist. Roseanne was the opposite of Foucault's docile body. She rejected cultural constraints of appropriate feminine behavior and beauty and, like Shear, refused to apologize or disappear. In fact, Roseanne embodied one of the most iconic fat performances to date, as I will discuss in the next section.

## The Fat Lady Sings: Roseanne's Ultimate Fat Performance

Roseanne was gaining popularity and artistic credibility, and her TV series was doing well when she accepted the invitation to sing the national anthem for the opening of a Padres baseball game in July of 1990 in honor of "Working Women's Night." She grossly misunderstood her audience and exhibited the ultimate fat behavior when she stood before a crowded baseball arena and sang the "Star Spangled Banner" badly.[39] She created a national scandal, invoking the public ire of, among others, President George Bush, who called her performance "disgraceful," when she screeched the anthem off-key and parodied the masculine world of baseball by grabbing her crotch and spitting as part of her performance. Critics, George Will in particular, compared her performance to national catastrophes ranging from the decay of American cities to the Japanese sneak attack on Pearl Harbor.[40] I assert that part of what sparked such passionate public outcry over her ill-received parody was the implied anti-Americanism of her fat body. Not only was her poor rendition of the song offensive, but more significantly, her body was offensive. Roseanne audaciously stood there in her unruly fat body and violated a myriad of cultural boundaries even before she opened

her mouth. Kathleen Rowe suggests: "Not only did she violate the space of baseball, but she encroached on another masculine territory—that of joke maker. Arnold "made" a joke, and a tendentious one, containing a thinly veiled message of aggression. Refusing to play the passive victim herself, she forced men into that role."[41]

In this way, I believe Roseanne deeply disturbed hegemonic ideals of national pride and identity. Had Reba McEntire, who eventually also had a sitcom based on herself as a blue-collar mom and was more slender and attractive by ideal standards, made the exact same joke, singing off-key and grabbing her crotch, would it have generated the national furor that Roseanne did?[42] It is probably true that any comedian poking fun at the sacred cows of baseball and patriotism would be vilified, but I believe the vehemence of the national response toward Roseanne was exacerbated by her fatness. Because she did not apologize for her size, Roseanne's performance of the national anthem, as well as her performance of herself in her TV series up to that point, could arguably be construed as feminist. Thus, she stands apart from Kirstie Alley's performance of self, in which Alley panders to fat stereotypes by assuring the viewer that she is ashamed of her fatness and is trying comically, desperately to lose weight and rejoin the ranks of patriotic Americans. In Bourdieu's terms, Alley is decidedly not "indifferent to the objectifying gaze."

Significantly, however, it was not long after the national anthem incident that Roseanne began to alter her appearance. She recovered from the public relations snafu caused by her performance, continuing to gain Hollywood clout and economic power. She did so, in part, by finally capitulating to hegemonic beauty standards following her anthem misstep. After years of maintaining her defiantly fat figure, Roseanne began to lose weight and have plastic surgery to bring her appearance more in line with popular representations of (attractive) women in television. She had her stomach stapled, lost more than sixty pounds, and eventually had liposuction, a breast reduction, and a nose job. For this, some of her critics have dubbed her "Roseanne Benedict Arnold."[43] Could this, on some level, have been a response to the landslide of negativity she endured following the anthem incident? She crossed a line with that "joke," offending a nation, and it seems possible that she began to make reparations by containing her unruly body. Rowe notes that barely a year after the anthem incident, and coinciding with the beginnings of her physical transformation, Roseanne publicly came out as a survivor of incest and child abuse, thus mitigating her defiant behavior by attributing it to a childhood trauma and fulfilling cultural beliefs that fatness arises from some hidden emotional or mental deficiency. In doing so, Roseanne offered a culturally acceptable explanation for her previously truculent conduct.[44]

Thus Roseanne did successfully mollify her public detractors by embracing the stereotype of fatness as a symptom of mental pathology. Her show ran another five years and integrated the evolution of Roseanne's changing physical and public persona. The show steered away from Roseanne's domestic tribulations as a fat, blue-collar housewife and tackled more controversial and socially aware subject matter, including teen pregnancy, homosexuality, spousal and child abuse, as well as Roseanne's character's decision to undergo a breast reduction to relieve back pain.

After her series ended, Roseanne largely dropped out of the spotlight. She had a brief run as a talk-show host and returned to her roots as a stand-up comedian in an HBO special, *Blonde and Bitchin'* (2006), in which her political commentary aligned with Margaret Cho's. She actively indicted George W. Bush for his policies and championed gay marriage. She took aim at the diet industry pointing out that she has basically had her stomach removed and still maintains her weight at 180 pounds. She concluded the show by realizing her two worst fears: dancing in her underwear and (significantly) singing in public. Although some have criticized her as a traitor for all the surgical intervention she underwent to change her appearance, this recent stand-up performance seems to indicate that her core ideology does indeed lean toward a pro-female and fat-activist stance. I am inclined to view Roseanne's early fat performances as politically-charged and pro-fat versus Alley's, which capitulated to stereotypes in an effort to gain public appeal and capitalize on cultural prejudices.

## Reading Fat

With the aforementioned examples, I have shown how some fat performers deliberately use cultural interpretations of their bodies to enhance their storytelling or take a feminist-activist stance against the rigid confines of beauty as represented by mainstream media. However, critics often make unwarranted assumptions about the nature of a character based on the appearance of the actress. Thus, a performer's body type colors critical reception, which in turn can alter the playwright's intention for the character. Bodies that are fat or "more-than" add a layer to critical interpretation of a character; they are cultural signifiers to which spectators attach beliefs and assumptions that cannot be separated from the performance itself.

In her watershed study of gender bias in *The Feminist Spectator as Critic*, Jill Dolan points out how reviewers responded to *'night, Mother* in light of Kathy Bates's fat appearance. She notes that the responses of male critics to Bates's character, Jessie, were based on her physical appearance, which altered their reception to the play. The critics collapsed Bates's fatness into their reading of her character and justified that her weight motivated her

wish to commit suicide. As Dolan writes: "Although the fatal, tragic flaw in Norman's text is epilepsy, the production's received flaw, which provides the cause of Jessie's ultimate demise, is fat . . . John Simon, in *New York Magazine*, was most blatant in his word choice. He called Jessie 'fat, unattractive, and epileptic.'" Other reviewers followed in kind: "These critics correlated what they saw onstage to the play's motivating action so emphatically that Jessie's appearance became more significant than Norman's actual dramatic device."[45] This quotation perfectly exemplifies how the fat female body becomes the lens through which critics read the character. It is no wonder that casting directors hesitate to cast actresses whose bodies do not fit within culturally ascribed boundaries of slenderness. In the latter half of the twentieth and early twenty-first century, the only neutral female body is unobtrusively thin.

There are many examples of a review being colored by a performer's body size such as Richard Eder's review of Shelley Winters's 1978 performance in *The Effect of Gamma Rays on Man-in-the-Moon Marigolds*. In this case, he reviews her performance somewhat negatively in light of her fat body, suggesting that Winters failed in the role due to her lack of subtlety, which, his word choice indicates, is wrapped up in her fat appearance. Eder ascribes fat behavior to Winters's interpretation, which he sees as wrong for the role. He describes her performance as "oversized," calling her entrance "blowsy" and "massive." Later he describes her as "an eggplant rolling downstairs" and "a frump of a clown on one loud unchanging level . . . exploiting the play, not interpreting it."[46] All of his critiques allude to the visual, and he seems to collapse her interpretation into her stout appearance. It is impossible to assess whether Winters's performance was as weak as Eder indicates. However, the fact that much of his critique conjures the same fat prejudices I have been discussing throughout makes his criticism suspect. Likewise, Charles Isherwood's unfavorable review of Kristen Johnston's reprisal of the role of Anna, in Vogel's *Baltimore Waltz*, also seems to collapse her large size into the shortcomings of her interpretation. Isherwood writes that the six-foot actress is "miscast" and deems her stage presence "larger than life" and overly comic. Again, his language seems to dwell as much on her size as on her acting. He concludes that "Ms. Johnston may simply be too healthy a theatrical presence to communicate persuasively the true depth of Anna's fear and confusion."[47] Based on this review, it could be that Johnson's acting fell short, but it could also be that Isherwood cannot conceive of a six-foot-tall, broad-shouldered woman as vulnerable. When I saw this performance at The Signature Theatre in 2008, I found her interpretation to be compellingly sensitive and nuanced.

On the other hand, sometimes an oversize actress adds to critical reception. For example, almost no review of O'Neill's *A Moon for the Misbegotten*

or Albee's *Virginia Woolf* fails to mention the physical size of the actress playing Martha and Josie respectively, and in that case, reviewers seem to believe that an oversize body enhances the performance. Recall from chapter four that *New York Times* reviewer Ben Brantley praised Kathleen Turner's portrayal of Martha, dubbing her the "big-breasted brawler" and referring to her as "the body," while referring to Bill Irwin, who played George, as "the brain."[48] Other examples of actresses whose fat bodies enriched critical reception of their performance include Jayne Houdyshell, who was nominated for a Tony for her performance in Lisa Kron's *Well* (2006), and Anna Manahan, who won the Tony for her performance in Martin McDonough's *The Beauty Queen of Leenane* (1998). In both cases, these rotund actresses enjoyed critical success for their performances as "smothering mothers." Reviewers gushed over Manahan's performance of a cruel, controlling mother. Ben Brantley called Manahan "a large woman [who] seems to fill and anchor the room . . . a mother who appears as immoveable as a mountain."[49] Although neither of these texts explicitly calls for fat actresses, the bodies of these particular performers enhanced critical reception of their overbearing characters.

As Elizabeth Grosz points out in *Space, Time, and Perversion,* the body is a surface of inscription. She writes: "Western body forms are considered expressions of an interior, of a subjectivity . . . The body becomes a text, a system of signs to be deciphered, read, and read into. Bodies speak, without necessarily talking, because they become coded with and as signs . . . They become intextuated, narrativized; simultaneously, social codes, laws, norms, and ideals become incarnated."[50]

Thus, a fat or oversize body onstage is automatically inscribed with all the cultural assumptions I have described in earlier chapters. Even more insidious, because of the proliferation in twenty-first-century mass media of women's bodies as extremely slender, muscular, and toned, whether by nature, cosmetic surgery, or airbrushing, Americans have become accustomed to recognizing only those bodies as "normal" or neutral. Any body outside of those standards is "read" through the lens of culturally produced meanings.

## Conclusion

In this chapter, I have focused on a select few diverse "fat performances." Some performers, such as Claudia Shear, Margaret Cho, and even Roseanne have taken a pro-fat, feminist-activist stance and aimed to subvert or challenge stereotypes. These women deliberately used their performing bodies as sites of protest. With their performances, these actresses reject cultural assumptions of heteronormative beauty and use their unruly

bodies to destabilize hegemonic power structures. Knowing that their bodies would be read as cultural texts before they even spoke, these performers have tried to make the most out of their oversize bodies, either by challenging or maintaining the cultural status quo.

However, actresses like Kathy Bates, Shelley Winters, Kristen Johnston, and Kathleen Turner have had their oversize bodies read despite their performances. Contemporary critics are unable to separate the female performer's body from her interpretation of a character or role. Any female body that does not fall within the very slender, homogenized beauty standards as proliferated by various cultural texts in the late twentieth and early twenty-first centuries cannot escape being read with an additional narrative that American audiences impose on them. Thus, their bodies are branded against their will and relegated by critics to "fat performances," regardless of the actresses' actual characterization of their parts.

# 10

# Enter Fat Actress

When I first conceived of this project in 2005, there were virtually no fat actresses to be found on stage or screen unless they were the target of jokes or crudely pathologized in some way. Kirstie Alley presented a glimmer of hope, but as I have discussed, instead performed a fat-face minstrelsy that further solidified stereotypes and pandered to weightist humor, capitalizing on fat-shaming. With a few exceptions in recent years such as *Drop Dead Diva* (2009) and *Mike & Molly* (2010), between 2005 and the present, representations of fat have been primarily depicted on reality-based and/or competition-based television programs such as *The Biggest Loser* and *Extreme Weight Loss*. These programs capitalize on fat-shaming and depict "real" people subjecting themselves to grueling regimens and public humiliation, not only in the form of the verbal abuse heaped on them from trainers and co-contestants, but in the exercise and eating scenarios they are compelled to engage in throughout the course of the show. Camera work frequently emphasizes the materiality of their fat bodies, trying to elicit disgust in the viewers by zooming in for close-ups on participants' rolls of fat or sweat dripping from their faces/bodies. Indeed, *The Biggest Loser* features multiple scenarios designed to emphasize the materiality of participants' flesh and provoke disgust.[1] For example, there is a weigh-in segment during which the players strip down to their underwear and stand on a giant counterweight scale. Their semi-nude bodies including rolls of fat and cellulite are fully exposed to the studio and television audience. In this vulnerable state, the players await the judges' ruling. Suspension builds as the judges measure each contestant's weight loss in order to decide whether he or she will be cut from their teams for failing to lose enough pounds or "pull their weight" in the various (usually exercise-based) competitions. The fat contestants perform this mortification on national television as they pursue weight loss.

These shows operate under the assumption that all fat people can and should lose weight. In their quest for financial gain or celebrity status—albeit short-lived—the participants in these programs reinforce an abject identity of fatness. They engage in fat-face minstrelsy for the camera and display shame and ignominy when confronted on-camera by trainers, coaches, chefs, and other fellow fatties on the program. Without having interviewed the individuals who have appeared in these shows, I cannot know their motives for subjecting themselves to on-camera degradation. The programs—like much reality TV in my view—capitalize on a kind of "shame pornography" that relies on participants revealing the most humiliating and volatile of emotions and responses to any given situation. The scenarios are staged for maximum competitiveness and emotional exposure, frequently geared toward inducing the subjects to experience fear, physical pain, to cry, or to argue violently with one another. For years these kinds of programs represented the majority of fat subjectivities Americans saw on television. Fat subjecthood as depicted by these reality performers was that of apology for their fatness and the associated pathological behaviors that their fat bodies imply. This abjection is what I believe many Americans think a fat person should feel and is certainly what the media typically compels them to feel.

Indeed, Memphis-based (fat) photographer and professor, Haley Morris-Cafiero proved as much with her photographic series "Wait Watchers or Pictures of People Who Mock Me," (2013) in which she captured photographs of anonymous passersby in a variety of public settings such as Times Square, a city sidewalk, a park, and so on, visibly mocking or sneering at her fat body as they encounter her.[2] With no provocation or knowledge of Morris-Cafiero as a person, strangers seem at ease openly ridiculing her. Their actions seem based in the belief that because she is fat, and therefore ashamed of her appearance, she will not confront their cruelty. This fearless ridicule of Morris-Cafiero, or any number of fat subjects depicted on TV or Internet memes, corroborates the widely-held perception that fat people, or those whose bodies exceed normative standards as dictated by the media, are ashamed of their appearance.

Yet, there are some who would disagree with me and perhaps even argue that fat people are not embarrassed enough. For example, in 2012 during a job talk based on my work in this book, someone in the audience—a theatrical costume designer—took issue with my assertion that many American women experience profound shame for their body size if it is fat or exceeds normative proportions. She expressed concern that, as a costumer, she could no longer costume her actresses in stock garments because they were too fat. Moreover, she asserted that in her view, college-age women were not ashamed of having what she classified as fat bodies. "They wear

t-shirts that are too small and let their stomach rolls hang out over the tops of their jeans." She said. "They make no effort to hide their fat. They do not seem at all ashamed to me."[3] I was troubled by her underlying assumption that they should be ashamed. And I was skeptical that this observation bore any evidence of changing attitudes surrounding so-called fat girls of the next generation.

## A New Generation of Fat Actresses

However, in recent months my certainty on this issue of shame has been challenged by some up-and-coming "Gen Y" fat actresses, namely Lena Dunham and Rebel Wilson, who either are not ashamed of their nonnormative bodies, or at least do not perform shame in how they present themselves on TV and film. Cultural perceptions of fat may not have changed in terms of the continued preoccupation with weight loss and the obesity epidemic as portrayed in mass media, but in recent years we have seen an emergence of female performers who reject these cultural assumptions. The success of Dunham and Wilson builds on that of Melissa McCarthy, and I believe their performances may be changing the discourse surrounding representations of fat in our culture. Even more thrilling, this new generation of fat actresses is blazing a trail particularly on the small screen, one of the mediums most responsible for proliferating negative stereotypes of fat.

All three actresses have gained recognition and acclaim in the past two years. In addition to her success on the small screen in *Mike & Molly,* McCarthy had a supporting role in the highly successful female-driven comedic movie *Bridesmaids* (2011), for which she was nominated for an Oscar. She followed that up with two more starring roles in major motion pictures in 2013, *The Heat* and *Identity Thief.* Unfortunately, *Identity Thief* was predominately fat-face minstrelsy; McCarthy's character was a greedy, thieving, lying sociopath who gets her comeuppance. Despite terrible reviews (some of which cruelly took aim at McCarthy's appearance), the movie grossed $175 million. However, *The Heat*—ostensibly a female buddy-cop movie—which, like *Bridesmaids* was written by a woman, had an impressive box-office opening weekend and grossed $158,948,636 in the United States. The movie was so popular that currently there are talks of a sequel.[4] While *The Heat* still cast McCarthy in the "Oscar" role of the *Odd Couple* opposite Sandra Bullock as the uptight "Felix," I would argue that the role allowed McCarthy to move beyond fat-face minstrelsy and portray a more evolved, if comical character. It also featured two women in traditionally masculine roles working together to overcome adversity, which in itself is feminist considering the action genre.

McCarthy's clout as a TV and film star now rivals that many "normal-sized" Hollywood actresses. According to *Forbes*, McCarthy was one of the top twenty highest paid TV actresses in 2012.[5] As of this writing McCarthy is in the center of a publicity storm surrounding her appearance on the November 2013 "Women in Hollywood" *Elle* magazine cover (November 2013.) McCarthy is being honored as among Hollywood's most influential female performers, but some were scandalized that the cover photo featured McCarthy glammed up but wearing a designer coat that completely

**Figure 10.1**    Melissa McCarthy at the 2011 Emmys
© Frank Trapper/Corbis.

obscured her body, while other featured actresses within the pages of the magazine were scantily clad. Regardless of the implications of this choice, it is clear that McCarthy's star is on the rise and her status has increased to cover girl on exactly the kind of women's magazine (*Marie Claire*) in which her critics once suggested that all fat people should "get a room" rather than expose the public to their fat.[6]

While McCarthy was breaking boundaries on the big screen, two other fat actresses began shaking things up on the small screen, producing and writing their own work and showcasing their nonnormative bodies centrally within the narratives, thus rejecting assumptions that fat people want to lose weight or should apologize for their appearance. Lena Dunham and Australian-born actress Rebel Wilson are these "Gen-Y" pioneers writing and sometimes producing and directing their own work for primetime television.

Lena Dunham has quickly impressed critics and garnered awards and success with her HBO series *Girls*, which she writes, stars in, produces, and frequently directs. *Girls*, which premiered in 2012, is now filming its third season and has been nominated for multiple awards including a Golden Globe for best television series and best performance by an actress for Dunham. Dunham plays Hannah Horvath, one of the four central female characters. Hannah is a twenty-something struggling to become an adult, trying to find her place as a writer in present-day New York City. Clinical definitions of obesity aside, twenty-eight-year-old Dunham would be considered fat by most contemporary Hollywood standards. She has unshapely legs with apparent cellulite on them and a visible belly roll. Her character's costumes are unflattering and frequently emphasize rather than disguise these un-ideal features (as the aforementioned costumer would have her do). Neither the costumes nor the camerawork on *Girls* makes an attempt to flatter or glamorize Dunham as Hannah (although when she appears coiffed on the red carpet, Dunham can hold her own as a starlet). Moreover, she frequently appears nude in the series, displaying her pear-shaped body which is somewhat small-breasted, large bottomed, and not particularly toned or tight. Moreover, her breasts appear to be real as opposed to gravity-defying implants, which means they are not precisely spherical and they "hang" rather than sit up high, which lends a "flabby" appearance.

Dunham's frank nudeness on the series has been fodder for critics and fans alike. As the character of Hannah, Dunham appears nude in many different scenarios, few of them sexual and none of them particularly flattering, all of which flies in the face of how viewers are accustomed to seeing naked women on TV (in this case on Home Box Office, a subscription-based network that allows for nudity and strong language.) More typically female nudity occurs in an explicitly sexual scenario and the actress

portraying the role has a body that is in keeping with Hollywood standards—fantastically toned, slender, large/firm breasted, hairless, and so on. The makeup, lighting, and camera work generally glamorize their naked bodies and the performer as a sexual object. That is not the case in *Girls*, which makes Dunham's nudity a watershed moment in screen portrayals of women. For example, a scene may find her character exposed on the toilet having an intimate conversation with her roommate—"as girls do." In one episode, the scenario has her nude, sitting in a tub eating a cupcake (with no irony or apology). In another episode she shares a bath with a friend in a moment of (nonsexual) tenderness. Even when her nakedness is in the course of a sexual encounter, it is rarely glamorized. In the first season she has a series of "hookups" with Adam Driver (played by Adam Sackler). The scenarios are grittily realistic and generally depict their sexual intimacy with little prurient allure. When Hannah disrobes to have sex, it is not a striptease but rather an awkward doffing of garments that is at times comical and hardly sexy. Their sex is also depicted without erotic charm and is sometimes awkward, even humiliating as the two characters struggle to connect emotionally and find sexual satisfaction. Sackler, who plays Adam, is not classically handsome, but he is very tall relative to Dunham, slender, and extremely fit—"buff." It is a source of humor for characters within the show as well as critics of the show that Adam rarely wears a shirt and his "perfect" body is frequently on display. I argue that this reversal—whereby the male body is eroticized and displayed for sexual pleasure while the female figure is not—disrupts the "male gaze" and offers a possibility for feminist spectatorship.

It is also significant that there is no mention among the characters of the discrepancy in fat or fitness between Hannah and Adam. One post-coital moment features the two characters in their underwear, and Adam is playing with the fat on Hannah's belly. He is not mocking her or telling her to lose weight; rather he is reveling in her body in the afterglow in his awkward manner, which is appropriate to his quirky character. And Hannah does not shy from this kind of touching or act embarrassed. In fact, in the context of the show, Hannah's weight is never a subject. Despite the fact that the premise of *Girls* is twenty-something girls coming of age, there is virtually no discussion of bodies, weight-loss, or beauty. Instead the emphasis is on the relationships among the young women and their interior lives and professional ambitions, which further solidifies a feminist stance.

Dunham's nudity in the first season of *Girls* earned such notoriety that the opening comic sketch of the 2012 Emmys, hosted by Jimmy Kimmel, featured a skit in which several of the nominated actresses convene in a bathroom prior to the show and, through a series of silly turns, discover Dunham nude in a bathroom stall sitting on the toilet eating a cake. When

starlet who opened the door apologizes for barging in on her she says, "I don't mind."[7] Clearly Dunham is embracing the public's fascination with her forthright nudity despite her nonnormativized figure. She is most definitely not ashamed nor is she trying to discipline her figure into disappearing. As head writer of *Girls*, Dunham creates storylines and scenarios that disrupt hegemonic male-driven narratives about women in which the female characters are drawn from a masculine fantasy of reality.

However, Dunham has also been the target of significant public vitriol and mockery for her unabashed nudeness and her fat figure. For example, radio personality Howard Stern called her a "little fat girl who kinda looks like Jonah Hill."[8] Even a porn parody of the show—*This Ain't Girls* riffs on Dunham's body: the porn actress, Alex Chance, who plays Dunham's character Hannah, eats ice cream in an unflattering crop-top and panties, emphasizing her belly roll before the porn progresses to the requisite girl-on-girl sex scenario.[9] Dunham has not commented on the porn, except to tweet that she thinks it is "gross"—but Chance feels a connection with Dunham because they both have what she describes as natural bodies. (Chance feels she has been sidelined in the porn industry for being neither thin enough nor fat.)

The most interesting backlash surrounding Hannah's frank sexuality and nonnormative body thus far came after an episode in season two, "One Man's Trash," which aired on February 10, 2013. In this episode, Hannah's character has a "lost weekend" of sex with a married stranger named Joshua played by Patrick Wilson. Most people would agree that Wilson is classically handsome, unlike Sackler who is uniquely charismatic rather than traditionally attractive. Forty-one-year-old Wilson is six feet tall with blonde hair, blue eyes, and a chiseled jaw. Joshua and Hannah have a chance encounter in front of his brownstone, and the characters have immediate chemistry. They proceed to have sex and spend a magical weekend together making love and getting to know one another. In one sequence Hannah plays ping pong topless. Given their disparate lives (and ages) as well as their respective emotional baggage, the two realize there is no future between them, and they part at the end of the episode. Clearly this was just a fling, and Hannah has gained more sexual experience and self-knowledge.

Following the first airing of that episode, the blogosphere went wild. Based on what viewers perceived as a discrepancy between the actors' relative attractiveness, many commented that it was completely "unrealistic," "unbelievable," and so on that these two characters would have sex. Wilson as Joshua was far too handsome to have sex with dumpy Dunham as Hannah.[10] (And, as with every episode, Hannah's costumes in "One Man's Trash" are designed to emphasize Dunham's bodily "imperfections.")

Viewers argued that it was unrealistic that Dunham and Wilson's characters would have sex with comments such as "Hotttt Patrick Wilson would *never* hook up with a Fatniss Everdeen like Lena Dunham."[11] There was such controversy about the episode that Patrick Wilson's wife eventually responded to it, as did Dunham. Dagmara Dominzyck (Wilson's wife) seemed compelled to defend Dunham when she tweeted "Funny, his wife is a size 10, muffin top & all, and he does her just fine. Least that's what I hear. Rule #1 never say never."[12]

Dunham's response to the media storm was:

> I get so tired of having to cry out "misogyny," but that's what's going on in this situation. People questioning the idea that a woman could sleep with a man who defied her lot in the looks bracket hews so closely to these really outdated ideas about what makes a woman worth spending time with. Really? Can you not imagine a world in which a girl who's sexually down for anything and oddly gregarious pulls a guy out of his shell for two days? They're not getting married. They're spending two days [having sex], which is something that people do.[13]

As Dunham points out, the outcry over the onscreen coupling not only illustrated the rampant misogyny that continues to permeate our culture and the ubiquity of the male gaze in popular representations but also hints at the blurring of the lines between actor and character.

On the one hand, *Girls* is innovative for not glamorizing the female body, sexual encounters, or city living. Arguably, the writing, the characters, and the filmic style of the show are more representative of real life than the beloved HBO series *Sex in the City*, for example. However this realistic style—which is not reality television as with *The Biggest Loser*—seems to have created an interesting tension whereby viewers conflate Dunham and Wilson, the actors, with their characters. The implication that Dunham is too fat/unattractive to have sex with Wilson is troubling regardless, but the fact that viewers fail to make the distinction between actors and the roles they play points to a culture in which the lines between the virtual and the real have become blurred. I will return to this concept later in the chapter.

The episode caused enough controversy that Wilson responded to it in several interviews. He too was troubled by the conflation of his person with the character: "I really wasn't expecting so much response to that episode. I didn't expect people to have such an opinion on my taste. As a *person*, not just a character. That was really strange and invasive and weird. People thought they had any clue about me. You can judge my acting all you want, but it's really interesting when people were like, 'Patrick Wilson would never do that.' *What?* Who are you? [*Laughs.*] You have no idea. You don't even know my middle name." Wilson went on to try and

account for the backlash asserting, as I have, that viewers fail to separate Lena Dunham, the writer, producer, actress from her character, Hannah Horvath on the show. He goes on to defend how the chemistry between the two characters was plausible: "And here's the thing: A lot of people can't separate Lena Dunham from that character, so therefore they judge me as

**Figure 10.2**    Lena Dunham at the 2013 Golden Globes
© MARIO ANZUONI/Reuters/Corbis.

Patrick, because they're judging Lena as her character. But both characters are damaged. People talked about Joshua like he had his stuff together and I was like, 'What are you talking about? He's as much as a train wreck as she is!' She's just more vocal about it."[14]

It is important to note that, unlike her fat predecessors on TV who often had producing control over characters based on themselves, such as Roseanne or even Kirstie Alley, Dunham's character is not based on herself. Although, of course, as with any writer, she may be inspired by her personal experiences. Moreover, Dunham, as of this writing, is the lead writer of *Girls,* where her predecessors were not. I assert that all of the aforementioned innovation of *Girls* in which the male gaze is disrupted and the female characters are not generally eroticized or commodified is a direct result of a woman spearheading the writing.[15] Could Dunham's creative control portend a new generation of women who are wresting control of the female body in representation out of the hands of male producers? Now that women have more influence over the narratives and representations of their own bodies in the media, will we see a reemergence and celebration of full and varied female bodies that disappeared in the early twentieth century?

## Super Fun Night: A "Post-Fat" Program?

McCarthy and Dunham may have helped pave the way for Rebel Wilson, another fat actress, to take control of her image in a national television sitcom. Wilson is the creator and lead writer for *Super Fun Night,* a comedy about three quirky female roommates who try to overcome their social awkwardness by going out on dates every Friday night. Wilson gained attention not only in a memorable cameo in the movie *Bridesmaids* but also as the gregarious, preternaturally confident character "Fat Amy" in the sleeper movie hit *Pitch Perfect* (2012). Wilson, who is significantly larger than Dunham, has been described as "round in a way that seems like an attribute; she has a post-fat state of mind. She does not shy away from her size. Instead she embraces the fact that she is different."[16] Her executive producer, Conan O'Brien, explains his commitment to Wilson's talent. He says, "It's harder and harder to find authenticity . . . She has an incredible will, but she is completely unself-concious in how she presents herself. That willingness to be bold and her innate likability is contagious."[17] Like Dunham, Wilson is the show's creator and lead writer. And with regard to the pilot script of *Super Fun Night,* which Wilson wrote and included an image of two geeky girls hugging when she sent it over to O'Brien, he thought: "These are not the type of women depicted on TV, and I want to

see them."[18] Arguably this is true; audiences are ready to see more diverse female bodies and complex characterizations of women and girls on stage and screen. However, the question remains as to whether the ratings will demonstrate this.

As of this writing, only a handful of episodes of *Super Fun Night* have aired, and the ratings are mediocre. Some critics assert that the show continues to rehearse clichéd stereotypes, but I argue that Wilson is not performing fat-face minstrelsy or relying on fat jokes. Similar to the way in which Paula Vogel's dramaturgy enrolls the audience in the female characters as subjects rather than objects, the reversal is in the subjectivity of the protagonist, Kimmie Boubier, played by Wilson. Kimmie is a socially awkward, comic character, and she sometimes makes choices that work out badly and therefore are funny. But as an audience, we are invested in her as the protagonist; every episode begins with a direct "video-diary" address from Kimmie to the camera. Therefore, she is the character with whom viewers take the journey. Kimmie is not "othered," nor is she the object; instead she is the subject with whom we identify. Thus, the humor does not rely on viewers identifying as "not fat" in the way that, for example, *Fat Actress* did. Moreover, as of this writing, no episode has explicitly alluded to her weight or focused on Kimmie's eating habits. There are several allusions to her eating junk food for emotional comfort, but her "normal-sized" roommates participate in this activity, which disassociates it from an explicitly fat behavior into a female bonding behavior.

### Enter Fat Audience

For me, what is groundbreaking about Dunham's work especially, but also Wilson's show, is that they reject the abject fat identity and embody more positive fat subjectivities. The fat characters they create have dignity and agency in their respective worlds. And perhaps more significantly, *Girls* and *Super Fun Night* assume a "fat audience." By that I mean, as opposed to Alley's show in which the comedy relied upon viewers identifying as "not fat" and therefore enjoying the joke at the expense of the fat character, *Girls* and *Super Fun Night* (to a lesser degree) imagine a fat audience (which for me, is a synonym for feminist audience) who see themselves in these characters and identify with them rather than judging them or distancing themselves. Moreover, fat is not the focus of these characters and their stories; it is incidental. Within that framing, as created by Dunham and Wilson, Hannah Horvath and Kimmie Boubier refuse to participate in the ubiquitous narrative of fat shame. In doing so, they invite a fat audience to see themselves reflected in the body-diversity of these characters.

# Conclusion:
# Rethinking Realism

This book seeks to offer a reconsideration of the fat female body in various fields of cultural production in the United States. Through exploring cultural assumptions associated with the fat female form in representation, including psychological pathologies, as well as class and race issues, I have demonstrated the ways in which the body of a fat actress speaks without saying a word. I have also tried to highlight and thus destabilize deeply ingrained attitudes about fat.

Chapter one not only traces the roots of fat as an American cultural production but also explores the ways in which women's bodies in particular are inextricably bound to their identities. The notion that a woman *is* her body is deeply rooted in Western philosophy and continues to permeate our culture. Therefore we cannot separate her appearance from her behavior—in essence, from her mind and spirit—in contemporary representation. Chapters two through nine offer various models and examples of how fat plays out onstage and screen. Playwrights use fat and fat behavior not only as a means to develop their characters emotionally but also as a dramaturgical strategy to move the plot forward. Fat actresses are cast not just for their acting skills but for what their physical presence brings to the role. The appearance of a fat female body conveys qualities and engenders responses that are much more intricate than the practice of typecasting. It is a cultural construction of beliefs and perceptions that stem from ideologies influenced by Victorian ethics, Puritan morality, and the American ethos of self-determination and individualism. The discourse surrounding fat in our culture intersects with issues of class and race and requires complexity in interpretation.

Furthermore, I suggest that fat is a lived identity of outsiderness and internalized oppression that goes beyond outward appearances. Fat is an ontological position as much as a physical description. Fat prejudice is a culturally constructed subjugation produced discursively and through various social practices and institutional hierarchies in American culture. If we acknowledge this as a possibility, we create potential for reframing

and reconsidering fat in our culture. The aforementioned fat actresses have begun the work of destabilizing these cultural narratives.

However, to further reclaim fat from the margins of American culture, I look to Anthony Kubiak's argument in *Agitated States: Performance in the American Theater of Cruelty* in order to move beyond a materialist study of theatre as a cultural text and further explore what he calls "the ontologies of performance."[1] Kubiak asserts that Americans operate in a society of self-reflexive specularity in which we monitor and reflect behavior and culture through watching and being watched.[2] Kubiak also argues that mass media encourages this culture of specularity and perpetuates cultural violence through the "propagation of anti-intellectuality that seems the hallmark of American society."[3] Americans are a product of their own pioneer mentality. Increasingly over the twentieth and twenty-first centuries, the pursuit of higher education, intellectualism, and self-reflection has come under suspicion as unpatriotic, elitist behavior that goes against the avowed simplicity of our American mythology. Kubiak suggests that we are a culture immersed in illusion, constantly negotiating the virtual and the real, and that this situation arises in part from the rigid Puritan culture of surveillance and correction on which our country is (relatively recently) founded.[4] He reminds us that our founding Puritan forefathers were steeped in religious traditions of self-watching. Similar to Foucault's model of the Panopticon and a self-governing society, Puritan religious culture, perhaps in response to the lack of religious ritual and established religious spaces of their European ancestors, is rooted in the concept that God and the community are watching. Kubiak writes,

> In the case of the Puritans, theater, though absent as an institution, nonetheless acts in the interior as a kind of performance feedback loop that forms the very basis of morality. One is constantly assessing and reassessing *how one acts* in order to ascertain if one has *acted well*. In fact, even one's intentions are objectified as exhibition or *show* through the interior watching and are moved out of the realm of the merely intentional into the realm of the performative (how I present myself to myself), in the performance itself . . . The issue, ultimately, in the Puritan mind becomes the ability to construct one's own character, to construct character itself.[5]

This notion offers a penetrating insight into the formation of American ideology as inherently theatricalized. Our culture is intrinsically theatrical, from our political and military pageantry to the performative displays of our judicial system to the theatricality of our international goodwill gestures, such as dropping food and supplies to the needy from planes. At the same time, the aforementioned anti-intellectualism, which discourages national self-reflection, has engendered a nation of narcissists in a

culture of theatricality who are unable to see past their own subjectivity. He sees this manifest in the American theatrical tradition, which is rooted in realism and frequently takes the mythology of the American dream as its central theme. Kubiak draws on Lacanian theory when he writes, "[t]heatricality was and is the *ungrounded signifier* of American culture, a signifier that is at once everywhere and nowhere . . . Hence the inability to discern the distance between the virtual and the real, the distance that Lacan gives over to the Symbolic."[6]

Kubiak makes this assertion as part of his manifesto on the importance of American theatre as a potential tool for negotiating the Real and the Imaginary. And he points to the inherent problem with realism as the reigning primary dramaturgical form in middlebrow theatre. I suggest that the vast proliferation of performances disseminated in mass media, from TV and movies to the Internet, podcasts, and YouTube, contributes to and is an extension of the tradition of theatrical realism, and that this tradition collapses the distance between the virtual and the real in American culture. Thus, we need to address the mode of realism and how we understand it in various cultural texts in order to use theatre as an effective tool for renegotiating the real and the virtual performative.

As of this writing, reality shows continue to dominate programming trends in twenty-first-century television. In the evening primetime lineup, even fictional sitcoms and dramatic nighttime soaps—still arguably modes of realism—have been subsumed by the "more real" reality programming. In essence, this falls into the same American theatrical tradition that Kubiak is critiquing. The formula of casting "real people," frequently putting them in competitive circumstances, often with the promised prize of becoming a "star," adding dizzying layers of meta-celebrityhood, has proven to be a most popular mode of reality entertainment. Competition shows ranging from *American Idol, So You Think You Can Dance, Survivor, The Biggest Loser*, and *Extreme Weight Loss* to "occupational" reality programs such as *Lizard Lick Towing, Duck Dynasty, The Real Housewives*, or *Swamp Men* all promise "Average Joe American" a shot at stardom, which has become a most prized accomplishment in our specular, voyeuristic, middle-class culture.

Ultimately, of course, all of these participants are performing a sometimes-scripted version of themselves for the reality camera. The participants are screened, auditioned, and groomed for their moment in the spotlight, although this is not generally disclosed. The premise of this kind of programming is that an "ordinary person" has been plucked from his or her daily life and is now appearing as himself or herself, on television. Especially with the advent of the Internet, it has become increasingly possible for anyone to appear on (digital) film and to live his or her life in the public eye. This encourages people to imagine themselves only one step

removed from a professional actor with all that entails—from fame and power to appearance and beauty. More and more "regular people" are blurring the line between reality and fiction as they attempt to participate in these reality shows. Some see themselves as starring in their own reality show as they post self-made films and blog to a potential Internet audience of millions.

A perfect example of the way in which reality shows provoke a blurring of the lines between truth and fiction is the couple who managed to crash the first White House state dinner of Barack Obama's presidency on November 24, 2009. Michaele and Tareq Salahi, a couple aspiring to reality show stardom, slipped past security and "crashed" the state dinner. The glamorously dressed couple, who brought their own makeup artist, even paused on the red carpet for press photographers.[7] They posed alongside the vice president and the White House chief of staff and posted the photos on their Facebook page. They were also photographed shaking hands with the president. They were hoping to gain attention in their bid to appear on *The Real Housewives of D.C.*, part of a television franchise that recruits "regular" folks to live their lives on TV.[8] This astonishing breach of security resulted in inquiries into White House procedures and, no doubt, cost the government plenty of money and a few secret service agents their jobs.[9] The couple then appeared on *Larry King Live*. This incident came just a few months after a Colorado family, also trying to gain attention from television producers, instigated a national search for their child, whom they led authorities to believe was trapped inside a homemade air balloon and floating through the sky. The story made national news, and viewers were able to watch in real time as rescuers attempted to capture the runaway balloon and save the boy, who was later found hiding in his garage. When the family went through the ubiquitous nationally televised interview process following the incident, including, again, *Larry King Live*, they were exposed as hoaxers trying to gain celebrity attention in hopes of landing a reality series about inventors. The allure of this kind of press coverage is exacerbated by media coverage of real-life dramatic events, such as the plane that safely crash-landed into the Hudson River in January of 2009. The news story was co-opted by the media and packaged as "info-tainment." This real-life event had the perfect dramatic narrative: It prominently featured the heroic actions of "regular guy" Chesley Sullenberger, the captain who "ditched" the plane without loss of life. Some news channels even developed and played specific theme music before reporting on the accident and gave the events surrounding the incident a neatly packaged, marketable name, dubbing it "Miracle on the Hudson."[10]

Arguably, the players in "Crashing Couple" and "Balloon Boy" could be construed as harmless publicity mongers in a long tradition of celebrity

seekers. (Who can forget the streaker behind David Niven at the 1974 Academy Awards?) On the other hand, in both the aforementioned instances, these individuals duped public officials and private citizens in their ruses. The secret service agents *really* faced disciplinary actions at their jobs, and there was *real* inquiry into White House security. Hundreds of local rescuers and government agencies *really* participated in trying to save the little boy, at significant financial and emotional expense. Millions of Americans watched the "Balloon Boy" story play out in real time and shared in the fear and suspense of the rescue. There were real consequences for these performative actions.[11] As Michael Hirschorn, former vice president of programming for reality-centric TV for VH1, puts it, "prospective reality stars [are] becoming smarter about 'self-producing,' knowing they have to inject drama into the shows. At this point, there must be what, a thousand reality personalities on TV at any time?"[12] The notion that thousands of "regular" individuals are self-producing a version of themselves (with added drama) for reality programs speaks to the idea that America is a culture steeped in its own theatricality, and that Americans are preoccupied with performing their own reality. The internet age has intensified this phenomenon.

Consequently, it is not only live theatre as a cultural text but other entertainment media in the mode of realism that blur distinctions between the virtual and the real. According to Kubiak, "[t]heater as a phenomenon represents a historically situated critical feedback loop that moves from play to culture, from culture to unconscious subject, and back again."[13] He asserts that American culture has been "unknowingly immersed in, and formulated through theater, the ontologies and strategies of seeing and being seen, of revelation and concealment."[14] He argues, "The appearance of the authentic and the material (i.e., the material conditions of cultural production) must be empirical, demonstrable; they must be, in other words, repeatable. In the case of cultural materialism, the connections between attitudes and ideas and cultural production must be *shown*. The provability or authenticity relies, in other words, on empirical verifiability, on a re-creation or replay, or socially and psychically speaking, on theater."[15] Thus, we live in a culture in which the "copy" of a female body as represented onstage and screen supersedes the real bodyies of average American women.[16] I believe this observation has profound implications not only for how we read bodies onstage and in various cultural texts but also for what audiences perceive as "realistic." The constant repetition of the slender, homogenized female body has become empirically verifiable as the authentic. Female bodies represented in film and TV, Lena Dunham and Rebel Wilson notwithstanding, are typically excessively thin in relation to the average American woman. It is part of the job description for starlets to maintain an extremely slender, muscular physique. However, unlike the

average middle-class American woman, successful Hollywood actresses have financial means and professional motivation to engage in plastic surgery and to enlist personal trainers, personal chefs, and so on. This is in addition to all the help they receive from "industry magic," such as makeup and airbrushing, in order to accomplish their slender, polished appearance. Not only is the lifestyle of a film actress conducive to maintaining her appearance, but it is a career imperative to keep up her homogenized beauty. Despite all the technological advances in the film industry, it seems that we still have not developed a camera that does not "add ten pounds" to the performer, as the saying goes. As a result, film and TV performers have made it a practice to maintain extreme slenderness and indeed, over the years, have gotten even slenderer as the cultural aesthetic has gradually gotten even slimmer.[17] However, considering the dwindling gap between celebrity and "real" person as depicted in reality-based TV programming and the proliferation of self-produced internet programming, many "average" middle-class women, who do not have the accoutrements that a celebrity has, nonetheless feel pressure, or more insidiously, feel as if it ought to be *possible* for them to look like a "star." In light of Kubiak's theory, in which Americans persist in blurring the line between the virtual and the real, we are all potentially on the same plane as any performer we see on TV or onstage. And, as I mentioned in chapter one, bearing in mind the economics of commercial and regional theatre, and the increasing crossover between film and stage for performers, the female bodies we see onstage in live theatre are frequently part of the "cult of slenderness" demanded by the film and television industry. Yet all of these bodies are perceived by a middlebrow white audience as realistic, even though they do not necessarily represent real women's bodies and may have been modified by any or all of the practices that I mention above.

Since TV and film actresses are more recognizable to a wider middle-class audience, it is not surprising that economic considerations result in the overlap in casting from stage to screen. Thus, the bodies of these actresses are embedded in Kubiak's cultural feedback loop, wherein the "copy" depicted onstage or on TV has overtaken the original as to whom audiences recognize as "realistic."[18] The bodies of professional actresses, which are groomed, toned, and trained as a career necessity in the same way a professional athlete maintains his or her skills in order to excel in sports, are the cultural texts (in the context of realism) in which white, middle-class American women see themselves mirrored.

Thus, American audiences have become so accustomed to the slender, homogenous beauty aesthetic as proliferated in mass media that any body that strays outside that parameter interferes with the viewer's notion of what is believable—or what is realistic. Therefore, the only neutral female

body in representation, or perhaps more accurately, the only "realistic" body in representation is the slender, dainty, hyperfeminine white woman. If a female performer's body falls outside these cultural notions of authenticity, by being fat, tall, or of color, then her body is adding a layer of meaning beyond the textual narrative. In some cases, when the role in question calls for a particular kind of personality, as I have demonstrated through my examples in chapters three and four, this effect is desirable, and directors and actors benefit from this unconscious cultural collusion between audience and playwright. However, in many other cases, this consequence is an unrecognized byproduct and severely limits the possibilities of whom audiences will believe in a majority of roles in the context of realism.

In other words, a traditional romantic "boy meets girl" scenario in dramatic representation, such as Neil Simon's *Barefoot in the Park*, would not be understood as realistic if the female performer's body appeared fat. Even though "normal-" sized men fall in love with size sixteen women all the time in real life, a play that represented this would become another kind of story. For another specific contemporary example, consider Sarah Ruhl's *In the Next Room or The Vibrator Play*, which was on Broadway from 2009 to 2010. The play is ostensibly realistic, with a linear plot and a fully realized stage and costume design representing an upper-class American household circa 1880 at the dawn of electricity. The two female leads were played by fairly well-known actresses (Laura Benanti and Maria Dizzia) who have significant film, TV, and stage credits. Ms. Benanti, who won a Tony for her performance in the title role of *Gypsy* and was the romantic lead of this drama, is not only traditionally beautiful but slender as a reed. This is especially suspect considering that if historical accuracy was a factor, the time period in which the play is set would call for a fuller-figured woman to play the role. I propose that were the role to be played by the equally talented, attractive, and age-appropriate Marissa Jaret Winokur (who also won a Tony for her portrayal of Tracy Turnblad in *Hairspray*), critics and audiences would somehow perceive her depiction as unrealistic—inauthentic—or even perverse. At the very least, as I have demonstrated in previous chapters, if Ms. Winokur had played the role, it would have connoted some qualities about the character that the playwright and director did not intend. Interestingly, the only fat—or realistically sized—actress to appear in this production was Quincy Tyler Bernstine, an African American. Because audiences are more accustomed to seeing large black women in representation, particularly those depicted in a lower economic and social status, as was the case in *The Vibrator Play*, Ms. Bernstine's body could still be read as authentic in the context of the realism that has been shaped by twenty-first-century theatre and film practices.

Because popular representations of women have persistently reenacted a homogenized white slender beauty and demonized fat—transcending the real female body with an enhanced, idealized female form as verifiably authentic—audiences have difficulty understanding a fat female body in the context of realism without attaching to it some of the fat pathology I have described in earlier chapters.

## Revising Aesthetics

Thus, "realistic" representations of women in performance remain prohibitively slender despite the statistical fact that average American women commonly wear sizes twelve, fourteen, and sixteen. Yet these sizes are frequently considered plus-size by the fashion industry.[19] Recuperating fat in representation would require a fundamental shift in cultural perceptions of realism onstage, as well as changes in the casting practices that perpetuate this phenomenon.[20] In other words, we must interrupt Kubiak's cultural feedback loop. Or perhaps more accurately, if we cannot use theatre more effectively to interrogate theatricalities of culture as Kubiak suggests, we can at least endeavor to reprogram the feedback loop.

Kathleen LeBesco points out the obstacles facing such a paradigm shift; media and other consumer industries are reluctant to promote any display of fatness that suggests fat acceptance because of the potential consequences for the health and beauty industries.[21] And there does seem to be reluctance among consumers to truly accept plus-size mannequins, for example. This resistance—intolerance, really—is exemplified in a "Critical Shopper Review" of the new JCPenney store in Herald Square, New York City, that appeared in *The New York Times*. Cintra Wilson, who conspicuously positions herself as "not fat," writes: "It took me a long time to find a size 2 among the racks. There are, however, abundant size 10's, 12's, and 16's . . . To this end, it had the most obese mannequins I have ever seen. They probably need special insulin-based epoxy injections just to make their limbs stay on. It's like a headless wax museum devoted entirely to the cast of "Roseanne."[22] Notice the disparaging tone with which Wilson singles out the sizes of the average American woman, and how she situates herself as the superior size two. This is, quite literally, spatial profiling. The fact that the store is JCPenney, not Ralph Lauren or some other pricey designer store, also implies classism in addition to fat discrimination.

However, as LeBesco points out, it is not only the fashion industry that is guilty of fat discrimination. Fat women, as well as the millions of women who are struggling to lose the ten pounds that will make them as "camera ready" as popular female icons, will not be able to stop the cycle of

self-loathing and battling their bodies until bigger bodies are presented as "normal" in the media.[23] LeBesco writes,

> As long as no one questions the genesis of the idea that fat is dirty, as long as no one questions why the larger social structure benefits from the marginalization of fat individuals, as long as fat people remain complicitous with this larger structure, fat as bad will continue to seem natural rather than be exposed as the social construction that it is . . . [I]t will be assumed, through today's culturally constructed historical blinders, that fat is something that is now and forever has been bad, and this will serve as the rationale for the continued oppression of fat people.[24]

Middle-class white women will continue to position themselves in relation to popular representations of the female figure, which, according to Kubiak's theory, they perceive on some level as more authentic than their own apparently imperfect bodies.

Despite all news reports telling us that Americans are fatter than ever, it is still somewhat difficult to locate a strong fat female presence in any area of performance. Yet, the national discourse surrounding fat does seem to be shifting slightly thanks to trail blazers like Lena Dunham, Melissa McCarthy, and Rebel Wilson, ironically all film and TV actresses. Another example of this shift is the film *Precious* (2009) which generated a lot of press coverage and Academy-Award buzz. *Precious* tells the story of a fat, dark-skinned black woman and addresses many of the questions I raise in chapter seven. It is hardly surprising that Lee Daniels, a well-regarded, African-American, independent film director, had to rely on private investors to raise the initial $8 million production budget.[25] Indeed, the heroine of *Precious* is the most disenfranchised American possible: a fat, black, illiterate woman on welfare. However, in my view, Precious, played by Gabourey Sidibe, is portrayed as heroic, because to some degree she lives up to the American ideals of self-determination; she does not lose weight, but she achieves her modest goals of escaping her abusive home and collecting both of her children under her own roof. Still, aside from the potential audience reach of *Precious*, the field of cultural production in which these aforementioned fat performances operate is relatively small and is not entirely based in the mode of realism. *Precious*, as gritty and realistic as much of the filmmaking is, features flights of fancy in the mind of the main character when she imagines herself as a skinny, white, blonde girl.

When we consider that the aforementioned Puritan ideals of temperance and discipline are manifested physically in human form by angular, slender lines, and that, conversely, the vices of sloth and gluttony are depicted in round folds of human flesh, then the representation of the fat

female on stage in the latter half of the twentieth century and early twenty-first century has served to maintain a cultural status quo that includes deep-seated misogyny. It is not by chance that the female body needs deviate only slightly from the established norm to be considered outside that norm or "other," and that a white male body has to appear significantly fat before it will be publicly censured. This double standard continues to permeate our society and is at the heart of many ongoing feminist concerns.

Nor is it surprising that fat prejudice remains one of the last socially acceptable forms of discrimination. Like sexuality, fat is perceived by many to be a deliberate choice and therefore deserving of inequitable treatment socially and by government and political decisions.[26] Anti-fat bias is a byproduct of American ambivalence that at once celebrates discipline, control, and thinness as the outward show of moral character but at the same time revels in our food surplus and freedom of choice. This is reflected in the contradictory myths of abundance and scarcity flourishing simultaneously in our culture. Especially in large cities, but even in suburban developments, as our population grows, space is tightly controlled and regulated through economic and market forces. Mass-producing culture dictates the size of everything, which results in a "one-size-fits-all" concept of industrialized civilization that further promotes the idea of scarcity of space in our daily environments. Hence, we have spatial profiling directed even at our bodies.[27] Even the size of theatre seats is designed to maximize potential while simultaneously enforcing conformation to a certain body type. Our global crisis over the scarcity of basic resources such as fuel, our environmental crisis over pollution and global warming, our recent economic crisis, and the ever-present moral justifications for living moderately have us all "tightening our belts" and "doing more with less" and "cutting back on consumption." Yet a stroll down any aisle in a Whole Foods or a Walmart sends a completely different message; there is an overabundance of everything, and not only is it is immediately available to the consumer, but it is a necessity to maintain American quality of life. Demographic statistics tell us that Americans are taller and heavier than ever before, but that we should feel bad about it. This dichotomy is at the crux of a schism between the real and the virtual.

However, with the emergence of characters like Tracey Turnblad, whose figure and superior morality challenge physical, racial, and gender stereotypes, or a character like Precious, whose struggle for human dignity is clearly and immediately identifiable, or Hannah Horvath, whose unselfconscious quest for meaningful relationships and a sense of self are infinitely relatable, fat can take on new meanings. "Body-blind" casting practices can also serve to destabilize cultural assumptions and initiate new ways of reading bodies in representation.

## Fat Manifesto: Reclaiming Fat Onstage

In her essay "Performance, Utopia and the 'Utopian Performative,'" Jill Dolan suggests that theatre can transform communities and change perceptions. She declares, "Live theatre remains a powerful site at which to establish and exchange notions of cultural taste, to set standards, and to model fashion, trends, and styles . . . [T]heatre and performance can articulate a common future, one that's more just and equitable, in which we can all participate more equally with more chances to live fully and contribute to the making of culture."[28]

If we agree with Dolan, live theatre is the perfect medium to (begin to) rupture the cultural feedback loop and change the way audiences read female bodies onstage. Live theatre is a place where we can re-create culture by putting all body sizes and shapes in all performance modes, but especially in the context of theatrical realism. Indeed, during her plenary address at the 2008 American Theatre in Higher Education (ATHE) Conference, Dolan discussed the dangers of "liberal arts acting programs that conform to egregious racial and body-profiling practices of mainstream, professional casting practices."[29] She envisions theatre practice as a utopian model of society through which students are shaped into citizens of the world and a "forum in which ideas and possibilities for social equity and justice are shared."[30] Furthermore, Dolan suggests that the making of theatre is a transformational cultural practice that can offer audiences "glimpses of utopia."[31]

I am inspired by Dolan's notion of the utopian performative as way to help rethink body realism when it comes to women onstage. The liveness of theatre offers a medium in which we can investigate fat and model a utopian world of body diversity. University theatre is a prime venue to begin to change casting practices that adhere to rigid physical stereotypes and reshape what audiences view as "realistic" when it comes to female bodies in representation. I would argue that audiences are still more accepting of color-blind casting than "body-blind" casting. However, university theatre could be an opportunity to model true body democracy and include all sizes as part of the world represented onstage, to practice "body-blind casting." There is no reason college productions could not draw from the diversity of female bodies in their department (rather than encouraging eating disorders and perpetuating stereotypes) and cast a fat girl as Emily in *Our Town*, or a tall and broad-shouldered Juliet for a waif-like Romeo. If we draw from current cultural demographics, it is perfectly "realistic" to imagine either of these young, romantic characters might be a fat person.

Admittedly, university theatre is hardly a wide field of cultural production in terms of both the producers and the consumers of college theatre.

However, if one function of university theatre is to cultivate future directors, playwrights, performers, designers, and filmmakers, then it is an opportunity to begin a cultural shift with the next generation of artists. If the next wave of theatre artists builds on the work of Dunham, McCarthy, and Wilson, and no longer stigmatizes fat, and no longer views body diversity in casting as anomalous, they might eventually take these trends to the professional level. Through persistent repetition of fat in modes of realism and representation, perhaps we can reprogram the feedback loop so that the slender homogenous Hollywood bodies to which audiences have become accustomed—the copies—no longer suppress the originals when it comes to body type.

# Notes

## Introduction

1. E. J. Dickson, "Gandolfini's Death Prompts Rampant Fat Shaming," *Salon.com*, June 20, 2013, http://www.salon.com/2013/06/20/gandolfinis_death_prompts_ rampant_fat_shaming/ (accessed June 23, 2013).
2. See for example, Allison Van Duson, "Is Your Weight Affecting Your Career," *Forbes.com,* May 21, 2008, http://www.forbes.com/2008/05/21/health-weight-career-forbeslife-cx_avd_0521health.html (accessed July 3, 2013).
3. Elin Diamond, *Unmaking Mimesis* (New York: Routledge, 1997), 4.
4. Edward Albee, *Who's Afraid of Virginia Woolf?* (New York: Signet Books, 1963).
5. Here I will engage with Eric Lott's *Love and Theft: Blackface Minstrelsy and the American Working Class* (New York: Oxford University Press, 1995) and discuss the ways in which Alley's performance is a kind of "fat-face" minstrel show where the performer eventually gets to remove the mask and even capitalize on being the privileged "other."
6. Rex Reed, "Declined: In *Identity Thief*, Bateman's Bankable Billing Can't Lift This Flick Out of the Red," *New York Observer*, February 5, 2013, http://observer.com/2013/02/declined-in-identity-thief-batemans-bankable-billing-cant-lift-this-flick-out-of-the-red/ (accessed October 27, 2013).
7. For example, Judith Butler, *Gender Trouble: Feminism and the Subversion of Identity* (London: Routledge, 1993) and Peggy Phelan, *Unmarked: The Politics of Performance* (London: Routledge, 1993).
8. Anthony Kubiak, *Agitated States: Performance in the American Theater of Cruelty* (Ann Arbor, MI: University of Michigan Press, 2002), 22.
9. Here I am assuming a play that fits within the broad definition of realism.

## Chapter 1

1. Many feminists have critiqued or endeavored to demonstrate the phallocentricity of Freud's theories and the shortcomings of his work as it pertains to understanding and treating women, including Luce Irigaray in *This Sex Which Is Not One* (Ithaca, NY: Cornell University Press, 1985) or Nancy Chodorow in *Feminism and Psychoanalytic Theory* (New Haven, CT: Yale University Press, 1991) and *Femininities, Masculinities, Sexualities: Freud and Beyond* (Lexington, KY: University Kentucky Press, 1994).

2. Simone de Beauvoir, *The Second Sex*, trans. H. M. Parshley (New York: Vintage Books, 1974).

3. Paul Campos, introduction to *The Obesity Myth* (New York: Gotham Books, 2004). I will return later to Campos's argument, which elaborates on the ways in which the government and medical authorities have distorted available evidence on the relationship between weight and health and fostered fat as a pariah of society, resulting in significant economic benefits for the diet and pharmaceutical industries but no significant advances in the so-called obesity epidemic. See also the documentary *Miss Representation* by Jennifer Siebel Newsom, which debuted at the Sundance Film Festival 2011. (Official website accessed January 9, 2012, www.missrepresentation.org.)

4. Jane Gallop, *The Daughter's Seduction: Feminism and Psychoanalysis* (Ithaca, NY: Cornell University Press, 1982), Gen.3:1–24.

5. Ibid., Mark. 6: 21–9.

6. Katharine Briggs, *An Encyclopedia of Fairies: Hobgoblins, Brownies, Bogies, and Other Supernatural Creatures* (New York: Pantheon, 1976), 287–91.

7. For a detailed discussion of this, see "Hunger as Ideology" in Susan Bordo, *Unbearable Weight: Feminism, Western Culture, and the Body* (Berkeley, CA: University of California Press, 1993), 99–133.

8. This discussion is also informed by Bordo's *Unbearable Weight: Feminism, Western Culture, and the Body*, among other theorists.

9. Bordo, *Unbearable Weight: Feminism, Western Culture, and the Body*, 165. Bordo is summarizing Mary Douglas's argument in *Natural Symbols* (New York: Pantheon, 1982).

10. Michel Foucault, *The History of Sexuality Volume I: An Introduction*, trans. Robert Hurley, 1990 ed. (New York: Vintage Books, 1978); Pierre Bourdieu, *Masculine Domination*, trans. Richard Nice (Stanford, CA: Stanford University Press, 2001).

11. Nadia Medina, Kate Conboy, and Sarah Stanbury, eds., introduction to *Writing on the Female Body: Female Embodiment and Feminist Theory, Gender and Culture Reader* (New York: Columbia University Press, 1997).

12. Foucault, *The History of Sexuality Volume I: An Introduction*, 135–69.

13. Michel Foucault, *Discipline and Punish: The Birth of the Prison*, trans. Alan Sheridan, 2nd ed. (New York: Vintage Books, 1995), 156.

14. Ibid., 201.

15. For a full discussion of this, see Sandra Lee Bartky, *Femininity and Domination: Studies in the Phenomenology of Oppression* (New York: Routledge, 1990), 81.

16. Margo Maine, *Body Wars: Making Peace with Women's Bodies, an Activist's Guide* (Carlsbad, CA: Gurze Books, 2000), 116.

17. See for example Peter N. Stearns, *Fat History: Bodies and Beauty in the Modern West* (New York: New York University Press, 2002). Or Hillel Schwartz, *Never Satisfied: A Cultural History of Diets, Fantasies, and Fat* (New York: Anchor Books, 1986), upon whose work much of this chapter is built.

18. On the other hand, in the mid nineteenth century, Stanton was ahead of the fashion curve and was criticized, along with Amelia Bloomer, for wearing the "bloomer costume," which was similar to the pantaloons and skirts young

American girls had been wearing since the 1820s. Although the outfit released women from the cultural burden of the corset, it was said that the look was not complimentary to the body of a mature woman. Stanton said later, "We knew the Bloomer Costume could never be generally becoming, as it required perfection of form, limbs, and feet, such as few possess, and we who wore it knew that it was not artistic" (quoted in Schwartz, *Never Satisfied*, 56). It seems abundant flesh in a woman was more fashionable if it was contained and sculpted by a corset.

19. Stearns, *Fat History*, 13.
20. Laura Fraser, *Losing It: America's Obsession with Weight and the Industry That Feeds on It* (New York: Penguin Books, 1997), 31.
21. Schwartz, *Never Satisfied*, 168–71.
22. Stearns, *Fat History*, 32.
23. Schwartz, *Never Satisfied*, 124–28.
24. Stearns, *Fat History*, 54.
25. Ibid., 60.
26. Quoted in Stearns, *Fat History* (New York, New York University Press, 2002), Kindle edition; Francis Benedict, "Food Conservation by Reduction of Rations," *Nation 101*, 1918, 355–57.
27. Susan Faludi, *Backlash: The Undeclared War Against American Women* (New York: Anchor Books, 1991), 50.
28. Maine, *Body Wars*, 118; Stearns, *Fat History*, 72.
29. James S. McLester, "The Principles Involved in Treatment of Obesity," *Journal of the American Medical Association* 82 (1924): 2103.
30. *Stearns, Fat History,* 105.
31. Quoted in Stearns, *Fat History*, 83; Murray Siegel, *Think Thin* (New York, 1971), 28 and 103; Theodore Rubin, *The Thin Book* (New York, 1966), 11, 46, 54; Sidney Petrie, *The Lazy Lady's Easy Diet* (West Nyack, NY, 1968); Frank J. Wilson, *Glamour, Glucose, and Glands* (New York, 1956).
32. Ibid., 83.
33. Although many flappers bound their breasts in order to achieve the slender, lean line dictated by the fashion.
34. Stearns, *Fat History*, 87.
35. Fraser, *Losing It*, 40–43.
36. Campos, *The Obesity Myth*, 42; Amy Erdman Farrell, *Fat Shame: Stigma and the Fat Body in American Culture* (New York: New York University Press, 2011), 14.
37. Stearns, *Fat History*, 118–19.
38. J. Eric Oliver, *Fat Politics: The Real Story Behind America's Obesity Epidemic* (New York: Oxford University Press, 2006), 46–9.
39. Campos, *The Obesity Myth*, 14.
40. Ibid., 38.
41. Campos, *The Obesity Myth,* 137–8.
42. Glenn A. Gaesser, *Big Fat Lies: The Truth About Your Weight and Health* (Carlsbad, CA: Gurze Books, 2002).
43. Fraser, *Losing It*, 209–32. See also Gaesser, Campos, and Oliver.

44. Michael Gard and Jan Wright, *The Obesity Epidemic: Science, Morality, and Ideology* (New York: Routledge, 2006), 106.
45. For further discussion, see also Abigail Saguy's chapter "The Blame Frame" in *What's Wrong With Fat?* (London, Oxford University Press, 2013), 69–106.
46. Gard and Wright, *The Obesity Epidemic*, 62.
47. Tara Parker Pope, "The Fat Trap," *New York Times Magazine*, January 1, 2012.
48. Oliver, *Fat Politics*, 73.
49. Ibid., 74.
50. Greg Critser, "Let Them Eat Fat," *Harper's Magazine*, March, 2000, 41–7. Critser went on to write a book called *Fat Land* in 2003, which, as Michael Gard and Jan Wright point out in *The Obesity Epidemic*, is written in a nonacademic style but clearly is intended for the reader to understand as a serious, scientifically informed contribution.
51. Susan Bordo, *Twilight Zones: The Hidden Life of Cultural Images from Plato to O.J.* (Berkeley, CA: University of California Press, 1997), 8.
52. David Lempart, "Size Matters," *The Atlantic,* 2008. See also "Fat Bias Worse for Women," in *The New York Times,* March 31, 2008.
53. P. Goldblatt, M. Moore, and A. Stunkard, "Social Factors in Obesity," *JAMA* 192 (1965): 1039–44.
54. Oliver, *Fat Politics*, 79–81.
55. Ibid., 85.
56. Judith Butler, *Gender Trouble: Feminism and the Subversion of Identity* (London: Routledge, 1999), 134.

## Chapter 2

1. Pierre Bourdieu, *The Field of Cultural Production.*
2. David Savran touched on this when he wrote, "Perhaps the most obvious distinction between theatre and mass culture is the former's considerably higher admission price. A ticket to Broadway or a regional theatre can cost up to ten times the price of a movie ticket . . . Theatre's costliness means that it remains a more specialized art form and its audiences (like those for many independent films) are often well-educated and highly professionalized spectators." *The Playwright's Voice: American Dramatists on Memory, Writing, and the Politics of Culture* (New York: Theatre Communications Group, 1999), iv.
3. *Fat Chance* actually played at the Colony Studio Playhouse in Los Angeles and other California venues but never transitioned to Broadway. *My Fat Friend* originated at the Globe Theatre in London and did have a successful Broadway run. However, I posit that the cultural fields encompassing a London/West End or New York/Broadway audience and that of a Los Angeles-based playhouse audience are similar in their predominately white, upper-middle-class demographic and taste for material with commercial appeal.
4. "My Fat Friend," *Internet Broadway Database*, http://www.ibdb.com/production.php?id=3323 (accessed September 6, 2010).

5. Lance Morrow, "Taking It Off," *Time*, April 15,1974, http://www.time.com/magazine/article/ (accessed February 18, 2008).

6. Clive Barnes, "My Fat Friend From Britain," *New York Times*, April 1, 1974, http://newyorktimes.com (accessed February 2, 2008).

7. Charles Laurence, *My Fat Friend*, Oberon Modern Plays (London: Oberon, 2003), 97.

8. Ibid., 34.

9. Ibid., 52.

10. Ibid., 61.

11. Ibid.,109.

12. Ibid., 79.

13. Redgrave was Weight Watchers' spokesmodel from 1983 to 1991. See her entry at Internet Movie Database, http://www.imdb.com/name/nm0001655/otherworks (accessed November 13, 2008).

14. Alex Witchel, "Cherry Jones at the Peak of Her Powers," *New York Times Magazine*, September 22, 2013, (34–39).

15. Judy Klemesrud, "Lynn Redgrave Fat? Only with Pads Now," *New York Times*, April 13, 1974.

16. For a full discussion on the way in which obesity triggers disgust and/or fear of contamination as it relates to bodily fluids such as sweat and tears or rolls of flesh, see William Ian Miller's *The Anatomy of Disgust* (Cambridge, MA: Harvard University Press, 1997).

17. Produced at Blue Sphere in 2002 according to *Talkin' Broadway* review, http://www.talkinbroadway.com/regional/la/la52.html. I also contacted Samuel French directly, and they had the following production history of amateur performances since 1999: Firehouse Cultural Center, FL; Octad Lakeside Productions, Lakeside, CA; Willits Community Theatre, Willits, CA; The Valley Players, Green Valley, AZ.

18. Brochu is an actor-playwright-novelist-composer based in Los Angeles who has been a player on the LA theatre scene and on the New York theatre scene for years.

19. Jim Brochu, *Fat Chance* (New York: Samuel French, 1993), V.

20. Ibid., 37.

21. Ibid., 53.

22. Ibid., 62.

23. Ibid., 76.

24. The notion that a fat person literally overflows with tears or sweat, for example, is another common social fear/stereotype. For a full discussion on fear of contamination as it relates to bodily fluids, see William Ian Miller's *The Anatomy of Disgust* (Cambridge, Harvard University Press, 1997).

25. When *The Heidi Chronicles* hit Broadway (1989), Jill Dolan was among many feminist scholars who criticized the play as "co-opted" and "assimilated to the liberalism of those who sell out to established systems like the meritocracy of mainstream American theatre." She believed the play "belittled and dismissed the feminist movement" and that, "[I]t's form—realist comedy—and

its context—Broadway and subsequently American regional theatres—meant a priori that the play was ideologically corrupt and had nothing useful to say to or about feminism." After Wasserstein's death (2006), an article appeared in *Theatre Journal* in which Dolan revised her some of her earlier assertions and explored the possibilities for feminist aims in popular theatre and the work of liberal feminist playwrights within that. Jill Dolan, "Feminist Performance Criticism and the Popular," *Theatre Journal* 60 (2008): 433–5.

26. Sue-Ellen Case, *Feminism and Theatre* (New York: Routledge, 1988), 124.
27. Laura Cunningham, "Beautiful Bodies," in *Plays for Actresses*, ed. Eric Lane & Nina Shengold (New York: Vintage Books, 1997), 158.
28. Ibid., 239.
29. Susan Bordo, *Unbearable Weight: Feminism, Western Culture, and the Body* (Berkeley, CA: University of California Press, 1993), 99–134.
30. Madeleine George, *The Most Massive Woman Wins*, in *Plays for Actresses*, eds. Eric Lane and Nina Shengold (New York: Vantage Books, 1997), 275–6.
31. Ibid., 284.
32. Ibid., 278.
33. Ibid., 286
34. Sandra Lee Bartky, *Femininity and Domination: Studies in the Phenomenology of Oppression* (New York: Routledge, 1990), 77.
35. George, *The Most Massive Woman*, 291.
36. *The Vagina Monologues* was made into a movie for HBO with Eve Ensler reprising her role. It has also been performed at Madison Square Garden with a celebrity cast. It has been translated into multiple languages and is performed around the world each year on February 14th to promote V-Day, which is a global nonprofit that raises money for charities dedicated to stopping violence against women. For more information, see http://newsite.vday.org/.
37. Eve Ensler, preface to *The Good Body* (New York: Villard, 2004).
38. *The Good Body*, with its Broadway venue and popular appeal, may be an example of what Jill Dolan is referring to when she writes, "I also find lately that many would-be 'downtown,' materialist, feminist performance artists hold a lot in common with many so-called uptown, liberal feminist playwrights. Although they might employ different techniques and styles (and budgets) to address different topics in very different production contexts, their aspirations are similar and simple: to reach as wide an audience as possible with innovative, socially progressive work." Jill Dolan, "Feminist Performance Criticism and the Popular," *Theatre Journal* 60 (2008): 435.
39. Ibid., 7–9.
40. Ibid., 86.
41. Charles Isherwood, "Our Bellies, Ourselves: Eve Ensler Talks About Fat," *New York Times*, November 16, 2004.
42. Pierre Bourdieu, *Masculine Domination*, trans. Richard Nice (Stanford, CA: Stanford University Press, 2001), 38.
43. Ibid., 41–2.
44. *A Moon for the Misbegotten* was composed in 1947 but saw its most successful performances in the last third of the twentieth century.

## Chapter 3

1.  Eugene O'Neill, *A Moon for the Misbegotten* (New York: Vintage Books, 1974), 1.
2.  Ibid., Introduction by Barbara Gelb.
3.  Ibid., 76–7.
4.  Barbara Gelb, "A Second Look, and a Second Chance to Forgive," *New York Times*, March 19, 2000, http://newyorktimes.com/ (accessed April 25, 2008).
5.  Jason Robards and Colleen Dewhurst, performance of *A Moon for the Misbegotten*, directed by Jose Quintero, recorded in 1974 for New York Public Library Theatre on Film and Tape Archive.
6.  Frank Rich, "Kate Nelligan in 'Moon for the Misbegotten,'" *New York Times*, May 2, 1984, http://newyorktimes.com/ (accessed April 25, 2008).
7.  Ben Brantley, "A Moonlight Night on the Farm, Graveyard Ready," *New York Times*, April 10, 2007, http://newyorktimes.com/ (accessed April 25, 2008).
8.  Ibid.
9.  Sara Krulwich, image of Cherry Jones and Roy Dotrice in *A Moon for the Misbegotten*, http://www.eoneill.com/artifacts/reviews/mfm5_times.htm (accessed March 4, 2014).
10.  Edward J. Moore, *The Sea Horse* (Clifton, NJ: James T. White and Company, 1969), 7–8.
11.  Mel Gussow, "The Sea Horse's Star (and Its Author) Sheds Alias," *New York Times*, April 22, 1974, http://thenewyorktimes.com/ (accessed March 8, 2008).
12.  Moore, *The Sea Horse*, 17.
13.  Mel Gussow, "Two Poignant Characters in Irwin's 'Sea Horse,'" *New York Times*, March 5, 1974, http://newyorktimes.com/ (accessed March 8, 2008).
14.  Moore, *The Sea Horse*, 56.
15.  Gussow, "Two Poignant Characters in Irwin's 'Sea Horse,'" *New York Times*, March 5, 1974, http://www.nytimes.com, Gussow reviewed it again on April 16, 1974 after it transferred and called the performances "tender" and "wistful" and praised the playwriting.
16.  Terrence McNally, *Frankie and Johnny in the Clair de Lune* (New York: Dramatists Play Service, 1988), 5.
17.  In the *New York Times* op-ed article he wrote on June 23, 1991, entitled "Theater: Hearing Voices is the Good Part in Writing a Play," McNally writes that he envisioned Kathy Bates playing Frankie the entire time he was writing, although he did not know her personally.
18.  McNally, *Frankie and Johnny*, 30.
19.  Ibid., 42.
20.  See Lucille Lortel off-Broadway database for replacement casts and awards nominations, http://www.lortel.org/LLA_archive/index.cfm?search_by=show&title=Fat%20Pig (accessed November 10, 2008).
21.  Sara Krulwich, image of Ashlie Atkinson and Jeremy Piven in the MCC production of *Fat Pig*, http://www.nytimes.com/imagepages/2004/12/16/arts/16pig_CA0ready.html (accessed March 4, 2014).
22.  Neil LaBute, *Fat Pig* (New York: Faber and Faber, 2004), 15.

23. Ibid., 16.

24. John Simon, "Whispers and Size," *New York Magazine*, December 27, 2004 http://nymag.com/nymetro/arts/theater/reviews/10737/ (accessed May 9, 2014); Dan Bacalzo, "Review of *Fat Pig*, *Theatremania*, December 15, 2004, http://www.theatermania.com/new-york-city-theater/reviews/12-2004/fat-pig_5453.html (accessed May 10, 2014); and Ben Brantley, "She's Fat, He's a Man, Can They Love?", *New York Times*, December 16, 2004, http://www.nytimes.com/2004/12/16/theater/reviews/16pig.html?_r=0 (accessed May 10, 2014).

## Chapter 4

1. Jennifer-Scott Mobley, "Tennessee Williams' Ravenous Women: Fat Behavior Onstage," *Fat Studies: An Interdisciplinary Journal of Weight and Society* 1:1 (2012): 75–90. Reprinted by Permission of Taylor and Francis.

2. Samantha Murray, *The 'Fat' Female Body* (New York: Palgrave Macmillan, 2008), 13–14.

3. Andrea Elizabeth Shaw also uses the term "fat behavior" with essentially the same meaning as above in her book, *The Embodiment of Disobedience* (New York: Lexington Books, 2006), 50.

4. According to the Internet Movie Database, www.imdb.com (accessed November 11, 2008), Magnani's poor English skills prevented her from appearing in the Broadway production, which instead starred Maureen Stapleton, who won a Tony for her performance. Magnani won an Oscar for her portrayal of Serafina in the movie version of *The Rose Tattoo*.

5. Tennessee Williams, *The Rose Tattoo*, in *Three by Tennessee* (New York: Signet Classic, 1951; reprint, 1976).

6. For a full discussion on the notion of the Fat Woman "letting herself go," see Cecelia Hartley's essay "Letting Ourselves Go" in *Bodies Out of Bounds: Fatness and Transgression*, eds. Jana Evans Braziel and Kathleen LeBesco (Berkeley, CA: University of California Press, 2001).

7. Mary Douglas, *Purity and Danger: An Analysis of Concept of Pollution and Taboo* (New York: Routledge, 1966), 2.

8. Williams, *The Rose Tattoo*, 160–61.

9. Ibid., 163.

10. Ibid., 170.

11. Ibid., 171.

12. Ibid., 175.

13. Ibid., 199–200.

14. For an image of Stapleton, see http://www.allposters.com/-sp/Actress-Maureen-Stapleton-Performing-in-a-Scene-from-The-Rose-Tattoo-Posters_i8523041_.htm.

15. Mercedes Ruehl and Anthony Lapaglia, performance of *The Rose Tattoo*, directed by Robert Falls, recorded in June, 1994, for New York Public Library Theatre on Film and Tape Archive.

16. Ibid., 208.
17. Within Serafina's immigrant community, Mangiacavallo's name would be understood for its full meaning.
18. Tennessee Williams, *The Night of the Iguana,* in *Three by Tennessee* (New York: Signet Classic, 1961; reprint 1976).
19. Ibid., 256.
20. Ibid., 9.
21. Ibid., 9.
22. Ibid., 10.
23. Ibid., 20.
24. Ibid., 65.
25. Ibid., 74.
26. Ibid., 85.
27. Vincent Canby, "Tennessee Williams in Deep Complexity," *New York Times,* March 22, 1996, http://nytimes.com/ (accessed November 26, 2008).
28. Tennessee Williams, *Small Craft Warnings* (New York: New Directions Books, 1972).
29. Williams, *Small Craft Warnings,* 16.
30. Ibid., 40–41.
31. Ibid., 57.
32. Ibid., 37.
33. Ibid., 63.
34. Edward Albee, *Who's Afraid of Virginia Woolf?* (New York: Signet Publishing, 1962; reprint, 1983), 7.
35. Susan Bordo, *Unbearable Weight: Feminism, Western Culture, and the Body* (Berkeley, CA: University of California Press, 1993), 116–17.
36. Albee, *Who's Afraid of Virginia Woolf?,* 16.
37. Ibid., 24.
38. Ibid., 59.
39. Ibid., 188.
40. Ibid., 35.
41. Ibid., 90.
42. Naomi Wolf, *The Beauty Myth: How Images of Beauty Are Used Against Women* (New York: Harper Perennial, 2002), 187.
43. Kathleen LeBesco, *Revolting Bodies?: The Struggle to Redefine Fat Identity* (Amherst, MA: University of Massachusetts Press, 2004).
44. In her article "The Body and Reproduction of Femininity," Susan Bordo makes a compelling argument for female-associated disorders such as hysteria, anorexia, and agoraphobia as being involuntary responses to the patriarchal order through which women's bodies/minds pathologically resist subordination despite their outward attempts to comply. Honey's medical mishaps could potentially fall into this category. See *Writing on the Body: Female Embodiment and Feminist Theory,* eds. Katie Conboy, Nadia Medina, and Sarah Stanbury (New York: Columbia Press, 1997).
45. Ben Brantley, "Marriage as Blood Sport: A No Win Game," *New York Times,* March 21, 2005, http://nytimes.com/ (accessed October 25, 2013).

46. Ben Brantley, "How the Divas Did It," *New York Times*, May 20, 2005, http:// nytimes.com/ (accessed October 10, 2005).

47. Turner was also well reviewed for her portrayal of the aging seductress Mrs. Robinson in the stage production of *The Graduate* in 2002. Significantly, she also had a recurring role in the popular TV show *Friends* as Chandler's *dad*, who had had a sex-change operation and was now his lascivious mother.

48. Charles Isherwood, "Mess With Her or Not: You'll Get an Earful," *New York Times*, December 7, 2012, www. nytimes.com (accessed July 1, 2013).

## Chapter 5

1. *The Minneola Twins*, the other half of this collection, is a satirical piece that pits Myrna the "good twin" with large breasts against Myra the "evil twin," who is identical except for her small breasts. In some ways this works against my theory wherein larger bodies are victimized and smaller bodies are rewarded or at least shielded from male violence. At the same time, that the "evil twin" is small breasted reveals a flip side of the patriarchal aesthetics that dominate women's bodies in our culture.

2. Paula Vogel, *How I Learned to Drive*, in *The Mammary Plays* (New York: Theatre Communications Group, 1998).

3. Ibid., 15–16.

4. Indeed, research surrounding anorexia in girls links the eating disorder with, among other factors, a young woman's desire to halt her sexual maturation process and remain a child without womanly curves and breasts as signifiers of adult sexuality.

5. See Cecelia Hartley, "Letting Ourselves Go: Making Room for the Fat Body in Feminist Scholarship," in *Bodies Out of Bounds: Fatness and Transgression*, eds Jana Evans Braziel and Kathleen LeBesco (Berkeley, CA: University of California Press, 2001), 62.

6. Paula Vogel, *Hot 'N' Throbbing*, in *Baltimore Waltz and Other Plays* (New York: Theatre Communications Group, 1996).

7. Ibid., 238.

8. A *Glamour* study (February 1984) that has been replicated many times polled thirty-three thousand women, and 75 percent considered themselves too fat, while only 25 percent were actually above Metropolitan Life Insurance Standards and 30 percent were actually below.

9. Hartley, "Letting Ourselves Go," 71.

10. Vogel, *Hot 'N' Throbbing*, 356.

11. Ibid., 292.

12. Paula Vogel, *The Baltimore Waltz* in *The Baltimore Waltz and Other Plays* (New York: Theatre Communications Group, 1996), 20–1.

13. At that time, Johnston was arguably "fat" by Hollywood standards. Several years later an article in the *Los Angeles Times* in which she discusses how a burst ulcer caused her to lose sixty pounds, and the tabloids assumed she was trying to get her career back on track, suggest that indeed the actress is

perceived within the industry as overweight. Michael Ordona, "Kristen John-ston Steals the Scene," *Los Angeles Times*, January 8, 2009, http://www.latimes.com/entertainment/news/movies/la-et-performance8-2009jan08,0,1423636.story (accessed February 27, 2009).

14. Charles Isherwood, "Death-Defying Fantasy Fueled by Love When AIDS Was a Nameless Intruder," *New York Times,* December 6, 2004, http://newyorktimes.com/ (accessed December 7, 2008).
15. Elyse Sommer, "Review: Baltimore Waltz," December 12, 2004, http://www.curtainup.com/baltimore waltz.html (accessed December 1, 2008).
16. Beth Whitaker, "Finding the Happy Day," interview with Paula Vogel in *The Signature Edition* 7.1 (New York: 2004).
17. Vogel, *The Baltimore Waltz*, 131.
18. Ibid., 171.

## Chapter 6

1. See Sander L. Gilman's essay "Black Bodies, White Bodies: Toward an Ico-nography of Female Sexuality in Late Nineteenth Century Art, Medicine, and Literature," in *The Feminism and Visual Culture Reader*, ed. Amelia Jones (New York: Routledge, 2003), 136–150. Also, Amy Erdman Farrell, *Fat Shame: Stigma and the Fat Body in American Culture* (New York: New York University Press, 2011).
2. Gilman, "Black Bodies, White Bodies," 150.
3. bell hooks, "Selling Hot Pussy: Representations of Black Female Sexuality in the Cultural Marketplace," in *Writing on the Body: Female Embodiment and Feminist Theory*, eds. Nadia Medina, Katie Conboy, Sarah Stanbury (New York: Columbia University Press, 1997), 113–28.
4. Andrea Elizabeth Shaw, *The Embodiment of Disobedience: Fat Black Women's Unruly Political Bodies* (New York: Lexington Books, 2006).
5. It is worth mentioning that Vanessa Williams was actually forced to give up her crown in 1984 following the unauthorized circulation of some nude photos she had posed for prior to her pageant days. She posed erotically with another woman simulating lesbian sex. Unfortunately for Williams, the photos corrob-orated American anxieties about black female sexuality that I discuss in this chapter.
6. Shaw, *The Embodiment of Disobedience: Fat Black Women's Unruly Political Bodies*, 20.
7. Ibid., 21.
8. Ibid., 9. See Shaw for Granny Nanny, and for lyrics to "Baby Got Back" by Sir Mix-A-Lot see http://www.azlyrics.com/lyrics/sirmixalot/babygotback.html (accessed June 15, 2009).
9. Ibid., 108–12. See Shaw for more detailed discussion of Rainey's performance style.
10. August Wilson, *Ma Rainey's Black Bottom* (New York: Plume, 1981), 86.

11. Shaw, *The Embodiment of Disobedience: Fat Black Women's Unruly Political Bodies*, 108–10. See also Abigail C. Saguy, *What's Wrong With Fat* (New York: Oxford University Press), 95–106.
12. Wilson, *Ma Rainey's Black Bottom*, 48.
13. Ibid., 52–3.
14. Frank Rich, "Theater: Wilson's 'Ma Rainey' Opens," *New York Times*, October 12, 1984, http://newyorktimes.com (accessed April 27, 2009).
15. Shaw, *The Embodiment of Disobedience: Fat Black Women's Unruly Political Bodies*, 9.
16. Lisa M. Anderson, *Black Feminism in Contemporary Drama* (Urbana, IL: University of Illinois Press, 2008), 53.
17. Ibid., 65.
18. Suzan-Lori Parks, *Venus* (New York: Theatre Communications Group, 1997), 35.
19. Ibid., 85.
20. Sara L. Warner, "Suzan-Lori Parks's Drama of Disinterment: A Transnational Exploration of *Venus*," *Theatre Journal* 2 (2008): 181–99.
21. Parks, *Venus*, 127.
22. Ibid., 155–6.
23. Mark O'Donnell and Thomas Meehan, *Hairspray* (New York: Applause Books, 2002), xv.
24. Ibid., 3.
25. Ibid., 9.
26. Here I should mention that the character of Edna, who is enormously fat, has traditionally been played by a man in drag. It is actually a kind of double drag because it is a man dressed as a woman and disguised (or enhanced) as fat, which is a drag persona in itself. Drag Queen Divine originated the role in the movie, and Harvey Fierstein originated the role on Broadway. Interestingly, John Travolta, more traditionally known for straight macho roles, donned drag and padded up to play the role in the movie-musical remake (2007). That Tracy's fat mom is actually played by a man in drag potentially complicates my reading of this piece. For purposes of this chapter, however, I will rely on the story narrative, which treats Edna as a woman and more or less elides the drag component. However, the double drag is an example of the complex mixing of fat and queer that I will discuss in the next chapter.
27. *Meehan, Hairspray*, 27.
28. Ibid., 29.
29. David Gates, "Finding Neverland," *Newsweek*, July 13, 2009. In comparing the careers of Michael Jackson and Elvis Presley, Gates reminds us that when Presley's records were first played on the radio in Memphis, the DJs "made a point of noting that he graduated from the city's all-white Humes High School, lest listeners mistake him for black." For me, Link's "Elvis Style" puts him in that same category occupied by Presley (and Jackson) of a "transracial" figure.
30. Meehan, *Hairspray*, 67.
31. Ibid., 69.
32. Ibid., 74–5.
33. Ibid., 77.

34. On June 13 2013, a Florida jury of all-white women turned in a not-guilty verdict against (Hispanic) George Zimmerman, who claimed self-defense when in 2012 he chased down and shot seventeen-year-old African American Trayvon Martin who was wearing a hoodie and armed only with a bag of candy. The trial, which was televised, and the verdict brought race relations to the forefront of national conversation for a myriad of reasons, including that one of the key witnesses for the prosecution of Zimmerman was Rachel Jeantel a fat, dark-skinned black woman who was patronized by the defense attorney and scrutinized in the media for her appearance and seemingly defiant demeanor.
35. Linda Martín Alcoff, "Toward a Phenomenology of Racial Embodiment," in *Race*, ed. Robert Bernasconi (Malden, MA: Blackwell, 2001), 268.
36. Ibid., 268.
37. Ibid., 268.
38. Ibid., 272.
39. Samantha Murray, *The 'Fat' Female Body* (New York: Palgrave Macmillan, 2008), 34–7. See also Jennifer Terry and Jaqueline Urla, "Mapping Embodied Deviance," in *Deviant Bodies*, eds. Jennifer Terry and Jaqueline Urla (Bloomington, IN: Indiana University Press, 1995), 1–18.
40. In fact, CNN reporter Ginny Craves asserts in "The Surprising Reason Why Being Overweight Isn't Healthy" that fat discrimination by medical practitioners, particularly toward women, keeps oversize patients from getting optimum care. Patients' complaints are often dismissed by doctors as a symptom of being overweight and thus go undiagnosed until the condition has reached a more critical phase. Could this be why obesity is allegedly driving up the cost of health care? For example, breast, uterine, or bowel cancer are much more manageable at stage one than stage four. http://cnn.com (accessed January 23, 2010).
41. Murray, *The "Fat" Female Body*, 40–42.
42. Many theatergoers have seen productions where the (frequently closeted) leading man or woman exhibits all the appropriate heteronormative behavior, but he or she simply lacks chemistry with the opposite sex and, on an intuitive level, recognize these actors as queer.
43. Again, by queer bodies I mean those who occupy a position outside of heteronormative sexuality, including lesbians, gay men, bisexuals, transsexuals, and transgendered individuals.

## Chapter 7

1. Shaw, *The Embodiment of Disobedience: Fat Black Women's Unruly Political Bodies*, 72.
2. Judith Butler, *Gender Trouble: Feminism and the Subversion of Identity* (London: Routledge, 1999), 47–48.
3. According to Internet Movie Database, www.imdb.com (accessed June 30, 2009).
4. Charles Isherwood, "Mess With Her or Not: You'll Get an Earful," *New York Times*, December 7, 2012, http://www.nytimes.com (accessed July 10, 2013).

5. Because the play was set in England and originally intended for a British audience, Marcus was commenting on the British obsession with their popular soap operas. However, Americans are not far removed in this cultural stereotype, and the play transferred easily to Broadway.
6. Frank Marcus, *The Killing of Sister George* (New York: Bantam Books, 1969), 1.
7. Ibid., 32.
8. Ibid., 78.
9. Walter Kerr, "Theater: 'The Killing of Sister George' Arrives," *New York Times*, October 6, 1966, http://www.nytimes.com/ (accessed April 10, 2009).
10. Babs Davy, Maureen Angelos, Dominique Dibbell, Peg Healy, Lisa Kron, *The Five Lesbian Brothers/Four Plays* (New York: Theatre Communication Group, 2000), xiv.
11. Ibid., 123.
12. Lisa Kron is a good example of the subjectivity of fat. Many would not consider her fat, but her appearance was slightly heavier than the other Brothers who (according to production stills) were quite trim and athletic looking at the time. She played the compulsive-eating fat character of Peaches. Indeed, Kron seems to self-identify as fat; in her autobiographical solo play, *Well*, she frequently makes fat jokes at her own expense.
13. Babs Davy, *The Five Lesbian Brothers/Four Plays*, 118.
14. Ibid., 175–6.
15. Michel Foucault, *Discipline & Punish: The Birth of the Prison*, trans. Alan Sheridan, 2nd ed. (New York: Vintage Books, 1995), 195–228.
16. Robin Bernstein, *Cast Out: Queer Lives in Theater*, eds. Jill Dolan and David Roman, Triangulations (Ann Arbor, MI: University of Michigan Press, 2006), 160–61.

## Chapter 8

1. Petra Kuppers, "Fatties Onstage: Feminist Performances," in *Bodies Out of Bounds: Fatness and Transgression*, eds. Kathleen LeBesco and Jana Evans Braziel (Berkeley, CA: University of California Press, 2001), 278.
2. I am uncomfortable with the word willpower because I am not convinced it is "all" that is required for people to lose weight. There has been research that suggests that some individuals would have to put immoderate amounts (over and beyond avoiding cookies or giving up fast food) of effort into losing weight or maintaining a certain low weight. In his recent book, *The End of Overeating* (New York: Rodale, 2009), David Kessler MD suggests that overeating is a biological challenge brought on by changes in our food-production industry since the 1980s that cause a short circuit in the brain's food-regulating mechanisms. Most recently, "The Fat Trap," an article in *The New York Times* by Tara Parker Pope discusses the latest research that indicates dieters permanently alter their bodies' metabolisms and hormones that resulting in more significant cravings and a reduction in various hormones that help maintain weight loss.
3. Bordo, *Unbearable Weight: Feminism, Western Culture, and the Body*, 116–17.

4. *9½ Weeks* (1986) is a cult-classic film directed by Adrian Lyne starring Mickey Rourke and Kim Basinger that chronicled a steamy love affair between two strangers. The film was rated R and featured many racy sex scenes including one in which he blindfolds her and feeds her all sorts of "sexy" food from the fridge such as honey and strawberries.

5. In a 2004 interview with *People* magazine, Alley seems to agree with these stereotypes. She tells her interviewer that fat looks funny, stating, "I think that's why people through history laugh at fat people. They're round and funny looking. I am funny looking." When asked about her sex life, she replied, "I'm not going to have sex while I am fat." (*People*, December 6, 2004, 88–9.)

6. Eric Lott, *Love and Theft: Blackface Minstrelsy and the American Working Class* (New York: Oxford University Press, 1993), 143.

7. Alley has very publicly gone up and down her weight spectrum several times since the airing of *Fat Actress*.

8. By September 2010, according to tabloids and talk-show appearances, Alley has gained all the weight back again, plus some, proving that dieting does not work, as much medical evidence suggests. She appeared on *Oprah* and, after blaming herself for "falling off the wagon," told Oprah she had a new diet secret and was going to quickly lose the seventy-five or so pounds again. http://www.oprah.com/dated/oprahshow/oprahshow-20090417-kirstie-alley (accessed August 6, 2009). Alley participated in the reality show *Dancing With the Stars* in the fall of 2011 and lost one hundred pounds, presumably due to the intense training schedule, but she also began taking and selling her own organic diet products. As of January 2012, Alley remained at her slimmest size in decades.

9. Lott, *Love and Theft*, 112–3.

10. Ibid., 115.

11. As a feminist, I do not mean to imply that stereotyping all attractive girls as dumb and shallow is any less offensive than exploiting fat stereotypes, but in the course of this work, I am focusing on reframing fat.

12. *King of Queens* is another romantic half-hour sitcom that ran on CBS from 1998 to 2007, about a blue-collar couple played by Kevin James and Leah Remini. He was an IPS (UPS) truck driver, and she was a legal secretary. Although Kevin James, as the husband, was fat for most of the series (he lost weight at one point during the course of the show), Remini, as the wife, basically adhered to Hollywood standards of slenderness.

13. Lott, *Love and Theft*, 142.

14. However, by 2012 Melissa McCarthy had changed the game, winning an Emmy in 2011 for her portrayal of Molly as well as being nominated for a SAG and an Academy Award for best supporting actress for her comic role in the movie *Bridesmaids*.

15. McCarthy was not Hollywood slender when she played a secondary character on *Gilmore Girls*. She played the lead character's best friend and was, appropriately, a zealous chef.

16. Unlike film or television, there is a significant presence of fat performers in stand-up comedy, ranging from Roseanne's early work to Louis Anderson, Rosie O'Donnell, Ralphie May, Gabriel Iglesias, and Mo'Nique, to name a few.

However, typically the comedic routines of these performers focus entirely on self-deprecating comedy of being fat.

17. McCarthy reprises this fat-face gesture in the opening sequence of the 2013 film *Identity Thief*. The character, after successfully stealing someone's credit card, goes to a bar and buys drinks for all, drinking to excess until she gets thrown out, at which point she projectile vomits.

18. See http://www.marieclaire.com/sex-love/dating-blog/overweight-couples-on-television (accessed October 30, 2010). Her blog sparked fat-positive protesters to stage a "kiss-in" outside the Hearst building in New York. http://blogs.wsj.com/speakeasy/2010/10/30/anti-marie-claire-protestors-stage-a-kiss-in-at-hearst-building-denounce-fatties-blog-post/tab/print/ (accessed October 20, 2010).

19. Here, the word *fat* is insufficient. As yet, Fat Studies lacks vocabulary to denote the differences in body size that impact how bodies are read in representation. Molly is fat. But Mike is much fatter. I would bet that Melissa McCarthy is not too far from the national female average for weight, which, according to recent studies is 164 pounds. Yet for TV purposes, she is fat. To me, in the first season Billy Gardell looks "obese"—whatever that means in semiotic terms. Furthermore, he carries his fat lower and around his hips (as opposed to high and in the chest), which also contributes to how his body is read. The shape of his fat feminizes him, which is not the case for all fat men. Actor John Goodman, for instance, carries his fat higher and has a more blocky upper body which, I assert, reads as more masculine. As of this writing, Gardell has lost about sixty-pounds; *Mike & Molly's* producing network hired a personal trainer for him. http://www.youtube.com/watch?v=sP-X7dtCCrg (accessed July 17, 2013).

20. Callendar's Minstrels, sometimes known as the Original Georgia Minstrels (est. circa 1876) were one of the most significant forerunners of the all-black minstrel troupe. For more on black minstrel troupes, see *A History of African American Theatre*, eds. Harold G Hill and James Hatch (Cambridge: Cambridge University Press, 2003).

21. http://starcasm.net/archives/168218 (accessed July 17, 2013).

## Chapter 9

1. Cho's performance I saw live, and my exploration of Shear's performance is based on the text and reviews, as well as a recording at the New York Public Library Theatre on Film and Tape Archive.

2. Here I should note that, in terms of performing the "self," these performers take a page from a rich tradition of feminist solo autobiographical performance that evolved in the late sixties and early seventies. However, none of them, except perhaps Cho, self-identify as feminist. As Marvin Carlson writes, "[T]he most elaborately developed area of identity performance, both in theory and in practice, has involved performance by women." He goes on to state, "[O]ne of the first manifestations of feminist performances, and still an important approach, utilized specifically autobiographical material . . . with a consciousness of the

political and social dimensions of such material." Marvin Carlson, *Performance* (New York: Routledge, 1996) 157–62. Female performance artists such as Yvonne Rainer, Carolee Schneeman, Rachel Rosenthal, and Deb Margolin are just a few examples of those who paved the way for performance of the self as a feminist performance strategy.

3. Peggy Phelan, *Unmarked: The Politics of Performance* (London, Routledge, 1993), 5.
4. Ibid., 10.
5. Ibid., 7.
6. Judith Butler, *Gender Trouble:Feminism and the Subversion of Identity* (London: Routledge, 1999), 194.
7. David Savran, *Taking It Like A Man: White Masculinity, Masochism, and Contemporary American Culture* (Princeton, NJ: Princeton University Press, 1998), 8.
8. Claudia Shear, *Blown Sideways through Life* (New York: Dial Press, 1995), 41.
9. J. Eric Oliver, *Fat Politics: The Real Story Behind America's Obesity Epidemic* (New York: Oxford University Press, 2006), 72–3.
10. Frank Rich, "Fat and 64 Jobs Later, Misfit Finally Finds a Niche Onstage," *New York Times*, September 22, 1993. The review is favorable, but it is remarkable that Rich makes a point to inaccurately guess her age (she was, in fact, 31 at the time) highlighting his focus on her physical characteristics.
11. See Lortel Archives Internet Off-Broadway Database, http://www.lortel.org/LLA_archive/index.cfm?search_by=people&keyword=name&first=Claudia%20&last=Shear&middle (accessed September 26, 2009).
12. Margo Jefferson, "Self-Portraits on Stage: Perspective Is Crucial," *New York Times*, July 30, 1995, http://nytimes.com/ (accessed September 26, 2009).
13. Marc Peyser, "The Ultimate Working Girl," *Newsweek*, November 8, 1993.
14. Shear, *Blown Sideways*, 41.
15. Butler, *Gender Trouble*, 166.
16. Ibid., 166–7.
17. My emphasis.
18. Shear, *Blown Sideways*, 2–4.
19. Ibid., 4.
20. David Lempert in "Women's Increasing Wage Penalties From Being Overweight and Obese," in *The Atlantic*, March 2008, reports that there is growing prejudice toward fat white women in the job-market as found by the U.S. Bureau of Labor Statistics. In 1981 a woman with the hypothetical "overweight" body-mass in the 75th percentile (about 165 pounds for a 5'4" woman) could expect to earn 4.29 percent less than her slimmer colleagues. In 2000 that same woman could expect to earn 7.47 percent less.
21. I viewed a performance of this recorded during the show's run at New York Theatre Workshop at the New York Public Library Theatre on Film and Tape Archive on June 21, 2013.
22. In her televised performance *I'm the One that I Want* (2000), Cho detailed how her producers requested that she lose weight because her Korean face was too round for the camera. She went on such a radical diet that she landed in the

hospital with kidney failure. She also chronicles the years of dieting, bulimia, binge exercise behavior, and poor health that followed this incident in her life.

23. Cho is married to a man but self-identifies as queer. She is extremely active in promoting LGBT interests and is a darling of gay fans. She also openly discusses her bisexual activities as part of her comedy.

24. I originally found these on Cho's blog: http://www.margaretcho.com/ (accessed May 18, 2008). She posted the hate mail on her blog as it came to her, including email addresses, in hopes that her fans would engage and deter the attacks. I tried to access the emails again on her site as of July 21, 2009, and it looks as though they have been removed or archived. However, they can still be found at the following link, if you care to read some of the most horrifying, racist hate mail you can imagine: http://www.apj.us/20040114CroMag.html#20040115. The site also chronicles how a transcript from Cho's comedy routine in 2004 was inaccurately edited and posted by Matt Drudge on a right-wing website called freerepublic.com, resulting in the onslaught of hate mail.

25. This joke was a wink to the YouTube phenomenon in which budding performance artist Chris Crocker recorded himself passionately begging the camera for the same thing. The video went viral for several weeks in September 2007.

26. Certainly the viewers could have left for many reasons, but my personal perception, based on a few negative remarks I overheard while she was performing, is that they were especially offended by her fatness and also by her send-up of patriotism. I have also seen men jeer at Dirty Martini at The Slipper Room, a downtown burlesque performance venue in New York City.

27. Jill Dolan, *The Feminist Spectator as Critic* (Ann Arbor, MI: University of Michigan Press, 1991), 65.

28. Dolan writes, "[A]lthough Finley bases her work in the body, her content is not the biologically ordained capabilities idealized in cultural performance art. She focuses on the circulation of sexual power assumed by a woman who will not be socialized as sexually submissive according to her assigned gender role." Ibid., 66.

29. In fact, Finley appeared nude in *Playboy* (July 1999).

30. Liepe-Levinson, *Stripshow: Performances of Gender and Desire*, 96–100.

31. Ibid., 98–100. Liepe-Levinson also discusses the regular practices of excessive exercise, tanning, hair removal, and plastic surgery that many striptease performers engage in as part of maintaining a competitive edge in the field.

32. In *How I Met Your Mother*, the notorious womanizer Barney (played by openly gay actor Neil Patrick Harris) frequents strip clubs. Bodies of female strippers are frequently part of the backdrop.

33. http://www.mylifetime.com/on-tv/shows/drop-dead-diva/cast (accessed on July 27, 2009).

34. Aside from her appearance in the ABC series *All American Girl*, based on her life as a Korean American, which ran for about nineteen episodes in 1994, http://www.imdb.com/title/tt0108693/ (accessed July 27, 2009), Cho also had her own VH1 "reality show" called the *Margaret Cho Show*, which ran for about eight episodes in 2008, http://www.vh1.com/shows/the_cho_show/episodes.jhtml (accessed on July 27, 2009). *All American Girl* was marginally more

successful but was canceled in part because Cho could not lose enough weight to satisfy the network.

35. You can watch some of Roseanne's early comic routines online: http://www.youtube.com/watch?v=bqqThuH_qGI&feature=related (accessed July 27, 2009), http://www.youtube.com/watch?v=UIBNO5y66xA&NR=1 (accessed July 27, 2009).

36. Oliver, *Fat Politics*, 75.

37. http://www.imdb.com/title/tt0094540/ (accessed on July 28, 2009).

38. Kathleen Rowe, *The Unruly Woman: Gender and the Genres of Laughter* (Austin, TX: University of Texas, 1995), 64–5.

39. You can find a poor-quality video of this historic moment on YouTube at http://www.youtube.com/watch?v=DrFW2aYHVR8 (accessed August 1, 2009). I found it interesting that at the time of my viewing there were many recent (within the week) viewer responses to the video—an event that happened almost ten years ago. Interestingly, some of the negative responses likened her fatness and lack of patriotic pride to liberal Judge Sonia Sotomayor, who is Puerto Rican, and was then in the confirmation process to be the next U.S. Supreme Court Justice. Here again, we see the connection between fat, race, and liberal politics in the cultural landscape.

40. *Rowe, Unruly Women*, 50–2.

41. Ibid., 69.

42. McEntire is also a popular country-western singer, so we'd have to suspend disbelief that she would sing off-key for a laugh.

43. Part of her transformation included taking her new husband's last name of "Arnold." She has subsequently divorced and now goes simply by Roseanne.

44. Rowe, *Unruly Women*, 215–16.

45. Dolan, *The Feminist Spectator as Critic*, 30.

46. Richard Eder, "Stage: 'Marigolds,' With Shelley Winters," *New York Times*, March 15, 1978, http://www.nytimes.com/.

47. Charles Isherwood, "Death-Defying Fantasy Fueled by Love When AIDS Was a Nameless Intruder," *New York Times*, December 6, 2004, http://www.nytimes.com/ (accessed December 2008).

48. Ben Brantley, "Marriage as Blood Sport: A No Win Game," *New York Times*, March 21, 2005, http://www.nytimes.com/ (accessed October 10, 2005).

49. Ben Brantley, "Theater Review: A Gasp for Breath Inside an Airless Life," *New York Times*, February 27, 1998, www.nytimes.com (accessed August 22, 2009).

50. Elizabeth Grosz, *Space, Time, and Perversion: Essays on the Politics of Bodies* (New York: Routledge, 1995), 34–5.

## Chapter 10

1. See also Jennifer-Scott Mobley, "Fatsploitation: Disgust and the Performance of Weight Loss," in *Fat: Culture and Materiality*, eds. Christopher Forth and Alison Leitch (London, Bloomsbury Academic, 2014).

2. For more information see http://haleymorriscafiero.com/about/ (accessed October 31, 2013).

3. In a recent op-ed in the *Daily Mail* published on July 9, 2014, Linda Kelsey seems to agree. The headline reads "Why Are Today's Young Woman So Unashamed About Being Fat." She expresses disdain at seeing fat women apparently comfortable in scanty summer clothes, dismisses anorexia and eating disorders, and encourages fat shaming. See http://www.dailymail.co.uk/femail/article-2686676/Why-todays-young-women-unashamed-fat-Horrified-rolls-flesh-shes-witnessed-summer-LINDA-KELSEY-takes-no-prisoners.html?utm_content=buffer31f67&utm_medium=social&utm_source=facebook.com&utm_campaign=buffer.

4. http://www.imdb.com/title/tt2404463/ (accessed May 20, 2014).

5. Megan Casserly, "The New Girls of Television, How Women Could Rule the Primetime Emmys," *Forbes.com*, July 19, 2012, www.forbes.com/pictures/lml45kgih/no-17-melissa-mccarthy-2/ (accessed October 26, 2013).

6. Maura Kelly, "Should Fatties Get a Room?" Marie Claire.com, October 25, 2010, www.marieclaire.com/sex-love/dating-blog/overweight-couples-on-television (accessed October 26, 2013).

7. "Jimmy Kimmel Emmy Opening," posted September 23, 2012, http://www.youtube.com/watch?v=PItNqKh8DW8 (accessed October 1, 2013).

8. Leah Simpson, "Why I Wouldn't Want a Body Like a Victoria's Secret Model, By Lena Dunham," *DailyMail.Com.UK*, March 14, 2013, www.dailymail.co.uk/tvshowbiz/article-2293308/Lena-Dunham-Why-I-wouldnt-want-body-like-Victorias-Secret-model.html (accessed November 3, 2013).

9. Laura Stampler, "What it's Like playing Hannah in the Girls Porn Lena Dunham Hates," *TimesNewsFeed*, October 3, 2013, http://newsfeed.time.com/2013/10/03/what-its-like-playing-hannah-in-the-girls-porn-lena-dunham-hates/ (accessed November 3, 2013).

10. See for example Maureen Ryan's op-ed in The Huffington Post: "'Girls' Star Lena Dunham and Patrick Wilson: Haters Your Confusion About Attraction is Amusing," February 13, 2013, http://www.huffingtonpost.com/maureen-ryan/girls-lena-dunham-patrick-wilson-attraction_b_2674853.html (accessed November 3, 2013).

11. Anna Breslaw, *Jezebel.com*, July 20, 2013, http://jezebel.com/patrick-wilson-agrees-the-backlash-to-his-girls-ep-was-849969324 (accessed October 18, 2013).

12. Lauren Yapalater, "Patrick Wilson's Wife Puts the Lena Dunham Controversy to Rest," *Buzzfeed.com*, February 1, 2013, http://www.buzzfeed.com/lyapalater/patrick-wilsons-wife-puts-the-lena-dunham-controversy-to-rest (accessed November 2, 2013).

13. Jessie David Fox, "Lena Dunham Addresses Criticism on the Patrick Wilson Episode," *Vulture.com*, June 7, 2013, http://www.vulture.com/2013/06/dunham-on-the-patrick-wilson-episode-debate.html (accessed November 3, 2013).

14. Jennifer Vineyard, "Patrick Wilson on *The Conjuring*, Exorcisms, and Opening Your Mind to Ghosts," *Vulture.com*, July 19, 2013, www.vulture.com/2013/07/conjuring-patrick-wilson-interview.html (accessed September 19, 2013).

15. In some episodes Dunham shares the writing credit with a team, but she is creator and designated head writer.

16. Lynn Hirschberg, "Misfit," *New York Magazine*, September 23, 2013, 36–40.
17. Ibid., 38.
18. Ibid.

## Chapter 11

1. Anthony Kubiak, *Agitated States: Performance in the American Theater of Cruelty* (Ann Arbor, MI: University of Michigan Press, 2002), 290.
2. Ibid., 6–7.
3. Ibid., 7.
4. Ibid., 19.
5. Ibid., 33.
6. Ibid., 13.
7. It is significant that not only were the Salahis a handsome, well-dressed white couple, but Ms. Salahi is an extremely slender blonde woman who appeared quite glamorous—like a movie star if you will. I suspect if the Salahis had been fat by current standards, or people of color, they would not have slipped past security so easily.
8. The show originated with "The Real Housewives of Orange County" and has branched into "The Real Housewives" of New York and New Jersey. Each season, the program features a collection of couples and films their lifestyle and all the drama the participants can generate for the camera. (This might include extramarital affairs, getting one's kids into school, fights among friends, etc.)
9. Helene Cooper and Brian Stelter, "Obamas' Uninvited Guests Prompt an Inquiry," *New York Times*, November 27, 2009, http://www.nytimes.com/2009/11/27/us/politics/27party.html?hp (accessed November 27, 2009).
10. CNN, FOX, and New York One, for example, had a "Miracle on the Hudson" graphic and a music lead-in specific to the incident, which they reported on for weeks (January, 2009).
11. In fact, the "Balloon Boy" parents, Richard and Mayumi Heene, faced charges and were sentenced on December 23, 2009. He was sentenced to ninety days in jail and she to twenty days in jail. They were both given four years of probation during which time they may not earn any money related to the stunt. http://www.nytimes.com/aponline/2009/12/23/us/AP-US-Balloon-Boy.html (accessed January 1, 2010).
12. Cooper and Stelter, "Obamas' Uninvited Guests," *New York Times*.
13. *Kubiak, Agitated States*, 20.
14. Ibid., 30.
15. Ibid. 22–23.
16. Ibid., 22.
17. For example, if you view a popular TV series from the late seventies or early eighties, such as *Laverne and Shirley*, *Dallas*, or *Remington Steele*, you might be surprised, as I was, that the actresses appear pudgy to a twenty-first-century viewer. (Some of them also have remarkably smaller breasts than a present-day TV viewer is now accustomed to seeing.)

18. In other words, the bodies of actresses and models that are a kind of "copy" that many "average" American women (the originals) view as real or authentic when in fact, the representations of the actresses are altered by technology and the actresses themselves participate in extreme body modification practices (dieting, plastic surgery) that most middle-class American women cannot duplicate for economic reasons.

19. I spoke to a buyer at SAKS Fifth Avenue, which is a high-end store on the cutting edge of fashion. She says that many designers carry up to a size fourteen, but very few carry a sixteen. She added that sizes twelve to fourteen are considered for "bigger women" and that SAKS has a special department for big women on the top floor (out of sight?). In my experience, lower-end stores such as GAP and Old Navy do carry up through size sixteen.

20. Kathleen LeBesco, *Revolting Bodies: The Struggle to Redefine Fat Identity* (Amherst, University of Massachusetts Press, 2003), 71.

21. Ibid., 71.

22. Cintra Wilson, "Playing to the Middle," *New York Times*, August 13, 2009, http://www.nytimes.com/2009/08/13/fashion/13CRITIC.html?scp=1&sq=playing%20to%20the%20middle&st=cse. (accessed May 20, 2014).

23. LeBesco, *Revolting Bodies: The Struggle to Redefine Fat Identity*, 72.

24. Ibid., 28.

25. See "The Audacity of Precious," *The New York Times Magazine* (October 25, 2009) for an extensive article about Daniels and the making of *Precious*, including the difficulty of finding a very fat, dark-skinned black actress to play Precious. www.nytimes.com/2009/10/25/magazine/25precious-t.html?_r=l&emc=atal&page (accessed October 26, 2009).

26. Michael Pollan's best-selling book *In Defense of Food: An Eater's Manifesto* (New York: Penguin Books, 2008) is one of many recent studies that investigate how the proliferation of "faux" food-science as well as genetically modified food, and the excess of corn-products in our food chain (thanks, in part, to government-subsidized farming initiatives) have actually contributed to the so-called obesity problem in our country. He suggests that some of the damage done by these practices is irreversible in terms of national health and weight concerns. Indeed, fat may not be as much of a choice as many perceive it to be. Furthermore, statistical evidence has repeatedly demonstrated that dieting does not work in so far as 90 to 95 percent of dieters gain back all the weight they have lost (plus some) within five years of losing it.

27. For example, the question of whether fat people should be required to purchase two airline seats or be charged a "fat tax" has become an increasingly frequent topic in the news media.

28. Jill Dolan, "Performance, Utopia, and the 'Utopian Performative,'" *Theatre Journal* 53 (2001): 455.

29. Jill Dolan, plenary address at the American Theatre in Higher Education Conference, Denver, CO, 2008.

30. Dolan, "'Utopian Performative,'" 456.

31. Ibid.

# Bibliography

Albee, Edward. *Who's Afraid of Virginia Woolf?* 1962. New York: Signet Publishing, 1983.

Alcoff, Linda Martín. "Toward a Phenomenology of Racial Embodiment." In *Race*, edited by Robert Bernasconi, 267–83. Malden, MA: Blackwell, 2001.

Anderson, Lisa M. *Black Feminism in Contemporary Drama*. Urbana and Chicago: University of Illinois Press, 2008.

Angelos, Maureen, Babs Davy, Dominique Dibbell, Peg Healy, and Lisa Kron. *The Five Lesbian Brothers/Four Plays*. New York: Theatre Communications Group, 2000.

Barnes, Clive. "Stage: 'My Fat Friend' From Britain." *New York Times*, April 1, 1974. http://www.nytimes.com.

Bartky, Sandra Lee. *Femininity and Domination: Studies in the Phenomenology of Oppression*. New York: Routledge, 1990.

Basile, Giambattista. *Pentamerone: English Stories from the Pentamerone*. Translated by Batsy Bybell. New York: Hard Press, 2006.

Benedict, Francis. "Food Conservation and Reduction of Rations." *Nation 101* April, 1918, 355–57.

Bernasconi, Robert, ed. *Race*. Malden, MA: Blackwell Publishers, 2001.

Bernstein, Robin. *Cast Out: Queer Lives in Theater*. Edited by Jill Dolan and David Román. Ann Arbor, MI: University of Michigan Press, 2006.

Boero, Natalie. *Killer Fat: Media, Medicine, and Morals in the American "Obesity Epidemic."* New Brunswick, NJ: Rutgers University Press, 2012.

Bordo, Susan. "The Body and Reproduction of Femininity." In *Writing on the Body: Female Embodiment and Feminist Theory*, edited by Katie Conboy, Nadia Medina, and Sarah Stanbury, 90–113. New York: Columbia University Press, 1997.

_____. *Twilight Zones: The Hidden Life of Cultural Images from Plato to O.J.* Berkeley, CA: University of California Press, 1997.

_____. *Unbearable Weight: Feminism, Western Culture, and the Body*. Berkeley, CA: University of California Press, 1993.

Bourdieu, Pierre. *Distinction: A Social Critique of the Judgment of Taste*. Translated by Richard Nice. Cambridge, MA: Harvard University Press, 1994.

_____. *The Field of Cultural Production: Essays on Art and Literature*. Edited with an introduction by Randal Johnson. New York: Columbia University Press, 1993.

_____. *Masculine Domination*. Translated by Richard Nice. Stanford, CA: Stanford University Press, 2001.

Brantley, Ben. "A Gasp for Breath Inside An Airless Life." *New York Times*, March 21, 2005. http://www.nytimes.com/.

_____. "How the Divas Did It." *New York Times*, May 20, 2005. http://nytimes.com/.

_____. "Marriage as a Blood Sport: A No-Win Game." *New York Times*, March 21, 2005. http://www.nytimes.com/.

_____. "A Moonlit Night on the Farm, Graveyard Ready." *New York Times*, April 10, 2007. http://www.nytimes.com/.

_____. "She's Fat, He's a Man. Can They Find Love?" *New York Times*, December 16, 2004. http://nytimes.com/.

Braziel, Jana Evans, and Kathleen LeBesco, eds. *Bodies Out of Bounds: Fatness and Transgression*. Burbank, CA: University of California Press, 2002.

Breslaw, Anna. "Patrick Wilson Agrees the Backlash to His Girls Episode was Scary, Dumb." Jezebel.com, July 20, 2013. http://www.jezebel.com.

Briggs, Katharine. *An Encyclopedia of Fairies: Hobgoblins, Brownies, Bogies, and Other Supernatural Creatures*. New York: Pantheon, 1976.

Brochu, Jim. *Fat Chance*. New York: Samuel French, 1993.

Brownell, K., and R. Puhn. "Bias, Discrimination, and Obesity." *Obesity Research* 9 (2001): 788–805.

Brumberg, Joan Jacobs. *The Body Project: An Intimate History of American Girls*. New York: Vintage Books, 1997.

Butler, Judith. "Against Proper Objects." *Differences: A Journal of Feminist Cultural Studies* 62 (1994): 1–25.

_____. *Bodies that Matter: On the Discursive Limits of "Sex."* London: Routledge, 1993.

_____. *Gender Trouble: Feminism and the Subversion of Identity*. London: Routledge, 1999.

Campos, Paul. *The Obesity Myth: Why America's Obsession with Weight Is Hazardous to Your Health*. New York: Gotham Books, 2004.

Canby, Vincent. "Tennessee Williams in Deep Complexity." *New York Times*, March 22, 1996. http://nytimes.com/.

Caputi, Jane. *Goddesses and Monsters: Women, Myth, Power, and Popular Culture*. Madison, WI: University of Wisconsin Press, 2005.

Carlson, Marvin. *Performance: A Critical Introduction*. New York: Routledge, 1996.

Case, Sue-Ellen. *Feminism and Theatre*. New York: Routledge, 1988.

_____, ed. *Performing Feminisms: Feminist Critical Theory and the Theatre*. Baltimore, MD: Johns Hopkins University Press, 1990.

Casserly, Megan. "The New Girls of Television, How Women Could Rule the Primetime Emmys," Forbes.com, July 19, 2012. http://www.forbes.com/.

Crais, Clifton, and Pamela Scully. *Sara Baartman and the Hottentot Venus: A Ghost Story and a Biography*. Princeton, NJ: Princeton University Press, 2008.

Critser, Greg. "Let Them Eat Fat: The Heavy Truths About American Obesity." *Harper's Magazine*, March, 2000, 41–7.

Cunningham, Laura. "Beautiful Bodies." In *Plays for Actresses*, edited by Eric Lane and Nina Shengold, 156–256. New York: Vintage Books, 1997.

Diamond, Elin. *Unmaking Mimesis: Essays on Feminism and Theater*. London: Routledge, 1997.

Dickson, E. J. "Gandolfini's Death Prompts Rampant Fat Shaming." Salon.com, June 20, 2013. http://www.salon.com.

Dolan, Jill. "Feminist Performance Criticism and the Popular: Reviewing Wendy Wasserstein." *Theatre Journal* 60 (2008): 433–457.

_____. *The Feminist Spectator as Critic.* Ann Arbor, MI: University of Michigan Press, 1991.

_____. "Performance, Utopia, and the 'Utopian Performative.'" *Theatre Journal* 53 (2001): 455–79.

_____. *Presence and Desire: Essays on Gender, Sexuality, and Performance.* Ann Arbor, MI: University of Michigan Press, 1993.

_____. *Utopia in Performance: Finding Hope at the Theater.* Ann Arbor, MI: University of Michigan Press, 2005.

Douglas, Mary. *Purity and Danger: An Analysis of Concepts of Pollution and Taboo.* New York: Routledge, 1966.

Edar, Richard. "Stage: 'Marigolds,' With Shelley Winters." *New York Times*, March 15, 1978. http://www.nytimes.com/.

Ensler, Eve. *The Good Body.* New York: Villard, 2007.

Faludi, Susan. *Backlash: The Undeclared War Against American Women.* New York: Anchor Books, 1991.

Farrell, Amy Erdman. *Fat Shame: Stigma and the Fat Body in American Culture.* New York: New York University Press, 2011.

Forth, Christopher C., and Alison Leitch, eds. *Fat: Culture and Materiality.* London: Bloomsbury Academic, 2014.

Foucault, Michel. *Discipline & Punish: The Birth of the Prison.* Translated by Alan Sheridan. 2nd ed. New York: Vintage Books, 1995.

_____. *The History of Sexuality Volume I: An Introduction.* Translated by Robert Hurley. ed. New York: Vantage Press, 1990.

Fox, Jessie David. "Lena Dunham Addresses Criticism on the Patrick Wilson Episode." Vulture.com, June 7, 2013. http://www.vulture.com.

Fraser, Laura. *Losing It: America's Obsession with Weight and the Industry That Feeds On It.* New York: Penguin Books, 1997.

Gaesser, Glenn A. *Big Fat Lies: The Truth About Your Weight and Health.* Carlsbad, CA: Gürze Books, 2002.

Gard, Michael, and Jane Wright. *The Obesity Epidemic: Science, Morality, and Ideology.* New York: Routledge, 2006.

Gates, David. "Finding Neverland." *Newsweek*, July 13, 2009, 35–39.

Gelb, Barbara. "A Second Look, A Second Chance to Forgive." *New York Times*, March 19, 2000. http://www.nytimes.com/.

George, Madeleine. "The Most Massive Woman Wins." In *Plays for Actresses*, edited by Eric Lane and Nina Shengold, 269–92. New York: Vintage Books, 1997.

Gilman, Sander L. "Black Bodies, White Bodies: Toward an Iconography of Female Sexuality in Late Nineteenth-Century Art, Medicine, and Literature." In *The Feminism and Visual Culture Reader*, edited by Amelia Jones, 136–150. New York: Routledge, 2003.

_____. *Fat: A Cultural History of Obesity.* Malden, MA, Polity Press, 2008.

Glenn, Susan A. *Female Spectacle: The Theatrical Roots of Modern Feminism*. Cambridge, MA: Harvard University Press, 2000.

Grosz, Elizabeth. *Space, Time, and Perversion: Essays on the Politics of Bodies*. New York: Routledge, 1995.

_____. *Volatile Bodies: Toward a Corporeal Feminism*. Bloomington: Indiana University Press, 1994.

Gussow, Mel. "The Sea Horse's Star (and Its Author) Shed Alias." *New York Times*, April 22, 1974. http://www.nytimes.com/.

_____. "Two Poignant Characters in Irwin's 'Sea Horse.'" *New York Times*, March 5, 1974. http://www.nytimes.com/.

Hartley, Cecilia. "Letting Ourselves Go: Making Room for the Fat Body in Feminist Scholarship." In *Bodies Out of Bounds: Fatness and Transgression*, edited by Jana Evans Braziel and Kathleen LeBesco, 60–73. Berkeley, CA: University of California Press, 2001.

Heddon, Deirdre. *Autobiography and Performance*. New York: Palgrave Macmillan, 2008.

Hirschberg, Lynn. "Misfit," *New York Magazine*, September 23, 2013, 36–40.

Holmes, Rachel. *African Queen: The Real Life of the Hottentot Venus*. New York: Random House Publishing Group, 2007.

hooks, bell. "Selling Hot Pussy: Representations of Black Female Sexuality in the Cultural Marketplace." In *Writing On the Body: Female Embodiment and Feminist Theory*, edited by Nadia Medina, Katie Conboy, and Sarah Stanbury, 113–128. New York: Columbia University Press, 1997.

Irigary, Luce. "The Power of Discourse." In *This Sex Which is Not One*. Ithaca, NY: Cornell University Press, 1985.

Isherwood, Charles. "Death-Defying Fantasy Fueled by Love When AIDS Was a Nameless Intruder." *New York Times,* December 6, 2004. http://www.nytimes.com/.

_____. "Our Bellies, Ourselves: Eve Ensler Talks About Fat." *New York Times*, November 16, 2004. http://www.nytimes.com/.

Jefferson, Margo. "Sunday View: Self-Portraits Onstage: Perspective is Crucial." *New York Times*, July 30, 1995. http://www.nytimes.com/.

Kelly, Maura. "Should Fatties Get a Room?" Marie Claire.com, October 25, 2010, http://www.marieclaire.com.

Kerr, Walter. "Theater: 'The Killing of Sister George' Arrives." *New York Times*, October 6, 1966. http://www.nytimes.com/.

Kessler, David. *The End of Overeating: Taking Control of the Insatiable American Appetite*. New York: Rodale Books, 2009.

Klemsesrud, Judy. "Lynn Redgrave Fat? Only With Pads Now." *New York Times*, April 13, 1974. http://www.nytimes.com/.

Kron, Lisa. *Well*. New York: Theatre Communications Group, 2006.

Kubiak, Anthony. *Agitated States: Performances in the American Theater of Cruelty*. Ann Arbor, MI: University of Michigan Press, 2001.

Kulick, Don, and Anne Meneley, eds. *Fat: The Anthropology of an Obsession*. New York: Penguin Group Inc., 2005.

Kuppers, Petra. "Fatties Onstage: Feminist Performances." In *Bodies Out of Bounds: Fatness and Transgression*, edited by Jana Evans Braziel and Kathleen LeBesco, 277–91. Berkeley, CA: University of California Press, 2001.

Kwan, Samantha and Jennifer Graves. *Framing Fat: Competing Constructions in Contemporary Culture*. New Brunswick, NJ: Rutgers University Press, 2013.

LaBute, Neil. *Fat Pig*. New York: Faber and Faber, 2004.

Laurence, Charles. *My Fat Friend*. London: Oberon Modern Plays, 2003.

LeBesco, Kathleen. *Revolting Bodies: The Struggle to Redefine Fat Identity*. Amherst, MA: University of Massachusetts Press, 2003.

LeBesco, Kathleen, and Peter Naccarato, eds. *Edible Ideologies: Representing Food and Meaning*. Albany, NY: State University of New York Press, 2008.

Lempart, David. "Size Matters." *The Atlantic*, March, 2008, 32.

Liepe-Levinson, Katherine. *Stripshow: Performances of Gender and Desire*. New York: Routledge, 2002.

Lott, Eric. *Love and Theft: Blackface Minstrelsy and the American Working Class*. New York: Oxford University Press, 1993.

Maine, Margo. *Body Wars: Making Peace with Women's Bodies, an Activist's Guide*. Carlsbad, CA: Gürze Books, 2000.

Marcus, Frank. *The Killing of Sister George*. New York: Bantam Books, 1969.

McDonagh, Martin. *The Beauty Queen of Leenane and Other Plays*. New York: Vintage Books, 1998.

McNally, Terrence. *Frankie and Johnny in the Claire De Lune*. New York: Dramatists Play Service, 1988.

———. "Theater: Hearing Voices is the Good Part in Writing A Play." *New York Times*, July 23, 1991. http://www.nytimes.com/.

Meehan, Mark, and Thomas O'Donnell. *Hairspray*. New York: Applause Books, 2002.

Miller, William Ian. *The Anatomy of Disgust*. Cambridge, MA: Harvard University Press, 1997.

Moore, Edward J. *The Sea Horse*. Clifton, NJ: James T. White and Company, 1969.

Morrow, Lance. "Taking It Off." *Time*, April 15, 1974, http://www.time.com/.

Murray, Samantha. *The 'Fat' Female Body*. New York: Palgrave Macmillan, 2008.

Oliver, Eric J. *Fat Politics: The Real Story Behind America's Obesity Epidemic*. New York: Oxford University Press, 2006.

O'Neill, Eugene. *A Moon for the Misbegotten*. New York: Vintage Books, 1974.

Ordona, Michael. "Kristen Johnston Steals the Scene." *Los Angeles Times*, January 8, 2009. http://latimes.com/.

Parks, Suzan-Lori. *Venus*. New York: Theatre Communications Group, 1997.

Phelan, Peggy. *Unmarked: The Politics of Performance*. New York: Routledge, 1993.

Pollan, Michael. *In Defense of Food*. New York: Penguin Books, 2008.

Rich, Frank. "Fat and 64 Jobs Later, Misfit Finally Finds a Niche Onstage." *New York Times*, September 22, 1993. http://www.nytimes.com/.

———. "Kate Nelligan in 'A Moon for the Misbegotten.'" *New York Times*, May 2, 1984. http://www.nytimes.com/.

———. "Theater: 'Ma Rainey' Opens." *New York Times*, October 12, 1984. http://www.nytimes.com/.

Roth, Moira, ed. *Rachel Rosenthal*. Baltimore, MD: Johns Hopkins University Press, 1997.

Rothblum, Esther, and Sandra Solovay, eds. *The Fat Studies Reader*. New York: New York University Press, 2009.

Rowe, Kathleen. *The Unruly Woman: Gender and Genres of Laughter*. Austin, TX: University of Texas Press, 1995.

Ryan, Maureen. "'Girls' Star Lena Dunham and Patrick Wilson: Haters, Your Confusion About Attraction is Amusing." The Huffington Post, February 13, 2013. http://www.huffingtonpost.com.

Saguy, Abigail C. *What's Wrong with Fat?* Oxford: Oxford University Press, 2013.

Savran, David. *The Playwright's Voice: American Dramatists on Memory, Writing, and the Politics of Culture*. New York: Theatre Communications Group, 1999.

_____. *A Queer Sort of Materialism: Recontextualizing American Theater*. Ann Arbor, MI: University of Michigan Press, 2003.

_____. *Taking it Like a Man: White Masculinity, Masochism, and Contemporary American Culture*. Princeton, NJ: Princeton University Press, 1998.

Schildrick, Magrit, and Janet Price, eds. *Feminist Theory and the Body*. New York: Routledge, 1990.

Schneider, Rebecca. *The Explicit Body in Performance*. New York: Routledge, 1997.

Schwartz, Hillel. *The Culture of Copy: Striking Likenesses and Unreasonable Facsimiles*. New York: Zone Books, 1996.

_____. *Never Satisfied: A Cultural History of Diets, Fantasies, and Fat*. New York: Doubleday, 1986.

Sedgwick, Eve Kosofsky. *Epistemology of the Closet*. Berkeley, CA: University of California Press, 1990.

_____. *Tendencies*. Durham, NC: Duke University Press, 1993.

Shaw, Andrea Elizabeth. *The Embodiment of Disobedience: Fat Black Women's Unruly, Political Bodies*. New York: Lexicon Books, 2006.

Shear, Claudia. *Blown Sideways Through Life*. New York: Dial Press, 1995.

Simon, John. "Whispers and Size." *New York Magazine*. December 27, 2004. http://nymag.com/.

Simpson, Leah. "Why I Wouldn't Want a Body Like a Victoria's Secret Model by Lena Dunham." Daily Mail.com, March 14, 2013. http://www.dailymail.co.uk.

Sommer, Elyse. "Review: Baltimore Waltz." Curtain Up.com, December 6, 2004. http://www.curtainup.com/.

Stampler, Laura. "What It's Like Playing Hannah in the Girls Porn Lena Dunham Hates." *Newsfeed.Time.com*, October 3, 2013. http//newsfeed.time.com/.

Stearns, Peter N. *Fat History: Bodies and Beauty in the Modern West*. New York: New York University Press, 2002.

Urla, Jaqueline, and Jennifer Terry. "Mapping Embodied Deviance." In *Deviant Bodies*, edited by Jennifer Terry and Jaqueline Urla. Bloomington IN: Indiana University Press, 1995.

Vineyard, Jennifer. "Patrick Wilson, *The Conjuring*, Exorcisms, and Opening Your Mind to Ghosts," Vulture.com, July 19, 2013. http://www.vulture.com.

Vogel, Paula. *The Baltimore Waltz*. In *The Baltimore Waltz and Other Plays*. New York: Theatre Communications Group, 1996.

_____. *Hot 'N' Throbbing*. In *The Baltimore Waltz and Other Plays*. New York: Theatre Communications Group, 1996.

_____. *How I Learned to Drive*. In *The Mammary Plays*. New York: Theatre Communications Group, 1998.

_____. *The Oldest Profession*. In *The Baltimore Waltz and Other Plays*. New York: Theatre Communications Group, 1996.

Warner, Sara L. "Suzan-Lori Parks's Drama of Disinterment: A Transnational Exploration of Venus." *Theatre Journal* 60, no. 2 (2008): 181–99.

Whitaker, Beth, ed. "Finding the Happy Day: Interview with Paula Vogel." *Signature Edition* 7, no. 1 (2004).

Wickstrom, Maurya. *Performing Consumers: Global Capital and Its Theatrical Seductions*. New York: Routledge, 2006.

Williams, Tennessee. *Night of the Iguana*. In *Three by Tennessee*. New York: Signet Classic, 1976.

_____. *The Rose Tattoo*. In *Three by Tennessee*. New York: Signet Classic, 1976.

_____. *Small Craft Warnings*. New York: New Directions Books, 1972.

Wilson, August. *Ma Rainey's Black Bottom*. New York: Plume, 1981.

Wolf, Naomi. *The Beauty Myth: How Images of Beauty Are Used Against Women*. New York: Harper Perennial, 2002.

Yapalater, Lauren. "Patrick Wilson's Wife Puts Lena Dunham Controversy to Rest." Buzzfeed.com, February 1, 2013. http://www.buzzfeed.com.

# Index

*9½ Weeks* (film), 127
   *Fat Actress* (television series), parody
     of "eating scene", 127–8

ABC (television network), 123, 131, *See*
     *also Huge* (television series)
*Agitated States: Performance in the*
     *American Theater of Cruelty*
     (Kubiak), 176
Albee, Edward, 6, 75–81, 85
   fat identity of characters, 95
   Vogel, Paula, compared to, 85, 88, 95
   *Who's Afraid of Virginia Woolf?*, 6,
     56, 65, 75–81, 85, 103, 135,
     141, 159–60
     Broadway revival (1976)
       Dewhurst, Colleen, in, 75
       Gazzara, Ben, in, 75
     Broadway revival (2005), *80*–1
       Irwin, Bill, in, 75, 160
       Turner, Kathleen, in, 75, *80*–1,
        114, 160
     Broadway revival (2012)
       Letts, Tracy, in, 75
       McKinnon, Pam, director, 75
       Morton, Amy, in, 75
       Tony nominations and wins, 75
     film version (1966), 76–7
       Burton, Richard, in, 75
       Nichols, Mike, director, 75
       Taylor, Elizabeth, in, 75, 77
     Martha (character), 6, 56, 65,
       76–81, 103, 114, 135, 160
     *Night of the Iguana, The*
       (Williams), compared to, 78

     original production (1962)
       Hagen, Uta, in, 75
       Hill, Arthur, in, 75
Alcoff, Linda Martin, 109–11
   fat stigmatization and race, on, 110
Alley, Kirstie, 7, 113, 123–31, *129*, 163
   *Amos 'n' Andy*, compared to, 125
   Barr, Roseanne, compared to, 154,
     155, 157, 158
   *Cheers* (television series), in, 124
   Dunham, Lena, compared to, 172
   *Fat Actress* (television series), in, 7,
     123–31, 133, 134, 142
   Jenny Craig, as spokesperson, 126,
     130, 131, 136
   McCarthy, Melissa, compared to, 136
   *Veronica's Closet* (television series),
     in, 124
   weightism, as perpetuator of, 125,
     128, 163
*American Bandstand* (television show),
     107
*American Idol* (television series), 177
*Amos 'n' Andy*, 7, 125
Anderson, Lisa M.
   *Black Feminism in Contemporary*
     *Drama*, 104
Angelos, Maureen, 117, *See also* Five
     Lesbian Brothers; *Secretaries,*
     *The*
Aristotle, 9
Arnold, Roseanne, *See* Barr, Roseanne
Atkinson, Ashlie
   *Fat Pig* (LaBute), in, 60–2
Aunt Jemima, 99

Baartman, Saartjie, 98, 104, 111
  posthumous display of genitalia, 105
  *Venus* (Parks), characterization, in, 104–6
"Baby Got Back" (Sir Mix-A-Lot song), 100
Bacalzo, Dan
  *Fat Pig* (LaBute), *Theatremania* review of, 61–2
"Balloon Boy", 178–9
*Baltimore Waltz, The* (Vogel), 7, 86, 91–2
  Anna (character), 91–2
  fat behavior of, 92
  Johnston, Kristen, in, 92, 159
  Jones, Cherry, in, 92
  plot, 91
  Signature Theatre revival (2004), 92
    Sommer, Elyse *Curtain Up* review, 92
Barbie, 17, 64
*Barefoot in the Park* (Simon), 181
Barnes, Clive
  *My Fat Friend* (Laurence), on, 32
Barnum, P. T., 130
Barr, Roseanne, 7–8, 126, 142, 147, 154–8, 160
  Alley, Kirstie, compared to, 154, 155, 157, 158
  *Blonde and Bitchin'* (HBO special), 158
  Bush, George W., invective against, 158
  Cho, Margaret, compared to, 154, 155
  Dunham, Lena, compared to, 154, 172
  gay marriage, championing of, 158
  McEntire, Reba, compared to, 157
  plastic surgery, 157–8
  *Roseanne* (television series), in, 126, 142, 155
  Rowe, Kathleen on, 155–6, 157
  Shear, Claudia, compared to, 155, 156
  "Star Spangled Banner, The," controversial performance (1990), 156–7

Bush, George H.W., criticized by, 156
  Will, George, criticized by, 156
  West, Mae, compared to, 155
Bartky, Sandra Lee, 43
Bates, Kathy, 57, 147, 158–9, 161
  *'night, Mother* (Norman), in, 158–9
  *Frankie and Johnny in the Claire de Lune* (McNally), in, 57
  *Misery* (film), in, 134
*Beautiful Bodies* (Cunningham), 31, 39–41, 48
  fat behavior in characters, 39–41
  *Fat Chance* (Brochu), compared to, 40
  *Heidi Chronicles, The* (Wasserstein), compared to, 39
  *My Fat Friend* (Laurence), compared to, 40
  Whole Theatre (Montclair, New Jersey), premiere production (1987), 40
*Beauty Myth, The* (Wolf), 79
*Beauty Queen of Leenane, The* (McDonough)
  Manahan, Anna, in, 160
Beauvoir, Simone de, 9
Benanti, Laura
  *Gypsy* (Styne-Sondheim musical), in, 181
  *In the Next Room or The Vibrator Play* (Ruhl), in, 181
Bentham, Jeremy, 11, *See also* Foucault, Michel; Panopticon
Bernstine, Quincy Tyler
  *Hairspray* (O'Donnell-Meehan-Shaiman-Wittman musical), in, 181
Best, Eve
  *Heiress, The* (R&A Goetz), in, 54
  *Moon for the Misbegotten, A* (O'Neill), in, 53–4
  Brantley, Ben on, 54
Betty Boop, 17

"Big, Blond, and Beautiful"
    (*Hairspray*), 109
"Big Butts" (*Fat Actress* episode), 126–8
*Big Fat Lies* (Gaesser), 21
*Big Momma's House* (film series), 130
*Biggest Loser, The* (reality television
    series), 123, 132, 163,
    170, 177
    *Girls* (television series), compared
        to, 170
    *Huge* (television series), compared
        to, 132
    weightism, as perpetuator of, 163
*Birth of the Clinic* (Foucault), 110
*Black Feminism in Contemporary
    Drama* (Anderson), 104
*Blonde and Bitchin'* (Barr HBO
    special), 158
Blonski, Nikki
    *Huge* (television series), in, 132
*Blown Sideways Through Life* (Shear),
    8, 141, 142–8, 150
    Cherry Lane Theatre, commercial
        run, 144
    New York Theatre Workshop, at, 144
    Rich, Frank *New York Times* review
        of, 144
    weightism, depictions of, 145
"Body Weight and Mortality Among
    Women" (*New England
    Journal of Medicine* study),
    20
Bonney, Jo
    *Fat Pig* (LaBute), director, 61
Booth Theatre
    *Good Body, The* (Ensler),
        production, 44
Bordo, Susan, 16, 26, 77
    *Unbearable Weight*, 41, 146
Boubier, Kimmie (character), *See Super
    Fun Night* (television series);
    Wilson, Rebel
Bourdieu, Pierre, 11, 31, 47, 157, *See
    also* Panopticon
    *Distinction*, 156

*Masculine Domination*, 47
    symbolic violence, concept of, 47
Brantley, Ben, 53–4, *See also New York
    Times*
    Best, Eve in *A Moon for the
        Misbegotten*, on, 54
    *Fat Pig* (LaBute), *New York Times*
        review, 61
    Jones, Cherry in *A Moon for the
        Misbegotten*, on, 54
    Manahan, Anna in *The Beauty
        Queen of Leenane*, on, 160
    Turner, Kathleen in *Who's Afraid of
        Virginia Woolf?*, on, 80
    weightism reflected in writing of, 54
*Bridesmaids* (film), 165, 172
Brochu, Jim, 40
    *Fat Chance*, 31, 36–9, 47, 56, 113
        *Beautiful Bodies* (Cunningham),
            compared to, 40
        Colony Studio Playhouse (Los
            Angeles), production, 36
        Mattie (character), 36–9, 56
        McLanahan, Rue, in, 31, 36
        *My Fat Friend* (Laurence),
            compared to, 38–9
        plot, 36–8
Brooks Atkinson Theatre
    *My Fat Friend* (Laurence),
        production, 32
Brown, Helen Gurley, 19
    *Good Body, The* (Ensler), interview
        portrayed, in, 45
Bullock, Sandra
    *Odd Couple, The*, (Simon) in "Felix"
        role, 165
Burke, Marylouise, 94
    *Oldest Profession, The* (Vogel), in, 94
Burton, Richard
    *Night of the Iguana, The* (Williams),
        in film version, 72
    *Who's Afraid of Virginia Woolf?*
        (Albee), in film version, 75
Bush, George H.W.
    Barr, Roseanne, attacks on, 156

Bush, George W.
  Barr, Roseanne, invective
    against, 158
Butler, Judith, 27, 113–14, 142,
    145, 153
  gender identity formation, on, 145
  *Gender Trouble*, 142

Campbell, Mary (Miss America
    1922), 17
Campos, Paul, 9–10, 20–1
  *Obesity Myth, The*, 10, 20
Canby, Vincent
  Mason, Marsha in *Night of the
    Iguana, The* (Williams),
    on, 72
Carroll, Helena, 73
  *Small Craft Warnings* (Williams),
    in, 73
Case, Sue-Ellen, 39
CBS (television network), 123, 131,
    132, *See also Mike & Molly*
    (television series)
"Chairman Mee-Oow," (sequence
    in *The Sensuous Woman*),
    150–1
Chance, Alex, 169
"Charlie's Angels" (*Fat Actress* episode),
    128–30, 134
*Cheers* (television series), 124
Cherry Lane Theatre
  *Blown Sideways Through Life*
    (Shear), commercial run, 144
Cho, Margaret, 8, 148–54, 160
  Barr, Roseanne, compared to,
    154, 155
  *Drop Dead Diva* (television series),
    in, 154
  fat performance of, 150–1, 153–4
  queerness, 148–50
  *Sensuous Woman, The*, 141, 148–54
    "Chairman Mee-Oow" sequence,
      150–1
    Dirty Martini (burlesque dancer),
      in, 151–2

fan dance to "Liebestod" (*Tristan
    und Isolde*), 153–4
Heffington, Ryan, striptease
    number, in, 152–3
Luna, Selene, in, 150
Shear, Claudia, compared to, 149,
    150
Spears, Britney on, 150
weightism, personal attacks as
    examples of, 148–9, 154
Ciccone, Madonna Louise, *See*
    Madonna
Circle in the Square Theatre
  *Frankie and Johnny in the Claire de
    Lune* (McNally), production,
    56
  *Rose Tattoo, The* (Williams), 1995
    revival, 67
Circle Repertory Theatre
  *Sea Horse, The* (Moore), production,
    54
Colony Studio Playhouse (Los Angeles)
  *Fat Chance* (Brochu), production, 36
*Cosmopolitan* (magazine), 19
Critser, Greg, 26, 149
  "Let them Eat Fat: The Heavy Truths
    About American Obesity"
    (*Harper's* article), 25
Cunningham, Laura
  *Beautiful Bodies*, 31, 39–41, 48
    fat behavior in characters, 39–41
    *Fat Chance* (Brochu), compared
      to, 40
    *Heidi Chronicles, The*
      (Wasserstein), compared
      to, 39
    *My Fat Friend* (Laurence),
      compared to, 40
    Whole Theatre (Montclair, New
      Jersey), premiere production
      (1987), 40
*Curtain Up*
  Sommer, Elyse, review of *The
    Baltimore Waltz* (2004
    Signature Theatre revival), 92

Cuvier, George, 98
Cuvier, Georges, 105
  *Venus* (Parks), characterization, in,
    105–6
Cyrus, Miley, 88

Daniels, Lee
  *Precious* (film), director, 183
Davis, Bette
  "more-than-ness," as example, 72
  *Night of the Iguana, The* (Williams),
    in, 72
Davy, Babs, 117, *See also* Five Lesbian
    Brothers; *Secretaries, The*
"Death Rate from Obesity Gains Fast
    on Smoking" (*New York
    Times* article), 20
de Beauvoir, Simone, *See* Beauvoir,
    Simone de; *Second Sex, The*
Descartes, René, 9
Dewhurst, Colleen, 6, 54, 141
  *Moon for the Misbegotten, A*
    (O'Neill), in, 53, 54
  "more-than-ness", as example, 141
  *Who's Afraid of Virginia Woolf?*
    (Albee), in 1976 Albee-
    directed revival, 75
Diamond, Elin, 4
Diamond, John, 130
Dibbell, Dominique, 117, *See also* Five
    Lesbian Brothers; *Secretaries,
    The*
*Dirty Blonde* (Shear), 144
  West, Mae, depiction, in, 144
"Dirty Diana" (Michael Jackson song)
  *Sensuous Woman, The* (Cho), use,
    in, 152
Dirty Martini [Marraccini, Linda]
    (burlesque dancer), 151–2
  *Sensuous Woman, The* (Cho), in,
    151–2
  "Proud to Be an American"
    (Lee Greenwood song),
    performance of, 151
*Distinction* (Bourdieu), 156

Dizzia, Maria
  *In the Next Room or The Vibrator
    Play* (Ruhl), in, 181
Dolan, Jill, 151–2, 158–9, 185
  *Feminist Spectator as Critic, The*, 158
  "Performance, Utopia and the
    'Utopian Performative'", 185
  plenary address, American Theatre
    in Higher Education (ATHE)
    Conference (2008), 185
Dominzyck, Dagmara, 170
Douglas, Mary, 10–11, 145
  gender identity formation, on, 145
  *Purity and Danger*, 66, 145
*Drop Dead Diva* (television series),
    123, 131–2, 163
  Bingum, Jane (character), 131
  Cho, Margaret, in, 154
  Elliott, Brooke, in, 131
  *Fat Actress* (television series),
    compared to, 131
*Duck Dynasty* (television series), 177
Dunham, Lena, 7–8, 165, 167–72, *171*,
    179, 183
  Alley, Kirstie, compared to, 172
  Barr, Roseanne, compared to, 154,
    172
  Dominzyck, Dagmara on, 170
  fat stigmatization, potential end of,
    186
  *Girls* (television series), in, 7–8, 154,
    167–72
  misogyny, on, 170
  nudity, 167–72
  Wilson, Patrick on, 170–2
  Wilson, Rebel, compared to, 172, 173

Eder, Richard, 159
*Effect of Gamma Rays on Man-in-
    the-Moon Marigolds, The*
    (Zindel)
  Winters, Shelley, in, 159
*Elle* (magazine)
  McCarthy, Melissa, in "Women in
    Hollywood" issue, 166

Elliott, Brooke
 *Drop Dead Diva* (television series), in, 131
embodied cultural text, 3, 4
*Embodiment of Disobedience: Fat Black Women's Unruly Political Bodies, The* (Shaw), 99
Ensler, Eve
 *Good Body, The*, 31, 44–8, 59
  Booth Theatre production, 44
  Brown, Helen Gurley, interview portrayed, in, 45
  Hartford Stage production, 45
  Isherwood, Charles, *New York Times* review of, 46
  *Most Massive Woman Wins, The* (George), compared to, 45, 47
  Pittsburgh Theatre Center production, 45
  Rossellini, Isabella, interview portrayed, in, 45
  structure, 45
 Vagina Monologues, The, 44
*Entourage* (television series)
 Piven, Jeremy, in, 61
Evangelista, Linda, 12
*Everybody Loves Raymond* (television series), 132, 137
*Extreme Weight Loss* (reality television series), 123, 163, 177
 weightism, as perpetuator of, 163

Faludi, Susan, 16
*Fat Actress* (television series), 7, 123–31
 ad campaign, 124
 Alley, Kirstie, in, 7, 123–31, 133, 134, 142
 "Big Butts" (episode), 126–8, 126
  *9½ Weeks* (film), parody, 127–8
 "Charlie's Angels" (episode), 128–30, 134
 *Drop Dead Diva* (television series), compared to, 131
 faux reality series, as, 154
 Kid Rock, in, 128

*Mike & Molly* (television series), compared to, 132–3, 134, 135
 *Super Fun Night* (television series), compared to, 173
 Travolta, John, in, 126
fat behavior, 19, 63–81, 85, *See also* "more-than-ness"
 *Beautiful Bodies* (Cunningham), in characters, 39–41
 *Fat Chance* (Brochu), characterization of Mattie, 36–8
 *Ma Rainey's Black Bottom* (Wilson), characterization of Ma Rainey, 101–3
 *Most Massive Woman Wins, The* (George), depicted, in, 41–4
 *My Fat Friend* (Laurence), characterization of Vicky, 33–4
 *Night of the Iguana The* (Williams), characterization of Maxine Faulk, 70–2
 *Rose Tattoo, The* (Williams), characterization of Serafina, 66, 67–9
fat, aesthetics of, 2–3, 16, 23, 64
 race and, 97, 103, 110, 111, *See also* Alcoff, Linda Martin; Anderson, Lisa M.; Baartman, Saartjie; fat black miscegenation; Gilman, Sander; *Hairspray* (O'Donnell-Meehan-Shaiman-Wittman musical); *Ma Rainey's Black Bottom* (Wilson); Murray, Samantha; Shaw, Andrea Elizabeth; *Venus* (Parks)
 symbolic violence and, 47
 Williams, Tennessee, reflected in work of, 72
fat, American history of, 12–19, *See also* Barbie; Brown, Helen

Gurley; Fletcher, Horace;
Gibson Girl; LaLanne, Jack;
Monroe, Marilyn; Russell,
Lillian; Miss America
Pageant; Stanton, Elizabeth
Cady; West, Mae
birth control, 14
diet culture, 13, 15–16
print media, in, 13–14, 18–19
fat black miscegenation, 23–5, 97–111
*Fat Chance* (Brochu), 31, 36–9, 47, 56,
113
*Beautiful Bodies* (Cunningham),
compared to, 40
Colony Studio Playhouse (Los
Angeles), production, 36
Mattie (character) , 36–9
Blum, Gertrude (character in *The
Sea Horse*), compared to, 56
Vicky (character in *My Fat
Friend*), compared to, 38
McLanahan, Rue, in, 31, 36
*My Fat Friend* (Laurence), compared
to, 38–9
plot, 36–8
fat, class and, 11, 15–16, 19, 20, 21,
22–4, 26, 27, 36, 40, 41, 57,
97, 107, 125, 132, 136,
137, 143–4, 154–6, 175,
180, 182–3, *See also* Barr,
Roseanne; *Mike & Molly*
(television series)
fat, definitions, 3
fat discrimination, 1–3, 24, 182–4
Morris-Cafiero, Haley, revealed in
work of, 164–5
fat drag, *See* Alley, Kirstie; Jones,
Cherry; Lawrence, Martin;
McLanahan, Rue; Paltrow,
Gwyneth; Redgrave, Lynn
fat dramaturgy, 5, 31–48, 54, 62,
*See also Beautiful Bodies*
(Cunningham); *Fat Chance*
(Brochu); *Good Body, The*
(Ensler); *My Fat Friend*

(Laurence); *Most Massive
Woman Wins, The* (George)
*'Fat' Female Body, The* (Murray), 64
fat-face minstrelsy, 7, 123–37, 154, 163,
165, *See also* Alley, Kirstie;
*Biggest Loser, The* (reality
television series); *Drop Dead
Diva* (television series);
*Extreme Weight Loss* (reality
television series); *Fat Actress*
(television series); *Huge*
(television series); McCarthy,
Melissa; *Mike & Molly*
(television series)
Kuppers, Petra, on, 124–5
fat and health, 1, 3, 5, 16, 19–22
fat and misogyny, 9–10, 16–17, 95
Dunham, Lena on, 170
*My Fat Friend* (Laurence), in, 34
*Two and a Half Men* (television
series), in, 54–5
fat performance, 6, 63–81, 141–61,
142, 150–1, 154, 156–7,
*See also* Alley, Kirstie; Barr,
Roseanne; Cho, Margaret;
Dirty Martini; Dunham,
Lena; McCarthy, Melissa;
Shear, Claudia; Turner,
Kathleen "more-than-ness"
and, 63–5
*Fat Pig* (LaBute), 6, 49, 59–62, 85
Atkinson, Ashlie, in, 60–2
Bacalzo, Dan, *Theatremania* review,
61–2
Bonney, Jo, director, 61
Brantley, Ben, *New York Times*
review, 61
*Frankie and Johnny in the Claire de
Lune* (McNally), compared
to, 59
Helen (character), 59–61
*My Fat Friend* (Laurence), compared
to, 59
Russell, Keri, in, 61
Simon, John, *New York* review, 61

*Fat Politics: The Real Story Behind America's Obesity Epidemic* (Oliver), 20

fat, queerness and, 32–5, 113–21, 148–54, *See also* Cho, Margaret; *Fat Chance* (Brochu); *Killing of Sister George, The* (Marcus); *Ma Rainey's Black Bottom* (Wilson); *My Fat Friend* (Laurence); Parsi, Novid; *Secretaries, The* (Five Lesbian Brothers)

fat stigmatization, 1–3, 20, 123, *See also* weightism
    dieting and, 15
    *Most Massive Woman Wins, The* (George), depicted, in, 43
    race and, 106, 110
    sexuality and, 114
    trend reversal in work of young fat actresses, 186

fat subjectivity, 3, 154, 164, 173

"Fatties on Stage" (Kuppers), 124–5

Faulk, Maxine (character), *See* Davis, Bette; Gardner, Ava; Mason, Marsha; *Night of the Iguana, The*; Williams, Tennessee

*Felicity* (television series), 61

*Feminist Spectator as Critic, The* (Dolan), 158

Ferrell, Conchata, 54–6
    *Hot L Baltimore* (Lanford Wilson play and television series), in, 55
    *Sea Horse, The* (Moore), in, 54
    *Two and a Half Men* (television series), in, 54–5

Finley, Karen, 152

"First Kiss" (*Mike & Molly* episode), 135

Five Lesbian Brothers, 7
    misogyny, highlighted in work of, 117–18
    Phelan, Peggy on, 118
    *Secretaries, The*, 7, 105, 117–20

Foucault's Panopticon, as parody of, 120
    *Killing of Sister George, The* (Marcus), compared to, 117
    male oppression and self-policing, depiction of, 118–20
    plot and character analysis, 118–20
    queerness, depiction of, 120
    Vogel, Paula, compared to, 117

Fletcher, Horace, 15

*Forbes* (magazine), 166

Foucault, Michel, 42, 110–11, 120, 156, 176, *See also* Panopticon
    *Birth of the Clinic*, 110
    "docile body," theory of, 27
    *scientia sexualis*, theory of, 25

*Frankie and Johnny in the Claire de Lune* (McNally), 49, 54, 56–9
    *Fat Pig* (LaBute), compared to, 59
    Frankie, character of, 56–8
    *Moon for the Misbegotten, A* (O'Neill), compared to, 57, 59
    *Sea Horse, The* (Moore), compared to, 56–7, 58–9

Fraser, Laura, 21

Freud, Sigmund, 9

Gaesser, Glenn
    *Big Fat Lies*, 21

Gandolfini, James, 1
    fat stigmatization in responses to death of, 1

Gardell, Billy, 133
    *Mike & Molly* (television series), in, 133, 136–7

Gardner, Ava, 72
    *Night of the Iguana, The* (Williams), in film version (1964), 72

Gazzara, Ben
    *Who's Afraid of Virginia Woolf?* (Albee), in 1976 Albee-directed revival, 75

Gelb, Barbara, 52

*Gender Trouble* (Butler), 142

George, Madeleine
　*Most Massive Woman Wins, The*, 31,
　　41–4, 45, 47, 48
　　fat behavior in characters, 41–4
　　fat stigmatization, depiction of, 43
　　*Good Body, The* (Ensler),
　　　compared to, 45, 47
　　Public Theatre production (1994
　　　Young Playwrights Festival),
　　　41
　　setting, 41

*Georgy Girl* (film), 32, 35

Gibson Girl, 14

Gibson, Charles Davis, 14

Gilman, Sander, 98–100

*Gilmore Girls* (television series), 133
　McCarthy, Melissa, on, 136

*Girls* (television series), 7–8, 154,
　167–72
　*Biggest Loser, The* (reality television
　　series), compared to, 170
　Horvath, Hannah (character), 154,
　　167–72, 173, 184
　"One Man's Trash" (episode), 169–72
　Sackler, Adam, in, 168
　*Sex in the City* (television series),
　　compared to, 170
　*Super Fun Night* (television series),
　　compared to, 173
　*This Ain't Girls* (porn parody), 169
　Wilson, Patrick, controversy
　　surrounding appearance on,
　　169–72

*Glass Menagerie, The* (Williams), 35

Globe Theatre (London)
　*My Fat Friend* (Laurence),
　　production, 32

*Godey's Ladies Book*, 13

*Gone with the Wind* (film), 99

*Good Body, The* (Ensler), 31, 44–8, 59
　Booth Theatre production, 44
　Brown, Helen Gurley, interview
　　portrayed, in, 45
　Hartford Stage production, 45

Isherwood, Charles, *New York Times*
　review of, 46
*Most Massive Woman Wins, The*
　(George), compared to, 45,
　47
Pittsburgh Theatre Center
　production, 45
Rossellini, Isabella, interview
　portrayed, in, 45
structure, 45

"Good Morning Baltimore"
　(*Hairspray*), 107

Goodman, John
　*Roseanne* (television series), in, 155

Graham, Billy, 19

Granny Nanny, 100

Grosz, Elizabeth
　*Space, Time, and Perversion*, 160

Gussow, Mel, 54–5

Hagen, Uta, 54
　*Who's Afraid of Virginia Woolf?*
　　(Albee), in original
　　production (1962), 75

*Hairspray* (O'Donnell-Meehan-
　Shaiman-Wittman musical),
　7, 97, 106–10, 113
　Bernstine, Quincy Tyler, 181
　"Big, Blond, and Beautiful", 109
　*Corny Collins Show, The*, 107
　"Good Morning Baltimore", 107
　Larkin, Link (character)
　　transracial figure, as, 108
　"Legend of Miss Baltimore Crabs,
　　The", 107
　Motormouth Maybelle (character),
　　108–9
　"Nicest Kids in Town", 107
　Turnblad, Edna (character), 108
　Turnblad, Tracy (character), 107–9,
　　113, 181, 184
　Von Tussle, Amber (character),
　　107–8
　Von Tussle, Velma (character), 107
　Winokur, Marissa Jaret, 181

Hannah Horvath (character), *See* Dunham, Lena; *Girls* (television series)

*Harper's* (magazine)
"Let them Eat Fat: The Heavy Truths About American Obesity" (Critser), 25

Hartford Stage
*Good Body, The* (Ensler), production, 45

HBO (cable television network), 1, 7, 61, 154, 158, 167, 170, *See also* Dunham, Lena; *Girls* (television series)

Healey, Peg, 117, *See also* Five Lesbian Brothers; *Secretaries, The*

*Heat, The* (film), 165

Heffington, Ryan
*Sensuous Woman, The* (Cho), striptease number, in, 152–3

*Heidi Chronicles, The* (Wasserstein), 39

*Heiress, The* (R&A Goetz), 54

Hill, Arthur
*Who's Afraid of Virginia Woolf?* (Albee), in original production (1962), 75

Hirschorn, Michael
reality television stars, on, 179

Hogan, Josie (character), *See Moon for the Misbegotten, A*; O'Neill, Eugene

homosexuality, *See* Cho, Margaret; *Fat Chance* (Brochu); fat, queerness and; *Killing of Sister George, The* (Marcus); *Ma Rainey's Black Bottom* (Wilson); *My Fat Friend* (Laurence); Parsi, Novid; *Secretaries, The* (Five Lesbian Brothers)

Horvath, Hannah (character), *See* Dunham, Lena; *Girls* (television series)

*Hot 'n' Throbbing* (Vogel), 7, 86, 89–90
Brechtian techniques, use of, 90

misogyny, highlighted, in, 89
Woman (character), 89–90
L'il Bit (character in *How I Learned to Drive*), compared to, 89–90
physical description, 89

*Hot L Baltimore* (Lanford Wilson play and television series), 55

Houdyshell, Jayne
*Well* (Kron), in, 160

*How I Learned to Drive* (Vogel), 7, 86–9
L'il Bit (character), 86–9
physical appearance, 86–7
Woman (character in *Hot 'n' Throbbing*), compared to, 89–90
misogyny, highlighted, in, 87, 89

*How I Met Your Mother* (television series), 153

*Huge* (television series), 123, 131–2
*Biggest Loser, The* (reality television series), compared to, 132
Blonski, Nikki, in, 132

*Iceman Cometh, The* (O'Neill), 49

*Identity Thief* (film), 165

"info-tainment", 177–9
"Balloon Boy", 178–9
Salahi, Michaele and Tareq, 178
Sullenberger, Chesley, 178

*In the Next Room or The Vibrator Play* (Ruhl), 181
Benanti, Laura, in, 181
Dizzia, Maria, in, 181

"invisibility-conspicuousness", 10, 142
Phelan, Peggy on, 142
Shear, Claudia, as example, 8, 143, 146–8

Irwin, Bill
*Who's Afraid of Virginia Woolf?* (Albee), in 2005 revival, 75, 160

Irwin, James, *See* Moore, Edward J.; *Sea Horse, The*

Isherwood, Charles
  *Good Body, The* (Ensler), *New York Times* review, 46
  Johnston, Kristen in *The Baltimore Waltz* (2004 Signature Theatre revival), on, 92, 159
  Turner, Kathleen in *The Killing of Sister George* (2012 Long Wharf Theatre revival), on, 81, 114

JCPenney
  Herald Square store review (Cintra Wilson), 182
Jenny Craig
  Alley, Kirstie, as spokeswoman, 126, 130, 131, 136
Johnston, Kristen, 161
  *Baltimore Waltz, The* (Vogel), in 2004 Signature Theatre revival, 92, 159
  Jones, Cherry in *The Baltimore Waltz* (Vogel), compared to, 92
Jones, Cherry, 6, 35, 52, 53–4, 92, 141
  *Baltimore Waltz, The* (Vogel), in original production, 92
  *Heiress, The* (R&A Goetz), in, 54
  Johnston, Kristen in *The Baltimore Waltz* (Vogel), compared to, 92
  *Moon for the Misbegotten, A* (O'Neill), in, 52, 92
  Brantley, Ben on, 54
  "more-than-ness," as example, 35–6, 53–4, 141
  weight loss of, 35–6
Josie Hogan (character), *See Moon for the Misbegotten, A*; O'Neill, Eugene
*Journal of the American Medical Association*, 17
Juba, *See* Lane, William Henry
Jumpin' Jim Crow, 7

Kelly, Maura, *See also Marie Claire* (magazine)
  "Should Fatties Get a Room?" (blog entry), 135
Kerr, Walter, 116–17
  *Killing of Sister George, The* (Marcus), *New York Times* review, 116–17
Kid Rock, 128
  *Fat Actress* (television series), in, 128
*Killing of Sister George, The* (Marcus), 7, 114–17
  film version (1968), 114
  Kerr, Walter, *New York Times* review, 116–17
  Long Wharf Theatre revival (2012), 81, 114
  Mrs. Mercy (character), 115–16
  Reid, Beryl, in, 114
  *Secretaries, The* (Five Lesbian Brothers), compared to, 117
  Sister George [Buckridge, June] (character), 114–17
    fat behavior of, 114–17
    Ma Rainey (character in *Ma Rainey's Black Bottom*), compared to, 116
    sexual deviance of, 115–17
  Turner, Kathleen, in self-directed revival, 81, 114
Kimmel, Jimmy, 168
Kimmie Boubier (character), *See Super Fun Night* (television series); Wilson, Rebel
*King of Queens, The* (television series), 137
Kron, Lisa, 117, 118, *See also* Five Lesbian Brothers; *Secretaries, The Well*
  Houdyshell, Jayne, in, 160
Kubiak, Anthony, 8, 176–7, 179, 180, 183
  *Agitated States: Performance in the American Theater of Cruelty*, 176

Kubiak, Anthony–*continued*
   American culture as one of
      illusion, theory of, 176
   Puritanical origins of American
      culture, on, 176
Kuppers, Petra
   "Fatties on Stage", 124–5
Kurtz, Swoosie
   *Mike & Molly* (television series),
      in, 133

LaBute, Neil
   *Fat Pig*, 6, 49, 59–62, 85
      Atkinson, Ashlie, in, 60–2
      Bacalzo, Dan, *Theatremania*
         review, 61–2
      Bonney, Jo, director, 61
      *Frankie and Johnny in the
         Claire de Lune* (McNally),
         compared to, 59
      Brantley, Ben, *New York Times*
         review, 61
      Helen (character), 59–61
      *My Fat Friend* (Laurence),
         compared to, 59
      Piven, Jeremy, in, 60–2
      Russell, Keri, in, 61
      Simon, John, *New York* review,
         61
Lacan, Jacques, 9, 177
*Ladies Home Journal*, 13, 19
LaLanne, Jack, 19
Lane, William Henry, 130, 136
Lange, Jessica, 80
*Larry King Live* (television show), 178
Laurence, Charles, 6, 40
   *My Fat Friend*, 6, 31, 32–6, 47, 59,
      113, 133
      Barnes, Clive, on, 32
      *Beautiful Bodies* (Cunningham),
         compared to, 40
      Brooks Atkinson Theatre,
         production, 32
      *Fat Chance* (Brochu), compared
         to, 38–9
      *Fat Pig* (LaBute), compared to, 59

Globe Theatre (London),
   production, 32
Henry (character), 32, 37
homosexuality, representation
   of, 32–5
*Mike & Molly* (television series),
   compared to, 133
Morrow, Lance, *Time* review, 32
plot, 32–3
Redgrave, Lynn, in, 31, 32
Rose, George, in, 32
Vicky (character), 32–5, 38
fat characterization, 33–4
Lawrence, Martin, 130
LeBesco, Kathleen, 182–3
   *Revolting Bodies*, 79
"Legend of Miss Baltimore Crabs, The"
   (*Hairspray*), 107
lesbianism, *See* Cho, Margaret; *Fat
   Chance* (Brochu); fat,
   queerness and; *Killing of
   Sister George, The* (Marcus);
   *Ma Rainey's Black Bottom*
   (Wilson); *My Fat Friend*
   (Laurence); Parsi, Novid;
   *Secretaries, The* (Five Lesbian
   Brothers)
Letts, Tracy, 75
   *Who's Afraid of Virginia Woolf?*
      (Albee), in 2012 revival, 75
"Liebestod" (*Tristan und Isolde*
   [Wagner]), 153
Lifetime (cable television network),
   123, 131–2, *See also Drop
   Dead Diva*
*Lizard Lick Towing* (reality television
   series), 177
*Long Day's Journey Into Night*
   (O'Neill), 49
Long Wharf Theatre, 114
   *Killing of Sister George, The*
      (Marcus), Turner-directed
      revival (2012), 81
*Losing It: America's Obsession with
   Weight and the Industry That
   Feeds on It* (Fraser), 21

Lott, Eric, 128–30, 132–3
  *Love and Theft: Blackface Minstreslsy and the American Working Class*, 125–6
*Love and Theft: Blackface Minstreslsy and the American Working Class* (Lott), 125–6
Luna, Selene, 150
  *Sensuous Woman, The* (Cho), in, 150
"Lynn Redgrave Fat? Only with Pads Now" (*New York Times* article), 35

"Mapping Embodied Deviance" (Terry, Urla), 110
*Ma Rainey's Black Bottom* (Wilson), 7, 97, 100–4, 113, 116, 121, 144
  Dussie Mae (character), 102, 113
  Ma Rainey (character), 101–3
  fat behavior of, 101–3
  Faulk, Maxine (character in *The Night of the Iguana*), compared to, 103
  Martha (character in *Who's Afraid of Virginia Woolf?*), compared to, 103
  physical description, 102
  sexual deviance of, 102
  Sister George (character in *The Killing of Sister George*), compared to, 116
  Merritt, Theresa, in, 103
  Rich, Frank, *New York Times* review, 144

Madonna [Ciccone, Madonna Louise], 23
Magnani, Anna, 65, 67
  *Rose Tattoo, The* (Williams), written for, 65
*Mammary Plays, The* (Vogel), 86
Manahan, Anna
  *Beauty Queen of Leenane, The* (McDonough), in, 160
Manhattan Theatre Club

*Frankie and Johnny in the Claire de Lune* (McNally), production, 56
Manheim, Camryn, 147
Marcus, Frank, 114, 116
  *Killing of Sister George, The*, 7, 114–17
  film version (1968), 114
  Kerr, Walter, review of, 116–17
  Long Wharf Theatre revival (2012), 81, 114
  Mrs. Mercy (character), 115–16
  Reid, Beryl, in original productions and film version, 114
  *Secretaries, The* (Five Lesbian Brothers), compared to, 117
  Sister George [Buckridge, June] (character), 114–17
  Turner, Kathleen in self-directed revival, 81, 114
*Marie Claire* (magazine), 135, 167
Marraccini, Linda, *See* Dirty Martini (burlesque dancer)
Martha (character), *See* Albee, Edward; Dewhurst, Colleen; Hagen, Uta; Morton, Amy; Turner, Kathleen; Taylor, Elizabeth; *Who's Afraid of Virginia Woolf?*
Martin, Trayvon, 109
*Masculine Domination* (Bourdieu), 47
Mason, Marsha
  *Night of the Iguana, The* (Williams), in
  Canby, Vincent, on, 72
Maxine Faulk (character), *See* Davis, Bette; Gardner, Ava; Mason, Marsha; *Night of the Iguana, The*; Williams, Tennessee
Mayo, Lisa, 4–5, *See also* Spiderwoman Theater
MCC Theatre
  *Fat Pig* (LaBute), production, 59–60
*McCall's* (magazine), 19

McCarthy, Melissa, 7, 133, 165–7, *166*, 183, 186
 Alley, Kirstie, compared to, 136
 *Bridesmaids* (film), in, 165
 celebrity status, 137
 *Elle* (magazine), featured in "Women in Hollywood" issue, 166
 fat authenticity of, 136–7
 fat stigmatization, potential end of, 186
 *Gilmore Girls* (television series), in, 133
 *Heat, The* (film), in, 165
 *Identity Thief* (film), in, 165
 mainstream movies, success, in, 123
 *Marie Claire* (magazine), in, 135, 167
 *Mike & Molly* (television series), in, 7, 123–4, 133, 136–7, 165
 *Odd Couple, The* (Simon), in "Oscar" role, 165
 Oscar nomination, 165
 Reed, Rex on, 7
McDaniel, Hattie, 99
McDonough, Martin
 Beauty Queen of Leenane, The
  Manahan, Anna, in, 160
McEntire, Reba, 157
McKinnon, Pam
 *Who's Afraid of Virginia Woolf?* (Albee), director, 2012 revival, 75
McLanahan, Rue, 31, 36
 *Fat Chance* (Brochu), in, 31, 36
McNally, Terrence
 *Frankie and Johnny in the Claire de Lune*, 49, 54, 56–9
  *Fat Pig* (LaBute), compared to, 59
  Frankie, character of, 56–8
  *Moon for the Misbegotten, A* (O'Neill), compared to, 57, 59
  *Sea Horse, The* (Moore), compared to, 56–7, 58–9
Meehan, Thomas, 107, *See also Hairspray* (musical, with

O'Donnell, Shaiman, Wittman) Merleau-Ponty, Maurice, 110
Merritt, Theresa
 *Ma Rainey's Black Bottom* (Wilson), in, 103
Metcalf, Laurie
 *Roseanne* (television series), in, 155
*Mike & Molly* (television series), 7, 123–4, 127, 131–7, 163, 165
 *Fat Actress* (television series), compared to, 132–3, 134, 135
 "First Kiss" (episode), 135
 Gardell, Billy, in, 133, 136–7
 Kurtz, Swoosie, in, 133
 McCarthy, Melissa, in, 7, 133, 136–7, 165
 Molly (character), 132, 133–5
 queer affinity, 133
*Misery* (film)
 Bates, Kathy, in, 134
Miss America Pageant, 17
Monroe, Marilyn, 18, 23, 124
*Moon for the Misbegotten, A* (O'Neill), 6, 92, 141, 159–60
 Best, Eve, in, 53–4
 Dewhurst, Colleen, in, 53, 54
 *Frankie and Johnny in the Claire de Lune* (McNally), compared to, 57, 59
 Gelb, Barbara, *New York Times* review, 52
 Hogan, Josie (character), 49–52, 160
  analysis, 50–2
  Blum, Gertrude (character in *The Sea Horse*), compared to, 55
  fat stereotypes, 50
  physical description, 49–50
  "more-than-ness," as example, 53–4
  portrayals, 52–4
  sexuality of, 50–2
 Jones, Cherry, in, 52, 53–4
 Nelligan, Kate, in, 53
 original production (1947), 49

Quintero, José, director, 1974
    revival, 53
Robards, Jason, in, 53, 54
Welch, Mary, in, 50, 52
Moore, Demi, 153
Moore, Edward J.
    *Sea Horse, The*, 49, 54–6, 58, 59
        Blum, Gertrude, character of,
            55–6
        Circle Repertory Theatre
            production, 54
        *Fat Pig* (LaBute), compared to, 59
        Ferrell, Conchata, in, 54
        *Frankie and Johnny in the
            Claire de Lune* (McNally),
            compared to, 56–7, 58–9
        plot, 55–6
        Riskin, Susan, written for, 57
Morris-Cafiero, Haley, 164–5
    "Wait Watchers" (photographic
        series), 164–5
    fat discrimination, revealed in work
        of, 164–5
Morrow, Lance
"more-than-ness", 2–3, *See also* fat
        behavior
    Davis, Bette, as example, 72
    Dewhurst, Colleen, as example, 141
    fat performance and, 63–5
    Faulk, Maxine (character in *The
        Night of the Iguana*), as
        example, 72
    health, as historic reflection of, 2, 13
    Jones, Cherry, as example, 35–6,
        53–4, 141
    Serafina (character in *The Rose
        Tattoo*), as example, 65–6
    Stapleton, Maureen, as example,
        67, 141
    Turner, Kathleen, as example, 141
Morton, Amy
    *Who's Afraid of Virginia Woolf?*
        (Albee) in 2012 revival, 75
*Most Massive Woman Wins, The*
    (George), 31, 41–4, 48

fat behavior in characters, 41–4
fat stigmatization, depiction of, 43
*Good Body, The* (Ensler), compared
    to, 45, 47
Public Theatre production
    (1994 Young Playwrights
    Festival), 41
setting, 41
MTV Video Music Awards, 150
Murray, Samantha, 110–11
    'Fat' Female Body, The*, 64
*My Fat Friend* (Laurence), 6, 31, 32–6,
    47, 59, 113, 133
    Barnes, Clive, on, 32
    *Beautiful Bodies* (Cunningham),
        compared to, 40
    Brooks Atkinson Theatre,
        production, 32
    *Fat Chance* (Brochu), compared to,
        38–9
    *Fat Pig* (LaBute), compared to, 59
    Globe Theatre (London),
        production, 32
    Henry (character), 32–5, 37
    homosexuality, representation of,
        32–5
    *Mike & Molly* (television series),
        compared to, 133
    misogynist rhetoric, in, 34
    Morrow, Lance, *Time* review, 32
    plot, 32–3
    Redgrave, Lynn, in, 31, 32
    Rose, George, in, 32
    Vicky (character), 32–5
        fat characterization, 33–4
        Mattie (character in *Fat Chance*),
            compared to, 38

Nelligan, Kate
    *Moon for the Misbegotten, A*
        (O'Neill), in Rich, Frank,
        on, 53
*New England Journal of Medicine*,
    20, 23
*New York Magazine*, 61, 159

New York Theatre Workshop
  *Blown Sideways Through Life*
    (Shear), production, 144
*New York Times*, 20, 35, 52, 61, 72, 80,
    81, 114, 143, 160, 182, *See
    also* Brantley, Ben; Gelb,
    Barbara; Canby, Vincent;
    Gussow, Mel; Isherwood,
    Charles; Kerr, Walter; Rich,
    Frank
  *Beauty Queen of Leenane, The*,
    review (Brantley), 160
  *Blown Sideways Through Life*, review
    (Rich), 143, 144
  "Critical Shopper Review" (Cintra
    Wilson), 182
  "Death Rate from Obesity Gains
    Fast on Smoking" (2004
    article), 20
  *Fat Pig*, review (Brantley), 61
  *Good Body, The*, review
    (Isherwood), 46
  *Killing of Sister George, The*, review
    (Isherwood), 81, 114
  "Lynn Redgrave Fat? Only with Pads
    Now" (1974 article), 35
  *Moon for the Misbegotten, A*, review
    (Brantley), 54
  *Moon for the Misbegotten, A*, review
    (Gelb), 52
  *Night of the Iguana, The*, review
    (Canby), 72
  *Sea Horse, The*, review (Gussow), 55
  *Who's Afraid of Virginia Woolf?*,
    review (Brantley), 80, 160
*Newsweek* (magazine)
  Shear, Claudia, interview, 145
"Nicest Kids in Town" (*Hairspray*), 107
Nichols, Mike
  *Who's Afraid of Virginia Woolf?*
    (Albee) film version (1966),
    director, 75
*'night, Mother* (Norman), 5, 158–9
  Bates, Kathy, in, 158–9
  Simon, John, *New York* review, 158

*Night of the Iguana, The* (Williams),
    69–72, 77, 85, 103
  Davis, Bette, in, 72
  Faulk, Maxine (character), 69–72
    animal behavior of, 69–70
    Dawson, Leona (character in
      *Small Craft Warnings*),
      compared to, 73
    fat behavior of, 70–2
    Hannah (character), dramatic
      contrast, 69, 72
    Ma Rainey (character in *Ma
      Rainey's Black Bottom*),
      compared to, 103
    Martha (character in *Who's
      Afraid of Virginia Woolf?*
      (Albee), compared to, 77
    "more-than-ness," as example, 72
    Serafina (character in *The Rose
      Tattoo*), compared to, 70
  film version (1964)
    Burton, Richard, in, 72
    Gardner, Ava, in, 72
Norman, Marsha
  *'night, Mother*, 5, 158–9
    Bates, Kathy, in, 158–9

O'Brien, Conan, 172
  Wilson, Rebel, on, 172
O'Donnell, Mark, 107, *See also
    Hairspray* (musical,
    with Meehan, Shaiman,
    Wittman),
O'Donnell, Rosie, 147
O'Neill, Eugene, 49
  *Iceman Cometh, The*, 49
  *Long Day's Journey Into Night*, 49
  *Moon for the Misbegotten, A*, 6,
    49–54, 141, 159–60
    Best, Eve, in, 53–4
    Dewhurst, Colleen, in, 53, 54
    *Frankie and Johnny in the
      Claire de Lune* (McNally),
      compared to, 57, 59
    Gelb, Barbara, on, 52

Hogan, Josie (character), 49–54, 160
Jones, Cherry, in, 52, 53–4, 92
Nelligan, Kate, in, 53
original production (1947), 49
Robards, Jason, in, 53, 54
Welch, Mary, in, 50, 52
*Obesity Myth, The* (Campos), 10, 20
*Odd Couple, The* (Simon), 165
*Oldest Profession, The* (Vogel), 7, 86, 91, 93–5
Burke, Marylouise, in, 94
Signature Theatre 2004 revival, 94
Oliver, J. Eric, 20, 23–4, 26–7, 143, 155
*Fat Politics: The Real Story Behind America's Obesity Epidemic*, 20
"One Man's Trash" (*Girls* episode), 169–72
Overeaters Anonymous, 133

Paltrow, Gwyneth
*Shallow Hal* (film), in, 4, 130
Panopticon, 11–12, 42, 120, 176, *See also* Bentham, Jeremy; Foucault, Michel
Parks, Suzan-Lori, 7
*Venus*, 7, 97, 100, 104–6, 121
Anderson, Lisa M., on, 104
Baron Docteur, The (character), 105–6
fat stigmatization and race, depiction of, 106
Venus (character), 104–6
Wilson, August, compared to, 106
Parsi, Novid, 121
Parton, Dolly
"Proud to Be an American," recording used in *The Sensuous Woman* (Cho), 151
"Performance, Utopia and the 'Utopian Performative'" (Dolan), 185
Peyser, Marc
Shear, Claudia, on, 145
Phelan, Peggy, 118
Five Lesbian Brothers, on, 118

"invisibility-conspicuousness," on, 142
*Unmarked*, 142
*Pitch Perfect* (film), 172
Pittsburgh Theatre Center
*Good Body, The* (Ensler), production, 45
Piven, Jeremy, 60–1
*Entourage* (television series), in, 61
*Fat Pig* (LaBute), in, 60–2
Plato, 9
Post, Emily, 17
*Precious* (film), 183
Sidibe, Gabourey, in, 183
Presley, Elvis, 108
"Proud to Be an American" (Lee Greenwood song), 151
Public Theater
*Most Massive Woman Wins, The* (George), production (Young Playwrights Festival 1994), 41
*Purity and Danger* (Douglas), 66, 145
*Pygmalion* (Shaw), 32

queerness, *See* Cho, Margaret; *Fat Chance* (Brochu); fat, queerness and; *Killing of Sister George, The* (Marcus); *Ma Rainey's Black Bottom* (Wilson); *My Fat Friend* (Laurence); Parsi, Novid; *Secretaries, The* (Five Lesbian Brothers)
Quintero, José
*Moon for the Misbegotten, A* (O'Neill), (1974 revival), director, 53

race, *See* fat black miscegenation; *Hairspray* (O'Donnell-Meehan-Shaiman-Wittman musical); *Ma Rainey's Black Bottom* (Wilson); *Venus* (Parks)

Rainey, Gertrude "Ma", 101
  *Ma Rainey's Black Bottom* (Wilson),
    characterization, in, 101–4
  West, Mae, compared to, 101
Ray, Anthony, *See* Sir Mix-A-Lot
*Real Housewives of D.C, The* (reality
    television series)
  Salahi, Michaele and Tareq, in, 178
*Real Housewives, The* (reality television
    series franchise), 177
reality television, 163–4, 170, 177–80,
    *See also Biggest Loser,
    The*; *Extreme Weight Loss*;
    "info-tainment"
Redgrave, Lynn, 6, 31, 32, 35–6
  *Georgy Girl* (film), in, 32, 35
  "Lynn Redgrave Fat? Only with
    Pads Now" (*New York Times*
    article), 35
  *My Fat Friend* (Laurence), in,
    31, 32
  weight loss, 35–6
  Weight Watchers spokesperson,
    as, 35
Reed, Rex
  McCarthy, Melissa, on, 7
Reid, Beryl
  *Killing of Sister George, The*
    (Marcus), in original
    productions and film
    version, 114
*Revolting Bodies* (LeBesco), 79
Rich, Frank, 53, 103
  *Blown Sideways Through Life*
    (Shear), review of, 144
  Merritt, Theresa in *Ma Rainey's
    Black Bottom* (Wilson), on,
    103
  Nelligan, Kate in *Moon for the
    Misbegotten, A* (O'Neill),
    on, 53
  Shear, Claudia, on, 143–4, 146
  weightism reflected in writing of, 53,
    103, 144
Richardson, Natasha, 80

Riskin, Susan, 54, 57
Robards, Jason, 54
  *Moon for the Misbegotten, A*
    (O'Neill), in 1974 revival,
    53, 54
*Rose Tattoo, The* (Williams), 65–9, 85,
    141
  Circle in the Square revival, 67
  Magnani, Anna, in, 65
  Ruehl, Mercedes, in, 67
  Serafina (character), 65–9
    animal behavior of, 66–7
    Dawson, Leona (character in
      *Small Craft Warnings*),
      compared to, 73
    fat behavior of, 66, 67–9
    Faulk, Maxine (character in
      *The Night of the Iguana*),
      compared to, 70
    physical description, 65, 67
  Stapleton, Maureen, in, 67
Rose, George
  *My Fat Friend* (Laurence), in, 32
Roseanne, *See* Barr, Roseanne
*Roseanne* (television series), 126, 137,
    142, 155
  Goodman, John, in, 155
  Metcalf, Laurie, in, 155
Ross, Diana, 98
Rossellini, Isabella
  *Good Body, The* (Ensler), interview
    portrayed, in, 45
Rowe, Kathleen, 155–6
  Barr, Roseanne, on, 157
Ruehl, Mercedes, 67
  *Rose Tattoo, The* (Williams), in, 67
Ruhl, Sarah
  *In the Next Room or The Vibrator
    Play*, 181
    Benanti, Laura, in, 181
    Dizzia, Maria, in, 181
Russell, Keri
  *Fat Pig* (LaBute), in, 61
  *Felicity* (television series), in, 61
Russell, Lillian, 5, 13–14, *13*, 23

Sackler, Adam, 168, 169
  *Girls* (television series), in, 168
Salahi, Michaele and Tareq
  "Crashing Couple," as, 178
  *Larry King Live* (television show),
    on, 178
  *Real Housewives of D.C, The* (reality
    television series), on, 178
Salomé, 10
Savran, David
  *Taking It Like a Man*, 142–3
Schneeman, Carolee, 152
*Sea Horse, The* (Moore), 49, 54–6,
    58, 59
  Blum, Gertrude (character), 55–6
    Hogan, Josie (character in *A
      Moon for the Misbegotten*),
      compared to, 55
    Martha (character in *Who's
      Afraid of Virginia Woolf?*),
      compared to, 56
    Mattie (character in *Fat Chance*),
      compared to, 56
  Circle Repertory Theatre
    production, 54
  *Fat Pig* (LaBute), compared to, 59
  Ferrell, Conchata, in, 54
  *Frankie and Johnny in the Claire de
    Lune* (McNally), compared
    to, 56–7, 58–9
  plot, 55–6
  Riskin, Susan, written for, 57
*Second Sex, The* (Beauvoir), 9
*Secretaries, The* (Five Lesbian
    Brothers), 7, 105, 117–20
  *Killing of Sister George, The*
    (Marcus), compared
    to, 117
  male oppression and self-policing,
    depiction of, 118–20
  Panopticon (Foucault), as parody
    of, 120
  plot and character analysis, 118–20
  queerness, depiction of, 120
  *Venus* (Parks), compared to, 105

WOW Café, production, 117
*Sensuous Woman, The* (Cho), 141,
    148–54
  "Chairman Mee-Oow" sequence,
    150–1
  Dirty Martini (burlesque dancer),
    in, 151–2
  fan dance to "Liebestod" (*Tristan
    und Isolde*), 153–4
  Heffington, Ryan, striptease
    number, in, 152–3
  Luna, Selene, in, 150
*Seventeen* (magazine), 19
*Sex* (Mae West play), 17
*Sex in the City* (television series), 170
  *Girls* (television series), compared
    to, 170
Shaiman, Marc, *See Hairspray* (musical,
    with Meehan, O'Donnell,
    Wittman)
*Shallow Hal* (film), 4, 130
Shaw, Andrea Elizabeth, 99–100, 101,
    103, 113
  *Embodiment of Disobedience: Fat
    Black Women's Unruly
    Political Bodies, The*, 99
Shear, Claudia, 7–8, 142–8, 160
  Barr, Roseanne, compared to, 154,
    155, 156
  *Blown Sideways Through Life*, 8, 141,
    142–8, 150
    Cherry Lane Theatre, commercial
      run, 144
    New York Theatre Workshop,
      at, 144
    Rich, Frank review of, 144
    weightism, depictions of, 145
  Cho, Margaret, compared to,
    149, 150
  *Dirty Blonde*, 144
    West, Mae, depiction, in, 144
  "invisibility-conspicuousness," as
    example, 8, 143, 146–8
  *Newsweek* interview, 145
  Peyser, Marc on, 145

"Should Fatties Get a Room?" (Kelly blog entry), 135
Showtime (cable television network), 123, 124, *See also* Alley, Kirstie; *Fat Actress* (television series)
Sidibe, Gabourey, 183
  *Precious* (film), in, 183
Signature Theatre, 94
  *Baltimore Waltz, The* (Vogel), 2004 revival, 92, 159
Simon, John
  *Fat Pig* (LaBute), *New York* review, 61
  *'night, Mother* (Norman), *New York* review, 159
Simon, Neil
  *Barefoot in the Park*, 181
  *Odd Couple, The*, 165
Sir Mix-A-Lot [Ray, Anthony]
  "Baby Got Back" (song), 100
*Small Craft Warnings* (Williams), 72–5, 85
  Carroll, Helena, in, 73
  Dawson, Leona (character), 72–5
    animal behavior of, 73–4
    fat behavior of, 73–5
    Faulk, Maxine (character in *The Night of the Iguana*), compared to, 73
    physical description, 74
    Serafina (character in *The Rose Tattoo*), compared to, 73
*Snow White and the Seven Dwarfs* (Disney film), 17
*So You Think You Can Dance* (reality television series), 177
Sommer, Elyse
  *Baltimore Waltz, The* (Vogel), Signature Theatre revival, *Curtain Up* review, 92
*Sopranos, The* (television series), 1, 153
*Space, Time, and Perversion* (Grosz), 160
Spears, Britney, 88

Cho, Margaret in *The Sensuous Woman*, on, 150
  MTV Video Music Awards, on, 150
Spiderwoman Theater, 5, *See also* Mayo, Lisa
Stanton, Elizabeth Cady, 13
Stapleton, Maureen, 67, 141
  "more-than-ness," as example, 67, 141
  *Rose Tattoo, The* (Williams), in, 67
*Striptease* (film), 153
Sullenberger, Chesley, 178
*Super Fun Night* (television series), 172–3
  Boubier, Kimmie (character), 173
  *Fat Actress* (television series), compared to, 173
  *Girls* (television series), compared to, 173
  Vogel, Paula, compared to work of, 173
*Survivor* (reality television series), 177
*Swamp Men* (reality television series), 177

*Taking It Like a Man* (Savran), 142–3
Taylor, Elizabeth
  *Who's Afraid of Virginia Woolf?* (Albee), in film version, 75, 77
Terry, Jennifer
  "Mapping Embodied Deviance" (with Urla), 110
*Theatremania*
  Bacalzo, Dan
    *Fat Pig* (La Bute), review, 61–2
*This Ain't Girls* (porn parody of *Girls* television series), 169
*Time* (magazine)
  Morrow, Lance
    *My Fat Friend* (Laurence), review, 32
"Toward a Phenomenology of Racial Embodiment" (Alcoff), 109
transracial figure, 108, 110

Alley, Kirstie, as modified example, 128

Travolta, John, 126

*Tristan und Isolde* (Wagner), 153

Turner, Kathleen, 161
  "more-than-ness", as example, 141
  fluctuations in appearance, 81
  *Killing of Sister George, The* (Marcus), in self-directed Long Wharf Theatre revival (2012), 81, 114
  *Who's Afraid of Virginia Woolf?* (Albee), in 2005 revival, 75, *80*–1, 114, 160

Turner, Tina, 98

*Unbearable Weight* (Bordo), 41, 146

*Unmarked* (Phelan), 142

Urla, Jaqueline
  "Mapping Embodied Deviance" (with Terry), 110

*Vagina Monologues, The* (Ensler), 44

Vargas, Alberto, 17

*Venus* (Parks), 7, 97, 100, 104–6, 121
  Anderson, Lisa M., on, 104
  Baron Docteur, The (character), 105–6
  fat stigmatization and race, depiction of, 106
  *Secretaries, The* (Five Lesbian Brothers), compared to, 105
  Venus (character), 104–6

Venus Hottentot, The, *See* Baartman, Saartjie; *Venus* (Parks)

*Veronica's Closet* (television series), 124

Vogel, Paula, 6–7, 77, 85–95, 105, 173
  Albee, Edward, compared to, 85, 88, 95
  *Baltimore Waltz, The*, 7, 86, 91–2
    Anna (character), 91–2
    Johnston, Kristen, in, 92, 159
    Jones, Cherry, in, 92
    plot, 91
    Signature Theatre revival (2004), 92
    Sommer, Elyse *Curtain Up* review, 92

Five Lesbian Brothers, compared to, 117

*Hot 'n' Throbbing*, 7, 86, 89–90
  Brechtian techniques, use of, 90
  misogyny, highlighted, in, 89
  Woman (character), 89–90

*How I Learned to Drive*, 7, 86–9
  L'il Bit (character), 86–9
  misogyny, highlighted, in, 87, 89

*Mammary Plays, The*, 86

*Oldest Profession, The*, 7, 86, 91, 93–5
  Burke, Marylouise, in, 94
  physical appetite of characters, 93–5
  Signature Theatre revival (2004), 94

Williams, Tennessee, compared to, 85, 88, 95

"Wait Watchers" (Morris-Cafiero photographic series), 164–5

Wasserstein, Wendy
  *Heidi Chronicles, The*, 39

Weight Watchers, 19, 89, 90
  Redgrave, Lynn, as spokesperson, 35

weightism, 7, 8, 9, *See also* fat stigmatization
  Alley, Kirstie, as perpetuator of, 125, 128, 163
  Cho, Margaret, attacks as examples of, 148–9, 154
  reality television and, 163
  Rich, Frank, reflected in writing of, 103, 144
  Shear, Claudia, depictions in *Blown Sideways Through Life*, 145
  Wilson, Cintra, reflected in writing of, 182

Welch, Mary
  *Moon for* the *Misbegotten, A* (O'Neill), in, 50, 52

*Well* (Kron)
  Houdyshell, Jane, in, 160

West, Mae, 17–18, 101, 144
  Barr, Roseanne, compared to, 155

*Dirty Blonde* (Shear), depiction, in, 144
Rainey, Gertrude "Ma," compared to, 101
*Sex* (play), 17
Westside Theatre
*Sea Horse, The* (Moore), production, 54, 56
*Who's Afraid of Virginia Woolf?* (Albee), 6, 56, 65, 75–81, 85, 103, 135, 141, 159–60
Broadway revival (1976)
Albee, Edward, director, 75
Dewhurst, Colleen, in, 75
Gazzara, Ben, in, 75
Broadway revival (2005)
Irwin, Bill, in, 75, 160
Turner, Kathleen, in, 75, *80*-1, 114
Broadway revival (2012)
Letts, Tracy, in, 75
McKinnon, Pam, director, 75
Morton, Amy, in, 75
Tony nominations and wins, 75
film version (1966), 76–7
Burton, Richard, in, 75
Nichols, Mike, director, 75
Taylor, Elizabeth, in, 75, 77
Martha (character), 6, 65, 76–81, 103, 114, 160
animal behavior of, 76–7
Blum, Gertrude (character in *The Sea Horse*), compared to, 56
fat behavior of, 76–9
Faulk, Maxine (character in *The Night of the Iguana*), compared to, 77
Honey (character), contrasted with, 78–80
Ma Rainey (character in *Ma Rainey's Black Bottom*), compared to, 103
Molly (character in *Mike & Molly*), compared to, 135
physical description, 76

original production (1962)
Hagen, Uta, in, 75
Hill, Arthur, in, 75
Turner, Kathleen, in, 160
Whole Theatre (Montclair, New Jersey)
*Beautiful Bodies* (Cunningham), premiere (1987), 40
Wilke, Hannah, 152
Williams, Tennessee, 6, 65–75, 77, 79
Broadway revivals, 80, 86
fat behavior of characters, 85
fat identity of characters, 81, 95
*Glass Menagerie, The*, 35
*Night of the Iguana, The*, 69–72, 77, 85, 103
Davis, Bette, in, 72
Faulk, Maxine (character), 69–72, 73, 77, 103
film version (1964)
Burton, Richard, in, 72
Gardner, Ava, in, 72
Mason, Marsha, in, 72
*Who's Afraid of Virginia Woolf?* (Albee), compared to, 78
*Rose Tattoo, The*, 65–9, 85, 141
Circle in the Square revival, 67
Magnani, Anna, in, 65
Ruehl, Mercedes, in, 67
Serafina (character), 65–9, 73
Stapleton, Maureen, in, 67
*Small Craft Warnings*, 72–5, 85
Carroll, Helena, in, 73
Dawson, Leona (character), 72–5
Vogel, Paula, compared to, 85, 88, 95
Williams, Vanessa, 99
Wilson, August, 7
*Ma Rainey's Black Bottom*, 7, 97, 100–4, 113, 116, 121, 144
Dussie Mae (character), 102, 113
Ma Rainey (character), 101–3
Merritt, Theresa, in, 103
Rich, Frank, review of, 144
Parks, Suzan-Lori, compared to, 106

Wilson, Cintra, 182
  weightism reflected in writing of,
    182
Wilson, Lanford, 55
Wilson, Patrick, 8, 169–72
  Dunham, Lena, on, 170–2
Wilson, Rebel, 8, 165, 167, 179, 183
  *Bridesmaids* (film), in, 172
  Dunham, Lena, compared to,
    172, 173
  fat stigmatization, end of, 186
  McCarthy, Melissa, compared
    to, 172
  O'Brien, Conan on, 172
  *Pitch Perfect* (film), in, 172
  *Super Fun Night* (television series),
    in, 172–3
Winokur, Marissa Jaret
  *Hairspray* (O'Donnell-Meehan-
    Shaiman-Wittman musical),
    in, 181

Winters, Shelley, 161
  *Effect of Gamma Rays on Man-
    in-the-Moon Marigolds*
    (Zindel), in, 159
*Wire, The* (television series), 153
Wittman, Scott, *See Hairspray* (musical,
    with Meehan, O'Donnell,
    Shaiman)
Wolf, Naomi, 16
  *Beauty Myth, The*, 79
WOW Café
  *Secretaries, The* (Five Lesbian
    Brothers), production, 117

Zindel, Paul
  Effect of Gamma Rays on Man-in-
    the-Moon Marigolds, The
    Winters, Shelley, in, 159
Zipper Factory, The
  *Sensuous Woman, The* (Cho),
    production, 150